Mendelowitz's Guide to Drawing

reproduced on the cover

Vincent van Gogh
(1853–1890; Dutch-French).
Les Saintes Maries de la Mer, detail. 1888.
Reed pen and ink on paper.
Musées Royaux des Beaux-Arts
de Belgique, Brussels.

Third Edition

Mendelowitz's Guide to Drawing

Revised by

Duane A. Wakeham
College of San Mateo

Holt, Rinehart and Winston
New York Chicago San Francisco Philadelphia
Montreal Toronto London Sydney
Tokyo Mexico City Rio de Janeiro Madrid

To Daniel Mendelowitz
Painter and Teacher
A Gentle and Honest Man

Acquiring Editor **Karen Dubno**
Project Editor **Karen Mugler**
Picture Coordinator **Barbara Curialle**
Production Manager **Nancy Myers**
Art Director **Louis Scardino**

Library of Congress Cataloging in Publication Data

Mendelowitz, Daniel Marcus.
 Mendelowitz's Guide to drawing.

 Rev. ed. of: A guide to drawing. c1976.
 Includes bibliographical references and index.
 1. Drawing—Technique. I. Wakeham, Duane, date
II. Title. III. Title: Guide to drawing.
NC730.M396 1982 741.2 81-20318
ISBN 0-03-057294-0 AACR2

Copyright © 1982 by CBS College Publishing
Copyright © 1967, 1976 by Holt, Rinehart and Winston
Address correspondence to:
383 Madison Avenue
New York, N.Y. 10017
All rights reserved
Printed in the United States of America
Published simultaneously in Canada
6 7 8 046 7 6 5

CBS COLLEGE PUBLISHING
Holt, Rinehart and Winston
The Dryden Press
Saunders College Publishing

Preface

Mendelowitz's Guide to Drawing is a comprehensive and systematic introduction to the art of drawing, focusing on the mastery of traditional skills as the basis for expressive drawing. It introduces the various categories of drawings and the functions they can perform, analyzes the basic art elements, explores media and techniques, and examines traditional areas of subject matter. Each topic is accompanied by a rich selection of master drawings as well as by a progression of studio projects designed both to allow beginning students, working alone or under the direction of a teacher, to master basic skills, and to encourage advanced students to use those skills creatively and expressively. The assignments have been made as flexible as possible so that they will serve the needs of many situations.

In September 1979 Daniel M. Mendelowitz, Professor Emeritus of Stanford University, invited me to assist him in preparing this third edition of his very respected introduction to the art of drawing. His request was made on the basis of a long friendship that began when, as a graduate student at Stanford, I was assigned to be his teaching assistant. During a period of twenty years I was his student, teaching colleague, and occasional painting companion. Throughout those years I benefited from his sensitive and thoughtful criticism, insightful guidance, and warm and generous encouragement. It was apparent that our shared attitudes about art and teaching would enable us to work together effectively in this new relationship.

I accepted his invitation with enthusiasm. Initial planning got under way, and we quickly agreed upon the major changes to be made. Professor Mendelowitz began outlining a new chapter on composition, a subject of particular interest to him, while I began restructuring the material on perspective. Unfortunately, his

death in February 1980 prevented him from working out the details of the project, and the responsibility for carrying out his intentions fell to me.

His brilliant organization of the previous edition greatly facilitated the process of revision. While closely following the format of the earlier volume, I have made a number of changes and additions. The analysis of the art elements in Part Three has been expanded to include the new chapter on composition. In the same section, the chapter on perspective has been thoroughly revised. The chapters in Part Five that deal with traditional areas of subject matter have been placed in a new sequence in order to introduce still life first; working from readily available still-life subjects, the novice gains drawing experience that will be useful in later excursions into landscape drawing, figure drawing, and portraiture. An introduction to illustration has been added as a new feature in Part Six. More than half of the illustrations are new to this edition, and American artists are represented more fully. The number of projects has been increased, and more sketchbook activities have been included. I feel confident that these changes and the new material are faithful to the character and intent of Professor Mendelowitz's plan for the book, and that they will result in a text that is even more broadly applicable and more useful to beginning drawing students than previous editions.

Many people have assisted in the preparation of this revised edition of *Mendelowitz's Guide to Drawing.* I am grateful to Mrs. Daniel Mendelowitz for her initial encouragement when I first was asked to participate in the revision and for her continued expression of confidence when carrying out the project became my responsibility. I want to acknowledge the contributions of two of my colleagues at College of San Mateo: Alanson Appleton, who gave me generous and expert assistance in preparing Chapter 14, "The Portrait," and Joe Price, whose lecture survey of commercial illustration provided the general outline for Chapter 15. The following teachers reviewed the manuscript: Judith M. McWillie, University of Georgia; Stephen Marsh, Daytona Beach Community College; Thomas V. Morgan, Saddleback Community College; and George Roberts, University of Idaho. I thank them for their helpful comments and suggestions.

Special thanks go to Richard Sutherland of Foothill College, who selected and catalogued over 500 drawings as possible illustrations, typed the manuscript in all its various forms, and compiled the index. His sense of purpose and organization were invaluable in all stages of the project.

I want to express my appreciation to the staff at Holt, Rinehart and Winston, particularly to Barbara Curialle for her determination in the difficult task of locating drawings and securing permission to reproduce them, and to Karen Mugler, who expertly guided the book through all stages of production. I was impressed not only by their efficiency but by their patience and good humor.

San Francisco D.A.W.
November 1981

Contents

Contents

Part One
Introduction

1 The Nature of Drawing

"Intimate," "delightful," "spontaneous," "direct," "unlabored"—these adjectives carry special implications of the affection that many critics and connoisseurs feel for that particular form of artistic expression known as *drawing*. Part of the reason for this fondness must certainly reside in the very informal and personal nature of the body of master drawings that comprise our legacy from the past. Unlike more elaborately finished works, drawings offer an intimate contact with the act of creation and thereby permit the viewer insights into the artist's personality. Like notes in a diary, drawings often present direct notation made by artists for themselves alone, free of artificial elaboration or excess finish.

If we compare a master painting with one of its preliminary sketches, we see not only the different approach and manner of execution characteristic of the two processes, but we also find hints of the artist's progress in conceptualization (Figs. 1, 2). In the drawing, we can sense the impulses that formed the final work and can perhaps see the gestation process that accompanied its creation. An exciting empathy occurs as we recognize the artist's enthusiasms, the sense of discovery, the lively interplay of hand, eye, mind, brush, pen, or pencil, and paper—all intensely human aspects of the creative art.

Another factor also helps to explain the appeal and power of drawing. The incomplete or fragmentary work, precisely because it does not provide a fully developed statement, may evoke a greater play of the observer's imagination than does a more finished expression. A sketchy work can be interpreted and becomes meaningful in terms of the viewer's individual experience. Our minds can readily supply the unspecified details in Eugène Delacroix's *Arab on Horseback Attacked by a Lion* (Fig. 3). By contrast the closure of a carefully finished work such as Jean Auguste Dominique Ingres' *Doctor Robin* (Fig. 4) largely excludes such imaginative wanderings on the part of the viewer.

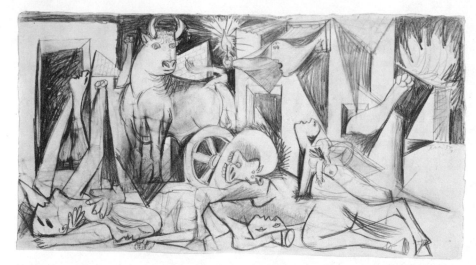

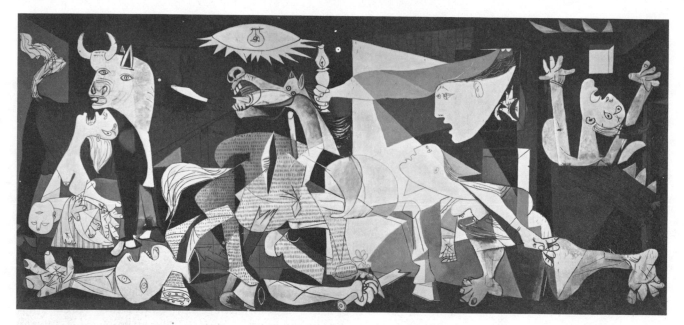

What Is Drawing?

The word *drawing* is used today almost exclusively in relation to the visual arts, and its meaning is generally understood. However, the origins of its precise definitions offer interesting insights. "Draw" comes from a source common to both Latin and Teutonic languages and means to "pull" or "drag"—an idea still evident in nonartistic contexts, as when we say "drawing a cart across the road." Of course, the act of drawing implies making a mark by pulling or dragging a tool across a receptive background, usually a piece of paper.

A quick glance through Part Four of this book will reveal that drawing encompasses a potentially endless variety of media. While it is perhaps more common to think of drawing in terms of black marks on white paper, many drawings include color, even a full spectrum of colors. Contemporary drawing exhibitions have come to include almost any works done on paper, with the result that it is almost impossible to separate drawing from painting (Fig. 5).

One source of confusion is the common reference to drawing as a "graphic art." Technically, this term should be reserved for print processes such as etching, engraving, lithography, and serigraphy, in which *multiple* images are transferred to paper from a master plate, block, or silkscreen. A drawing, by compari-

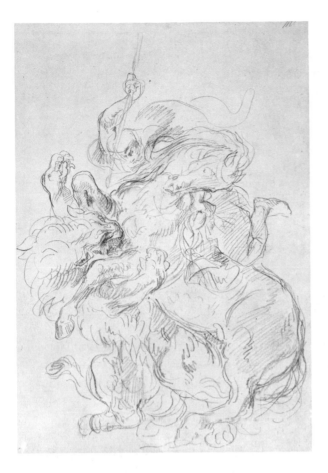

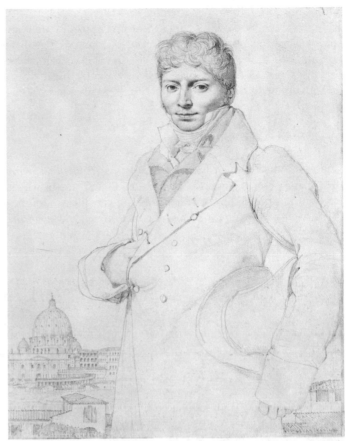

above: 3. Eugène Delacroix (1798–1863; French).
An Arab on Horseback Attacked by a Lion. 1849.
Pencil, 18⅛ × 12″ (46 × 30 cm).
Fogg Art Museum, Harvard University, Cambridge, Mass.
(Meta and Paul J. Sachs Collection).

above right: 4. Jean Auguste Dominique Ingres
(1780–1867; French).
Doctor Robin. c. 1808–09.
Pencil, 11 × 8¾″ (28 × 22 cm).
Art Institute of Chicago
(gift of Emily Crane Chadbourne).

right: 5. Robbie Conal (b. 1944; American).
Ghost of a Chance. 1980.
Powdered graphite, pencil, and oil paint on rag paper;
4′9″ × 3′7½″ (1.45 × 1.1 m).
Courtesy the artist.

son, is unique, calling for the initial and direct application of image to ground. It is appropriate, however, to include some prints in an analysis of drawing since the original images were drawn onto the master plates (Fig. 6).

Categorization in all the visual arts has become increasingly less important; the lines between areas of endeavor have blurred. Artists today worry more about achieving the desired effect than about what process is used.

Types of Drawings

Chapter 3 discusses at length the various types of drawings and the functions they can perform. As an introduction to the art, however, we should briefly touch upon the different roles drawing can fill. We might identify three broad categories—drawings that *describe, visualize,* and *symbolize.*

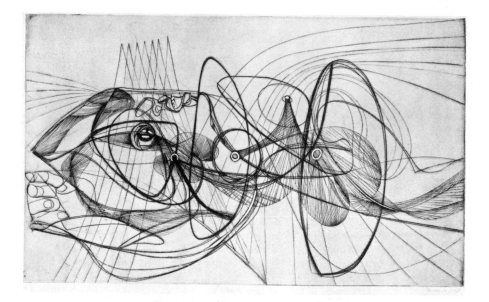

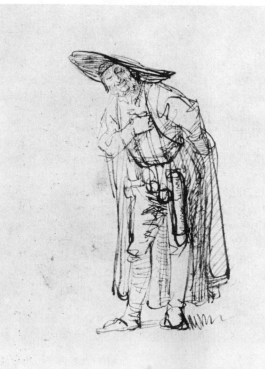

above: 6. Stanley William Hayter (b. 1901; English). *Death by Water.* 1948. Engraving, 13⅜ × 23″ (35 × 59 cm). National Gallery of Art, Washington (Rosenwald Collection).

left: 7. Rembrandt van Rijn (1606–1669; Dutch). *Actor in the Character of Pantalone.* Pen and brown ink, 7½ × 5″ (19 × 13 cm). Groninger Museum, Groningen, Netherlands.

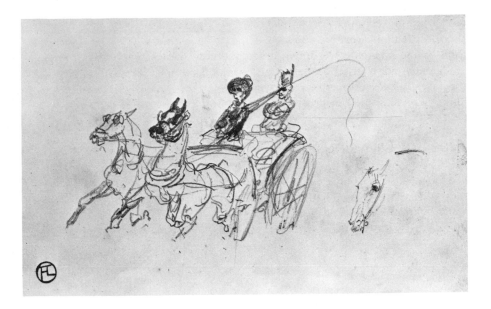

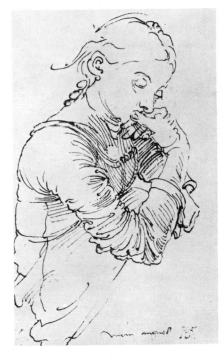

To many people, drawing means recording that which is before the eyes. This may entail a quick sketch executed in a personal shorthand that demonstrates the unique traits of the artist (Figs. 7, 8) or a carefully observed study, greatly detailed and nearly photographic in its accuracy (Figs. 16, 20). A drawing can be done in pure line (Fig. 9) or with lights and shadows for modeling, or the artist might choose to enrich it with color (Pl. 11, p. 255).

Drawing can also visualize a nonexistent situation or an object conceived in the imagination of the artist (Figs. 10, 45). It could even be an abstract vision that gives few clues to its figurative origins, if indeed these exist (Fig. 11). Controlled splotches, smears, streaks, and runs, valued for their own expressive character as well as for their textural variety, add still another dimension to the abstract repertoire (Fig. 12).

The third category of drawings is based upon the use of symbols. Objects, ideas, and concepts are represented as plans, diagrams, or cartoons (Figs. 10,

The Nature of Drawing

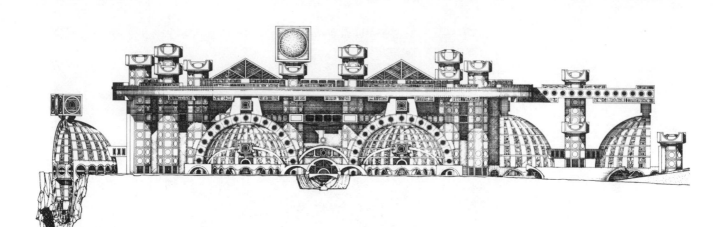

above: 10. Paolo Soleri (b. 1919; Italian-American).
Arcosanti (elevation for proposed megastructure). c. 1969.
Pen and ink, 4 × 13' (1.22 × 3.96 m).

left: 11. Bruce Conner (b. 1933; American).
Untitled. 1962.
Pen and ink,
12 × 8⅞'' (30 × 23 cm).
Courtesy the artist.

below: 12. Jackson Pollock (1912–1956; American).
Birthday Card. 1951.
Ink and wash on paper,
16 × 20'' (41 × 51 cm).
Collection Clement Greenberg, New York.

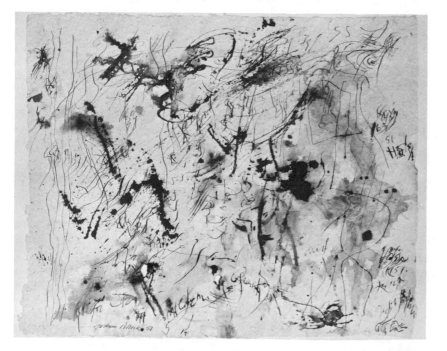

18). The various forms of symbolization are employed to allow direct and precise visual communication.

Claes Oldenburg utilized each of the three categories in his drawings of a drum pedal (Figs. 13–15). Figure 13 represents the drum pedal as most people might expect to see such an object. In Figure 14, Oldenburg has imaginatively visualized the assembly in two different states of collapse, while the *Schematic Rendering* (Fig. 15) is a diagram that explains how the mechanism is assembled. All three drawings depict the same object, yet each drawing serves a separate function and provides the viewer with different information.

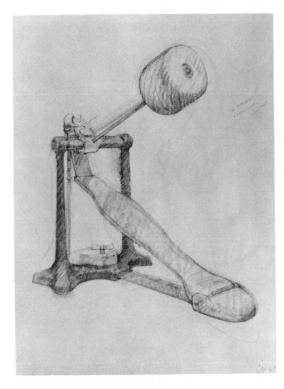

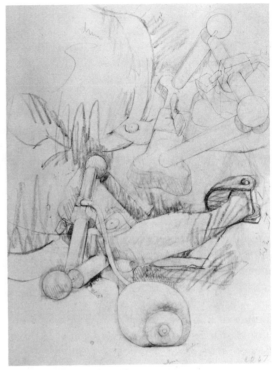

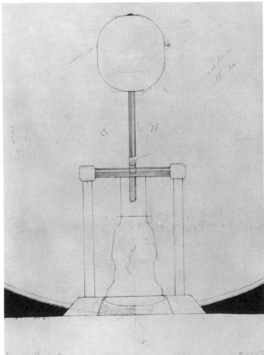

above left: 13. Claes Oldenburg
(b. 1929; Swedish-American).
Drum Pedal Study. 1967.
Pencil, 29 × 21½'' (74 × 55 cm).
Collection Kimiko and John Powers.

above: 14. Claes Oldenburg
(b. 1929; Swedish-American).
*Drum Pedal Study—Visualization
of Collapsed Version.* 1967.
Pencil, 29 × 25½'' (74 × 65 cm).
Collection Kimiko and John Powers.

left: 15. Claes Oldenburg
(b. 1929; Swedish-American).
*Drum Pedal Study—Schematic
Rendering from Back.* 1967.
Pencil and wash,
29 × 21½'' (74 × 55 cm).
Collection Kimiko and John Powers.

The three categories need not be treated independently. The drawing of the collapsed pedal, for example, incorporates both visualization and description. In each category, drawings can range from simplified, preliminary indications of form and ideas to intricately detailed, finished drawings. The effectiveness and completeness of any drawing depends not so much upon elaborate development as upon the degree to which it conveys the artist's intent.

Expressive Drawing

It has been said that Pablo Picasso was born knowing everything there was to know about drawing. In contrast, Vincent van Gogh is described as a person with no natural talent who became an artist through sheer determination. Although many people believe that they cannot draw, those with an interest in learning, plus the willingness and persistence to master some basic skills, can develop the ability to record with a certain degree of accuracy objects that are placed before them. Such drawing depends to a large degree upon learning to see. Drawing, however, as suggested by the examples reproduced in this book, involves more than making an accurate rendering of a subject, just as it requires more than the skillful manipulation of media and technique. Drawing is about content; it presents a point of view, interpretation, and expressions of the individual artist.

As viewers we respond to those works that not only draw us closest to the artist by allowing us to share an interest, emotion, or insight, but also allow us to project our own experience and feelings. We find most appealing drawings that offer more than an ordinary depiction of a subject, drawings that reveal qualities about the artist as well as the subject. In studies of Manet (Fig. 16), Edgar Degas depicts his model with great sensitivity, creating from direct observation an image that is both literal and poetic. Less literal, though nonetheless compelling, is Larry Rivers' portrait of Edwin Denby III (Fig. 17), which combines vigorous drawing with a keen sense of selectivity. Equally effective in conveying a strong feeling of humanity, in spite of the deceptively childlike quality of the drawing, is Paul Klee's *Trio Conversing* (Fig. 18). Comparing the three works, each done in pencil, we can see that while the choice of medium and technique contributes significantly to the effectiveness of the drawings, it is the individual sensitivity, character, and intention of the artist that gives expressive character to each of the works.

The Role of Drawing Today

Like much else in our artistic heritage, our conceptions about the role of drawing in the arts comes to us largely from the Renaissance. During the early years of that period, drawing as we now practice it became established as the foundation of training in the arts. A long-term academic apprenticeship, which called for drawing from nature as well as copying studies executed by master artists, prepared students for their profession. In later centuries this system, with only slight alteration, continued as the accepted means of artistic training.

In the 20th century this procedure has been seriously challenged. The impact of abstract painting, of Expressionism, Conceptualism, Minimal Art, and other contemporary movements tends to make the arduous disciplines of earlier times seem irrelevant to the needs of the contemporary student. Many teachers and students go further. They believe that highly structured training can even inhibit the development of original and innovative forms of expression by encouraging students to depend upon trite and outworn formulas, rather than allowing their inner resources free play.

The early training of artists as diverse as Henri Matisse, Pablo Picasso, Paul Klee, Wassily Kandinsky and Piet Mondrian—all schooled in the conventional

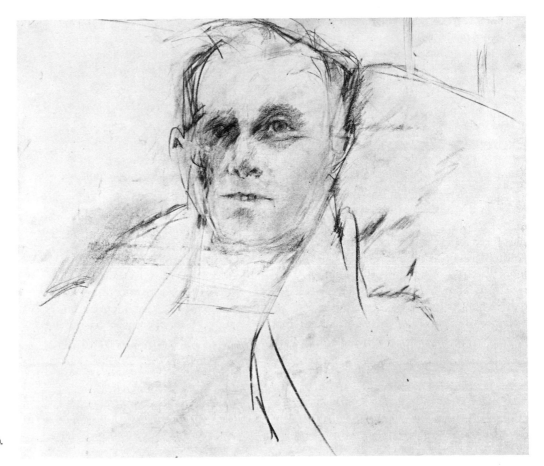

below:
16. Edgar Degas
(1834–1917; French).
Studies of Manet.
c. 1864–65.
Pencil on pink paper,
16 × 11'' (41 × 28 cm).
Louvre, Paris.

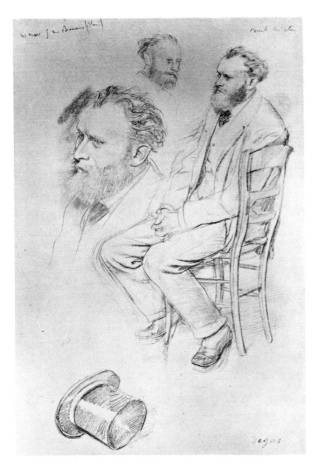

above: 17. Larry Rivers
(b. 1923; American).
Edwin Denby III.
1953. Pencil,
16⅜ × 19¾'' (42 × 50 cm).
Museum of Modern Art, New
York (given anonymously).

below: 18. Paul Klee
(1879–1940; Swiss-German).
Trio Conversing.
1939. Pencil,
8½ × 11½'' (21 × 29 cm).
Collection Felix Klee, Bern.

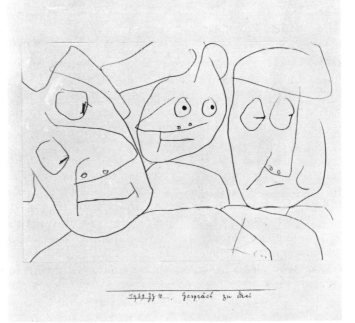

The Nature of Drawing

regimen—would seem to contradict this attitude. Matisse himself, in a 1948 letter, wrote:

> I have always tried to hide my own efforts and wished my work to have the lightness and joyousness of a springtime which never lets anyone know the labors it has cost. So I am afraid the young, seeing in my work only the apparent facility and negligence in the drawing, will use this as an excuse for dispensing with certain efforts I believe necessary [Fig. 19].

The initial experiences of the beginner leave an indelible imprint upon subsequent development. While academic procedures of the rigidity maintained in the ateliers of past masters no longer seem appropriate, a program of guidance and instruction remains vital to artistic development. Although making accurate descriptive drawings need not be the ultimate goal, learning to *see* size, shape, and space relationships and developing the discipline and control to translate convincingly what is seen onto a sheet of paper, provide a basic and essential vocabulary for the artist. Having acquired that vocabulary, the artist is then free

19. Henri Matisse
(1869–1954; French).
Acrobat. 1952.
Brush and black ink on paper,
41⅜ × 29½″ (105 × 75 cm).
Private collection.

20. James Torlakson
(b. 1951; American).
Bondage.
1980. Pencil,
10 × 13⅞″ (25 × 35 cm).
Brooklyn Museum.

to choose to draw in whatever style is pleasing and seems appropriate to that which is to be expressed.

Rather than abandoning the discipline of drawing as irrelevant to contemporary art, we must learn to reinterpret the craft in terms of today's standards. A much wider range of expression is now accepted as drawing than was true in the past. This is a natural outgrowth of the increased variety of styles that exist generally in the art world where abstractions (Fig. 12) flourish side by side with the most disciplined realism (Fig. 20; Pl. 6, p. 221) or with exuberant whimsy (Fig. 18). Our increased catholicity of taste is, to an equal extent, the result of psychological understanding about the nature of human beings, with a consequent sympathy toward a broader range of expression.

Drawing has an essential role to play in our world, both as a means to an end—in the development or conceptualization of other expressions—and as an end in itself. The revived popularity of representational styles testifies to a felt need for draftsmanly qualities in art. Most important, however, is the immediacy of drawing—a quality perfectly in tune with the spontaneity and free expression so greatly prized in contemporary society. Drawing is very much an art of today.

Part Two
Initial
Experiences

The subject chapters that follow have been structured around a series of projects with specific instructions for novice artists. In order that individual students be stimulated to realize their unique personal capacities, the projects encompass a very wide range of activities. The purpose of the assignments is not to make beautiful drawings, nor even necessarily to make successful drawings. The purpose is to learn to draw by making drawings—many drawings. Success should not be determined on the basis of one experience, one drawing. Students should not discard any of their drawings since development and improvement become most apparent when later works are compared to early efforts.

Students working without a teacher might prefer to carry out the suggested projects in the order in which they appear. Generally speaking, the exercises increase in difficulty throughout the progress of the book, although there is no rigid adherence to this scale. Even if all the projects are not executed, students should read each one carefully to understand the concept presented. If an individual undertaking should not be satisfying, the student should be willing to repeat an assignment. Anything, whether it be playing a musical instrument, meditating, swimming, or drawing, becomes easier and more effective with continued practice.

Practice contributes to increased technical competence and control. Most drawings fail, however, not from lack of skill, but rather from lack of planning. Many artists and students mistakenly believe that planning automatically destroys freshness and spontaneity. The contrary is more often true, since knowing what one intends to do allows the artist to enter into the drawing process directly and spontaneously. The uncertainty and confusion that accompany lack of planning frequently result in working over and overworking a drawing. In such

instances, once the drawing problems have been solved, it can be advantageous to redo the drawing to achieve the desired freshness. When you have been working steadily and closely for an extended period, it is helpful to take a brief break so that you can return, look at what you are doing with a fresh eye, and hence avoid overworking your drawing.

With increasing development of skills, confidence, and intensive interests, the student may wish to concentrate on one type of drawing, one medium, or one variety of subject. This natural tendency should be exploited, since growth in *depth* is more important to artistic maturity than growth in *breadth*. Breadth of experience serves the primary function of helping individuals to find themselves. It is true, however, that any serious and intensive activity eventually demands an expansion of horizons. The beginner must constantly guard against the tendency to buttress an emerging artistic ego by repeating minor successes and thus neglecting the possible discovery of full strengths and capacities.

The work of most mature artists reveals a pattern of periods of intensive concentration within a narrow framework of special problems alternating with periods of exploration and experimentation. It is not only wise, but essential, for the beginner to travel a similar path, concentrating on areas of particular interest as long as they remain challenging but, when success comes too easily, moving on to something else. It is true that without experience any new medium, technique, or subject may seem difficult, yet serious students soon discover that the understanding, discipline, and proficiency developed in one area is directly applicable to another. Although success is not always immediate nor insured, each project, each new experience contributes to creative growth. The value to be derived from the individual assignments can be only that value that the student is willing to give to it. Exploration in breadth combined with concentration in depth requires the unique discipline that characterizes the artist—an inner control in which deep satisfactions and dynamic dissatisfactions alternate to stimulate continued growth. Through such discipline the art student discovers and reveals personal abilities, establishing the basis for mature artistic expression.

The drawings reproduced in this book are offered to acquaint you with a variety of creative uses of media and techniques, to introduce you to different approaches to handling form, composition, and subject matter. You are not encouraged to attempt to copy any of the drawings line for line. There is little value in that. It would be, however, both appropriate and beneficial to practice drawing in the manner of some of the many examples provided for you as a means of acquiring a broader vocabulary.

2

Beginners' Media

Beginners should concentrate on the media that are least demanding. The important thing is to draw as freely and uninhibitedly as possible, so that the transmission of impressions, ideas, and impulses will be direct and unselfconscious. Pencil, charcoal, ball-point pen, felt-tip pen, and brush and ink should meet initial needs and provide ample possibilities for expression. The following equipment and materials are generally standard and suffice to commence working (Fig. 21). Other materials and tools can be added later.

> drawing board (basswood or masonite), 20 by 26 inches
> thumb tacks (to hold individual sheets of paper to basswood board)
> masking tape (to hold individual sheets of paper to masonite board)
> newsprint pad, 18 by 24 inches
> heavy clips (to hold newsprint pad to the drawing board)
> 4B or 6B graphite drawing pencil
> large soft pencil eraser
> stick charcoal (soft) and compressed charcoal (0 or 00)
> kneaded eraser
> chamois
> fixative (and fixative blower if fixative is not available in pressurized cans)
> ball-point and felt-tip pens (medium and wide)
> India ink
> medium-size pointed brush (No. 10), of the best quality you can afford (Note: not an oil painting brush)

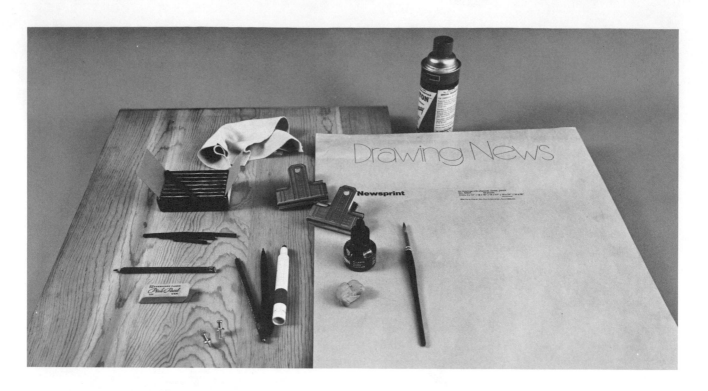

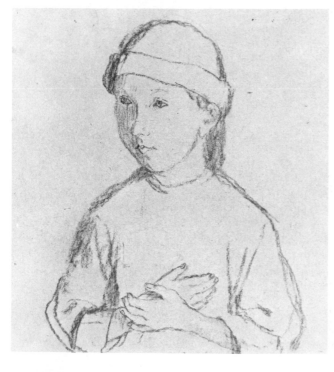

above: 21. Beginners' materials include: drawing board, newsprint, push pins, pencil eraser, drawing pencil (4B), stick and compressed charcoal, chamois, ball-point and felt-tip pens, clips, India ink, kneaded eraser, brush (No. 10 sable), and fixative.

left: 22. Gwen John (1876–1939; English).
Portrait of a Young Girl.
Charcoal on beige paper,
9¼ × 8¾'' (23 × 22 cm).
Courtesy Anthony d'Offay Gallery, London.

Charcoal

Charcoal, which is easy to apply and equally easy to remove, provides a rich and versatile medium for the beginner. At the outset, one should not overvalue expertise. Timidity most often inhibits development, while a relaxed use of charcoal encourages the direct expression of perceptions. Depending on the angle of the stick and the pressure exerted upon it, charcoal lines can be pale or dark, even in width or of varying widths, creating a repertoire for line drawings as well as for value studies (Fig. 22). Charcoal is particularly prized for the ease with which it can produce a wide range of darks and lights of varying textures.

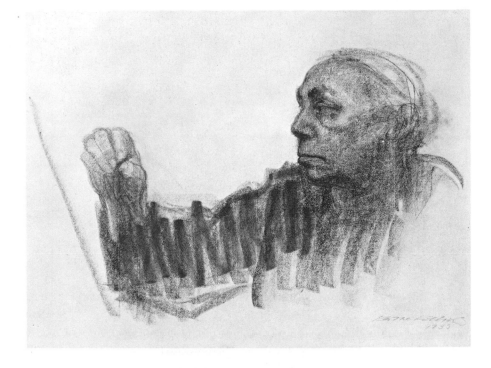

23. Käthe Kollwitz
(1867–1945; German).
Self-Portrait. 1935.
Charcoal on gray paper,
16 × 17'' (41 × 43 cm).
National Gallery of Art,
Washington, D.C.
(Rosenwald Collection).

24. Henri Matisse
(1869–1954; French).
*Reclining Woman with Flowered
Robe.* 1924. Charcoal,
19 × 24½'' (48 × 62 cm).
Baltimore Museum of Art
(Cone Collection).

Values from light gray to black result from dragging the stick on its side (Fig. 23) or from the application of sets of parallel or cross-hatched lines. When grays of minimum texture are desired, parallel lines and cross-hatching can be fused by rubbing gently with the fingers, with soft paper, or with a paper stump known as a *tortillon* (Figs. 24, 25). Charcoal can be easily erased. Large areas can be wiped away with a piece of chamois; more precise corrections can be made with a kneaded eraser that can be shaped to a rather sharp point. Accumulated charcoal dust can be removed from a chamois by flicking it against something solid or by washing it, while charcoal picked up by the eraser disappears in the process of kneading and shaping the eraser.

Beginners' Media

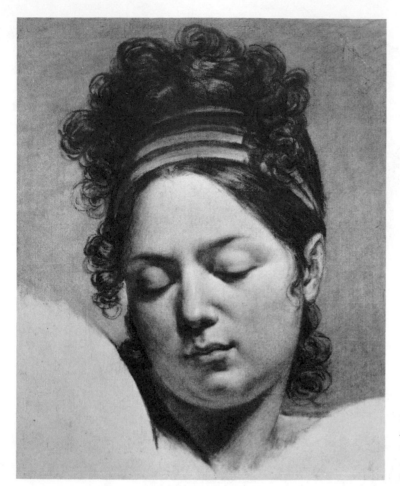

25. Pierre-Paul Prud'hon (1758–1823; French).
Head of a Woman (Marguerite).
Charcoal, 14 × 11″ (36 × 28 cm).
Art Institute of Chicago
(Simeon D. Williams Collection).

Project 1 Familiarize yourself with the nature of charcoal by drawing lines using varying amounts of pressure and changing the angle at which you hold the charcoal stick. Practice building tones with rapidly drawn clusters of diagonal parallel lines and cross-hatched lines. With the side of a piece of charcoal, lay down a smooth gradation of tone from black to very light gray. Do the same with lines fused by your fingers, reinforced by subsequent applications of charcoal and rubbing. In these preliminary exercises you will quickly become aware that while charcoal can be easily blended, it can be just as easily smudged, which necessitates learning to draw without resting your hand on the paper. To steady your hand for precise details, reach across and grasp the opposite side of the board with your other hand, using that arm to support your drawing hand.

Study the drawings in Figures 22 to 25 for the use of charcoal. In the first two examples the artists have relied upon the direct application of charcoal with gradations in tone resulting from variations in pressure rather than from blending as seen in the other drawings. In her *Self-Portrait,* Käthe Kollwitz not only represents herself at the drawing board but also allows the viewer to experience both the mental and physical process of drawing in the powerfully kinetic zigzag line that moves along the length of the arm connecting the eye, mind, and hand (Fig. 23). Notice how she grasps the short piece of charcoal in her fingers, the length being equal to the width of the bold strokes in the drawing. Perhaps nowhere has the act of drawing been more graphically illustrated.

Most of the grain evident in these drawings derives from the texture of the paper itself. The paper used in the 19th century for most charcoal drawings—and still preferred by many artists—has a grainy texture that holds the charcoal (Fig. 23). Newsprint, so popular today, has almost no texture, thus

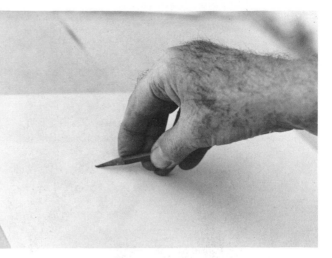

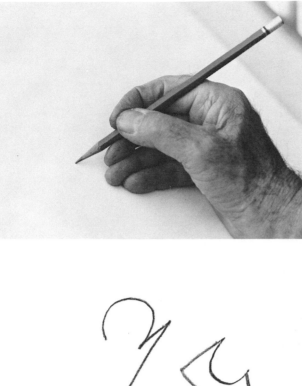

26. Line made by a pencil held in writing position.

27. Line made by a pencil held under the hand.

producing an effect more similar to that seen in Figure 24. In that drawing it appears that much of the detail in the flowered robe has been lifted out with a kneaded eraser.

Compressed charcoal is often referred to as chalk, and indeed many chalks are very similar to charcoal, except that they tend to be harder to erase. All the activities of Project 1 could also be executed in chalk.

Pencil

Project 2 The primary virtues of pencil for drawing are familiarity and relative cleanliness. Sharpen your pencil and scribble freely on a piece of newsprint paper. Observe the quality of line produced by the point of the pencil and by the side of the lead. Note the difference in line quality achieved by holding the pencil in an upright position as for writing (Fig. 26) and by holding it between the thumb and forefinger but under your hand (Fig. 27). Many artists prefer the latter position because it permits easier variation in thickness of the line; a slight shift of hand position utilizes either the point or the side of the lead.

Broad areas of dark value can be developed using a series of broad strokes made with the side of the lead rather than with the point. Draw a series of 2-inch squares and fill them with tones of varying degrees of darkness using the side of the lead. With bold pencil strokes, produce a gradation of tone from light to dark. Create even gray tones with separate strokes closely placed side by side; create other tones without any visible strokes. You will discover that even tones and smooth gradations both depend upon learning to control pressure and maintaining consistent directional patterns.

Beginners' Media

Project 3 Study the range of lines, textures, and values to be seen in Figures 28 to 32 and practice using a drawing pencil to achieve similar effects.

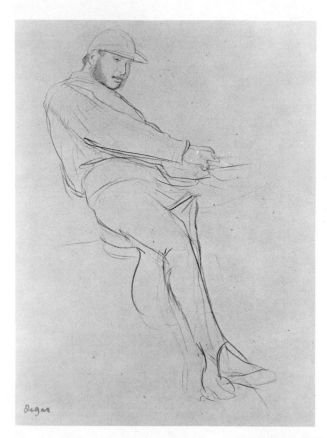

left: 28. Edgar Degas (1834–1917; French).
Jockey. 1878.
Pencil on light gray paper,
12¾ × 9⅝'' (32 × 24 cm).
Detroit Institute of Arts (John S. Newberry Bequest).

below: 29. John Constable (1776–1837; English).
Abingdon from the River. 1821.
Pencil, 6¾ × 10¼'' (17 × 26 cm).
Victoria & Albert Museum, London
(Crown Copyright).

Initial Experiences

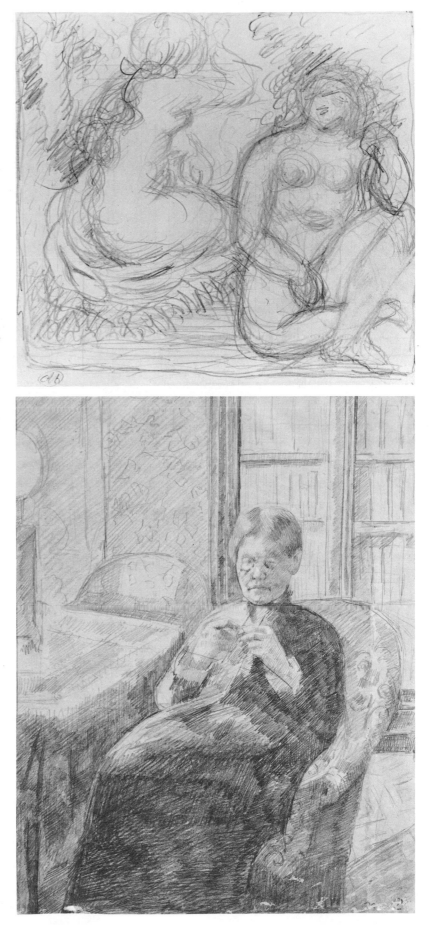

30. Aristide Maillol (1861–1944; French).
Two Nudes. Pencil,
8⅛ × 8¾'' (21 × 22 cm).
Fine Arts Museums of San Francisco,
Achenbach Foundation for Graphic Arts
(gift of Manug K. Terzian).

31. Mary Cassatt (1844–1926; American).
Portrait of an Old Woman Knitting. c. 1881.
Pencil, 11½ × 8¾'' (29 × 22 cm).
Metropolitan Museum of Art, New York
(gift of Mrs. Joseph du Vivier, 1954).

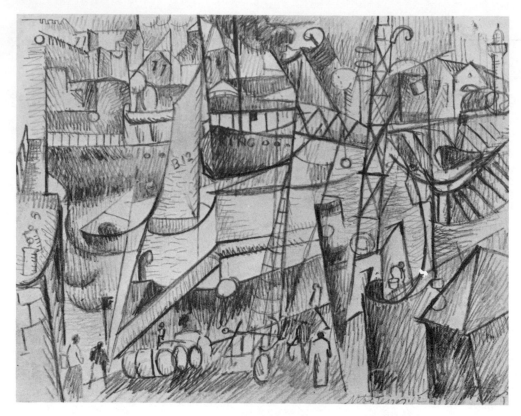

32. Albert Gleizes (1881–1953; French). *Port.* 1912. Pencil, 6 × 7⅝″ (15 × 19 cm). Solomon R. Guggenheim Museum, New York.

Ball-Point and Felt-Tip Pens

The familiar, easy-to-use, ball-point and felt-tip pens are capable of producing a variety of line widths. As such they provide the beginner with a graceful transition from pencil and charcoal to brush and ink. When directed to draw with a ball-point pen, beginning students are inclined to draw in outline. Feliks Topolski's pen-and-ink drawing *E. M. Forster and Benjamin Britten* (Fig. 33) suggests a method, easily duplicated with ball-point pen, that avoids strict outlining. David Park has used broad felt-tip markers to establish large, simplified patterns of light and dark (Fig. 34), while Pamela Davis has added a painterly quality to what is essentially a line drawing by smearing the felt-pen lines with a wet thumb on the arms and shirt (Fig. 35).

Project 4 *Experiment using ball-point and felt-tip pens of varying widths, taking full advantage of the strength and rich textures these pens permit (Fig. 36). Some inks are water-soluble and can be smeared, as in Figure 35; other inks are non-soluble. If you are not familiar with ball-point and felt-tip pens other than for ordinary writing purposes, you should be cautioned that the inks are of questionable permanence and often subject to pronounced fading from extended exposure to light.*

Brush and Ink

Brush and ink demand a certain assurance of execution, since lines cannot be erased. The bold, fluid lines that result from the free play of brush and India ink give a certain authority to a drawing, and a self-confidence emerges from the successful use of the brush. The flexibility of the pointed brush allows for a rich variation in lines and effects.

Initial Experiences

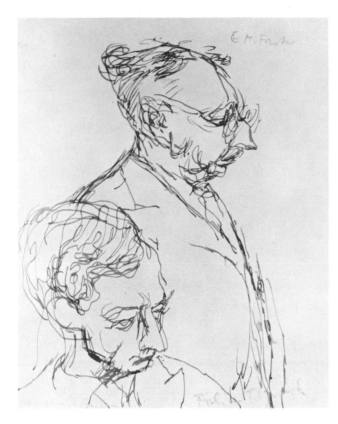

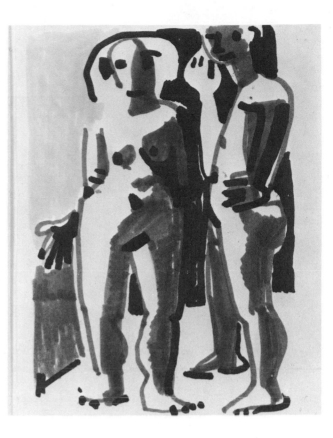

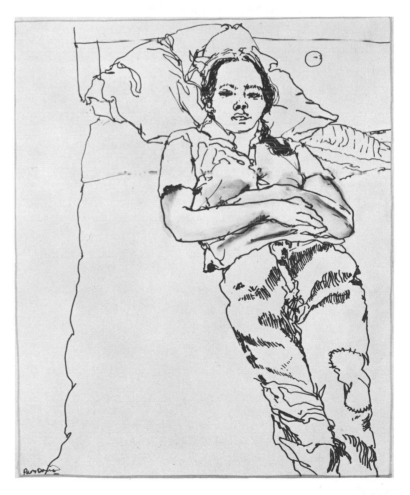

above: 33. Feliks Topolski (b. 1907; Polish).
E. M. Forster and Benjamin Britten.
Pen and brown ink, 9¾ × 7¾'' (25 × 20 cm).
Sotheby Parke-Bernet.

above right: 34. David Park
(1911–1960; American).
Standing Nudes. 1960.
Felt-tip pen, 11 × 9'' (28 × 23 cm).
Courtesy Maxwell Galleries, Ltd.,
San Francisco.

right: 35. Pamela Davis (b. 1955; American).
Carol. 1973.
Felt-tip pen, with wash effect
obtained by smearing with wet fingers;
19½ × 17'' (50 × 43 cm). Courtesy the artist.

above: 36. Paul Schmitt (b. 1937; American).
Farfields. c. 1971.
Felt-tip pen, 10 × 13¾″ (25 × 35 cm).
Collection Dan W. Wheeler, New York.

left: 37. Pablo Picasso (1881–1973; Spanish-French).
L'Amour Masqué. January 5, 1954.
Brush and ink, 12½ × 9⅜″ (32 × 24 cm).
Courtesy Galerie Louise Leiris, Paris.

Initial Experiences

above: 38. Hokusai
(1760–1849; Japanese).
The Mochi Makers,
from an album of studies.
Brush and ink,
16¼ × 11⅝'' (41 × 30 cm).
Metropolitan Museum of Art
(gift in memory of
Charles Stewart Smith, 1914).

right: 39. Ben Shahn
(1898–1969; Russian-American).
Self-Portrait. 1955.
Brush and ink,
9¾ × 6⅛'' (25 × 16 cm).
Museum of Modern Art, New York
(given anonymously).

Project 5 To commence drawing, dip your brush in India ink and then press it against the side of the bottle neck to remove excess ink and create a point. Practice making graduated lines as seen in Figures 37 and 38 by increasing and decreasing the pressure with which the brush is applied to the paper. Notice that the long, flowing lines in both examples convey an impression of lightness and aliveness in contrast to the heavier mood created by using short, broken strokes to delineate the forms in Figure 39. Be aware of the degree to which the choice of line contributes to the expressive character of each drawing. In Figure 40 the textural patterns and suggestions of modeling are done with a fully loaded brush,

Beginners' Media

27

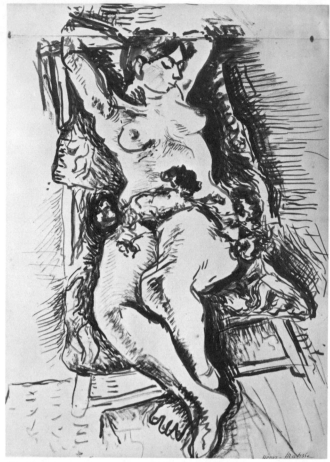

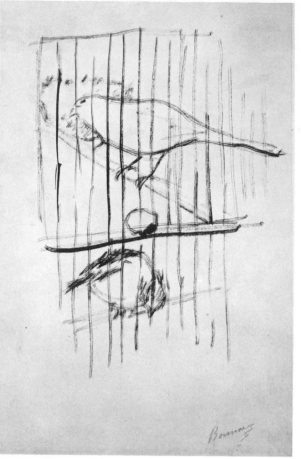

40. Henri Matisse (1869–1954; French).
Nude in a Folding Chair. c. 1906.
Brush and black ink on white paper,
25⅞ × 18⅜″ (66 × 47 cm).
Art Institute of Chicago.

41. Pierre Bonnard (1867–1947; French).
Canaries, drawing for *Histoires Naturelles.*
1904. Brush and ink,
12 × 7½″ (30 × 19 cm).
Phillips Collection, Washington, D.C.

whereas Figure 41 reveals the use of dry-brush. Investigate varied dry-brush ef-
fects by first wiping excess ink from the brush on paper toweling before dragging
the brush lightly over the paper. Observe the different qualities of brushed-ink
lines in the examples provided and then practice using the brush in similar ways.
At first your lines may seem hesitant and self-conscious or random and meaning-
less. Gradually, however, if your intention is to do more than simply cover a sheet
with brush strokes, you will start to feel comfortable working with the brush; you
will begin to develop the control necessary to give meaning and expression to
brush drawings.

3

Learning to Visualize, to Symbolize, to See

The three categories of drawings are those that record what is *seen,* those that *visualize* what is imagined, and those that *symbolize* ideas and concepts. Descriptive drawing, by fixing visual impressions in static forms, makes it possible to build knowledge step by step and eventually to discover the nature of forms too complex to be comprehended at a single glance. Each person's understanding of the visual character of the physical world is achieved largely by this patient accumulation of impressions. Beyond this descriptive function, much drawing serves to visualize ideas and concepts that, no matter how vivid in the mind of the originator, must remain nebulous and undefined until given fixed form. The third general function of drawing is to symbolize. Throughout history the arts have played a fundamental role in providing nonverbal symbols to communicate ideas. Many drawn symbols have the power to evoke the most complex train of associations, to unleash myriad interrelated concepts that historically surround certain motifs. These disparate aspects of drawing do not exclude one another; rather, the greatest drawings achieve their full emotional power because of the grandeur with which they combine all three aesthetic purposes.

42. Henri Michaux (b. 1899; Belgian).
Untitled. 1960. Brush and ink,
29⅜ × 42½'' (75 × 108 cm).
Museum of Modern Art, New York
(gift of Michel Warren
and Daniel Cordier).

Learning to Visualize

Many individuals become self-conscious and develop a "block" when asked to draw from imagination. These same people probably doodle freely, for when doodling they follow unconscious impulses with no concern about the artistic quality of their scribblings. Telephone note pads and school notebooks, particularly those for one's least interesting class, provide evidence of our propensity for doodling. An individual may scribble, make geometric patterns, fill in the empty areas in letters and numbers, embellish some existing design, or improvise in other ways without realizing that this is a type of creative activity.

Many mature artists, confident of their powers, improvise freely. They follow the dictates of their hands and allow pictorial motifs to flow forth in a manner analogous to that which occurs in free-association speech or writing (Fig. 42). A page of what might be seen as doodles by Henry Moore reveals an early stage in the creative process as he begins to visualize possible forms for a piece of sculpture (Fig. 43).

It is particularly valuable for the beginning artist to give free play to powers of improvisation, since the uninhibited markings produced without preplanning further the development of a personal and characteristic style. The idiosyncrasies of line, tone, and texture that appear, the angularities, curves, smoothness, blobbiness, regularity or irregularity of markings—all such preferences confirm and strengthen the unique aspects of an individual's way of working (Fig. 44). Such elements identify an artistic personality even in more disciplined drawings.

From earliest times people have had a natural tendency toward fantasy and visualization. Generations of children are taught to look for the lady or man in the moon, and almost everyone can see the shape of the Big Dipper, even though the images associated with many of the other constellations elude the casual star gazer. Almost everyone has experienced discovering recognizable forms in clouds, foliage, and other surfaces, textures, and patterns, both natural and manufactured. Leonardo da Vinci devoted a section of his notebooks to explaining that an artist looking at water-stained walls, rocks of uneven color, or embers of fire, can see in them "the likeness of divine landscapes . . . battles and strange figures in violent action, expressions of faces and clothes and an infinity

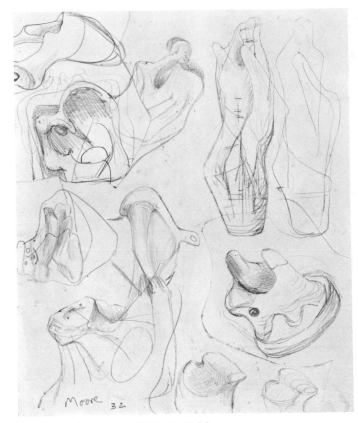

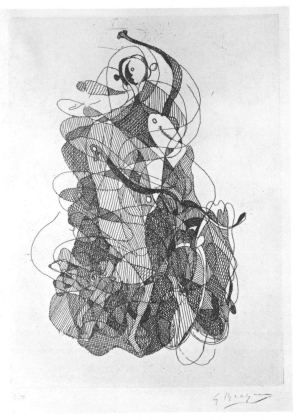

43. Henry Moore (b. 1898; English).
Transformation Drawing. 1932.
Pencil on paper, 9⅜ × 7⅞'' (24 × 20 cm).
Art Gallery of Ontario, Toronto (gift of Henry Moore, 1974).

44. Georges Braque (1887–1963; French).
Théogonie. 1934. Etching, 9⅜ × 6¾'' (24 × 17 cm).
Yale University Art Gallery, New Haven, Conn.
(Steefal Collection).

of things.'' Whether or not artists rely upon such sources, the origins of inspiration and invention are without limit. Artists have a responsibility for feeding their imagination. Students must develop the ability not only to look and see, but to look and imagine—to visualize, to see the different possibilities a single experience can suggest.

Project 6 Scribble randomly over a full sheet of newsprint. Sit back and give your imagination free rein as you look at the shapes and patterns you have drawn. In a relaxed dreamlike state, begin to be aware of the images that seem to appear and disappear. If you find that one image is more persistent than others, work into the drawing to make the form or forms more visible. Create areas of light and dark to define forms and space; add necessary details and develop a sense of composition.

As a variation of this project, look at rocks or rock formations, foliage, or other natural elements to find images. Shifting the direction of light focused on a piece of crumpled paper or cloth provides yet another starting point for stimulating the imagination. No matter what source is selected, beginners are encouraged to draw without inhibition. As you continue working with the projects presented throughout this book, remember that they are offered as learning exercises—the brilliance or success of an individual drawing is secondary to expanding your drawing experience.

Visualization, in addition to stimulating imaginative thinking and imagery, allows the artist to depict things that perhaps exist only as ideas or to give visual form to things not present. In 1972 Christo proposed extending an 18-foot-high cloth fence across 24½ miles of rolling hills in northern California, the fence

Learning to Visualize, to Symbolize, to See

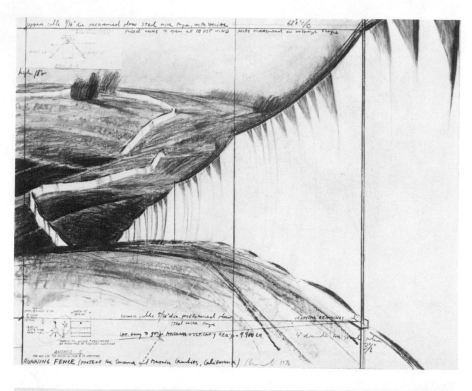

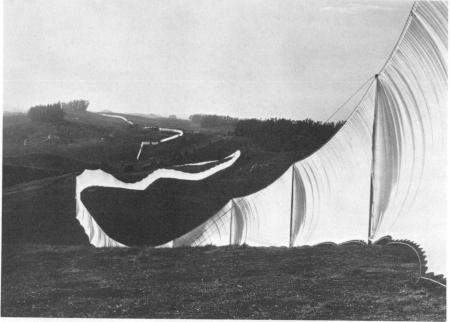

45, 46. Christo
(b. 1935; Bulgarian-American).
Running Fence. 1973–76.

above left: 45. Preparatory work.
Fabric, pastel, charcoal,
pencil and engineering drawings;
22 × 28'' (56 × 71 cm).
Courtesy the artist.

left: 46. *Running Fence* installed
in Sonoma and Marin Counties,
California, for two weeks.
1976. Height 18' (5.49 m),
length 24½ miles (39.43 km).

eventually to disappear into the Pacific Ocean. Having conceived of the Running
Fence, Christo was able to visualize what the effect would be (Fig. 45) before the
actual construction took place three and a half years later (Fig. 46).

Learning to Symbolize

To symbolize means to use a sign to represent, either arbitrarily or through
convention, a more complex entity or idea. Objects and qualities can be repre-
sented by symbols that may or may not resemble the symbolized subject. For
example, the sun is generally symbolized by a full circle surrounded by radiat-

47. Roy Lichtenstein
(b. 1923; American).
Explosion Sketch. c. 1965.
Colored pencil and ink,
5½ × 6½'' (14 × 17 cm).
Collection Mr. and Mrs.
Horace H. Solomon, New York.

48. Anonymous (age 5).
The Jellyfish.
Crayon, 8½ × 11'' (22 × 28 cm).
Collection Mrs. Daniel Mendelowitz,
Stanford, Calif.

ing lines or points, and the moon is commonly represented by a shape that mimics a crescent moon; on the other hand, the symbol used in architectural plans for an electrical outlet has no physical resemblance to an electrical outlet. The basic necessity for a successful symbol is that it be generally understood. Symbols proliferate in folk arts, where they convey widely held and readily accepted meanings. In today's society, trademarks and certain visual devices relied upon by comic strip artists, provide many of the most commonly understood symbols. Part of the nation's heritage is its symbols because they offer an effective means of embodying a complex of ideas into immediately recognized form. Thus, they serve as a convenient shorthand for nonverbal communication.

In *Explosion Sketch* (Fig. 47) Roy Lichtenstein has directly and simply symbolized the radiating waves of energy, matter, and sound typically associated with an explosion. Children between the ages of three and ten rely heavily upon universally understood symbols based on ideas rather than visual analysis. In Figure 48, a young child has symbolized a jellyfish by drawing a known form, the human figure, but giving it a distinct characterizing feature—jellylike legs.

Learning to Visualize, to Symbolize, to See

Project 7 This assignment is directed toward creating a drawing that will symbolize a concept, idea, or feeling. Select one of the following words and do a drawing that symbolizes your concept of that word—"construction," "destruction," "growth," "movement," "anxiety," "tranquility," "transformation." You may choose to work abstractly, relying upon lines, shapes, and patterns, or you can interpret the concept with representational forms (Fig. 129). Michelangelo, for example, believed that it was possible to express any idea using the human figure. Whichever approach you select—perhaps a combination of both—it is important that some aspect of your concept be apparent to another person.

Intensifying Expressive Character

It is important that art students think about and develop those attitudes that will contribute to the emergence of a unique personal style. This is suggested not to impose discouraging unattainable demands for originality and style, but rather to encourage critical analysis of the kinds of solutions that seem most immediately available. Beginning students frequently are willing to settle for imagery that is ordinary and commonplace. Project 7, for example, might easily result in such a drawing.

Symbolic content alone does not determine the full range of meaning conveyed by a symbol. Equally important is the way in which it is drawn. Qualities such as thinness or thickness of lines, the textures resulting from different media and grounds, and all aspects of the art elements affect the expressive character of a symbol and help determine its full meaning. In Ben Shahn's *Silent Music* (Fig. 49) the vivacious, almost humorous delineation of music stands and chairs creates a pattern of criss-crossed and parallel, thin and light lines that suggest musical themes, counterpoint, and harmonies. Very different are the heavier lines evoking more solidly constructed forms in *Davits* as drawn by Stuart Davis (Fig. 50).

49. Ben Shahn
(1898–1969; Russian-American).
Silent Music. 1955.
Screenprint,
17¼ × 35'' (44 × 89 cm).
Philadelphia Museum of Art
(purchase, the Harrison Fund).

Project 8 Look critically at the drawing done for the preceding project and ask yourself whether you would find it interesting if it had been drawn by someone else. Perhaps by working back into the drawing, you can strengthen the image

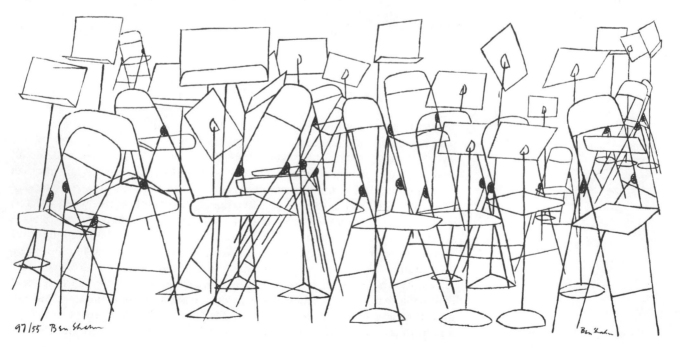

97/55 Ben Shahn

Ben Shahn

50. Stuart Davis
(1894–1964; American).
Davits. 1932.
Brush and ink with chalk,
28¼ × 20¼'' (72 × 51 cm).
Fogg Art Museum, Harvard
University, Cambridge, Mass.
(bequest of Meta and Paul J. Sachs).

through changing the quality of lines, by clarifying or amplifying the light and dark, by making certain lines or shapes more dominant. You might prefer to do a second drawing in which you rethink your original concept, or for which you select a different subject. For this type of assignment, you will find it useful to make small preliminary sketches as a means of examining a variety of possibilities before committing yourself to working full size.

Learning to See

Perhaps the most fundamental discipline involved in drawing is learning to record what one sees. Contrary to popular misconceptions, this is not primarily a matter of manual skills. The physical requisites for drawing are minimal: average sight and average manual dexterity. *Drawing is a matter of seeing,* rather than of 20/20 vision and deft fingers. Here we are not considering the special qualities of an original or powerful artist but rather the skill and habits involved in becoming an adequate draftsman—a person who can look at an object; analyze the relationships of size, shape, space, value, and texture; and then create an analogous set of relationships on paper as a graphic record of visual perceptions.

Learning to draw necessitates learning to see in a new way. From earliest childhood our hands, our bodies, and most of all our eyes—placed in our swivel-pivoting heads—appraise objects in terms of their three-dimensional character. This is how we know them. It is, therefore, frequently difficult for a beginner drawing a cube placed at eye level to avoid showing the top plane of the cube, knowing that it is there even though it cannot be seen. When we start to draw, we are shocked to discover the degree to which any object except a sphere presents a different appearance each time we change the position of our eyes in relation to it. The beginning draftsman is faced with a new problem: three-dimensional knowledge must be reevaluated and translated into two-dimensional patterns based on a fixed relationship between the draftsman's eyes and the object being drawn. Since actual spatial depth is absent from the surface of the drawing paper, three-dimensional reality must be interpreted as a two-dimensional pattern. Descriptive drawing is illusion. Much of learning to draw

Learning to Visualize, to Symbolize, to See

consists of discovering how things *appear* rather than how they *are,* and it is not until we begin to draw that most of us realize the tremendous difference between what we *know* about objects and what we *see.*

Learning to draw, then, demands a reevaluation of visual experience, a new dependence on visual cues about the appearance of objects and their relationships in space. Most of us are familiar with the art of children, which is based upon concepts of how things are; near forms are placed at the bottom of the page, more distant objects appear higher on the page with each separate form depicted as a complete image. Folk artists and traditional Oriental artists often employ the same devices for representing spatial depth. Most people in Western cultures, however, readily accept two other concepts relating to forms in space: (1) one object placed in front of another partially obscures the object in back; (2) objects appear to diminish in size when seen at a distance (Fig. 51). (Think how you shift your head in a movie theater to prevent the relatively small head immediately in front of you from obscuring most of the giant screen.) Both of these aspects are common knowledge and can be observed without any special training; but when we try to depict more subtle phenomena, the problems become more difficult.

51. Henri de Toulouse-Lautrec (1864–1901; French). *The Laundress.* 1888. Brush and black ink, with opaque white on cardboard; 30 × 24¾″ (76 × 63 cm). Cleveland Museum of Art (gift of Hanna Fund).

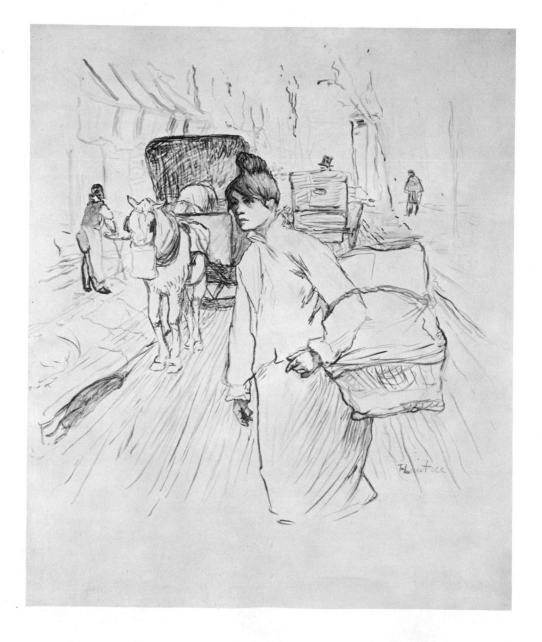

Foreshortening

The representation of three-dimensional forms as seen from a variety of view-points demands a precise kind of observation. Changes occur in the appearance of a single object when the viewpoint is altered. Geometric or architectural objects are seen and drawn in *perspective,* which can be accomplished by following a system of rules (see Chapter 8). *Foreshortening* is the term that applies to organic and anatomical forms seen in perspective. Drawing a foreshortened view depends upon the careful observation of overlapping shapes and diminishing scale rather than upon a set of rules (Figs. 52, 53).

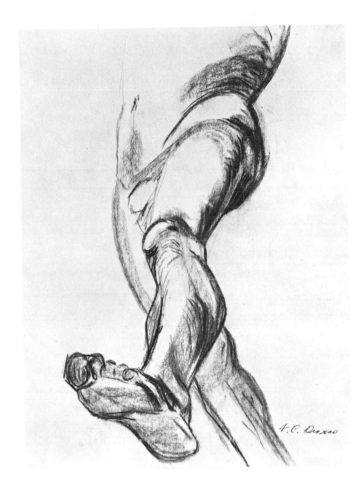

left: 52 José Clemente Orozco (1883–1949; Mexican).
Legs. 1938–39. Charcoal on light gray paper,
25⅞ × 19⅝'' (66 × 50 cm).
Museum of Modern Art, New York (Inter-American Fund).

right: 53. John Hamilton Mortimer
(1741–1779; English). *Reclining Nude.*
Pen and wash, 8⅞ × 10⅞'' (23 × 28 cm).
Art Institute of Chicago.

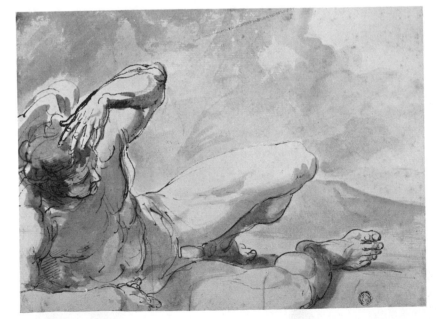

Project 9 Drawing the complex undulations of large leaves involves a careful analysis of the twistings and turnings of foreshortened forms. Select a large, not too flat leaf that is fairly rigid, preferably with undulating edges. A tracing of the leaf pressed flat would provide one description of the leaf, but one having little to do with its appearance as it exists in space. Identical as they may be in size and shape, no two leaves on a plant will be seen as the same shape, nor will any single leaf retain the same appearance when viewed from a different angle. As you work on this assignment, try to avoid thinking of the leaf as a leaf; see it instead simply as lines and shapes. Draw the form as viewed from many different angles, noticing the constantly changing relationships of shape, size, and proportions. You will discover that you produce more accurate descriptions of the form selected by attending to lines, shapes, and proportions rather than by "trying" to draw a leaf.

Project 10 Take a branch with three or four leaves on it and draw the cluster—magnolia or avocado leaves are excellent (Fig. 54). Most important in this and subsequent projects is to base your drawings on visual analysis. Look repeatedly at what you are drawing. Draw exactly what you see, not what you think you know or what you think it should be. Make a similar sequence of drawings of other fairly large, solid, organic objects.

Project 11 The foreshortening of simple rectangular forms can be introduced by making some drawings of this book. The book will appear as a perfect rectangle only if held vertically at eye level or placed flat on a table and viewed directly from above. In any other position it acquires a nonrectangular shape. Draw the book in a number of positions seen from varying viewpoints. In doing so, do not think of it either as a book or a rectangle. See it simply as a series of shapes enclosed within four straight lines, lines that sometimes appear to be parallel, sometimes appear to converge. Though you know the actual shape and proportions of the rectangle, draw what you see, even when the narrow width of the rectangle appears to be much greater than its length. You will become aware that visual

54. Ellsworth Kelly
(b. 1923; American).
Five-Leaved Tropical Plant. 1981.
Pencil on paper,
18 × 24″ (46 × 61 cm).
Collection Mr. and Mrs.
S. I. Newhouse, Jr., New York.

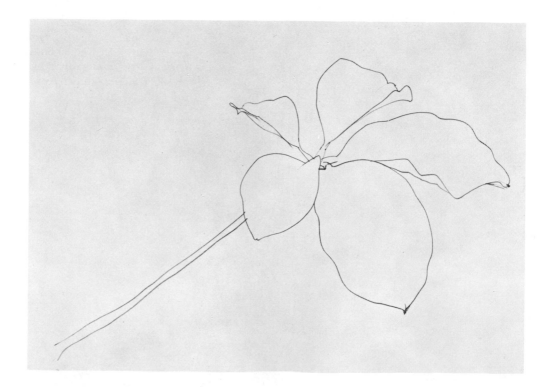

analysis of a geometric shape is unrelated to determining the exact dimensions of the object; it is a matter of establishing relative proportions. A more systematic development of perspective will be undertaken in Chapter 8.

Mechanical Aids to Perception

We have been working with relatively simple forms to acquaint the beginning student with habits and concepts involved in representational drawing. The next project, involving more complex forms, introduces certain mechanical aids and procedures useful in determining relationships of size and shape. Although the ultimate goal is to develop eye, mind, and hand coordination, one should be familiar with any simple mechanical aid that can help ascertain size and shape relationships and help determine the correct position or angle of a line. Sometimes such devices help to guide initial judgments at the start of a drawing; sometimes they help identify mistakes.

Certain poses and gestures are frequently employed to identify particular activities. To mimic an artist at work, one has only to close one eye and sight along an upright thumb extended at arm's length. In truth, this gesture depicts one of the most useful aids to perception. It is an action that even the most experienced artists employ to great advantage, especially during the preliminary stages of drawing and painting from life.

Figures 55 to 57 illustrate how a pencil can be used to check critical vertical and horizontal alignments, as well as serve as a measuring device to determine proportional relationships. If you are positioned directly in front of your drawing, it is possible to locate the horizontal by sighting along the top of your drawing board; the vertical can be determined by using the corner of a room or building. It is easier to maintain the correct angle when the pencil is held at arm's length. Consistent measurements depend upon holding the implement at arm's length, since any change in distance between the pencil and the eye destroys the accuracy of the measurement.

In Figure 55 the pencil, used as a plumb line, is held so that it appears to rest against the front leg. It indicates that the bottom of the leg is to the left of the

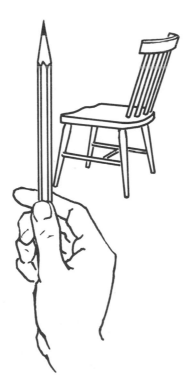

55–57. Any drawing instrument can be a useful aid in perceiving alignments.

55. Held in a vertical position, a pencil serves as a plumb line to determine vertical alignments.

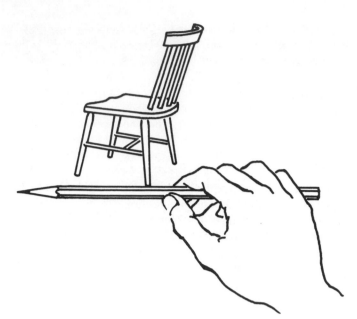

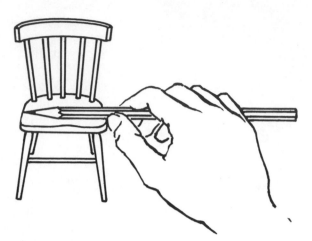

left: 56. Held as a true horizontal, a pencil helps to determine horizontal alignments.

above: 57. A pencil held horizontally at arm's length permits optical measurement of the chair seat.

front corner of the seat. The angle formed by the pencil and the leg clearly shows the degree to which the leg varies from vertical. As the pencil is moved to the right it will reveal other significant alignments, for example, where the bottom of the left rear leg appears in relation to both the left and right ends of the top piece.

The pencil held in a true horizontal position (Fig. 56) is equally useful in determining relationship of above and below. If the pencil were moved up so that it appeared to touch the bottom of the right front leg, it would be possible to ascertain whether that detail should be drawn above or below the point where the rung connects with the back leg.

Developing the habit of using the pencil as a measuring device to establish relative proportions is one of the most important aids in learning to see—thus learning to draw. In spite of what we actually see, it is startling to discover how much our perception, unchecked, is influenced by what we know about an object. When we know that in physical reality one dimension is greater than another, our natural inclination is to draw it that way, being convinced that we also see it that way. Taking the frontal view of the chair seen in Figure 57, one might have difficulty in determining the proportion of height to width. Holding the pencil at full arm's length and allowing the tip of the pencil to optically "touch" the left edge of the seat, you can mark the width of the seat on the pencil by moving your thumbnail to the point corresponding to the right edge of the seat. Turning the pencil vertically, being certain to keep your thumbnail in place on the pencil, allows you to estimate that the height of the chair, as drawn, is about two and a quarter times greater than the width of the seat. The measurement, based on the image seen, is taken from the lowest point to the highest point, in this example the bottom of the front legs to the center point of the top piece. You should be aware that although in actuality the entire top edge of the back of the chair would be equidistant from the floor, the center of the back appears to be higher than the outer corners when viewed from above.

Project 12 Place a wooden chair in front of you in a number of positions: facing you, turned away from you, sideways, at an angle, on its side, upside down, and tilted. Study it carefully in each position, noting how the size and shape relationships among the parts change with each different position. Use your pencil in the manner described to determine the location of major points, correct angles, and

Initial Experiences

relative proportions. When you begin to feel comfortable using the pencil as an aid in perceiving the chair, do a number of drawings of the chair in various positions, letting your pencil serve as a measuring device as well as a drawing implement.

Anyone wishing a greater challenge is invited to choose a more difficult subject such as a bicycle. Even objects of great complexity can be depicted with amazing accuracy when the pencil is used to search out the essential visual clues.

Defining Forms with Negative Space

A viewfinder created by cutting a small square opening in a piece of light cardboard or stiff paper serves as another aid that enables an artist to study vertical, horizontal, and proportional relationships. The viewer is held at a distance that permits the entire object to be seen through the aperture. By allowing the object to fill as much of the square as possible, letting the object appear to touch the edges of the opening, the *negative space* that surrounds the object becomes defined as shapes (Fig. 58). Often it is possible to draw an object more correctly by delineating the negative space, rather than the object itself, since an artist generally has fewer concepts about the shape of space as compared to what is known about the object.

Project 13 Cut a 2-inch square opening in a piece of cardboard. Look at a chair through the viewer and draw the negative spaces—the areas left between the edges of the square and the contour of the chair, the shapes you see between the rungs, legs, stretchers, and other parts. Even a simple wooden chair provides an excellent exercise in drawing, since it consists of a number of parts of varied

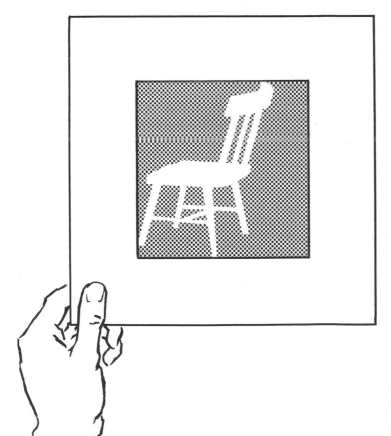

58. A simple viewing square cut from cardboard or stiff paper enables the artist to see vertical, horizontal, and proportional relationships, and permits analysis of negative space.

Learning to Visualize, to Symbolize, to See

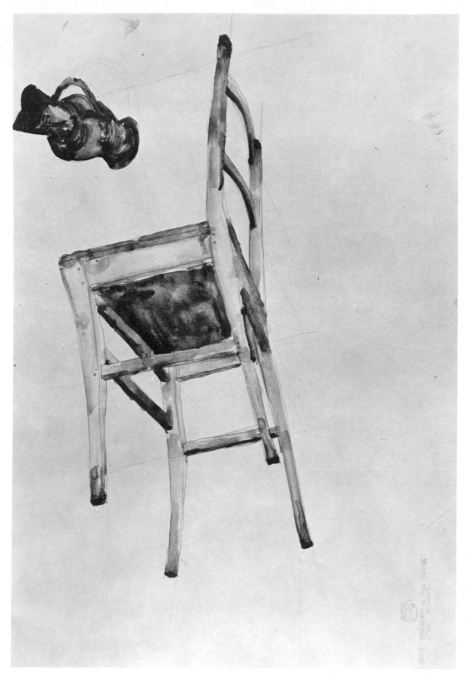

59. Egon Schiele
(1890–1918; Austrian).
*Organic Movement
of Chair and Pitcher.*
1912. Pencil and watercolor,
18⅞ × 12⅛'' (48 × 31 cm).
Albertina, Vienna.

shapes. Its forms are not strictly geometric, nor are they as subtle as anatomical or organic forms. For additional drawings arrange the chair so that it is viewed from an unusual angle—tipped on its side, turned upside down, rotated to an unfamiliar position. It is difficult for the inexperienced artist to perceive the potential of interesting forms inherent in very familiar, commonplace objects. Notice how Egon Schiele created a very interesting drawing (Fig. 59) by selecting an unusual viewpoint from which to look at a simple chair.

When drawing, it is necessary to observe your subject continuously. Most mistakes occur from drawing without looking at the model. You should use a pencil to establish vertical and horizontal guides and the cutout square as a viewer to do the preliminary planning and laying out of a drawing or to clarify a relationship of parts. Overreliance on such aids, however, can impede the development of independent judgments and of eye-hand coordination.

Initial Experiences

Sketchbook Activities

We learn to see by looking; we learn to draw by drawing. The regular practice of sketching is essential to continuous development. In time, the response of the hand to the eye becomes spontaneous. Carry a sketchbook with you at all times and draw in it whenever you have a few free minutes. Sketch anything and everything—people, animals, things (Figs. 60 to 62). Frequently, objects that do not seem promising prove intriguing to draw. Intriguing or not, draw whatever

right: 60. Paul Klee
(1879–1940; Swiss-German).
Fritzi. 1919. Pencil on paper,
7⅝ × 10⅝'' (19 × 27 cm).
Museum of Modern Art, New York
(gift of Mrs. Donald B. Straus).

below: 61. Pablo Picasso
(1881–1973; Spanish-French).
Scène de Bar, page of studies.
c. 1900. Conté,
5 × 8⅛'' (13 × 21 cm).
Courtesy Christie, Manson
& Woods Ltd.

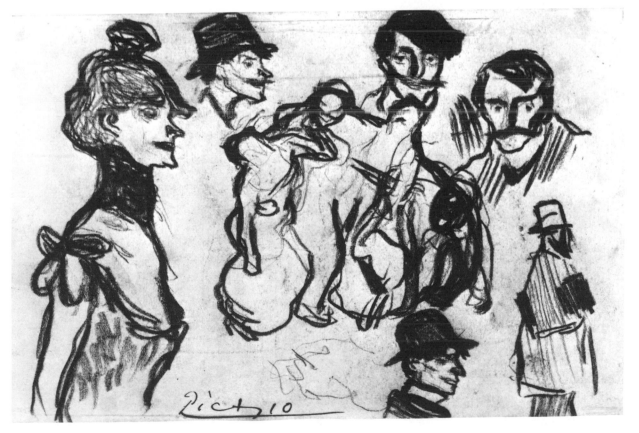

Learning to Visualize, to Symbolize, to See

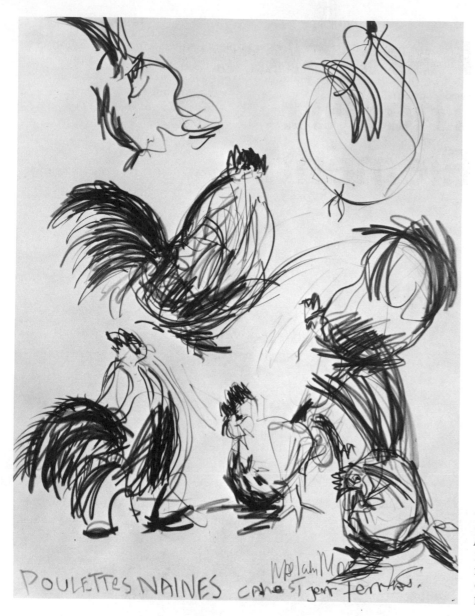

POULETTES NAINES

62. Malcolm Morley
(b. 1931; English).
Poulettes Naines. 1979.
Pencil on paper,
24 × 18″ (61 × 46 cm).
Courtesy Xavier Fourcade, Inc.,
New York.

you see before you at those moments when you are free to draw. When you accept that every sketch, every drawing you do is a learning experience, you no longer need be concerned about choice of subject matter—anything becomes an appropriate subject. Sketches are not meant to be finished drawings; more often they are notations in which an artist records a visual impression of something seen, remembered or imagined. Sketchbooks for artists are like journals for writers. They provide a continuous source of motifs and ideas for compositions as well as an entertaining record of the past.

Part Three
The Art Elements

Line, defined in the dictionary as "a long thin mark frequently made with a pencil," does not exist in nature. As a device invented to describe and circumscribe, it provides the basis for the simplest kinds of artistic expression. At the same time, line serves in the creation of the most complex and sophisticated works of art.

Value, the quality of relative darkness or lightness, provides for greater emotional impact—one might almost say for drama. We relate light and dark to many varied experiences: right and wrong, day and night, sunshine and shadow, even intelligence and stupidity. Dark and light seem to parallel many of our emotional and intellectual experiences. It is through light and dark that we perceive form.

Form is the most fundamental of the art elements. We experience form in our earliest stages of awareness and continuously thereafter; we sense it in everything we handle. Round, square, organic, geometric, and numberless other descriptions of form are known to us consciously or unconsciously. Geometry, a fundamental mathematical discipline, was born from the desire to describe form rationally. The two-dimensional aspect of form is *shape.* In its negative aspect, we know form as *space.*

Texture, a surface attribute of form, is unique in that we experience it through more senses than sight alone. Roughness, smoothness, and many other textural qualities can be experienced through the sense of touch and are even an important part of taste, since qualities like grittiness, slipperiness, wetness, and dryness all enhance the pleasure of eating.

Composition is the organization of line, value, form, shape, space, texture, pattern, and color as the underlying structure of a picture. Just as in learning to write one can profit from dissecting a sentence to study the parts of grammar separately, so in drawing the interrelationships of parts to the whole can best be perceived by understanding the various elements and developing resourcefulness in their manipulation.

4 Line

Children draw chalk lines on sidewalks to define areas for game playing. Carpenters draw lines indicating where to cut boards. Television weather personalities draw sweeping lines to show the position of advancing storm fronts. For the artist, *line* is the most important graphic element that is transformed into greater meaning, force, movement, sensitivity, and emotion. There is almost nothing that cannot be symbolized with a line.

The simplest line suggests direction; divides space; has length, width, tone, and texture; and may describe contour. As soon as the line begins to change direction—to move in curved or angular fashion, to fluctuate in width, and to have rough or smooth edges—its active and descriptive powers increase many times (Fig. 65). The beginning student, learning to draw, soon discovers what is involved in assuming command over so powerful a tool. Line can be used objectively to describe forms and record visual observations, or subjectively to suggest, evoke, and imply an endless variety of experiences, conceptions, and intuitions. Every mark made on paper, whether it be a thoughtful line or just a careless scribble, will inevitably convey something of the maker to the sensitive observer.

The Contour Line

Lines do not really exist in nature. Artists, however, use lines to translate that which they see as three-dimensional reality into visual symbols on a flat, two-dimensional surface. Lines that delineate the edges of forms, separating each volume or area from neighboring ones, are termed *contour lines.* In its simplest and most characteristic aspect, contour line is of uniform width, is not reinforced by shading, and does not seek to describe modulations of surface within the outer contour unless they constitute relatively separate forms (Figs. 63, 64).

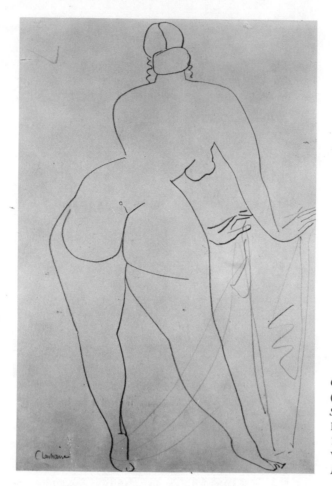

63. Gaston Lachaise
(1882–1935; French).
Standing Nude. 1922–32.
Pencil on paper,
17¾ × 11¾'' (45 × 30 cm).
Whitney Museum of
American Art, New York.

At its most expressive, contour line appears to follow the artist's eye as it perceives the edges of a form. To develop sensitivity and skill at contour drawing the student tries to master an exact and almost unconscious correspondence between the movement of the eye as it traces the exact indentations and undulations of the edge of a form and the movement of the hand holding a pencil or pen. This faculty of eye-hand coordination is invaluable in all drawing activities, because it involves knowing what the line should reveal before it is drawn.

Project 14 A soft pencil is best for beginning contour drawing because it produces a firm, relatively unmodulated line. Place in front of you a nongeometric, irregular form of some solidity—a shoe or boot, a book bag, a baseball mitt, your own hand or foot. (Strictly symmetrical objects are not good because beginners are likely to be disturbed by the inevitable deviations from symmetry that occur in contour drawing.) Although it may seem unnatural, position the object so that you must turn away from your paper to see it. In this way you will be less tempted to keep glancing at your drawing. Start drawing at some clearly defined point, attempting to work about life-size. Let your eye move slowly along the contour of the form, keeping your pencil moving in pace with the movement of your eye. Try to respond to each indentation and bulge with an equivalent hand movement. Do not let your eye get ahead of your pencil. Both looking and drawing should be slow and deliberate; speed is not your goal. When you come to a point where the contour being followed disappears behind another or flattens out to become part of a larger surface, stop, glance back at your drawing if necessary to determine another starting point, and commence drawing the adjoining surface. Contour drawings done with minimum reference to the paper often grow wildly out of proportion, but accuracy is not a primary concern; rather, contour drawing is an

The Art Elements

64. Ellsworth Kelly
(b. 1923; American).
Apples. 1949.
Pencil on paper,
17⅛ × 22⅛'' (43 × 56 cm).
Museum of Modern Art, New York
(gift of John S. Newberry,
by exchange).

exercise in coordinating the eye and the hand. Change the position of your subject and repeat the procedure. Draw other objects, placing them in other than their usual positions so that you see them in different perspective. After you begin to feel some confidence in your drawings, attempt the same exercise, this time drawing with the opposite hand.

Project 15 As a challenging and valuable exercise, close your eyes, and draw the same object from memory by recreating the visual and physical sensation. The process is more important than the immediate results, stimulating as it does visual recall, which provides the basis for drawing from memory.

Project 16 Do a contour drawing of a more complex form or group of objects—a bunch of bananas, celery, beets, or carrots; a paper bag or basket with onions, leeks, and vegetables or fruits of irregular shape; various kitchen utensils such as an eggbeater or electric mixer; a telephone. Remember that very ordinary objects increase in visual interest when tipped on their sides or seen in other than their customary positions. Begin with the closest form or the most forward part. Try to draw all around each form or part without checking your drawing. Draw with long continuous lines (Fig. 63) rather than short sketchy lines and do not be concerned about making corrections. You will notice that the distortion that naturally occurs contributes to the expressive character of your drawing. Later you may deliberately choose to introduce a similar kind of distortion into other drawings. When executed by a sensitive artist, a contour drawing of even the simplest forms acquires great distinction and elegance through the disciplined purity of line (Fig. 64).

Sketchbook Activities

Practice contour drawing in your sketchbook, establishing the habit of looking at the subject rather than at your drawing. Effective drawing depends upon learning to see. Even when you are not drawing, practice looking at objects as if you were, letting your eye slowly examine every fraction of an inch of contour. Later, try drawing such objects from memory.

Line

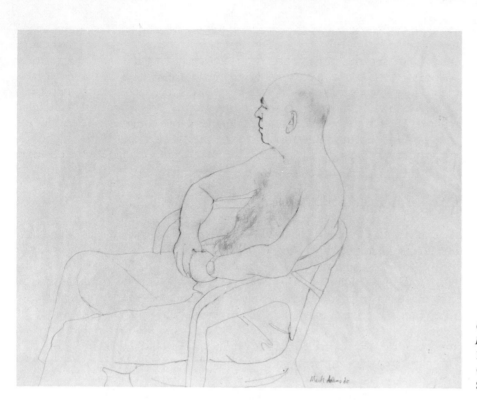

65. Mark Adams (b. 1925; American).
Portrait of Daniel. 1965.
Pencil, 18¼ × 23¼" (46 × 59 cm).
Collection Mrs. Daniel Mendelowitz,
Stanford, Calif.

The Contour of Varied Width

A comparison of the drawings reproduced in Figures 63 to 66 reveals that the latter two show a more expressive line. This increase in expressive power results from two factors; first, a careful study and consequently a more subtle perception of form; and second, a sensitive linear expression of these subtle perceptions as evidenced in variations of line width. By changing pressures of the hand in response to the importance of a detail, a shift of direction in a contour, or an overlapping of forms, the artist produces a sensitivity of line deriving from and evocative of a complex set of associations. Sometimes a thicker line suggests the darker value created by a shadow, which by virtue of its darkness makes a stronger impact. In a sense, varying line widths function in a manner analogous to the ways that degrees of emphasis in speech reflect the different values a speaker places upon words.

Mark Adams' *Portrait of Daniel* (Fig. 65) is worth thoughtful examination so that the function of each individual line can be understood and appreciated. No single line attracts attention to itself at the expense of the figure. The fact that the heaviest lines appear in the face reflects the artist's interest in the features as the focal point of the portrait study. Interestingly, the ear has been drawn in lighter line, since it seems less crucial in establishing the character of the sitter. The weighty handling of the profile also suggests that the opposite side of the face may be in partial shadow while the ear appears in full light. Firm, heavy line stresses the upper contour of the figure's left arm to differentiate the muscular surface from the flaccid edge of the underarm. The contour line defining the entire upper length of the forward arm merits particular study. Such changes in line width represent a spontaneous response to visual and motor stimuli, for the very act of drawing, involving such factors as varying directions of movements or modifications in hand position, produces thicker and thinner lines.

Project 17 *Select a subject involving some overlapping of forms such as a house plant with broad distinctive leaves. A cabbage with several leaves peeled back would work well. Or you might want to sit before a mirror and draw a*

self-portrait. Do not, however, be concerned with creating an exact likeness. This time, alter pressure on the pencil to describe overlapping planes, darkness of shadow, movement in space, and other aspects of form that can be implied by changes in the width and darkness of line. Allow pressure on the drawing instrument to vary in accordance with your instinctive appreciation of the importance of each contour rather than changing line widths in a consciously calculated manner. Such a method of drawing demands more continuous reference and cross-reference to the subject than did the previous contour drawings, but remember that it is better to keep your eyes on the subject than on the drawing.

Lost and Found Edges

A continuous contour of uniform weight results in a persistently two-dimensional effect. By introducing variations in thickness and weight, one can make a line appear to advance and recede in space, contributing to the illusion of three-dimensionality of drawn forms. As seen in Figure 65, changes both in weight and darkness also can differentiate between hard and soft edges. Such effects are maximized when used in combination with "lost and found edges." Look carefully at the head in Figure 65. Even though we know that the surface of the bald head is firm, its outline is not hard throughout. In fact, it virtually disappears, is lost, just above the hairline and then is found again to be continued with slightly increased firmness down the back of the neck and over the shoulder.

Lines define edges, and we tend to see the edges of forms more clearly defined as we focus our attention on them. Drawings, however, have greater visual interest when edges receive different treatment. The same edge can appear to be soft or sharp depending upon the light it receives and its relationship to surrounding objects. Where there is a distinct contrast, a sharp, firm line finds the edge; where values are the same or closer, the edge becomes lost, to reappear when another condition exists. A line may be lost by stopping it short before it passes behind another form, thereby creating a sense of space between forms. Using lost and found edges depends upon learning to see them.

66. Henri Gaudier-Brzeska
(1891–1915; French).
Standing Nude with Back Turned.
1913. Pen and ink
on white paper,
11 × 10'' (23 × 26 cm).
Fogg Art Museum,
Harvard University,
Cambridge, Mass.
(gift of Lincoln E. Kirstein).

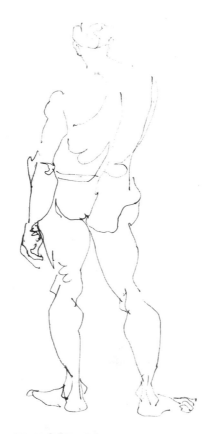

The Searching Line

The approach to contour drawing that has been presented depends upon the slow and deliberate delineation of form. In contrast, a second technique that relies upon a searching line encourages greater freedom and spontaneity. As the term *searching* implies, it is an approach to drawing in which the hand and drawing instrument move freely and quickly across the surface of the paper, either in continuous rhythm (Fig. 67) or in a series of more broken lines (Fig. 68), sometimes following contour, at other times drawing through, around, and across form (cross-contour) to find the gesture and major lines of movement within the form. Unlike contour drawing with its single outline, the searching line results in a multiplicity of lines generally suggestive of energy and vitality. The rapid movement and frequent directional changes produce variations in pressure, line width, and degree of darkness that automatically produce accents plus a feeling of volume. The searching line is not to be construed as undisciplined, meaningless scribbling. As a technique it requires that you begin to see, feel, and draw total form, rather than isolated details. In Figure 67, the artist, even after establishing the lines of movement, the gestures, continued to explore the form to find the lines that give the desired degree of definition.

Project 18 For beginning students the searching line works best with pencil, crayon, chalk, ball-point pen, or a pen that has its own ink supply. In Figure 68 you can sense the interruptions necessary to dip the pen into the ink.

Although we are all inclined to want to draw things that interest us, you should realize that these projects are meant as learning exercises and that subjects need not be chosen for any particular aesthetic value. Select any readily available subject. Before you begin drawing, spend a few minutes looking at the object you have chosen. Let your eye roam around, through, and over the form freely without stopping to focus on any one part. As you look, become conscious of the continuous movement of your eyes and when you begin to draw allow

below left: 67. Anonymous (16th century; Italian). *Dancing Figure*. Red chalk. Metropolitan Museum of Art, New York (gift of Cornelius Vanderbilt, 1880).

below: 68. John Vanderbank (1694–1739; English). *Levade between Pillars*. 1730. Pen and ink, 8⅝ × 6½'' (22 × 17 cm). British Museum, London (reproduced by courtesy of the Trustees).

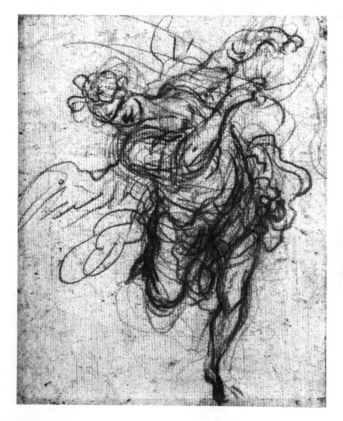

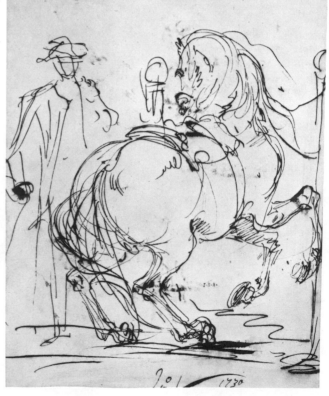

your hand the same freedom of movement. Draw with one continuous line without lifting your pencil from the paper. Look at the object as you draw, glancing at your paper only when necessary. You will experience the same distortions apparent in the earlier contour drawings. The purpose in drawing without looking at your paper is to develop a direct connection between seeing and drawing, eliminating as much as possible the intermediate step of thinking about how to record what is seen as well as the subsequent judgment of what is "correctly drawn." Repeat this assignment frequently, eventually drawing the human figure or other living forms (Fig. 62). Remember that mirrors allow you to be your own model. Try to recreate the experience by drawing with your eyes closed (Project 15).

Sketchbook Activities

Add to your other sketchbook activities the habit of interpreting things that you observe with a searching line. You will find it a useful technique for recording people on the move, letting it serve as pictorial shorthand (Fig. 8).

The Modeled Line

Throughout the ages, artists have felt the need to reinforce pure outline with suggestions of modeling, for many subtleties of form cannot be revealed by the single line, even one of varying thickness. There is a natural tendency when drawing to amplify differences in line width by means of additional lines, hatchings, or other graduated values to help describe the complexities of form perceived in the model. This begins to be evident in Figure 68. Additional lines and scribbled shading on the horse's rump, belly, and inside the foreleg enrich the sense of three-dimensionality. Figures 69 and 70 embody further departures from simple outline to enlarge the sense of form.

69. Raphael (1483–1520; Italian).
Apollo Playing a Viol,
study for *Parnassus.* Pen and ink,
10⅜ × 7⅞'' (27 × 20 cm).
Musée des Beaux-Arts, Lille.

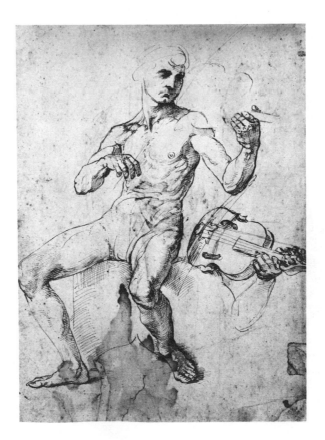

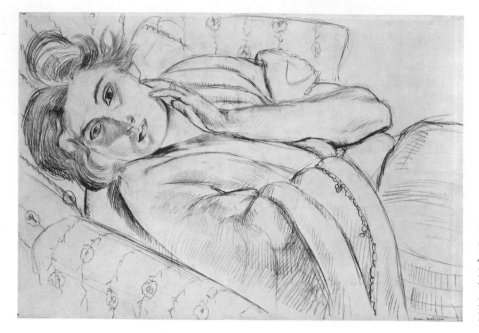

70. Henri Matisse
(1869–1954; French).
Reclining Woman. c. 1919.
Pencil, 14⅜ × 21¼'' (37 × 54 cm).
Yale University Art Gallery,
New Haven, Conn. (bequest of
Edith Malvina K. Wetmore).

Project 19 Select a subject of some complexity, one that seems to call for more than contour. Draw it freely in outline, allowing your hand to move easily so that the lines are not rigid. Observe the form carefully as you draw, letting your line be sensitive to roundness, flatness, and meeting of surfaces. It is important that each aspect of a drawing be made to function significantly. Do not, as students sometimes do, think that a careless beginning "can be saved" in a later stage. Whatever is added should augment what has been done, not cover up or correct. When the initial drawing is complete, shade the form near the contour with groups of light, parallel lines that curve according to the direction the form seems to take (Fig. 70). Study the edges carefully, and modify the curvature of the shading lines in any way that seems to describe the form more fully. If the curved shading lines (hatching) separate from the outlines, making the two seem unrelated, see if lines drawn parallel to the edges of the form and merging into the outline will bind them together.

Develop your facility with this method of using line by drawing many different objects. Do not attempt full modeling in light and shadow (Fig. 84); merely add supplementary lines, tones, and textures to reinforce the contours to create a fuller sense of form than can be achieved by pure outline.

Hatching, Cross-Hatching, and Scribbled Tones

Modeling can be introduced into line drawings through varying degrees of *hatching* (parallel lines), *cross-hatching* (criss-crossing patterns of parallel lines), and *scribbling* (random, multidirectional lines). Figures 71 through 73 illustrate the building of tone and the defining of both shape and volume through a fuller development of each technique. A glance through this book offers abundant evidence of the reliance artists place upon these methods.

Project 20 Make an arrangement of several relatively simple objects that possess a fullness of form—two or three apples, pears, or tomatoes grouped with an open paper bag, which can be standing upright or placed on its side; an unoccupied pair of shoes, either neatly arranged side by side or left as they were dropped. Do separate drawings using hatching, cross-hatching, and scribbling to define forms and produce tonal differences. Vary both the thickness of line and

The Art Elements

54

the spacing between lines to produce different tones. Establish the placement of the objects with a light pencil line, but develop the forms without relying upon contour line. Experiment with a variety of drawing tools—crayon and pen and ink as well as pencil or a cluster of bamboo skewers dipped in ink. The size of your various drawings will be determined by the medium selected.

right: 71. Harold Altman
(b. 1924; American).
Matriarch. 1961.
Felt-tip pen,
16½ × 20'' (42 × 51 cm).
Philadelphia Museum of Art
(gift of Dr. and Mrs. William Wolgin).

below: 72. Emilio Greco
(b. 1913; Italian).
Nude Study for Sculpture. 1954.
Pen and ink.
Victoria & Albert Museum, London
(Crown Copyright).

below right: 73. Henry Moore
(b. 1898; English).
Half-Figure: Girl
from *Heads, Figures, and Ideas*
sketchbook. 1956.
Pen and ink,
8¾ × 6⅞'' (22 × 17 cm).
Courtesy the artist.

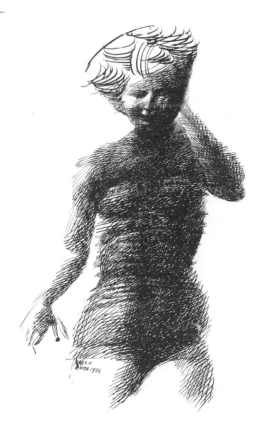

The Calligraphic Line

Calligraphy, defined as "beautiful writing," has been undergoing a resurgence in more recent years. As anyone who has even attempted calligraphy knows, "beautiful writing" demands practice and patience. In drawing and painting, when the beauty of line that emerges from a flourish of execution becomes a major aesthetic aim, the result is a true calligraphic line. Study the drawings in Figures 74 to 76—all splendid examples of calligraphic virtuosity. Each of these masterpieces of draftsmanship draws upon the lifetime of experience necessary to achieve a personal style, mature in its assured execution.

Beautiful and meaningful calligraphic line demands more than taking brush in hand to make lines of varying thickness. The beginner, without months, perhaps even years of practice, cannot hope to do more than become aware of the factors involved. Variations of line width, which characterize a calligraphic line, are determined by the gesture with which the line is made in combination with the amount of pressure with which the brush is applied to the drawing surface. For example, a sweeping stroke—made rapidly, commenced while the hand is in motion in the air and finished by lifting the hand while still in motion—usually

74. Rico Lebrun
(1900–1964; Italian-American).
Seated Clown. 1941.
Ink and wash,
with red and black chalk;
39 × 29″ (99 × 74 cm).
Santa Barbara Museum
of Art, Calif. (gift of
Mr. and Mrs. Arthur B. Sachs).

above: 75. Chaim Gross
(b. 1904; Austrian-American).
Circus Girls. 1932.
Brush and black ink on paper,
18¼ × 11¾″ (46 × 30 cm).
Courtesy Forum Gallery, New York.

above right: 76.
Willem de Kooning
(b. 1904; Dutch-American).
Untitled (Woman). 1961.
Brush and ink on paper,
23¾ × 18¾″ (60 × 47cm).
Hirshhorn Museum
and Sculpture Garden,
Smithsonian Institution,
Washington, D.C.

creates a tapered line that reveals both the action by which the line was drawn, and the variation in pressure. In the work of an experienced and excited drafts man, such gestures, far from being self-conscious and deliberate, result naturally from the action of drawing.

Beyond the gesture of execution, the character of a calligraphic line results from the medium used, for medium, to a degree, controls the gesture. A pointed brush with ink permits the greatest fluidity (Fig. 74); a flat bristle brush produces a more abrupt, slashing change from thick to thin (Fig. 76). Pencil, charcoal, and chalk (Figs. 67, 82) also respond to differing emphasis and reflect the movement of the hand in changes of width and value; lines become progressively fuller and darker with increased pressure.

Project 21 Throughout this project practice using both a well-sharpened pencil and a one-inch piece of charcoal. Hold each between the thumb and first two fingers as if you were extracting a thumbtack from your board (Fig. 27). This position encourages maximum facility in modulating line width. Keeping arm and wrist relaxed, make free, swinging, wavy lines, spirals, and gently curved shapes. Increase line widths by shifting pressure from the tip to the side. (The charcoal will allow greater variety of line width.) Holding your pencil or charcoal parallel to the direction of your line will make a narrow mark; turning it at right angles to the direction of the line increases the width. After exploring the different kinds of line, begin making large, rapid drawings of simple objects, working for an assortment of line widths.

When you begin to feel a freedom in your arm movements, switch to brush and ink. Begin all lines in the air, gradually allow the brush to touch the paper; finally, lift the brush as you complete the line. Keep the movement of your arm and hand and brush as fluid as possible. After an initial period of practice, look carefully at the quality of lines in the examples illustrated. Do not copy the drawings, but aim for a similar flexibility of line and freedom of execution.

Line

Project 22 Execute this project in soft pencil, charcoal, or chalk; then in brush and ink. Choose a subject that offers undulating contours—a wide-brimmed hat, a hiking boot or work shoe, a cluster of large leaves, potted geraniums and other plants, or a few vegetables. Spend a few minutes looking at the form, seeing it both in terms of contour and searching line, then begin to draw freely, allowing variations in line width to grow from the act of drawing. Keep your drawing sufficiently large so that your gestures can be free and unconstricted. Since drawings of this type should be executed quite rapidly, repeat each a number of times and finally select and keep the drawings you think have the most linear character and best express the character of the subject, the nature of brush and ink, and the act of drawing.

Experiencing Different Line Qualities

The preceding projects in this chapter were designed to demonstrate the functions of line—to define and describe shapes, spaces, volumes, gestures, and movements—line being used objectively. The suggested exercises that follow provide some initial explorations in the expressive qualities of line and focus on line used subjectively.

Mondrian acknowledged the expressive function of line when he stated, "Everyone knows that even a single line may convey an emotion." The expressiveness of a drawing depends in part upon the choice of drawing instrument and technique, combined with skill in manipulation. The quality of a line, however, is as much a result of the artist's attitude as it is dependent upon medium. If line were not expressive of the individual artist, all drawings would be very much alike—and yet, the drawings selected to illustrate this chapter are all very different one from another in their quality of line. The differences are expressive of the individual personalities of the artists, reflecting their feelings, attitudes, and points of view at the same time that they are defining and describing various forms. Artists find ways of working that are satisfying, comfortable, exhilarating, and "right" for their temperament. It is possible for the viewer to conclude that Robert Blum's lively, energized sketch of the painter and teacher

below left: 77. Robert Blum
(1857–1903; American).
William Merritt Chase.
Pencil on buff paper,
6¾ × 4½'' (17 × 11 cm).
Paul Magriel Collection.

below: 78. Raoul Dufy
(1877–1953; French).
The Painter's Studio, detail.
Brush and ink,
entire work 19⅝ × 26''
(50 × 66 cm).
Museum of Modern Art,
New York (gift of
Mr. and Mrs. Peter A. Rübel).

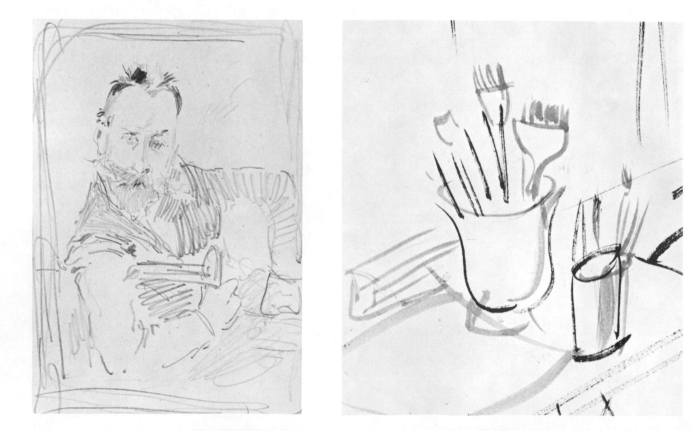

William Merritt Chase (Fig. 77) is as revealing of the temperament of the artist as it is expressive of the nature of the subject.

Certain qualities of line that distinguish individual drawings can be somewhat arbitrarily described as *lyric* (Fig. 78), *emphatic* (Fig. 79), *flowing* (Fig. 80), *tense* (Fig. 81), *meandering* (Fig. 82), and *encompassing* (Fig. 67). Such a classification merely attempts to isolate a few of the infinite possibilities of line quality.

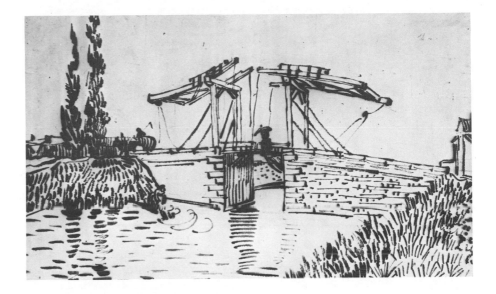

79. Vincent van Gogh (1853–1890; Dutch-French). *The Bridge at l'Anglois*, detail 1888. China ink, entire work 9½ × 12½″ (24 × 32 cm). Los Angeles County Museum of Art (Mr. and Mrs. George Gard De Sylva Fund).

80. Will Bradley (1868–1962; American). *Pausias and Glycera*. Pen and ink. Metropolitan Museum of Art, New York (gift of Fern Bradley Dufner, the Will Bradley Collection, 1952).

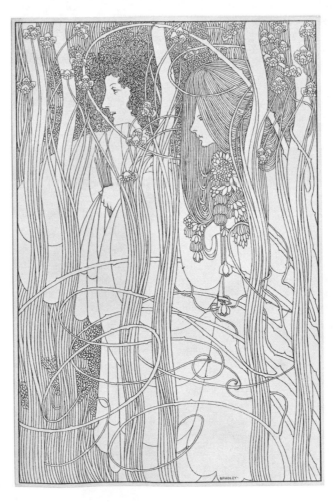

Project 23 Using the medium of your choice, explore the different ways to handle line that you have observed in these illustrations. You will probably feel the character of the line more sharply if you work in the same medium. It is possible, however, to achieve similar qualities using a different medium—for example, approximate the calligraphic character of Figure 78 using pencil (Proj. 21) instead of brush and ink. Work to develop versatility.

Draw in the manner of the examples provided rather than engaging in self-conscious copying. Accuracy is not as important as getting the "feel" of a way of working. You will discover that you like certain kinds of line movements, that they seem to come naturally to your hand. Be aware of that, and continue experimenting. When you have developed a familiarity with a variety of line qualities, make your own selection of subject matter that appears appropriate to each way of working, trying not to limit yourself to subjects similar to those illustrated.

Project 24 Remaining conscious that expressiveness is to be found in choice of line as well as subject matter, develop a series of drawings of the same subject, allowing the quality of line to convey different moods. For this exercise the nature of the subject matter is less important than the handling of line—a potted plant, a still life of familiar household objects, fruits and vegetables, a view into the corner of the room, a small area of a garden, a section of a tree. Whatever subject you select, consider the placement of your drawing on the paper and avoid letting images float in the middle of an essentially blank page. Draw large; use as much of the full sheet as possible.

Whenever you start drawing an object or idea, think about the kind of line that seems equally right for you and for the medium. It is productive to think about such matters as you are discovering the world of drawing in relation to your own artistic temperament. Gradually you will discover that you have developed an intuitive sensitivity to line, as well as the other art elements, so that choices need not always occur at a conscious level. The most important goal now is to work freely, experimentally, even playfully, realizing that impulse and feeling remain the catalyst for creative activity.

The Art Elements

5 Value

In the visual arts the term *value* denotes degrees of light and dark. White under brilliant illumination is the lightest possible value, black in shadow the darkest; in between occurs a range of intermediate grays. Pure black, white, and gray seldom occur in the natural world, for almost every surface has some local coloration, which in turn is influenced by the color of the source of illumination. Every surface, however, no matter what its color, possesses a relative degree of lightness or darkness that the artist can analyze and record as value. The systematic use of black, white, and the intervening grays in drawing is, like line, a convention of visual representation that we accept as an interpretation of perceptual experience.

While line adequately represents the contours of an object, subjects as a rule display characteristics and suggest moods that cannot be described fully by contour alone. Values clarify and enrich the space defined by simple line in five readily identifiable ways.

1. Three-dimensional form becomes apparent through the play of light and shadow, represented by shading.
2. The degree of value contrast determines the placement and relationships of form in space. Forms can be made to advance or recede through the degree of value contrast employed.
3. Value provides a fundamental element for creating pattern, for modulating and describing surface texture.
4. The pervasive mood of a drawing—dark and ominous, light and cheerful—derives from the artist's emphasis on tones at either end of the value scale.
5. Value contrasts convey dramatic power. Strong contrasts of light and dark, for example, can be manipulated to create points of accent in a composition and so draw attention to areas in terms of their importance.

The Value Scale

The beginning artist must learn to see relationships of value before attempting to produce convincing visual imagery. A value scale of nine steps (Fig. 83) duplicates the number of value changes that can be distinguished by most people. The range of values that exist in nature cannot be duplicated, which means that an artist can only approximate the effect of natural light.

Perception of value depends upon a number of factors: (1) the actual coloration of the subject, (2) its lightness or darkness relative to its surroundings, and (3) the degree to which the subject is illuminated or in shadow. Beginners often lose sight of value, seeing only color instead. Yet color has value, which must be analyzed as to its relative lightness or darkness when being translated into a black and white drawing. The apparent value of an area is relative to the value that surrounds it. The white, middle gray, and black dots superimposed on the value scale (Fig. 83) reveal the optical variations that occur in the apparent lightness and darkness of the same value when seen in relation to tones of greater or lesser contrast.

The *local value* of each object can be perceived only when seen free from the effect of light and shadow. When illumination is added, local values are lightened or darkened depending upon the degree of light. The novice often fails to acknowledge such changes. A white form is thought of entirely as light, although areas of it in shadow appear as medium or dark values (Fig. 86); a dark surface is represented as dark even though brilliantly illuminated. The artist must learn to see value relationships, rather than being influenced by what is known to be the local value. Only with experience can the artist attain a sharply analytical sense of values as they are affected by color and lighting.

As you begin to see value relationships, you must develop the ability to create corresponding tones using a variety of dry and wet media (Figs. 169 to 217). Controlling media to provide a full range of value is part of an artist's basic vocabulary. Traditional French Beaux-Arts academic training stressed the use of charcoal to obtain delicate gradations of value in which almost all suggestion of the method of application was carefully obscured (Fig. 84).

Because a vigorous range of lights and darks can be created with charcoal, the medium will prove convenient for many of the activities suggested in this section. With charcoal it is easier to move away from contour drawing into full three-dimensional modeling of form. Charcoal also seems to encourage drawing in a larger scale than does pencil or pen. For projects using charcoal, you may wish to add charcoal paper to the list of beginner's materials (p. 17). It affords greater texture than newsprint, is more durable, and so permits a more finished drawing.

Students may wish to experiment with other materials. Rodolfo Abularach's fine pen-and-ink drawing *Circe* (Fig. 85) exhibits a wonderfully rich range of values from the heavily cross-hatched, deep black pupil to the gleaming white, central highlight provided by the exposed paper ground. Notice that the highlight and dark of the pupil are intensified by being placed side by side against the low dark of the iris. (Compare with the corresponding section of the value scale.) The drawing also suggests that the use of pen and ink is not limited to linear representation nor small-scale works. (Project 20 explored the building of value with patterns of lines.)

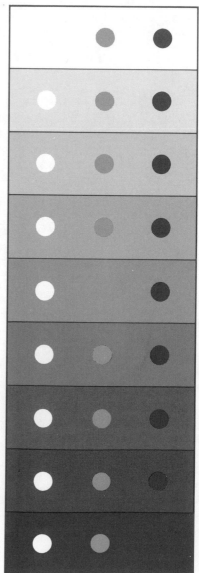

83. Value scale showing seven gradations between black and white, with inner circles of identical value.

Form Defined by Light

Every object has a specific three-dimensional character that constitutes its *form*. The simplest forms are spheres, cylinders, cubes, and pyramids. In contrast, a human head is a form of greater three-dimensional complexity. We are made aware of the unique aspects of each form as it is defined by light and shadow.

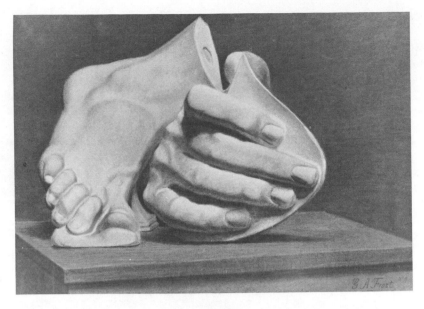

84. G. A. Frost
(19th century; American).
Still Life of Casts.
Charcoal, 14 × 21'' (36 × 53 cm).
Collection Mrs. Daniel Mendelowitz,
Stanford, Calif.

85. Rodolfo Abularach
(b. 1933; Guatemalan).
Circe. 1969. Ink on paper,
23 × 29'' (58 × 74 cm).
San Francisco Museum
of Modern Art (gift of the
San Francisco Women Artists).

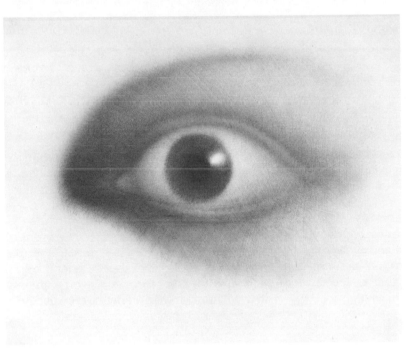

Light flowing across the surface of a three-dimensional form illuminates projecting surfaces, while those parts of the form that turn away from the light and are hidden from direct rays of light fall into shadow. Form is revealed by a continuous change of values.

Direction of light determines what portions of a form will be lighted; surfaces at right angles to the source of light receive the most light. Changing the position of the source of illumination can greatly alter the appearance of any object. Angular forms result in abrupt changes from light to dark (Fig. 86); spherical forms are defined by subtle gradations of tone (Fig. 87).

Project 25 Place a white or very light-colored geometric form (a cube or other polygonal shape) so that it receives strong light from above and to one side. You can easily see how the form of a polygon is revealed by light since the angular

Value

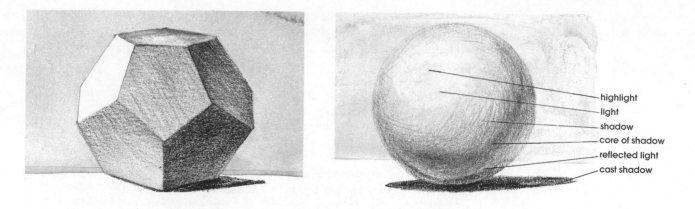

edges dividing its planes create sharp changes of value. If you do not have access to white geometric forms, a small cardboard carton with flaps opened at varied angles would be suitable. Observe the object and its cast shadows carefully. Using any suitable technique, build gradations of value corresponding to the separate planes of the form. Leave the white paper for the lightest surface, defining that plane by surrounding it with a gray tone rather than with a line (Fig. 86). Create the darkest value you can for the deepest shadow, which will be the cast shadow.

As you study the separate planes, you will notice that each surface appears lighter or darker at its outer edges depending upon the value of the adjoining planes (the same optical illusion can be detected between the steps of the value scale). A slight exaggeration of light and dark where planes join results in a stronger feeling of three-dimensionality.

Project 26 Changing the position of the source of illumination (or relocating the object in relation to the light) will increase or decrease the number of surfaces receiving light or falling into shadow. Do a series of quick studies depicting the changes that occur as the form is lighted from different angles—side, three-quarter, front, overhead, behind, below. Notice the shifting position of the cast shadow as the direction of light changes. (See Chap. 8, "Perspective.")

In this and other projects draw the objects as large as is practical for the medium you have chosen. Learn to use your full sheet of paper. Students have a tendency to draw too small, partly because smallness seems easier to encompass. A pencil drawing is too big when it is difficult to build values of even texture; a charcoal drawing is too small when the stick of charcoal seems clumsily oversize.

Chiaroscuro

Since the Renaissance, artists have employed *chiaroscuro,* or continuous gradations of value, to create the illusion of three-dimensional form. Chiaroscuro, which combines the Italian words *chiaro* (light) and *oscuro* (dark), involves systematic changes of value, easily identified in Figure 87, which shows a sphere under strong illumination. The elements of the system are highlight, light, shadow, core of the shadow, reflected light, and cast shadow. *Highlights,* the lightest values present on the surface of an illuminated form, occur upon very smooth or shiny surfaces. They are the intense spots of light that appear on the crest of the surface facing the light source (compare with Fig. 86). *Light* and *shadow* are terms for the broad intermediate values between the more defined areas of highlight and the *core of the shadow,* which is the most concentrated area of dark on the sphere itself. Being parallel to the source of light, the core of the shadow receives no illumination. *Reflected light*—light bounced back from nearby surfaces—functions as a fill-in light, making objects appear rounded by

above left: 86. Polyhedron with value planes suggesting illumination from a single source of light.

above: 87. Sphere showing the value gradations of traditional chiaroscuro.

The Art Elements

giving definition to the core of the shadow. Reflected light is never lighter than the shadow area on the lighted portion of a form. Shadows thrown by objects on adjacent planes are known as *cast shadows* and are always darker than the core of the shadow.

Project 27 Place a white or light-colored sphere, such as a beach ball or styrofoam ball, on a light surface. Provide strong illumination angling from above—a single light source plus reflected light is best, since multiple light sources create confusion. Study the form carefully before you begin to draw, observing how the shadow becomes intensified as the form turns away from the light with the core of the shadow receiving neither direct nor reflected light. No portion of the surface in the shadow area is as light as the part that receives direct light. Determine relative values; the light reflecting up into the shadowed portion of the sphere from the table top is lighter than the core of the shadow but darker than the lighted surface of the sphere. Proceed with your drawing, using the method you prefer to create smooth gradations of value. If the surface of the sphere is shiny, reserve the white of the paper for the highlight. Adding a light gray background will intensify the effect of brilliant illumination.

Project 28 The amount of the sphere's surface that is lighted or in shadow depends upon the placement of the light source. If positioned directly at the side, one half of the sphere will be lighted and one half in shadow with the core of the shadow perpendicular to the angle of light. Make a number of simplified drawings indicating the relative amounts of light and shadow as the direction of light changes, giving emphasis to the core of the shadow. Small, high-intensity reading lamps provide strong illumination and offer adjustable positioning as well as ease in moving.

Study of Seated or Sleeping Man by Jacob Jordaens (Fig. 88) provides an excellent illustration of how artists employed chiaroscuro to describe a complex form with broadly established areas of light, shadow, reflected light, and cast

88. Jacob Jordaens (1593–1678; Flemish).
Study of Seated or Sleeping Man.
Chalk, brush and wash;
11¼ × 10½″ (29 × 27 cm).
Los Angeles County Museum of Art
(Los Angeles County Funds).

89. George Biddle
(1885–1973; American).
Edmund Wilson. 1956.
Charcoal, 13 × 11¼″ (33 × 29 cm).
Sotheby Parke-Bernet.

shadows. The core of the shadow functions effectively to delineate the division
between light and shadow and combines with the reflected light to give a sculp-
tured fullness to the folds. Notice that the drawing displays no real highlights.
Since most cloth, other than silk and satin, does not have a shiny surface, render-
ing of fabric rarely requires highlights.

Project 29 Pin a light-colored piece of fabric (a napkin or a handkerchief will
do) to a wall or drawing board placed in a vertical position. Gather and drape the
fabric to create folds of some complexity. Add a strong light source to provide
definition. Pay particular attention to the way in which the core of the shadow,
reflected light, and cast shadow cause the folds to stand out in bold relief as you
draw with charcoal or pencil.

 In George Biddle's portrait of *Edmund Wilson* (Fig. 89), the modeling of
form with broad areas of light and shadow separated by a clearly defined core of
shadow follows the same system used for the sphere and the draped fabric.
Although there are no highlights in the drawing, small areas of cast shadow
under the nose and chin help define the form while the absence of dark accents
at the back of the neck and ear causes the form to recede. A sense of luminosity
results from the drawing's generally light tone in combination with the broad
simplification of light and shadow. Biddle's handling of the shadow side of the
face reveals that it is not necessary to render everything you see.

Project 30 Try a portrait head. If you are self-conscious about asking a friend to
pose, do a self-portrait working with a mirror. (Do not work from a photograph.)
Position your model so that the play of light and shadow from a light source
above and to the side clarifies the structure of the head. Work for solidity of form
rather than a likeness. Do not be concerned with details.

The Art Elements

Qualities of Light

Value changes can be gradual or abrupt, depending on the character of the form and the suddenness with which it turns away from the light. The degree of value change, or contrast between light and shadow, also depends upon the source of illumination. Brilliant artificial light results in strong light-dark contrasts with sharply defined dark shadows. Diffused light produces less value contrast between shadow and light areas. Cast shadows are soft and diffused. Because of the amount of reflected light in nature, shadows cast by sunlight are generally lighter and more luminous than those created by artificial light. To maintain consistency in a drawing an artist must consider the source and quality of light.

Form and Space

Space is shaped, demarcated, and made visible by *forms*. Space can be understood as the negative aspect, or complement, of form. Without forms to indicate spatial intervals, space cannot be perceived. Conversely, without space to articulate forms, those forms would merge into an undifferentiated blur.

Space, like form, is defined by light, which artists recreate in terms of value. Value not only defines objects, it also places and separates forms in space. Strong light-dark contrasts make forms appear to project, less contrast causes forms to appear to recede. In Peter Paul Rubens' *Lioness* (Fig. 90) the rump and the rear legs have been made to project toward the viewer through the addition of light chalk to create strong value contrast. The head of the animal, although rendered with strong darks, holds its place in space because no light accents have been added. The effect becomes more obvious when compared to Figure 91 in which

below: 90. Peter Paul Rubens (1577–1640; Flemish). *The Lioness.* c. 1618. Black, white, and yellow chalk; 15⅜ × 9¼'' (39 × 23 cm). British Museum, London (reproduced by courtesy of the Trustees).

below right: 91. Henri Matisse (1869–1954; French). *Dahlias and Pomegranates.* 1947. Brush and ink, 30⅛ × 22¼'' (77 × 57 cm). Museum of Modern Art, New York (Abby Aldrich Rockefeller Fund).

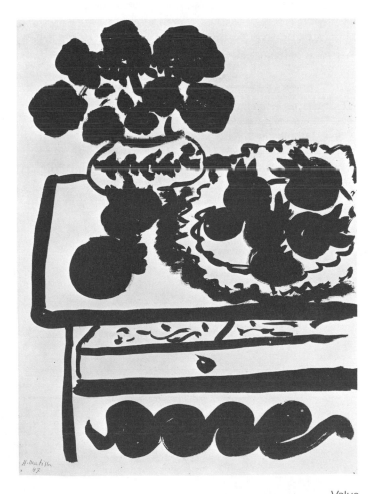

Matisse's uniform use of pure black and white pulls all of the forms forward so that space must be conceptualized by the viewer.

Although the aspect of Rubens' drawing being discussed is value as used to define form and space, the viewer or reader should remain aware that value has been used in conjunction with line, overlapping forms, and dramatic foreshortening. Drawing involves the interplay of various elements (see Chap. 7).

Further study of Figure 90 allows us to see Rubens' manipulation of value to place and separate forms in space. In the upper left quarter of the drawing the form is defined by contour line with little apparent differentiation in value between figure and background. In contrast, the entire length of the right side of the body, starting from the ear, appears darker than the background, except where the rear leg is seen as light against the shadow. The cast shadow, which lightens as it moves away from the foot, relates the animal to surrounding space by defining the ground plane.

The same use of light against dark and dark against light to create the illusion of light and space surrounding form can be seen in the studies of the polyhedron (Fig. 86) and the sphere (Fig. 87). Richard Diebenkorn employs boldly simplified patterns of light and dark with almost no modeling in the light areas to depict a figure seated in bright sunlight (Fig. 92). Julia Pearl produces a very different quality by using minimal value contrast in *Seated Figure* (Fig. 93).

Project 31 While careful analysis of observed tonal relationships contributes to a convincing representation of forms in space, it is also possible to establish spatial relationships by attending to the principle that light forms advance and dark forms recede. Arrange a group of familiar objects such as cups, jars, canisters, and pots so that by their placement you are aware of space. Do a charcoal drawing in which you define that space through the deliberate manipulation of value, using the lightest value for the closest object and increasingly darker values as the forms recede, with the darkest value reserved for the background. A strong light seen against a bold dark will appear to project more than the same light placed against a less contrasting value.

92. Richard Diebenkorn (b. 1922; American).
Seated Woman with Hat. 1967.
Pencil and ink wash, 14 × 17″ (36 × 43 cm).
Courtesy the artist.

93. Julia Pearl (b. 1928; American).
Seated Figure. 1956. Pencil,
8¾ × 7″ (22 × 18 cm). Collection
Mrs. Daniel Mendelowitz, Stanford, Calif.

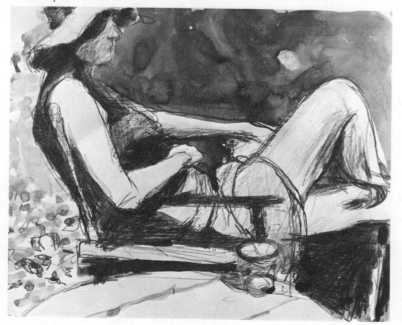

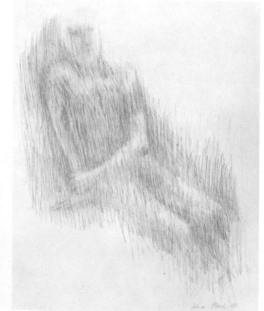

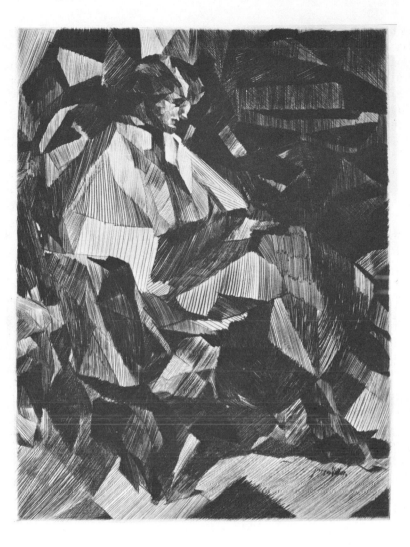

94. Jacques Villon
(1875–1963; French).
Yvonne D. de Profil.
1913. Drypoint,
21½ × 16¼″ (55 × 41 cm).
Los Angeles County Museum of Art
(Los Angeles County Funds).

Sketchbook Activities

Begin to see form and space as defined by light and shadow. In your sketchbook draw with masses of dark and light whether the subject be an object, figure, or landscape. Try blocking in shadow shapes without depending upon preliminary contour lines (Fig. 93). Continuous practice of this type of drawing develops a kind of shorthand for indicating form and increases your awareness of pattern.

Pattern

Jacques Villon's *Yvonne D. de Profil* (Fig. 94) is an arrangement of patterns of light and dark. The term *pattern,* used in this sense, refers to all of the individual shapes, defined by change of value, which combine to construct form and space. In its complex pattern of faceted planes, Villon's drawing can be seen as an elaboration of the polyhedron in Figure 86. Even a complicated subject can be reproduced with amazing accuracy when the artist concentrates on duplicating patterns of shapes and value rather than trying to draw the object itself.

Pattern, in addition to defining form and space, can function decoratively. Flat, unmodulated surfaces of dark and light produce pattern rather than form. We see the shape of an area and are conscious of its silhouette, but the sense of volume is minimized. Our awareness is directed instead to the decorative qualities of pattern. When pattern serves a decorative purpose, its chief role is to embellish, as in textile design, rather than to represent or symbolize.

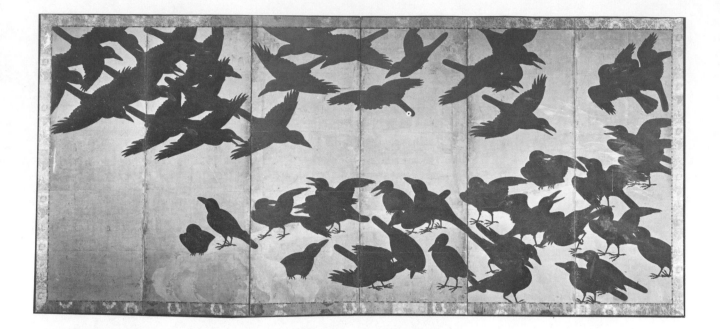

Patterns need not be limited to a regularly repeated design. The crows on the 17th-century Japanese screen (Fig. 95) create the impression of a strongly decorative pattern, yet very few of the shapes have been repeated and the groupings are highly irregular. The birds, which in reproduction appear as silhouettes, are seen in bold value contrast to the gold-leafed background. Looking at the spaces between the bird shapes, one begins to understand how an artist as inventive as M. C. Escher could conceive a work such as *Mosaic II* with its fascinating play of positive and negative areas (Fig. 96). In the Escher drawing, the viewer's eye is entertained constantly by the way in which dark forms command attention, only to give way to the figures that emerge as light-colored shapes. The delightful ambiguity of the grotesque and imaginative creatures that swarm over the page results from an almost equal distribution of light and dark. Escher has increased the visual complexity by modifying each form with added detail, but if one squints to the point where detail disappears, a rich pattern of dark and light shapes predominates. Squinting to eliminate detail always enables an artist to see value relationships as a more simplified pattern.

95. Anonymous
(early 17th century; Japanese).
The Hundred Black Crows,
one of a pair of six-fold screens.
Early Edo period.
Gold leaf and black ink
with lacquer on paper,
height 5'1¾'' (1.57 m).
Seattle Art Museum
(Eugene Fuller Memorial Collection).

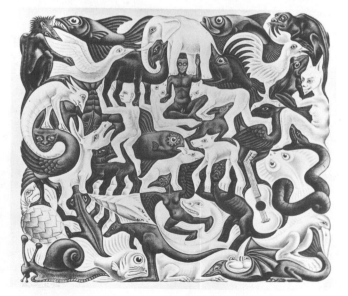

96. M. C. Escher (1898–1972; Dutch).
Mosaic II. 1957. Lithograph,
12½ × 15½'' (32 × 39 cm).
Escher Foundation, Gemeentemuseum, The Hague.

The Art Elements

Project 32 Work boldly and freely with India ink and brush to create patterns of black and white in which positive and negative shapes vie for attention. At this point do not attempt anything as calculated as Escher's Mosaic II. Although the desired effect can be achieved through the repetition of a geometric design, look once again at the amazing richness and variety seen in Figure 95 and work for a similar feeling of animation.

Pure silhouette, whether black on white or white against black, provides the greatest possible value simplification, yet by itself it is not sufficiently complex to be very entertaining. We can see how Aubrey Beardsley's elaboration of pattern in *The Peacock Skirt* (Fig. 97) increases the visual interest of his illustration. In the lower portion of the composition the pattern is white on a black shape that is silhouetted against a white background. The peacock fan and the headdress use black patterns and lines on a white ground, while elements in the drawing, such as Salome's face and the bodies of both figures are outlines creating the effect of white pattern on white ground. The stippled border of the fan plus the linear complexity of the man's garment further enrich the decorative scheme.

Matt Kahn employs similar reversals of light and dark to give visual form to sound in *The Doorbell* (Fig. 98). By introducing an intermediate gray tone he has produced the effect of black-on-black pattern. At the same time, the soft grays make the black and white seem even more vivid, the sound even more jangling.

Project 33 Choose a subject that has decorative pattern potentialities; perhaps one of your previous drawings would lend itself to a flat-patterned decorative treatment. With soft pencil and newsprint, plan your composition. Establish where you will place your black masses and white masses, where you will use

below: 97. Aubrey Beardsley
(1872–1898; English).
The Peacock Skirt, from *Salome.*
1894. Pen and ink,
9⅛ × 6⅝'' (23 × 17 cm).
Fogg Art Museum,
Harvard University,
Cambridge, Mass.
(Grenville L. Winthrop Bequest).

below right: 98. Matt Kahn
(b. 1928; American).
The Doorbell. 1955.
Ink and charcoal,
23 × 14'' (58 × 36 cm).
Private collection.

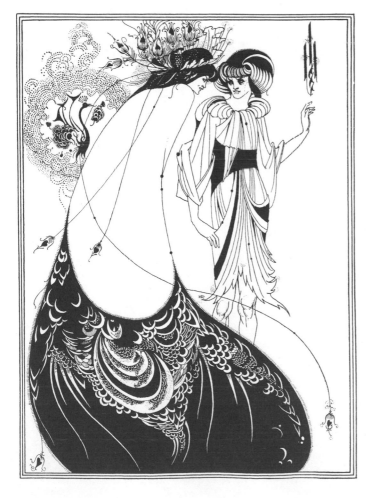

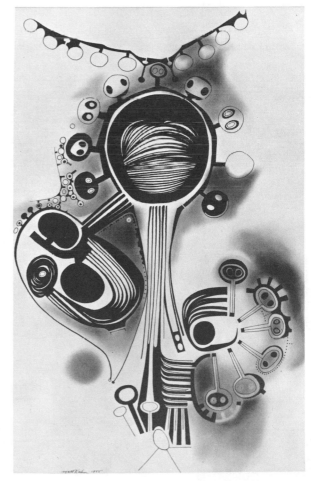

black outlines on white or leave white outlines on black. Transfer or copy your composition onto a sheet of drawing paper in light outlines and complete the drawing in ink, using a pen for fine line work and a brush for filling in large shapes. If you want a more refined drawing than your present equipment allows, try Bristol board and a metal pen point. Bristol board provides a brilliant white, takes ink well, and permits fine pen lines of even width.

Texture

Choice of value and manner of application are important in creating the illusion of different textures and surfaces. Even gradations of tone best describe hard, smooth, polished objects, while broken patterns of light and dark are appropriate to surfaces with stronger textural characteristics. Texture, which is the subject of Chapter 6, is introduced here to let us examine another aspect of value.

Max Ernst's *Maternity* (Fig. 99) clearly illustrates an earlier statement that value permits the depiction of characteristics that cannot be described by line alone. Although Ernst has achieved a sleek elegance in the purity and simplicity of his line, it is the glistening sheen produced by the white highlighting that makes the drawing so striking. Slight gradations of the white plus minimal modeling with black suggest volume. The technique works effectively because the middle value of the paper predominates.

Project 34 It is possible to develop a rich variety of textures and surfaces, smooth or rough, hard or soft, by drawing with white and black on paper of a medium gray value. Explore a number of different subjects that offer textural contrasts. A starched napkin, folded and pressed, provides an interesting pattern

below left: 99. Max Ernst (1891–1976; German). *Maternity,* study for *Surrealism and Painting.* 1942. Pencil and chalk on orange paper, 18⅞ × 12⅛″ (48 × 31 cm). Museum of Modern Art, New York (gift in memory of William B. Jaffe).

below: 100. Edwin Austin Abbey (1852–1911; American). *Head of a Celtic Woman,* study for the play scene in *Hamlet.* Charcoal and white chalk on red-brown paper, 28⅜ × 21⅝″ (72 × 55 cm). Yale University Art Gallery, New Haven, Conn. (Edwin Austin Abbey Memorial Collection).

The Art Elements

101. Jean Baptiste Camille Corot (1796–1875; French). *Landscape (The Large Tree)*. c. 1865–70. Charcoal, 9½ × 16¼'' (24 × 41 cm). Collection Mrs. Noah L. Butkin, Shaker Heights, Ohio.

of crumpled angularity and soft flowing surfaces when pinned to a wall. A very different quality characterizes silk, satin, or taffeta, which require exaggerated highlights similar to those in Figure 99. The broad flat planes of a fresh paper bag must be rendered differently from those of a sack that has been crushed. Try to distinguish between a transparent object such as a glass or jar and the polished reflective surface of a metallic bowl (Pl. 4, p. 155).

Begin to expand your vocabulary of drawing techniques by doing separate studies using each of the following methods. (1) Develop your images on middle-value gray charcoal paper, using white chalk to build lights, adding dark with charcoal (Fig. 100). Preserve the gray of the paper for all middle values; avoid mixing the chalk and charcoal to produce gray tones. By building the light and dark tones separately your drawing will appear cleaner, crisper, and more certain. (2) Make your own gray paper by laying an even tone of charcoal over a full sheet of white paper, using either soft charcoal or crushed compressed charcoal, which can be applied by rubbing gently with a soft cloth or piece of paper towel. Darker values are drawn in with compressed charcoal, while lighter tones and white are lifted out with a kneaded eraser (Fig. 101).

Range of Values and Expressive Use of Value

The use of value can range from pure black and white (Fig. 97) to drawings incorporating one or two intermediate grays (Fig. 102) or a full gradation of tones (Fig. 103). Intermediate values of gray bring additional enrichment to black and white, whether decorative pattern or representational image. Beyond that, value assumes a dominant role in determining the expressive mood of a drawing. A work that exploits full contrasts of value conveys a feeling of aliveness and vigor (Fig. 103). Compositions in which close value relationships dominate while contrasts are minimized may create a sense of quiet, soothing restfulness or of introspection and brooding subjectivity (Figs. 93, 101). Predominantly light compositions carry a sense of illumination, clarity, and perhaps a rational, optimistic outlook (Fig. 105), while compositions predominantly dark in value often suggest night, darkness, mystery, and fear (Fig. 101).

An artist selects and chooses from the value scale (Fig. 83) in much the same manner that a composer works with scales and keys to give mood and expressive character to a musical composition. In fact, the terms *high key, middle key, low key,* and *full range* are used to describe the general tonality of a drawing or painting.

Value

73

Full Range

As the term implies, a drawing with a full range of values is one that uses a complete gradation of tones from white to black (Fig. 103). Full range does not require equal distribution of all values. As in Charles Sheeler's *Interior, Bucks County Barn,* many of the tones play only a supporting role to the featured values, black and white.

In developing any drawing it is a valuable practice to determine the lightest light and darkest dark as a gauge from which to work. Without establishing some reference points, it is easy to overwork an area. It is generally advisable to err on the side of lightness since it is easier to darken an area than to lighten it. Many student drawings, intended as full-range drawings, lack interest because strong lights have been lost through overworking while the darks have not been made rich enough.

High Key, Middle Key, Low Key

Drawings categorized as high key, middle key, and low key are those based upon a limited number of closely related values. *High key* refers to the light values—white through middle gray on the value scale (Fig. 83), in which case the darkest value is no darker than middle gray (Fig. 93). A *middle-key* drawing includes the five values in the middle of the scale between light and dark; the dark half of the scale provides the *low key* (Fig. 101). In practice, it is the overall tonality that determines the key of any drawing rather than an exact duplicating of specific values. For example, in spite of some dark accents, Figure 104 is essentially a high-keyed drawing.

Drawings done on white paper in hard pencil—in fact, most line drawings irrespective of medium—carry as basically light in value (Figs. 4, 22). It is only through the extensive application of light gray tones or through the strategic placement of a few very dark accents, as in Wayne Thiebaud's *Standing Figure* (Fig. 105), that the predominantly pale tone of a drawing makes a strong impression. Compare your immediate response to Figures 93 and 105, noticing that the artist's deliberate handling of value elicits very different feelings.

The Art Elements

above left: 102. Winslow Homer (1836–1910; American). *Cavalry Soldier on Horseback.* c. 1863. Black and white chalk on brown paper, 13⅞ × 8⅜'' (35 × 21 cm). Museum of Fine Arts, Boston (anonymous gift).

above: 103. Charles Sheeler (1883–1965; American). *Interior, Bucks County Barn.* 1932. Conté, 15 × 18¾'' (38 × 48 cm). Whitney Museum of American Art, New York.

above: 104. Edwin Dickinson
(1891–1978; American).
*Studio, 46 Pearl Street,
Provincetown.* 1926.
Pencil, 17⅞ × 12¼'' (45 × 31 cm).
Collection E. C. Dickinson.

above right: 105. Wayne Thiebaud
(b. 1920; American).
Standing Figure. 1964.
Pencil, 10 × 8'' (25 × 20 cm).
Courtesy Allan Stone Gallery,
New York.

Project 35 Select a subject appropriate to a high-key (light-value) rendering—for example, a sunlit landscape or a still life devoid of strong darks and extensive shadow areas, perhaps one composed of basically light forms such as eggs or lemons in a white bowl. As a greater challenge, any subject, no matter what its actual tonality, can be transposed into a high-key drawing (Fig. 104). To do so, establish what will be the lightest and darkest values and work within that range. It will be necessary to simplify the values you see in order to compress them into the allowable number.

Determine size and shape relationships quickly, lightly, and without elaboration; block in broad value patterns as simply as possible; then study and define edges of forms, adding dark accents and highlights. That method is apparent in Edwin Dickinson's drawing of his studio (Fig. 104). Working on a lightly toned graphite background, Dickinson defined forms by adding darks and erasing the lights as described in Project 34. It is a technique well suited for developing high-key drawings.

Create a drawing surface of an even tone of pale gray by rubbing a small amount of powdered graphite onto a sheet of paper (graphite in stick or pencil form can be powdered on sandpaper). Use a fairly hard pencil (2H or 3H) to delineate your composition, add middle and darker values with pencil or rub in more graphite, and erase out lights. If you need darker accents, draw them with a soft pencil. We can see in Figure 104 that Dickinson used a lightly textured paper. Selecting a very white fine paper such as the Bristol board previously recommended for pen and ink results in a pale tonality of great elegance.

Project 36 Select a theme that will lend itself to a predominantly dark composition. Night subjects are, of course, ideal, but a wide variety of less obvious repre-

106. Calvin Albert
(b. 1918; American).
Ritual. 1954.
Charcoal, 29 × 23″ (74 × 58 cm).
Art Institute of Chicago
(Art Institute Purchase Fund).

sentational or symbolic concepts can be given a special character when presented in low key. A subject as radiant as a bouquet of summer flowers can be transformed into something ominous and mysterious through a change of value. You may wish to work on gray charcoal paper, allowing the value of the paper to determine your lightest light.

Value Contrasts for Emphasis

Variations in degrees of dark and light provide one of the most effective means for giving definition to forms in space (Fig. 90) and for accenting areas in a composition (Fig. 103). Forms are made to project or recede through degrees of light-dark contrast. Comparing once again Figures 105 and 93, we see that strong dark accents separate Thiebaud's woman from the background, while the absence of contrast causes Pearl's figure seemingly to dissolve into space.

Strong contrasts of light and dark, along with linear movements, create focal points that can direct the viewer's attention to parts of the composition according to their relative significance. Emphasis through dramatic value contrasts works equally well whether a composition is representational (Fig. 133) or abstract. Calvin Albert's abstract *Ritual* (Fig. 106) demonstrates an ascending sequence of darks silhouetted against lighter values and of lights flashing out against dark to create a visually satisfying pattern of dramatic complexity.

Project 37 Review the various drawings you have done for the projects in this chapter. Are there forms that could be made to appear more solidly three-dimensional by stronger modeling in light and dark? Could objects be made to exist more convincingly in space by increasing light-dark contrast to make forms project, lessening contrast to make them recede? Do the drawings lack interest because everything is presented with equal emphasis? Is it possible by intensifying focus on some forms or areas to produce a greater sense of drama and visual interest? Make whatever changes seem appropriate by altering value relationships. In some cases you may prefer to make a new drawing of the same or a similar subject.

The Art Elements

Texture

When we look at the world about us, we are conscious not only of form, space, color, dark, and light, but also of tactile qualities, a sense of the feel of surfaces, of roughness and smoothness, hardness and softness. Our perception connects many associations with these tactile experiences. For instance, smoothness may suggest refinement, luxury, expert craftsmanship; roughness tends to evoke vigor, heartiness, crudity, and careless finish. We have already established how the relative smoothness or roughness of a line can impart similar qualities to a drawing. In our industrial age, smoothness also implies machine finish as opposed to the less regular and less mechanical surface created by an individual using handcraft tools. This multitude of tactile sensations and associations we term *texture,* and its representation is fundamental to the aesthetic strength of any drawing.

Textural Character

Three factors determine the textural character of a drawing. First, in works concerned with picturing objects, there is the surface character of the objects represented (Fig. 90). Second, there are the textures inherent in the artist's materials—for example, coarse chalk on rough paper (Fig. 107) as contrasted to fine pencil on smooth paper (Fig. 108). Third, there is the suggestion of roughness or smoothness that results from the artist's manner of work. In Francisco Goya's *The Little Prisoner* (Fig. 109) the impetuous use of ink, evident in both the crinkly contour lines and the briskly applied hatchings, creates a sense of vitality less related to the surfaces being described or medium being used than to Goya's excited execution. These elements—the surface portrayed, the medium and ground, and the method of application—unite as the textural character of a drawing. Skillfully used, texture can contribute significantly to the expressiveness of a drawing; lacking a decisive sense of texture, a drawing tends to appear flaccid and weak.

107. James Abbott McNeill Whistler (1834–1903; American).
Portrait Study of a Woman's Head.
Black and white chalk on tan paper, 10¾ × 7¾″ (27 × 20 cm).
Paul Magriel Collection.

Familiar Surfaces

The minute moldings of a surface's structure are often so fine that textural character is difficult to perceive, while many surfaces are so familiar that we take them for granted and fail to be objective about the particulars of their textures.

Project 38 As artists we are concerned with the visual aspects of texture, yet we know that our most immediate experiences with texture are tactile. This project is intended to integrate the visual with the tactile. Most children, at one time or another, have reproduced the images that appear in relief on coins by placing a piece of paper over a coin and rubbing it with the side of the lead of a pencil. In the same manner, an artist can create a rich variety of textures by making rubbings of different textured surfaces. This exercise is intended to increase visual awareness of familiar textures through seeing them translated into images on a sheet of paper.

Use a soft pencil, stick graphite, or a black crayon with bond paper or tracing paper (newsprint tears too easily). Make rubbings a few inches square from textured surfaces in your immediate environment, both interior and exterior—bamboo and other woven placemats, wicker objects, rugs, toweling, corduroy and other fabrics, burlap-covered lamp shades, crumpled paper and kitchen foil; concrete or brick surfaces, wooden shingles, or fallen leaves; hard or soft surfaces; fine and rough textures; natural and manufactured textures. The possibilities multiply in relation to your awareness and sensitivity. Even though rubbings produce a reverse image, we often become more conscious of the visual qualities of texture when we see them presented as a pattern of marks on a sheet of paper, isolated from the object or surface itself. As you study the rubbings you will be aware that durable materials result in stronger patterns than soft materials such as fabric, a distinction that provides you with a clue about rendering textural differences.

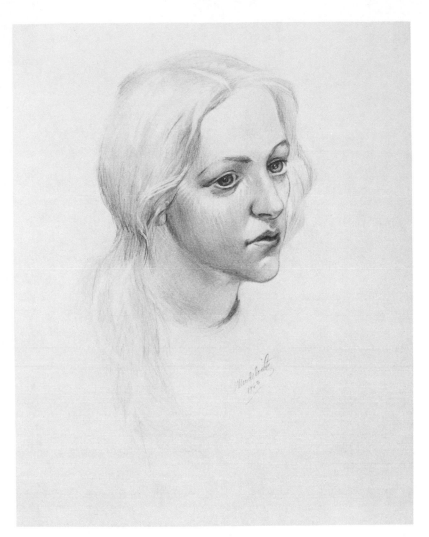

right: 108. Daniel M. Mendelowitz
(1905–1980; American).
Portrait of Annie. 1963.
Rubbed graphite pencil and eraser,
16 × 12″ (41 × 30 cm).
Collection Mrs. Daniel Mendelowitz,
Stanford, Calif.

left: 109. Francisco Goya (1746–1828; Spanish).
The Little Prisoner. 1810–20.
Pen and brown ink, with wash;
4⅜ × 3⅛″ (11 × 8 cm).
Prado, Madrid.

Texture

110. Mary Claire Draeger
(b. 1960; American).
Cloey's Afghan. 1980. Pencil,
9 × 11½'' (23 × 29 cm).
Courtesy the artist.

Rendering Textures

Textures created by rubbing can occasionally be introduced into a drawing, either through direct rubbing or as torn or cut shapes pasted onto the drawing. In each instance, the texture will appear as a relatively two-dimensional pattern. More frequently, texture is an element used to amplify representational drawing, necessitating some skill in rendering different surface characteristics. Some artists such as Mary Claire Draeger reveal an almost passionate fascination with texture in *trompe l'oeil* (fool-the-eye) renderings, which involve the meticulous copying of surfaces, textures, and details (Fig. 110).

Project 39 Enlarging the scale of a surface provides an excellent means of becoming aware of its exact character. Upon close examination the texture of many a familiar surface—a natural sponge, a slice of bread, or the skin of a cantaloupe—proves visually fascinating. Select a familiar textured surface. Light the surface sharply from above and to one side (a "raking" light) to emphasize and clarify its texture. Fill a 4- by 5-inch rectangle with a pencil rendering of the surface magnified many times, using dark and light values to create a maximum sense of its texture. It is suggested that you work with a variety of hard and soft pencils on Bristol board. Your aim should be to duplicate the texture as accurately as possible. Work slowly and plan to spend several hours on this project, working in whatever intervals your patience allows.

Textures of the Artist's Media

Different media produce different textures, as do different papers (Figs. 107, 108). Georges Seurat's charcoal and conté crayon studies (Fig. 178) exhibit textural patterns determined solely by choice of materials rather than being descriptive of the subject depicted.

The Art Elements

Project 40 For this project gather papers of varying roughness, smoothness, and surface grain (see pp. 134–135); small pieces will suffice. Collect chalk, crayons, pencils, assorted pens; and brushes, sponges, and other equipment for applying inks. Experiment with applying the different media to the papers. Use both the sides and points of dry media; cross-hatch and stipple in both dry and wet; combine all types of pens, sponges, brushes, and so forth.

Comparative Textures

Project 41 As an extension of the previous assignments, develop a full-page composition using texture as your subject. Select a media-and-paper combination from the last project. Cover the full sheet with a random, free-flowing pattern of some complexity drawn with light pencil lines. Using the medium selected, perhaps pen and ink, begin by adding texture to one shape. Move to adjoining shapes and introduce different or related textures, working to integrate them so that the completed drawing conveys a sense of unity rather than appearing as a two-dimensional patchwork of unrelated patterns. Allow patterns of light and dark to emerge by grouping shapes of the same or closely related values, working to achieve the effect of movement in space. The completed drawing should offer a richness of textural elaboration enhanced by a full range of values.

Project 42 Just as choice of line quality contributes to the expressive character of a drawing, so too does the textural quality determined by the various combinations of media and paper. Arrange a still life offering some textural variety. Select two contrasting combinations of media and paper from Project 40 and draw the same subject using each combination. Do not make meticulously detailed renderings, yet give some attention to suggesting textural differences. Study the completed drawings and determine which method of working seems most satisfying to you, in terms of both the activity and its end result.

Multiple Units of Texture

When we look at a tree, we are not aware of the countless leaves that make up the tree but rather fuse them into a single visual entity; a cluster of leaves becomes a tree. When we look at a tree, we see its multiple surface units as texture. An artist tends to suggest that textural character by wiggling the hand, stippling, making lines or splotches, or using any other measures that appropriately suggest the surface quality of the objects. Such movements of hand become almost automatic in time, the hand responding to the visual perception of texture as unconsciously as it responds to changes of direction when the artist is doing contour drawings.

The ways in which different artists respond to similar stimuli can be seen in the following sequence of details from drawings including trees and foliage (Figs. 111 to 115). Representing various trees and using different media, the drawings reflect a variety of traditions and divergent temperaments.

Project 43 Study the illustrations, analyzing possible ways of suggesting foliage—boldly stylized (Figs. 111, 112) or more naturalistically descriptive (Fig. 113)—all using value contrasts to create foliage masses. Select two or three trees from nature with sharp differences in the character of their foliage. Examine the elements that give each tree its particular character—the shapes of the foliage masses; the size of leaves; the size and shape of the areas of sky seen through the masses of foliage; the character of branch patterns, where branches are seen, and so forth. After you have analyzed these qualities, develop textures that communicate the character of the foliage masses, using whatever medium and technique seem appropriate. Select the texture you consider most satisfactory, and draw a full tree. Then draw another tree of very different character.

Texture

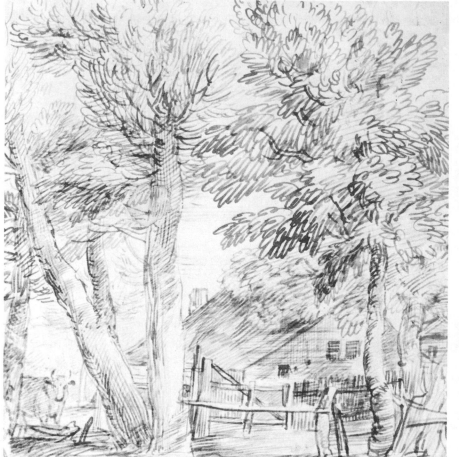

above: 111. Jan Lievens (1607–1674; Dutch). *Rural Landscape with Milkmaid,*
detail. Reed pen and brown ink on Indian paper, entire work 8¾ × 14⅛″ (22 × 36 cm).
Metropolitan Museum of Art, New York (Rogers Fund, 1961).

above right: 112. School of Sesshu (Eitoka?) (Late 15th century; Japanese).
Panel of a six-fold screen, detail. 1590. Sumi on rice paper,
entire panel 5′3″ ×1′9″ (1.6 × .53 m). Stanford University Museum of Art, Calif.
(Ikeda Collection, gift of Jane L. Stanford).

far left: 113. Heinrich Reinhold
(1788–1825; German).
Vineyard at Olevano, detail. 1822.
Pen and ink, with pencil;
entire work 10¼ × 12⅜″ (26 × 32 cm).
Staatliche Graphische Sammlung,
Munich.

left: 114. Rodolphe Bresdin
(1822–1885; French).
Bank of a Pond, detail.
Pen and India ink,
entire work 6½ × 6¾″ (16 × 17 cm).
Art Institute of Chicago
(gift of the Print and Drawing Club).

115. Alexander Cozens
(1716–1786; English).
Tree with Distant Mountain.
Brush and ink,
8⅞ × 12″ (23 × 30 cm).
British Museum, London
(reproduced by courtesy
of the Trustees).

Uniform Texture

Some artists prefer that the texture of a drawing assume an abstract character, determined by the mode of applying the medium rather than the nature of the subject. This method tends to emphasize the formal aspects of a drawing and seems best suited for stylized modes of expression, where a uniform texture prevails throughout a drawing (Figs. 116, 117). Such uniformity enhances the patternlike qualities of texture (Fig. 92).

116. Georges Seurat
(1859–1891; French).
Stone Breakers, Le Raincy.
c. 1881. Conté,
11⅞ × 14¾″ (30 × 38 cm).
Museum of Modern Art, New York
(Lillie P. Bliss Collection).

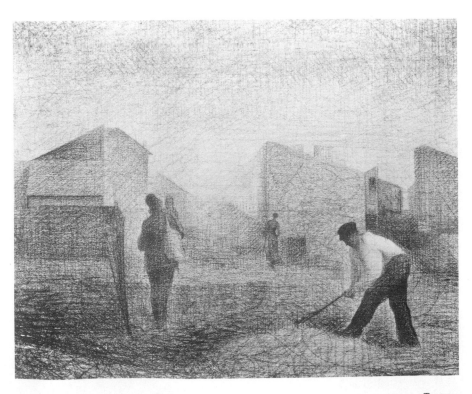

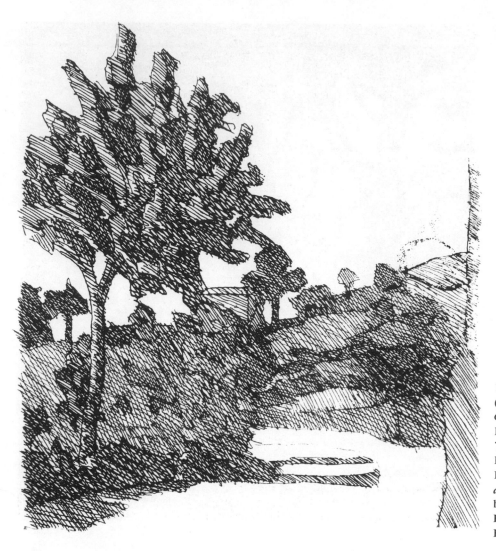

117. Giorgio Morandi
(1890–1964; Italian).
Countryside at Grizzana. 1932.
Etching on copper,
7¾ × 7'' (20 × 18 cm).
Private collection, Milan.
Reprinted from *L'Opere Grafica
di Giorgio Morandi,*
by Lamberto Vitali.
Published by Giulio Einaudi
Editore, Turin.

Project 44 Select an appropriate subject or plan a composition permitting a range of values using one uniform texture throughout. Allow forms to be simplified, but work to achieve a maximum sense of volume and space. The size of your drawing should be influenced by the scale of the texture chosen. Some suggested ways of working are: (1) scribbling in curved and circular movements; (2) scribbling in angular and straight-line movements; (3) cross-hatching; (4) stippling, using dots or commalike marks; (5) combining or modifying one or more of the above methods.

Expressive Use of Texture

The freedom or caution with which a medium is applied to paper, the degree to which hand and body are relaxed, expressions of inner tension or harmony, as well as intellectual convictions and aesthetic tastes—all these work together to form an artist's mature style. Each artist's style has its textural character (Figs. 118 to 120). The beginner frequently shows conscious preferences that take the form of admiration for some particular master's way of working, and very often the beginner gives legitimate expression to these preferences by following the manner of the master. Gradually, as the student matures as an artist, gaining assurance and independence from admired models, a unique and personal style of working evolves.

The Art Elements

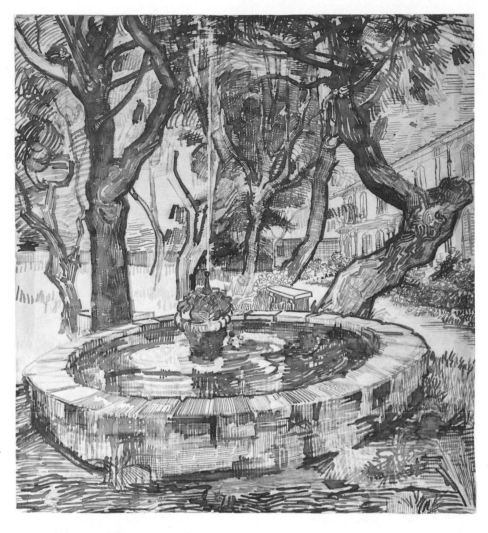

118. Vincent van Gogh
(1853–1890; Dutch-French).
Fountain in the Hospital Garden.
1889–90. Pen and ink on paper,
17½ × 18¾″ (45 × 48 cm).
National Museum
Vincent van Gogh, Amsterdam.

119. Henry Moore
(b. 1898; English).
*Two Sheep with Lambs
against a Hedgerow.* 1972.
Ball-point pen,
8¼ × 9⅞″ (21 × 25 cm).
Henry Moore Foundation.

Project 45 Study a number of drawings or good reproductions. Select ways of working that achieve descriptive, vigorous, appealing textural character, and adapt the method to objects or subjects of your own choosing; perhaps you might want to reinterpret some of your earlier drawings. To become familiar with any one technique, it will be necessary that you do numerous drawings in the same manner. At first you will probably want to refer to the master drawing; then as you acquire a feeling for the technique, put aside the model. It is important to work with similar materials if you wish to achieve similar effects. Van Gogh's patterns and textures, for example, depend upon the quality of line produced by a reed pen (Fig. 118), for which a bamboo pen offers a suitable substitute. Let it be your intention to learn to use a technique, not to make a copy. Feel the mood of the style and the manner in which it was carried out, whether slowly and methodically or rapidly and impulsively, whether with small finger strokes or large hand movements. Allow deviations to occur. It is important to discover the most satisfying ways of developing texture with a minimum of self-consciousness so that it becomes an integral element in composition, contributing to the expressiveness of a drawing.

120. Jasper Johns
(b. 1930; American).
Flag. 1958.
Pencil and graphite wash on paper,
7½ × 10⅜″ (19 × 26 cm).
Collection Mr. and Mrs. Leo Castelli.

Sketchbook Activities

When you find a way of working that appeals to you, either because it feels comfortable or because you like the results, practice it in your sketchbook (and elsewhere) so that it becomes a natural part of your drawing vocabulary.

The Art Elements

7 Composition

The success of a drawing derives in part from the appropriate matching of medium to subject matter. Effective drawing, however, requires more than learning to manipulate media skillfully to produce a satisfying representation of an object, for neither choice of subject nor beauty of technique is sufficient if the artist has not also been concerned with *composition*.

Composition, which is the structure of a picture as separate both from subject and style, is essentially abstract design. It is the selection and organization of line, shape, value, texture, pattern, and color, if used, into a unified, aesthetically pleasing arrangement embodying such principles of design as balance, harmony, rhythm, repetition and variations, dominance and subordination, and focus.

Principles of composition are not hard and fast rules never to be broken. They should be considered as guides or suggestions, which have been recognized and used effectively by successful artists for centuries. The same artists have felt free to interpret the principles, and you are urged to do the same, as long as the result justifies whatever you chose to do. To break rules effectively, it is first necessary to know what they are.

By general agreement, in good composition all elements are so satisfying as used that to alter one part would damage the work; nothing can be added nor subtracted. The parts have been integrated so that the whole piece is more important than any single element.

Beyond creating an aesthetically pleasing arrangement of line, shape, and other elements, composition contributes also to content and meaning. A drawing or painting (sculpture, music, and literature as well) is composed of three elements—subject matter, form or composition, and content. Subject matter alone is not a sufficient condition for a work of art. The significance of any work lies in its content or meaning. What does a viewer experience in looking at the work? What response does the piece elicit? The meaning given to the subject

depends largely upon the form (composition) selected by the artist. Beh Shahn said, "Form is the visible shape of content." Beyond having the skill to reproduce the likeness of an object and control media, the artist must know the principles of composition and be able to use the art elements expressively to insure full meaning to every drawing. From the preceding chapters you have begun to develop an awareness of the expressive potential of line, value, and texture. The focus of this section will be upon selection and organization of those elements according to basic principles of design.

As noted earlier, many drawings fail from lack of planning, and since composition is essential to successful drawing, planning plays a key role. Compositions cannot always be fully planned before you set pencil to paper because a change in one shape often necessitates a change in another. However, compositional studies made as quick thumbnail roughs allow you to solve many major compositional problems in advance.

Mary Cassatt established the essential composition for her painting *At the Opera* (Fig. 121) in an on-the-spot rough sketch (Fig. 122). The boldly simplified shapes of light and dark provide an effective visualization of the subject without elaboration of detail other than a few lines of written notes.

121. Mary Cassatt (1844–1926; American). *At the Opera.* 1880. Oil on canvas, 32 × 26″ (81 × 66 cm). Museum of Fine Arts, Boston (Charles Henry Hayden Fund).

122. Mary Cassatt (1844–1926; American).
Study for *At the Opera*. 1880.
Soft pencil on paper, 4 × 6″ (10 × 15 cm).
Museum of Fine Arts, Boston
(gift of Dr. Hans Schaetter).

123. Charles Sheeler (1883–1965; American).
New York. 1920.
Pencil, 19⅞ × 13″ (50 × 33 cm).
Art Institute of Chicago.

Selecting Format

Composition begins with the size and shape of the paper. Students have a tendency to start drawing without regard for the size of the paper. Occasionally they draw objects so large that they run off the sheet, but more frequently, the forms are drawn so small that wide borders of blank paper are left. Although drawings can be cropped and paper can be cut, it is valuable to learn to use the full size of the paper. If the drawing is to be smaller than the full sheet, four lines should be drawn to define the dimensions of the picture plane (Fig. 122). The edges of the paper or the drawn borders become the first four lines of any drawing. Composition is the relationship of all lines, shapes, and elements to the four edges as well as to each other.

The rectangle, as the most common compositional format, can be used vertically or horizontally. It has been suggested that we tend towards horizontal compositions because our eyes, set side by side, cause us to see images that are wider than they are high. While this may be true, certain subjects lend themselves to a vertical format (Fig. 123). Many people automatically assume that a vertical view of a vertical form would be most effective, whereas the height of an object might become more dramatic when placed in a horizontal composition (Fig. 124).

Working from nature or life, it is helpful to use a viewfinder with a rectangular opening to determine what and how much to include. By moving the viewfinder closer to your eye or holding it farther away, you can control the amount of area you see. Use it exactly as you would the viewfinder of a camera to find

Composition

124. Dominique Papety
(1815–1849; French).
Via Gregoriana. 1838.
Graphite pencil with blue ink
wash on gray paper,
13 × 17¾″ (33 × 45 cm).
Musée Fabre, Montpellier.

the most interesting view of the subject. Determine whether a horizontal or
vertical format is more appropriate. Two artists looking through viewfinders at
the same subject might well arrive at totally different compositions, both equally
satisfying. Unlike photographers, who are limited essentially to what they see in
the viewfinder, artists have the option to shift objects around within the space of
their pictures to improve composition. Forms can be added or eliminated to
provide better balance and create stronger visual interest.

Open and Closed Composition

Within the format selected, elements can be arranged into a *closed composition*
in which the forms seem well contained by the edges of the picture plane, or
into an *open composition* in which images appear unrelated to the size of the
paper, creating the impression that the composition, unlimited by the outer
edges, extends beyond the boundaries of the picture. "Open" implies some-
thing free, expansive, flowing, unrestrained, spacious, undefined; "closed" sug-
gests images that are contained, controlled, compact, complete.

Balance

Among the principles of composition, *balance* is given first consideration. In
fact, composition is defined as the balancing of the elements of design. Balance
may be either *symmetrical* or *asymmetrical.*

Symmetrical balance calls for dividing the composition into two halves with
seemingly identical elements on each side of a vertical axis. The two sides need
not be exactly identical as long as a feeling of balance is maintained. Symmetry
lends an aura of dignity and formality to a composition, but it also can seem stiff,
static, even dull and unimaginative.

Most artists, agreeing that diversity offers greater interest than sameness, pre-
fer asymmetrical balance. There are no rules for asymmetrical balance; it is
based upon a visual sense of equilibrium that can be felt more than it can be
measured. It can be likened to a teeter-totter. For children of the same size the

The Art Elements

125. F. H. Potter
(1845–1887; English).
Rest. Black chalk,
9⅝ × 13″ (24 × 33 cm),
Tate Gallery, London.

board is placed with one half on each side (symmetrical), whereas with a small child and a larger person it becomes necessary to shift the position of the board to provide more weight for the smaller of the two (asymmetrical). Based upon this image, heavier shapes are placed nearer the middle of a composition. In Figure 125 the small, intense light accent of the lamp offsets the greater complexity of muted form and pattern in the right half of the composition. The function of the hand of the figure as the fulcrum point is made more apparent by the central positioning of the picture frame.

Asymmetrical balance offers the artist greater compositional freedom. It is more flexible, more dynamic. It allows the introduction of greater movement and action.

Directional Lines

Chapter 4 introduced the expressive function of line in describing form, suggesting that certain qualities of line are better suited to one subject than another. *Direction of line* also serves to evoke an emotional response. While any composition incorporates various linear elements, a dominant mood can be established by placing emphasis on directional lines.

Long, relatively unbroken, horizontal lines, for example, are calm and restful, suggestive of peace, tranquility, and serenity. Vertical lines convey a feeling of dignity, stateliness, stability, and strength (Fig. 123). Combining vertical and horizontal elements produces a solid and orderly sense of structure similar to architectural construction.

Diagonal lines are dynamic, suggestive of action. Broken patterns of diagonals result in confusion and disorder; opposing diagonals create conflict and strife. Diagonal compositions generally are more forceful and disturbing than those based on a vertical and horizontal organization.

Curved lines are associated with grace, elegance, and gently flowing movement, while more complicated patterns of curves with frequent reversals produce greater animation, even agitation. By combining arcs and diagonal lines, Charles Sheeler (Fig. 126) and Cy Twombly (Fig. 127) created strongly contrasting moods, the first gentle and relaxing, the second expressing turbulence.

Composition

126. Charles Sheeler (1883–1965; American). *Yachts.* 1924.
Lithograph, 8¼ × 9¾″ (21 × 25 cm). National Museum of American Art,
Smithsonian Institution, Washington, D.C. (Museum Purchase).

127. Cỳ Twombly (b. 1929; American). *Untitled.* 1972. Oil on canvas,
4′9⅜″ × 6′4″ (1.47 × 1.95 m). Collection Nicola del Roscio, Rome.

128. Henri Matisse
(1869–1954; French).
The Plumed Hat. 1919.
Pencil on paper,
29⅞ × 14⅛″ (53 × 37 cm).
Detroit Institute of Arts
(bequest of John S. Newberry).

Learning to control the placement of each line and the patterns created by lines used in combination, provides a means of adding expression to a composition. Effectiveness, however, does not demand posterlike directness. In fact, directional lines can be introduced without actually being drawn, as evidenced in the invisible though unmistakable verticality of Matisse's *Plumed Hat* (Fig. 128). Although softened by the rich pattern of loops and gracefully undulating curves, it is the figure's almost rigidly upright pose that evokes such regalness.

Shape

Shape refers to the flat, two-dimensional aspects of form as opposed to volume. When a three-dimensional form is reduced to silhouette we become conscious only of its shape. Shapes can be defined by contour line and by changes of value, texture, and color, alone or in combination.

Shapes are available in an endless variety—simple and complex, symmetrical and asymmetrical, static and dynamic, descriptive and free form, hard-edged and with softened edges. Shapes can be *geometric* (rectangles, circles, triangles, diamonds), *rectilinear* (straight-sided), *curvilinear* (based on curves), *biomorphic* (irregular and free form), *organic* (related to nature and growth).

Shapes often exist as underlying compositional elements rather than as completely defined forms. They can be introduced into pictorial composition to establish an emotional effect as well as to provide structure. Two simplified figures locked into a triangular shape create a monumental image of human grief in a powerful drawing by Käthe Kollwitz symbolizing the artist's own personal loss in the death of her soldier son during World War I (Fig. 129).

Composition

129. Käthe Kollwitz
(1867–1945; German).
The Parents. 1920. Charcoal,
16¾ × 21⅞″ (43 × 56 cm).
Courtesy Deutsche Fotothek Dresden.

Project 46 One shape drawn on a piece of paper immediately sets up a relationship between it and the paper. Consider a single shape, such as a circle or triangle placed within a square or rectangle. In a series of thumbnail studies explore the relationship between the shape and the surrounding space as you move the shape within that area. Enlarge and reduce the size of the shape. Let the shape dominate the space; then let the space dominate the shape. Create both pleasing balance and disturbing tension. Introducing a second shape will establish a new set of relationships that must be balanced. Conflict, tension, and animation can be produced by grouping and overlapping shapes.

A shape cannot exist alone in a drawing; it can be seen only in relation to adjacent shapes and the space that surrounds it. Composition, therefore, involves *positive shapes* defined by *negative space*. (See Chap. 3.) It is as necessary to compose negative space as it is to be concerned with positive shapes.

Beth Van Hoesen has gone beyond a literal describing of leeks to create an animated interplay of positive shapes and negative space presented almost as two-dimensional design (Fig. 130). Even though the background is considered negative space, it can be seen as shapes every bit as interesting as the leeks. The way in which the leeks intersect only the lower and side edges of the composition in contrast to the unbroken upper edge adds vitality to the image.

Project 47 Continuing to work with a series of small sketches or studies, begin with a rectangle or square and cut (draw) five notches into the outer edges. They may be large or small and of any shape, although similar shapes result in a more unified design. Shade either the remaining shape or the cut-away segments to become more aware of positive and negative aspects. In all composition your purpose is to establish a sense of balance, even when you are working to create the effect of tension. Experiment with symmetrical and asymmetrical balance, with dominance and subordination. Explore the possibilities of leaving one, two, or even three edges unbroken. By rotating your drawings, you will become aware that the impact of the same composition can be altered by seeing it from another angle. Artists frequently look at a work in progress upside down or view it in reverse in a mirror to find compositional weaknesses.

The Art Elements

94

Look at your studies from both of the preceding projects. You probably feel that some are more interesting and successful than others. Can you determine why? Check for balance. If it is to be measured, it can only be done visually. What is the proportion of light to dark? There is no correct proportion; it is more a question of how the light and dark areas are distributed and balanced. Equal amounts of light and dark with equal emphasis between shape and space can result in a reversal of images where you see first one shape then the other, since it is impossible to focus on both images at the same time. In the Escher work (Fig. 96) this leads to purposeful confusion. When the effect is unintentional, it is simply confusion.

As a rule, dark shapes appear heavier than light shapes in terms of visual balance. However, optical illusions occur, and a light shape seen against a dark background appears larger than an identical black shape seen against a light background. This must be considered when establishing balance.

Project 48 In a rectangle based on a 3 to 4 proportion, place three circles in any grouping that seems pleasing in relation to the outer edges. Alter the shapes of each circle by cutting away sections without totally destroying the circular contour. The problem is not simply to modify the individual circles but to maintain a balanced composition. The balance can be more easily determined by adding shading to the shapes. Although each of the resulting shapes may be completely different, provide enough similarity to insure a sense of unity. Continue altering the shapes, adding back or cutting away, until the relationship of the shapes to each other, to the surrounding space, and the outer edges of the rectangle is both visually interesting and balanced.

Repetition—Pattern

The desired final effect of a composition is a sense of *unity*, which must be considered from the beginning. Unity can be achieved through the *repetition* of similar elements—lines, shapes, patterns, textures, and movements.

130. Beth Van Hoesen
(b. 1926; American).
Leeks. 1960.
Engraving and etching,
8 × 9¾″ (20 × 25 cm).
Courtesy the artist.

Repetition does not mean exact duplication, which tends to result in pattern. *Pattern* is the purposeful repetition of a shape or other element, which, if extended, has the quality of an overall design. Pattern can be used to create unity, but care must be taken not to let it become too emphatic or decorative. A pattern that is too complex becomes confusing to the viewer; one that is too simple appears dull and uninteresting.

The Japanese master Sōtatsu needed no more than two or three carefully chosen calligraphic brushstrokes to place a crane in flight (Fig. 131). Repetition of the motif begins to establish a pattern, yet by varying the intervals between the individual images and confining them to one area of the composition, the resulting pattern is neither monotonous nor decorative. The same brilliant balancing of repetition and pattern is seen in another Japanese work (Fig. 95).

Variation—Contrast

To prevent the repetition of any element from becoming either too obvious or monotonous, *variety* can be introduced to provide *contrast*. Variation can be as simple as an apparent change in spacing between forms or a slight modification of shapes (Figs. 131, 132).

A unified composition is not built on sameness. There can and must be variety; yet with each element that is introduced, with each principle considered, the determining factor is always balance. That which applies to two-dimensional design applies equally to compositions built around recognizable subject matter rendered three-dimensionally. Students too frequently think of design as existing apart from representational drawing, when in fact the two are inseparable.

Dominance—Subordination

No matter how varied the individual shapes, equal emphasis on each form is distracting if the viewer is asked to look from shape to shape, object to object, without a center of interest upon which to focus. In a successful composition

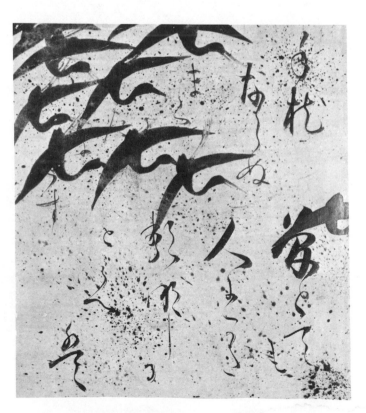

131. Underpainting
by Nonomura Sōtatsu
(1576–1643; Japanese),
calligraphy by Honnami Koetsu
(1558–1637; Japanese).
Poem, with birds in flight.
Ink on gray-blue paper,
gold-flecked; 7⅜ × 6⅝″ (19 × 16 cm).
Nelson Gallery-Atkins Museum,
Kansas City, Mo. (gift of
Mrs. George H. Bunting, Jr.).

132. Charles Roth
(b. 1948; American).
Servants: From a Line of Men, 1930.
1979. Etching and aquatint,
29¾ × 40½″ (76 × 103 cm).
Courtesy the artist.

certain elements assume more importance than others. As a center of interest, such elements become dominant; all other parts are subordinated to them. Although the artist wants the viewer to be conscious of everything in the drawing, to look at every detail, attention is ultimately focused on a dominant element. However, should that part be so dominant that it overwhelms everything else, the artist has allowed it to throw the composition out of balance. In symmetrical composition the center of interest will be placed in the middle of the composition. Most generally the focus of interest will not be centered in asymmetrical composition.

Movement

A picture with only one center of interest soon bores the viewer. Like a dramatist, novelist, or composer, an artist introduces secondary focal points, subplots as it were, leading the eye of the viewer from one to another and eventually directing attention back to the dominant focal point (Fig. 133). To accomplish this skillfully, the artist must establish directional paths of movement.

The flow of automobile traffic is programmed for us by directional arrows, barriers, signs instructing us to merge right or merge left, flashing yellow lights telling us to slow down and use caution, and red lights telling us to stop. An artist cannot assume that a viewer will know what to look at in a picture unless corresponding visual directions are provided. The artist must take responsibility for controlling the way the eye of the viewer is directed through the composition (Figs. 133, 134). The artist determines the sequence in which the eye moves from one area to the next, ultimately focusing on the center of interest. Paths of movement should flow smoothly. Pauses can be provided, but there must be no solid barriers resulting in a complete stop.

The eye tends to move rapidly between large shapes, moving more slowly through small complicated areas as it pauses to examine details. Tension points are like bottlenecks caused by too much traffic converging at the same spot. Tension can be introduced deliberately; too much might produce an unwanted and disturbing focal point, while too little, created by excessive space around objects, causes forms to seem unrelated.

Composition

133. George Bellows
(1882–1925; American).
The Cliff Dwellers.
Charcoal, black crayon,
brush and India ink,
with touches of watercolor;
21¼ × 27⅛″ (54 × 69 cm).
Art Institute of Chicago
(Olivia Shaler Swan
Memorial Collection).

134. Richard Diebenkorn
(b. 1922; American).
Still Life/Cigarette Butts. 1967.
Pencil and ink,
14 × 17″ (36 × 43 cm).
Courtesy the artist.

Project 49 Divide a rectangle of any size (from 4 to 6 inches to a full sheet of paper) into shapes that are interesting both individually and in relation one to another. The shapes should be varied in size and shape, providing areas of both simplicity and complexity. The design can be derived from straight lines, curved lines, irregular free-form shapes, or a combination of forms. Remember that similar shapes create unity, yet variety contributes to pictorial interest.

By introducing patterns of light and dark, plus an intermediate value, begin to establish centers of interest. Simplify shapes or engage in additional breaking up

The Art Elements

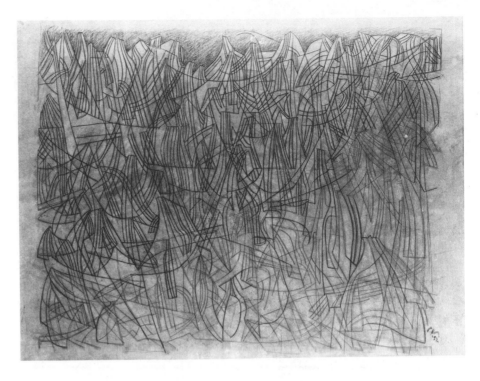

135. Mark Tobey
(1890–1976; American).
Mountains. 1952.
Crayon on paper
mounted on cardboard,
37⅜ × 47″ (95 × 119 cm).
Courtesy Preston, Thorgrimson,
Ellis & Holman, Seattle.

of space as you develop a flow of movement through the composition. Allow directional lines, linear patterns, and the repetition of shapes, spaces, intervals, and values to set up paths of movement. Integrate as many principles of design as possible into your composition.

Rhythm

Rhythm can be viewed in relation to repetition, variation, and movement (Fig. 135). All of the terms mentioned are recognized as elements of musical composition and they function the same whether in music or art.

The word *rhythm* automatically seems to evoke an image of flowing lines, yet it is not limited to curvilinear forms. Patterns of straight lines with attention to the repetition of groupings and intervals as well as direction of lines also establish rhythm (Fig. 136). The metre (rhythm) of a poem, for example, can be diagrammed with lines.

Project 50 Develop a composition with a rhythmic pattern created with only vertical, horizontal, and diagonal lines. Let each line intersect two borders of the paper or rectangle with no change in direction within any single line. Establish rhythm through changes in spacing and density of lines. Be concerned with creating an interesting composition with balance and centers of interest, rather than repetitious pattern.

Project 51 Follow the same instructions for the last assignment, substituting curved lines. Reverse curves or S-curves can be used.

Depth

In both two-dimensional design and three-dimensional representation overlapping forms suggest spatial depth (Fig. 137). We automatically see them as being one in front of another. The effect is heightened when the overlapped shapes

Composition

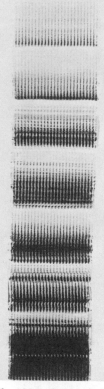

136. Heinz Mack (b. 1931; German). *Black Drawing.*
1965. Oil crayon rubbing, 5′ × 4′8″ (1.53 × 1.18 m).
Courtesy Galerie Denise René
Hans Mayer G.m.b.H., Düsseldorf.

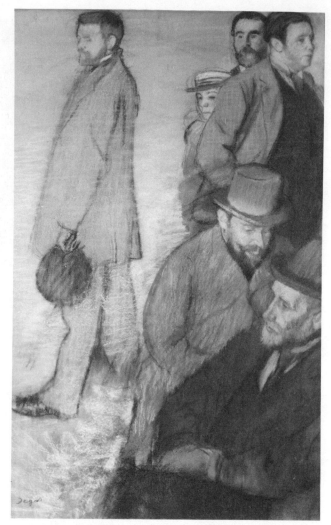

137. Edgar Degas (1834–1917; French). *Six Friends.*
c. 1885. Pastel and black chalk,
45¼ × 28″ (115 × 71 cm). Museum of Art,
Rhode Island School of Design, Providence
(Museum Appropriation).

also diminish in scale. Difference in scale often implies spatial distance. When two similar shapes are represented in different scale we are inclined to see the larger form as being closer. That interpretation comes from our conditioning in looking at illusionistic art in which the scale of an object is determined by its distance from the viewer.

Project 52 Select several interestingly shaped objects including a teapot or some similar form that has both positive and negative elements inherent in its design. Line them up on a table without grouping them into a composition. Study the contour of each form and see it as a flat shape. It will be helpful to do a simple contour drawing of each object.

Create a composition representing the objects as two-dimensional shapes, overlapping the forms to suggest spatial depth. Explore different ways of overlapping the shapes so that partially revealed forms are interesting as shapes apart from the objects they depict. Organize the objects to provide visual interest to the surrounding space. Develop the drawing in flat areas of light, dark, and intermediate values, using contrast as a means of providing focus. Overlapping shapes of the same value will result in new shapes, which can enhance the composition.

The Art Elements

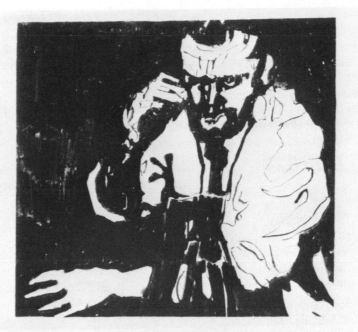

138. Paul Klee (1879–1940; Swiss-German). *Self-Portrait Drawing for a Woodcut.* 1909, 1939. Tusche; larger drawing 5 × 5⅝″ (13 × 15 cm), smaller drawing 2⅜ × 1″ (7 × 2 cm). Collection Felix Klee, Bern.

So long as the old and new shapes can be understood and do not interfere with spatial relationships they need not be separated. Remember that a balance of simplicity and complexity contributes to an interesting composition.

Value

Value is an essential element in pictorial composition. Forms can be defined by value and separated by it. Through value, balance is established, movement provided, spatial unity maintained, and expressiveness introduced. An artist must understand how to control value rather than be bound to a literal copying of what is seen. Whether working from life or imagination, the artist must take responsibility for rearranging, reversing, or intensifying patterns of light and dark to strengthen a composition.

Distribution of Value

The impact of a picture is based to a large degree on the distribution of light and dark. Strong patterns of dark against light and light against dark (Fig. 138) create a much different effect than light and dark used with middle-value grays (Fig. 133). Even against middle values the impression of white and black depends upon whether they are separated, appear side by side, or are surrounded one by the other.

Project 53 *Arrange three simple shapes (squares) in a rectangle so that two overlapping shapes float against the background with the third shape appearing in front of the other two. Using compressed charcoal fill in each separate area with a different value—white, light gray, dark gray, and black. Repeat the exercise four times using each of the values as the background and altering the values of the other shapes. Observe the changes in impact.*

Compose a second more elaborate composition using shapes of your own choosing. Plan a major center of interest and two minor ones. Develop the composition in values using the first part of the assignment as reference. Areas of greater contrast create focal points and separation; subtle value changes provide transition and subordination.

Value Defines Space

Forms are made to advance and recede through the degree of value contrast employed (Fig. 139). Against a dark background light shapes advance to the degree of their brilliance; against a white background, light tones are held closer to the background while dark shapes are projected forward (Fig. 83). The stronger the contrast, the more a form advances. When contrast is lessened, forms appear to recede.

It is sometimes appropriate to intensify the contrast between light and dark where forms overlap. Strict reliance upon alternating light and dark can become too obvious and mechanical a method. When it is desirable to group a number of light objects together or when the composition is to be high-keyed, exaggerated contrast in the form of a dark halo where forms overlap will create the necessary separation (Fig. 140). Shapes separated in this manner take on a strongly decorative character.

Project 54 *Working with such objects as tea kettles, cups, jars, and other familiar objects, develop a composition in which shapes of similar value are made to stand out in bold relief one from another through exaggerated separation as suggested above. The method is most effective when it combines sharp and softened edges. Avoid continuous outlining of each shape.*

139. Arshile Gorky
(1904–1948; Armenian-American).
Abstract Forms. 1931–32.
Pen and India ink,
22½ × 29″ (57 × 74 cm).
Art Institute of Chicago.

140. Juan Gris
(1887–1927; Spanish).
Flowers in a Vase.
1911–12. Charcoal,
18⅞ × 12½'' (48 × 32 cm).
Indiana University Art Museum,
Bloomington (Jane and Roger
Wolcott Memorial).

Separation and Integration

Closed form, in which a value is confined within the contour or silhouette of an object, stresses separation. *Open form,* when a value blends into a similar surrounding area without any obvious separation, allows the integration of various elements as well as producing a feeling of aliveness. When the same or similar values are placed side by side, edges begin to disappear and forms begin to merge. Such transitions serve to introduce movement by permitting the eye to flow from one area to another (Figs. 133, 141).

The same value can be made to function as both foreground and background without any loss of spatial depth as seen in Elmer Bischoff's *Girl Looking in a Mirror* (Fig. 142). The figure and its reflection are joined together where the reflected foot becomes one with the upper leg of the figure, allowing the eye to move from the foreground into the space of the mirror. A similar connection occurs when the shadowed side of the head merges with the dark background seen in the mirror. The reflected head both separates from the background and is integrated into it. Throughout the drawing the artist has used value contrast to separate the figure from the background in some areas and closely related values to lose the figure into the background. The eye is invited to move freely into and out of the picture space. Careful study of the drawing will reveal how skillfully Bischoff has integrated all of the elements and principles that have been discussed in this chapter.

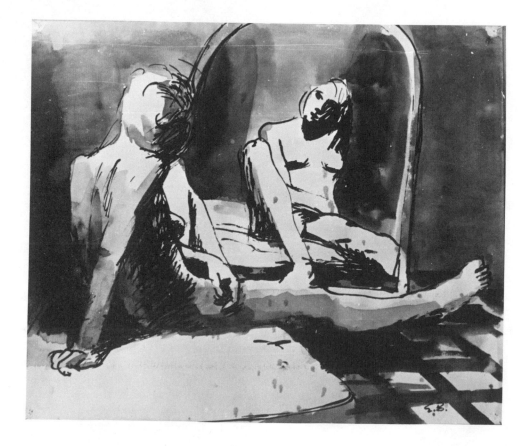

left: 141. Nevin Berger
(b. 1953; American).
Solvent Cans. 1979.
Monotype,
21⅝ × 29½'' (56 × 76 cm).
Collection Janet E. Turner.

below: 142. Elmer Bischoff
(b. 1916; American).
Girl Looking in a Mirror. 1962.
Ink and wash,
14¾ × 17⅞'' (37 × 45 cm).
San Francisco Museum
of Modern Art (purchase).

Project 55 In a series of charcoal studies, explore the use of limited value to establish the effect of movement into and out of space. Reserve white and black for accents. Use broad, simplified shapes. Notice in Figure 142 that volume has been suggested through relatively flat areas of tone without relying on extensive modeling. Use contrast to separate forms and focus attention, letting closely related values provide transition. Let light and dark flow from one area to another to provide movement and to prevent individual shapes from becoming too isolated.

The Art Elements

Avoid equal emphasis on light and dark; balance does not depend upon an even distribution of values. In each study let one value predominate. A limited number of values, well handled, can convey the impression of many tones.

Expressive Use of Value

The choice of value scale determines the expressive tone of each drawing. Light pictures generally suggest happiness and aliveness; dark pictures, heaviness and gloom. (Compare Fig. 37 and Fig. 133.) Consider, for example, how lighting is used to establish mood for films and television. Begin to notice how popular television comedies are brightly lighted while more serious dramas often rely upon darkness. In drawings and paintings the exaggerated use of *chiaroscuro* (pp. 64–65) contributes to a heightened sense of theatricality.

Sketchbook Activities

When you visit museums and as you look at paintings and drawings reproduced in art books and periodicals, analyze the composition of various works in terms of light and dark. Squinting allows you to see this more clearly.

As a sketchbook activity, develop the habit of making rough thumbnail sketches indicating the general distribution of light and dark as used by other artists. Do not make detailed copies of their works. Your sketches need be no more complete than the Mary Cassatt study (Fig. 122). Reduce forms to bold shapes. Simplify values, as much as possible, to white, black, and middle gray. Be aware of middle values used as transitions between light and dark. Notice where the greatest contrasts occur and how shapes interlock when values flow one into another. If you are enrolled in an art history class, you have the perfect opportunity to engage in this activity. Doing such sketches will make you more aware of all the elements of composition as they are integrated into a finished work of art.

Point of View

Selecting a point of view can determine the success of a drawing. Even after careful consideration and application of the principles of composition, a drawing might well seem dull and uninteresting simply because the subject has been presented from a very ordinary point of view.

Artists, not just students, frequently let themselves become trapped into relying upon a single point of view, either out of habit or because of restricted studio space (whatever space has been designated as a studio, whether it be the kitchen table, an area in the bedroom, the basement, or the garage). In drawing classes, instructors generally are confronted with space limitations when arranging setups, which must be made visible to everyone in the room. Because it is rarely possible to provide a rich variety of viewpoints, students must take the initiative to find interesting positions from which to draw. They should not, as some students are inclined to do, select one drawing bench or easel and stay there for an entire semester so that every still life or figure tends to be viewed from exactly the same eye level.

Compositions need not be monotonous if the point of view is varied. Develop the habit of making quick thumbnail sketches to examine a variety of possibilities. Extend your compositional vocabulary; add variety, drama, and interest by shifting to high or low eye levels. Occasionally employ an eccentric or unusual viewpoint. An eccentric point of view should add interest to the subject, not overwhelm it or create a sense of uneasiness.

A composition can be enhanced by cropping or by opening up and adding more space. Be certain that cropping is deliberate, not the result of poor planning. Thumbnail sketches allow you to consider different alternatives (Fig. 143).

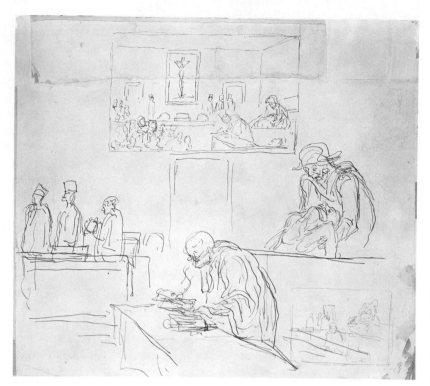

143. Honoré Daumier
(1808–1879; French).
Courtroom Scene.
Pen and ink on gray paper,
13⅝ × 16⅜″ (35 × 42 cm).
National Gallery of Art,
Washington, D.C.
(Rosenwald Collection).

Multiple Points of View

Representational drawing traditionally assumes a consistent point of view, each object drawn from the same eye level, each object occupying its own space. Many people have been conditioned to believe that visual representation is not accurate unless confined to a consistent viewpoint, yet no single fixed viewpoint exists for either the artist or viewer. In our every waking moment we continuously see everything we look at from shifting points of view, since it is nearly impossible for the eye to encompass even the smallest object without at least minimal movement of the eye. In fact, our visual perception of three-dimensional form and space depends upon continuous eye movement. Interestingly, to experience a drawing the eyes of the viewer must shift from one area to another in exactly the same manner that your eyes move around objects as you draw them.

Acknowledging this aspect of seeing has resulted in a freer approach to drawing, which introduces movement through the use of multiple points of view. Paul Cézanne, recognizing that no object could be fully explained when drawn from one viewpoint, chose to look at individual objects from different vantage points. By combining the various views into a composite image, he strengthened the sense of volume and structure.

Unlike Cézanne, the Cubists used multiple viewpoints to shatter the solidity of three-dimensional form. Objects were broken into fragments, which were reassembled in such a manner to tell the viewer more about the original object than could be visible from a single point of view (Fig. 144). In this departure from strict literal representation based on a static single viewpoint, images were given a great sense of aliveness.

Project 56 A Cubist approach involves juxtaposing segments of the three separate views—top, front or back, and side—into a composite drawing creating the impression of movement around the object in space. On separate sheets of tracing paper draw three different views of one object, keeping all drawings in the same scale. Place the three drawings one over the other. By shifting the three

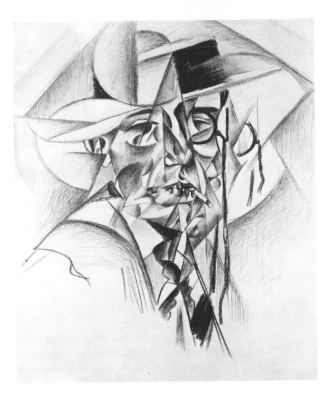

144. Gino Severini
(1883–1966; Italian).
Self-Portrait in Straw Hat.
1912. Charcoal,
21½ × 21⅝″ (54 × 55 cm).
Art Institute of Chicago.

drawings slightly, incorporate the most interesting and characteristic features of the object into a single drawing that reveals the character of the object as fully as possible and suggests movement around the object. Do not attempt to maintain a literal representation with a recognizable contour. Allow for distortion that will require the viewer to reassemble the fragments of information. Use shading to emphasize important contours and to suggest volume and space. Integrate the form into a complete composition. The initial planning of the composition can be done on tracing paper. Do a finished drawing in a medium of your own choosing.

Summary

The fundamentals of composition apply in spite of choice of medium, subject matter, and style. A knowledge of composition develops from looking at other works of art. Study the compositions of other artists, not for the purpose of duplicating what has been done, but rather to develop an awareness and sensitivity to composition.

It is probably impossible for any artist to deny having been influenced by looking at other pictures. Students in any field of creative activity learn by studying the work of others. Even in a classroom, it is difficult not to notice what fellow students are doing. Such looking is not confined to students. The creativity of professional artists is frequently stimulated by the works of others. Rembrandt, who collected prints and drawings by other artists, delighted in reworking their ideas, recreating them to satisfy his own artistic sensibility.

Although you may develop a preference for certain compositional devices, avoid becoming dependent upon formulas. Remain alert to the many possible approaches to combining media, technique, and style with the elements of composition to provide the fullest expression to your subject. It was suggested at the beginning of this chapter that artists have the freedom to interpret the principles of composition. There are no rules that cannot be broken; the only consideration is whether, by breaking a rule, you make the composition more effective.

Composition

Perspective

Drawings and paintings that stress three-dimensional representation can be described as *illusionistic,* for to create depth on a flat surface is to create an illusion. Much of the success of illusionistic art depends upon the skillful use of perspective.

Early in the fifteenth century, young Italian Renaissance artists sought a logical means for creating unified, measurable space and in doing so formulated the principles of *linear perspective.* One name traditionally mentioned as contributing to this development is Filippo Brunelleschi, whose interest in perspective stemmed from direct observations and analysis of visual phenomena. His original experiment involved painting a building on a small panel into which a peephole was drilled at a point corresponding to the eye level of the artist. Rather than looking directly at the painting, persons viewed its reflection in a mirror by peering through the peephole from the back. Confined to what could be seen with one eye through the small hole, Brunelleschi restricted vision to precisely the fixed point of view upon which linear perspective is predicated. The fact is, however, that we almost never view anything under such a condition; even when we hold our heads in a fixed position, our eyes are constantly in motion.

With the invention of the camera, photographs duplicating views previously depicted by artists verified the system devised by the Florentines; the lens of a camera served as a single eye in a fixed position. In Giovanni Battista Piranesi's 18th-century engraving of the interior of St. Paul Outside the Walls in Rome, and a photograph of the same structure (Figs. 145, 146), horizontal lines and the regular diminution of equally spaced elements create the illusion of vast interior space on a flat, two-dimensional surface. Whereas the camera, positioned at ordinary eye level, recorded what was before it, perspective permitted Piranesi to visualize with a sense of accuracy how the structure would appear to a viewer elevated 13 feet above the pavement. (See page 117 for an explanation.)

Linear perspective is a scientific method of determining the correct placement of forms in space and the degree to which such forms appear to diminish

145. Giovanni Battista Piranesi (1720–1778; Italian).
Interior of St. Paul Outside the Walls, Rome. 1749. Etching,
16 × 23¾″ (41 × 61 cm). Reprinted from *Views of Rome Then and Now*
by Herschel Levit. Published by Dover Publications, Inc., 1976.

146. Interior of St. Paul Outside the Walls, Rome. Photograph.

in size at a given distance. *Empirical perspective,* in contrast, relies upon what the artist observes rather than on a set of rules. An artist with a well-trained eye for seeing size and shape relationships, who can determine angles by sighting against vertical and horizontal edges, can create convincing and relatively accurate perspective without having to engage in the construction of space.

While knowledge of perspective is useful in drawing from nature, it is essential when drawing from imagination. The ability to construct space, to show the viewer how things would look if they existed, to determine dimensions accurately and figure the degree to which any dimension diminishes at a given distance, make the effort involved in learning perspective worthwhile. David Macaulay's remarkable book illustrations (Fig. 147) attest to the pictorial freedom and creative possibilities that derive from understanding linear perspective.

The assignments in this chapter are presented only as exercises to assist you in learning how perspective works, how it can be used to support and strengthen your drawings. Developing an increased awareness of the correct positioning and scale of objects in space and becoming more sensitive to the volume of objects and the space that they occupy will enable you to draw empirically with greater ease and certainty. The mechanics of perspective—that is, actually drawing the horizon line and vanishing points—can be set aside once you have an understanding of how the system works. But should it be necessary, you have a back-up system available for checking and correcting what you think you see.

Fixed Viewpoint and Cone of Vision

The rules of linear perspective are based upon objects seen from a fixed point of view. According to Brunelleschi's experiment that view is further restricted to what can be seen with one eye only, otherwise we can assume that he would have provided his panel with two peepholes. Our perception of depth and three-dimensionality, however, results from binocular vision. Without it we lose our depth perception, and if we think we see three-dimensionally with one eye closed, it is probably only remembered experience. Perspective drawing does not demand that you look at everything with one eye closed, only that you not shift the position of your head nor the direction of your gaze.

Everything that can be seen from one fixed position is contained within a *cone of vision* composed of the lines of sight radiating from the eye. The limits of your cone of vision are easily determined by extending your arms and inscribing within a vertical circle all that can be seen clearly as you look directly forward. Only a small portion of the immediate foreground falls within the cone in contrast to the expansive view of distant space. Centered in the cone of vision is the *central line of vision.*

Picture Plane

The term *picture plane* refers to (1) the surface upon which a drawing is made, and (2) a vertical section cut through the cone of vision to create the transparent plane upon which the images before you appear. The picture plane is perpendicular to your central line of vision. Perspective is most effective when the artist remains at some distance from the picture plane and the closest object; otherwise tiny objects in the immediate foreground appear to loom larger than bigger forms in the middle ground and background. Large forms drawn from too close a range will appear distorted. Objects drawn too close to the picture plane cause the viewer to feel as if he is standing with his nose pressed against the picture plane.

147. David Macaulay
(20th century; English-American).
Constructing a Gothic cathedral.
Pen and ink.
From *Cathedral*
by David Macaulay.
Copyright © 1973
by David Macaulay.
Reproduced by permission
of Houghton Mifflin Company.

Horizon Line

The *horizon line,* as it cuts across the picture plane, corresponds to the eye level of the viewer. Brunelleschi's peephole made certain that his painting was viewed from exactly the level at which it was painted. While effective, it is not always possible to duplicate the eye level for viewing, nor is it even necessary since the observer automatically assumes the artist's eye level. There is no other choice. A drawing representing a bird's-eye view does not change when looked at from below.

The horizon line indicates where sky and earth would appear to meet if the ground were perfectly flat and there were no intervening buildings, trees, or mountains. Instead, the placement of the horizon line on the picture plane is related to the height of the viewer above ground. As the viewer is elevated above ground level, the horizon line rises on the picture plane to reveal more ground; the closer to ground level, the lower the horizon line. The position of the horizon line determines how all objects are viewed, and its location must be known even when it falls above or below the picture plane.

Ground Plane

The *ground plane* is a flat horizontal plane extending to the horizon. It can also be referred to as the *floor plane* when drawing interior spaces, or the *table plane* when drawing objects placed on a table. The back edge of neither a floor plane nor a table plane will coincide with the horizon line unless drawn exactly at eye level.

Vanishing Points, Converging Parallel Lines

Any line that corresponds exactly to the viewer's *line of vision,* such as the edge of a table, a line between floorboards, or a curb line, though horizontal in space, will appear as a vertical line to the eye. If extended, it will meet the horizon line at a right angle. The point where the two lines touch becomes the *center of vision,* or *central vanishing point* (CVP), with the viewer directly opposite that point.

Parallel lines by definition always remain equidistant, yet it is our common visual experience that parallel lines appear to converge as they recede into space. All lines parallel to your line of vision, whether to the side, above, or below, will appear to meet at the CVP. This is the basis of *one-point perspective* (Fig. 148).

Additional parallel lines that do not lie parallel to your line of vision will vanish at other points along the horizon with a separate vanishing point for each different direction. Lines lying parallel to the picture plane do not converge.

One-Point Perspective

Project 57 Place an 8-inch square of paper or cardboard on a table so that it is square to your line of vision with the near edge at least 3 feet away as you are seated in front of it.

Study the square. The front and back edges remain parallel while the receding parallel sides appear to converge; the back edge appears narrower than the front edge. Measure the square using a pencil held vertically at arm's length. Let the pencil appear to touch the right front corner and check the visible space between the pencil and the back corner. Repeat with left corner. If the square is directly in front of you, the two spaces will be equal. Compare the relative width of the front and back edges. Also, determine the measurable vertical distance between the front and back edges as compared to the width of the front edge. These measurements provide the necessary clues for drawing the square. The depth measurement is critical; be as accurate as possible.

Draw the shape based upon your observations and measurements. Center it about 4 inches above the bottom of the page with the front edge no wider than 4 inches. The result will be a <u>foreshortened</u> square—a square seen in perspective. Extend the side edges until they meet to locate the CVP through which the horizon line is drawn across the width of the paper.

Project 58 Move the cardboard square one full width to the side, placing it in a new perspective. Measuring with your pencil, draw the square into position touching the first square. If drawn correctly, the front edges of both squares will be exactly the same length, as will the back edges, and the outer edge of the second square can be extended to the CVP. Although the shapes, as drawn, are of different configuration, they represent exactly the same shape. Continue the row of squares by extending the front and back horizontal lines, marking off the full width of the front edge of one square along the length of the bottom line and connecting each mark to the vanishing point.

148. Jan Vredeman de Vries
(1527–after 1604; Dutch).
Street scene with
one-point perspective.
From *Perspective* (Leiden, 1604).
Republished by
Dover Publications, Inc., 1968.

Project 59 Placing additional rows of squares into perspective is relatively simple. The side lines for the squares of all subsequent rows have already been established by the converging lines extending to the CVP; only the depth of each additional row remains to be determined.

A system that allows you to establish the correct depth for each new row can be explained with the aid of a diagram. Draw a 2-inch square in the upper corner of your paper. Locate the exact center of the square by drawing two diagonals to connect the corners. Vertical and horizontal lines drawn through the center point will divide the square into four equal units. Repeat the procedure in one of the four smaller squares. Notice that by extending the vertical and horizontal lines you can determine the center of the remaining three squares and divide them into equal units without drawing additional diagonals.

Through the use of diagonal lines you have created a 4-unit-square grid. Notice that the diagonals connecting the corners of the original square intersect each of the vertical and horizontal grid lines at points corresponding to the corners of the smaller squares. A tracing of the grid with just one long diagonal would reveal that given one set of parallel lines, either vertical or horizontal, and one small corner square, a single diagonal is sufficient to complete the grid.

Now return to the row of squares drawn in perspective. To construct a grid in perspective, select either of the end squares. Draw the diagonal of that square, beginning at the lower outside corner. Continue the line beyond the square, allowing it to cut across all of the existing converging side lines. Add horizontal lines at each point of intersection to create a grid as many units deep as it is wide.

To determine the correct depth for additional rows beyond the original grid, repeat the process by extending the diagonal of the end square in the top (back) row. Leonardo da Vinci's perspective study (Fig. 149) suggests the degree to which a grid can be expanded by extending all horizontal lines across the width of the drawing with additional converging lines placed at appropriate intervals.

The depth of the first row, in effect, is arbitrary. It depends upon accurate visual measuring. Once the depth of the first unit has been determined, the depth

149. Leonardo da Vinci
(1452–1519; Italian).
Perspective study for an
Adoration of the Magi. c. 1481.
Silverpoint, then pen and bistre,
heightened with white
on prepared ground;
6½ × 11½″ (17 × 29 cm).
Uffizi, Florence.

of all other units of equal size is automatically established. No additional decisions are necessary; therefore, it is essential that the first unit be measured and drawn as accurately as possible.

Project 60 The grid constructed in the previous project allows you to determine the proportional diminishing of units of equal measure as they recede in space on a horizontal plane. In perspective drawing, horizontal and vertical units of equal measure must be drawn to the same scale.

A matching vertical grid can be constructed from the existing horizontal grid. Draw vertical lines at each point where the horizontal lines intersect one of the outer receding ground lines. Since equal units of measurement on adjoining vertical and horizontal lines must be drawn in the same scale, transfer the measurements from the bottom line of the horizontal grid to the corresponding vertical. Complete the vertical grid by connecting each mark to the CVP.

Although the configuration of each unit varies, the horizontal and vertical grids are composed of identically proportioned foreshortened squares. Equal units of measurement on any line parallel to the picture plane, whether vertical or horizontal, remain constant; equal units diminish only when placed on lines that recede from the picture plane. Such observations will aid you in seeing and understanding foreshortened forms as you draw from life and will allow you to draw convincingly from imagination.

Using the horizontal and vertical grids, objects of any size can be drawn in proper scale at any given distance. Horizontal measurements can be projected vertically, vertical measurements projected horizontally.

Project 61 Corresponding diagonals of all squares in the horizontal grid, as parallel lines, will converge at common points when extended to the horizon line. Diagonals of the squares in the vertical grid will fall on a vertical line drawn through the CVP.

Project 62 Place a sheet of tracing paper over your original drawing. Do another drawing, in which you swing the vertical grid toward the center and raise the horizontal grid above the horizon. If you align each of the new grids with the existing grids you will discover that completing the project is a simple matter of extending already established measurements vertically and horizontally. If you choose to locate them in between existing lines, locate the desired position on the ground plane or vertical grid, draw a connecting line to the CVP, and proceed in the same manner.

The Art Elements

The closer a horizontal plane is to eye level (the horizon line), the less space you see between the parallel lines defining the front and back edges of the units, until when it reaches eye level, the surface of the plane becomes a single line identical with the horizon line. The same changes occur as vertical planes approach the central line of vision.

Project 63 If you have understood and successfully completed the grid problems, you have the information necessary to create a one-point perspective "fantasy" constructed out of solid square blocks and units composed of multiples of blocks. Spread the blocks across the width of the page, push them deep into space, stack them, let some of them float above the ground plane. To avoid confusion between construction lines and the blocks, after you work out the shape of each block or each group of blocks, trace over all edges that would be visible with a red pencil. When everything is complete, make a clean tracing of just the blocks and the horizon line but not all the grid lines.

Using Diagonals to Establish Depth

The illusion of depth is increased by the proportional diminution in the size and spacing of objects as they recede into space. The illusion is particularly noticeable when objects of the same size are placed at regular intervals (Fig. 145). Linear perspective offers different methods for determining the size of any form at a particular distance from the picture plane. A relatively simple system, not requiring a complete grid, is based upon the use of diagonal lines and might well be the method by which Jacopo Bellini figured the spacing of the figures in *Funeral Procession of the Virgin* (Fig. 150). The system is based on the principle that diagonals cross at the exact center of the plane; a vertical line through the center point divides the plane in half vertically (Proj. 59).

150. Jacopo Bellini
(c. 1400–1471; Italian).
Funeral Procession of the Virgin.
Pen and brown ink over black chalk
underdrawing on tan paper,
3¾ or 8⅛ × 11⅛″ (10 or 21 × 30 cm).
Fogg Art Museum, Harvard University,
Cambridge, Mass.
(bequest of Charles A. Loeser).

Project 64 Draw a horizon line and locate a vanishing point. At some distance from the vanishing point place a vertical line that extends both above and below the horizon, not equally. Connect the top and bottom of the vertical to the vanishing point. Move toward the vanishing point and place a second vertical line between the converging lines creating a rectangular plane in perspective. Add diagonal lines to find the center of the plane. Connecting that center to the vanishing point will establish a midpoint for other verticals drawn between the converging lines. To locate a third vertical spaced at the same interval, draw a diagonal from the top of the first vertical through the midpoint of the second and extend to the base line, at which point draw a third vertical. The process can be repeated until you run out of space.

This use of diagonals allows for the repetition of any regularly spaced vertical elements—fence posts, telephone poles, tree trunks, columns, corners of identical buildings, people. In Bellini's Procession (Fig. 150) the spacing of the figures is not mechanically repetitive; the distance between the last two figures in the first group is almost double that between the other figures. Bellini's drawing is based upon one-point perspective, the vanishing point lying just outside the left edge of the composition.

Scale

An object or form whose size can be comprehended establishes the scale for everything else in a perspective drawing. It is possible, for example, based on the height of an average figure, to calculate with some certainty that the city wall in Bellini's drawing (Fig. 150) is just over 30 feet high and lies approximately 100 feet to the right of the procession. These dimensions are calculated by placing a figure against the wall that can be seen between the figures at the right. The height of the figure has already been established; since all figures are viewed at eye level, his eyes would fall on the horizon line, his feet at the base of the wall. That measurement repeated on a vertical line to the top of the wall establishes the height. The same measurement turned horizontally and carried across to intersect the line of march provides the other dimension. The guard towers at the top of the wall tend to falsify the scale, making the wall seem much higher. The procession passes between 15 and 20 feet to your right, as determined by taking the height on any figure, probably less than 6 feet, and marking it off on a horizontal line projected from his feet to a point immediately below the CVP.

Figures in Space

Grids demonstrate clearly that units of the same size drawn to the same scale diminish proportionally as the distance from the observer increases. It was possible to add a distant figure of equal size to the Bellini drawing because the scale, the ground plane, and the eye level had already been established. When all three conditions are known, a figure can be placed at any spot within perspective space with the assurance that the size of the figure will be correct at that distance.

Project 65 Each of the accompanying drawings (Fig. 151) includes three figures plus a spot indicating where a fourth figure of matching height is to be placed. Draw lines connecting the feet of all the figures in each group, extending the lines in each direction until they converge with similar lines drawn to connect the heads. A single line drawn through the vanishing points establishes the horizon line for each group.

A line extended to the horizon line from the feet of one figure through the spot where the fourth figure is to be located and brought back to the head of the same

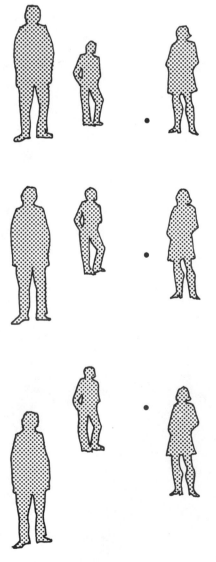

151. Determining scale of figures in space.

figure determines the height of the last figure. When the height of one figure is known, the size of a figure at any point on the ground plane can be determined. If the second figure is to be taller or shorter, the difference in height should be added or subtracted from the key figure before the head line is returned from the horizon line.

Figures Seen from Different Eye Levels

In Figure 151 the vertical alignment of the three groups of figures is purposely the same, the measurable height of corresponding figures is identical, and the resulting vanishing points can be connected by vertical lines; this means that the same figure in each drawing stands at exactly the same distance from the picture plane. With so many things identical, why don't the three drawings match? What is the one element that is not the same and what is the result of that difference?

The position of the horizon line changes in each drawing so that each group is viewed from a different eye level—Group 1 from below, Group 2 at eye level, and Group 3 from above. Notice the relationship of the figures in each group to their horizon line. When figures of the same size are shown standing on a level ground plane, the horizon line will cut across each figure at the same point whether the figures are placed in the foreground, middle ground, or background. In Group 1, the horizon line intersects all figures at about knee level, indicating that the heads of the figures are about 4 feet above the eye level of the viewer, assuming that the figures are between 5 and 6 feet tall. Group 2 is seen at eye level by a person of the same height—the heads all appear at the horizon line. The figures in Group 3 are viewed from a vantage point 12 feet above ground level because the distance from the horizon line to the head of each figure is equal to the height of each figure. A distance twice the height of the figures would increase the viewpoint to 18 feet. The vertical grid from earlier projects revealed that in one-point perspective units of equal measure on the vertical scale remain constant. This rule makes it possible to verify the height of the viewer above the floor in Piranesi's engraving of the church interior (Fig. 145).

Project 66 Do three studies in which several figures, adults and children, are placed in space arbitrarily so that (1) adults are seen at eye level; (2) adults are seen from 9 feet above ground level (a 6-foot figure will occupy two-thirds of the distance from ground to horizon line); (3) adults are seen from a child's level. Don't limit your drawing to people standing on the ground; be imaginative and create a setting with different levels. You may choose to repeat the same setting and grouping of figures for each drawing. Make an effort to draw each figure in proper perspective. Proportions established for one figure can be transferred to other figures using the procedure demonstrated in Figure 151.

Two-Point Perspective

Blocks placed square to the picture plane are drawn according to one-point perspective. Our experience of visual reality, which also includes blocklike objects seen at an angle, necessitates the introduction of two-point perspective. The basic principles of perspective are most evident in drawing simple cubes or rectangular blocks; and since very few objects exist that cannot be packed into square or rectangular cartons, learning to draw cubes in perspective correctly provides the raw material for constructing almost any form. Thomas Eakins, in his drawing for *Chess Players* (Fig. 152), used both one-point and two-point perspective to work out the spatial relationships of pieces of furniture in a room. The study also illustrates how Eakins transformed simple blocks into detailed specific forms.

152. Thomas Eakins
(1844–1916; American).
Perspective drawing for
Chess Players. 1876.
Pencil and ink
on cardboard,
24 × 19″ (61 × 48 cm).
Metropolitan Museum
of Art, New York
(Fletcher Fund, 1942).

Project 67 Place a cube or square box at a distance just close enough that you can reach out and move it easily. A clear plastic cube, such as those used for displaying photos, would be particularly appropriate.

Begin with the cube square to your line of vision so that you see only the front and top surfaces. In this position, representing one-point perspective, the front plane appears as a perfect square, the top as a foreshortened square.

Without moving the right front corner, rotate the cube clockwise one inch at a time. Study the cube in each new position. The front surface becomes the left side; the visible width of the left plane and the height of the left corner diminish as the right side appears. As the cube is rotated you see less of the left side and more of the right, with the height of the right outer corner increasing. Check the angle formed by the bottom edges of both sides against the horizontal line of a pencil held at arm's length. The less you see of a side, the greater will be the angle between the base of that side and the horizontal measuring line. When the cube reaches a 45 degree angle, you see equal amounts of both side planes receding at the same angle with the back corner appearing directly above the front corner. Because the sides are receding planes, the top and bottom edges as parallel lines will appear to converge.

The Art Elements

Project 68 Draw a series of cubes rotated to different angles above, at, and below eye level in relation to one horizon line. Each cube will require its own set of vanishing points. As long as the cubes remain level by maintaining the verticality of the corner lines, all vanishing points will fall on the horizon line.

On tracing paper draw the horizon line and the front corner lines of each cube. Locate just two vanishing points near the outer edges of the horizon line and redraw each cube to those points. In the first drawing the cubes are seen at random angles; in the second the cubes are square one to another.

Project 69 Select one cube from either of the previous drawings and extend it in both directions, using diagonal lines (Proj. 65) to determine the depth of each additional cube. (Extending the lines of all top edges to the vanishing points establishes a horizontal grid drawn in two-point perspective.)

Inclined Planes

Project 70 Place a box with open flaps on the floor in a position somewhat similar to that shown in Figure 153. Do a freehand drawing of the box inside and out, measuring with your pencil to establish size and shape relationships. With the experience gained from previous problems your drawing should be quite accurate.

Project 71 Set your drawing aside. Make a tracing of Figure 153 and with a ruler determine the vanishing points for all planes of the box, including the flaps. Draw the horizon line through the vanishing points of the sides. Notice that the long edges of the flaps, because they are parallel to the edge of the box, vanish at points on the horizon line, while the short sides of the flaps converge towards different vanishing points.

Vanishing points on the horizon line relate only to lines and planes that are parallel to the ground plane. Although the edges of the flaps are parallel to the sides of the box, they are not parallel to the floor. They are <u>inclined planes</u>. They have vanishing points on vertical lines that pass through the vanishing point of horizontal lines to which they are parallel. Vanishing points for <u>ascending planes</u> appear above the horizon; those for <u>descending planes</u> fall below the horizon. Ascending planes angle upward away from the viewer, descending planes angle downward from the viewer. Flap A might appear as a descending plane because it falls below the rim of the box. Extending its short sides, however, reveals that they converge upward.

Project 72 Check your drawing of the box (Proj. 71) to see whether empirically you drew the flaps in correct perspective. Do the long edges converge toward vanishing points on the horizon line? Do the short edges converge to vanishing points above or below the horizon? On a tracing paper overlay redraw the box so that all lines converge toward the appropriate and correctly aligned vanishing points.

153. Drawing inclined planes: box with flaps.

Uphill and Downhill Streets Perhaps you do not anticipate drawing flaps of boxes frequently. You may be surprised, however, to discover how often inclined planes occur, especially in landscapes and cityscapes. Pitched roofs, for example, are inclined planes, as are streets and roads that go up and downhill.

You may experience total confusion the first time you are confronted with representing an uphill or downhill street lined with buildings (Fig. 154). Until you have attempted to draw such a scene, it is very probable that you will have never really looked at buildings on a hill in terms of perspective. The scene becomes easier to draw when you remember that in spite of the incline, houses are built with level floors and vertical corners. All horizontal elements will be drawn to vanishing points on the horizon line, always at the eye level of the

154. Simplified perspective drawing
of downhill street
lined with buildings.

observer, whereas lines of inclined planes such as sidewalks, curbs, tops of telephone poles, and objects parallel to the street, such as automobiles, will converge at vanishing points either above (looking uphill) or below (looking downhill) the true horizon line. Rarely can an uphill or downhill street be drawn as one continuous inclined plane, since the roadbed levels out at cross streets. The level sections must be drawn to the true horizon line.

A puzzling phenomenon occurs when you do a drawing looking downhill. Even though the hill drops away from you in space, the lines representing the edges of the street are drawn as ascending lines (Fig. 154). The angle of ascent, however, is less than for lines representing a level plane, so that vanishing points for street lines appear below the true horizon line. (Only when drawing the underside of a descending plane would the edges converge downward.)

Project 73 Place tracing paper over Figure 154. Extend lines from the buildings to find the horizon line and the vanishing point for the buildings. Extend the lines of the cable car and foreground hill to determine the vanishing point for the inclined plane. The two points will be aligned vertically.

Project 74 Locate a site that provides an uphill or downhill view with forms that can be drawn in perspective—a city street with houses and cars, a country road

The Art Elements

120

with fences and farm buildings, or perhaps a campus view. Although steps are a series of vertical risers and horizontal treads, the angle of a stairway can be thought of as an ascending plane; sloping roofs are inclined planes. Study your subject thoroughly. Do a drawing in which all forms and planes appear in correct relationship.

Three-Point Perspective

In perspective, vertical lines remain vertical only so long as the head is held level. The corners of a rectangular object placed below eye level continue to appear vertical if the object is viewed from sufficient distance. When the same object is viewed from such close range that your must tip your head to look down at it, the corners appear to converge at a vanishing point below you. Looking up or down, by itself, does not create three-point perspective unless, as with Egon Schiele's drawing (Fig. 155), the object is also placed at an angle.

In this age of skyscrapers, when we have frequent opportunities to view great heights both from above and below, three-point perspective has become a familiar visual experience for most people (Fig. 156).

Project 75 Three point perspective can provide a sense of drama when used skillfully. Illustrators, in particular, use it to great effect. Something as ordinary as a cardboard box becomes dramatic when seen from an eccentric viewpoint. Usually we are so involved with packing or unpacking a carton that we don't notice the container at all. Study a box from several viewpoints and make drawings of it in three-point perspective. Include the flaps as well. As you draw, check angles against vertical and horizontal. Where the flaps converge at the corners of the box, study the negative space as an aid to seeing the shapes correctly.

Project 76 A group of tall buildings viewed from above (the reverse of Fig. 156) offers a more challenging three-point perspective problem. Begin by constructing a cluster of simple vertical blocks. Be aware that in three-point perspective, equally spaced surface details on a building will diminish as they go lower. Diagonal lines, as introduced in Project 64, can be used to divide the structures into equally spaced floors.

155. Egon Schiele
(1890 1918; Austrian).
*The Writing Desk of
Assistant Manager Karl Grünwald.*
1917. Black chalk,
11⅛ × 18⅛″ (30 × 46 cm).
Collection Dr. H. Rose,
Douglas, Isle of Man.

156. Charles Sheeler
(1883–1965; American).
Delmonico Building. 1927.
Lithograph,
9¾ × 6¾″ (25 × 17 cm).
Library of Congress,
Washington, D.C.

Circles in Perspective

A look at the rims and bases of bowls, cups, and other circular objects in the drawings of most students, and even of some advanced artists, indicates that the perspective of a circle is little understood. The three most frequent errors in drawing circles in perspective are seen in Figure 157: (1) outer edges drawn as points, (2) front and back edges flattened, (3) circle drawn too full so it appears tilted.

A circle seen in perspective assumes the shape of an *ellipse*. The exact form of an ellipse can best be visualized as a circle inscribed within a square that is then projected into perspective. To establish the correct relationship between circle and square, it is necessary first to study a circle in a square as seen full face (Fig. 158). The circle touches the square at the center point of each side, determined by lines drawn through the midpoint established by intersecting diagonals. It also helps to note the points where the circle cuts across the diagonals.

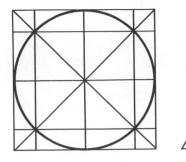

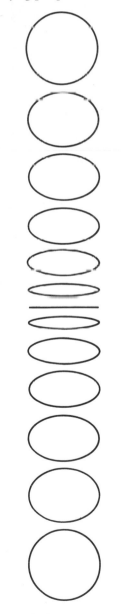

above: 157. Drinking glasses with circular edges drawn in faulty perspective.

above right: 158. Diagram: determining circle drawn in perspective.

below: 159. Ellipses drawn in varying perspectives.

Project 77 Based upon the diagram in Figure 158, draw a circle in perspective in the foreshortened square provided. Draw diagonals to locate the center lines. Correct positioning of the points where the circle crosses the diagonals can be determined by transferring the measurements from the bottom edge of the square (Fig. 158) and drawing lines to the vanishing point. Draw the circle so that it touches each of the eight reference points, making certain that it is a continuous curved line—no points, no straight lines.

Notice that as with any foreshortened rectangle, the center point of the circle in perspective is not equidistant between the front and back edge. The front half of the circle is larger and fuller than the back portion.

Project 78 Place tracing paper over the circle that you have drawn in perspective. Trace just the circle and what appears as the vertical center line. Remove the tracing so as not to be confused by all the construction lines. Lay a straight edge across the ellipse horizontally, sliding it up and down until you find the widest dimension. Draw that line. If your ellipse was drawn correctly, the horizonal line will divide the vertical center line into two equal parts. The point of intersection is the exact center of the ellipse. Compare the tracing with the first drawing. The center of the circle seen in perspective is not the same as the center of the ellipse. Although a circle in perspective assumes the shape of an ellipse, all ellipses are not circles seen in perspective.

The long center line of an ellipse is the *major axis,* the short center line is the *minor axis.* The axes, which bisect each other, *always* cross at right angles. The major axis is always the longest dimension across an ellipse, no matter at what angle the ellipse is drawn.

In most instances, circles shown in perspective on a horizontal plane are drawn with the major axes of the ellipses horizontal. If, however, a perspective circle does not seem to "sit right" in relation to objects surrounding it, when drawn as a horizontal ellipse, the ellipse can be rotated slightly toward the vanishing point. It should be stressed that a sense of correctness based upon what appears right is most important. Be careful, however, that you do not confuse what you *think* is correct with what a well-trained eye *sees* as correct.

Ellipses in Varying Perspective

The third common error—drawing a circle too full—creates an effect of a shifting point of view (Fig. 157). The fullness or openness of an ellipse is determined by eye level. If a drinking glass held upright is viewed in a sequence of positions from well below eye level to high above, the circle that is the rim of the glass will appear fully round only when the glass is positioned directly below or directly above. As the glass is elevated to eye level it is reduced to a straight line, gradually opening to fuller ellipses as it is raised above eye level (Fig. 159). By turning the drawing on its side, you see the same progression occur when a circle standing vertically is moved horizontally from side to side, or when a disc is rotated on a vertical axis.

Drawing Circular Objects

Cups, plates, bowls, glasses, bottles, tea kettles, coffee pots, pans, flower pots, baskets, lamp shades, records, wheels—the list of circular objects in our immediate environment available for drawing is not easily limited. When drawing a circular object from life, the correct degree of openness for the ellipse can be determined by measuring the optical vertical distance between the front and back rim in relation to the width, the two measurements corresponding to the major and minor axes of the ellipse.

Project 79 To draw two circles of the same size in perspective, one above the other, and insure that they are correctly foreshortened, first draw a cube in one-point perspective. Add circles to the top and bottom squares using diagonals and center lines as in Project 78. Connect the two circles with vertical lines at the outer edges to create a cylinder. The verticals should join the lower ellipse just behind the point where the major axis touches the rim to create the fullest effect of roundness. The width of the cylinder as drawn will be greater than the width indicated by the center line.

Project 80 Do a tracing that includes the complete upper ellipse, the two sides, and only the front portion of the lower ellipse. The cylinder will appear more three-dimensional. Notice that the curve of the bottom edge is fuller than the curve of the upper rim. When students cannot see the full ellipse, they have a tendency to draw the bottom curve flatter than it should be.

Do a series of tracings in which you transform the cylinder into a variety of forms. Treat it as a hollow cylinder and remove a vertical section—from the front, from the back, at the point where a diagonal intersects the circle, equal segments diagonally opposite each other. Remove a full quarter of the cylinder, various quarters, one half diagonally. Also treat it as a solid shape and cut various wedges out of it. For each separate image, trace only those portions of the upper and lower ellipses that would be visible, adding necessary verticals and connecting lines.

Few circular objects we see and draw are plain cylinders. In profile the sides curve, bulge, or flare, sometimes all in the same object, so that circles of various diameters are involved. To draw such objects correctly it is essential that all of the ellipses be centered one above the other.

Project 81 Small plastic cocktail glasses with tapered sides are perfect for studying ellipses. Make several freehand drawings of a plastic glass. Place it on a table 3 feet away from you; move it to 2 feet; then 1 foot. Observe how the distance between the ellipses changes until in the closest position they overlap. Draw the glass as it appears when held at different levels. In each drawing the upper and lower ellipses must be centered on each other with the minor axes of both on the same vertical line, the major axes horizontal.

The tapered forms that you have drawn could also represent clay flower pots. The reason for using the plastic glass instead of a flower pot is that the transparency of the glass allows the lower ellipse to be seen. Although glasses or flower pots best serve their function when maintained in an upright position, they become interesting and challenging drawing problems when resting on their sides.

Project 82 Tip a plastic glass or flower pot on its side. Seen in profile, neither the top nor the bottom is vertical, nor is an imaginary center line horizontal. Be aware, however, that both the top and bottom would be at right angles to the center line. Slowly rotate the object and study the ellipses. The major axes of both

ellipses are at right angles to the center line; the minor axes correspond exactly to the center line. The ellipse opens as you look more directly into the container, becomes narrower as the glass approaches profile position. Draw it freehand in several positions. Include the major and minor axes.

Ellipses in an Architectural Setting

A number of perspective problems involving ellipses arise when one is sketching architectural subjects. Arches, circular windows, the capitals and bases of columns, domes, round turrets, and towers—all involve the perspective of circles and partially circular forms. These curvilinear elements usually appear in conjunction with rectangular forms, and if the two are not handled consistently, the drawing will be weakened. It is often wise to use divided squares as a basis for making elliptical forms (Fig. 158), particularly when drawing a series of arches extending into perspective as in a long arcade (Fig. 160).

Two mid-18th-century architectural fantasies, both of which project a series of arched forms into planes at varied eye levels, provide an interesting comparison. Piranesi's *Monumental Staircase Leading to a Vaulted Hall* (Fig. 161) is presented with unusual power and conviction. The imaginative freehand study is admirable, however, for vigorous expressive drawing rather than for accuracy, since neither the architectural forms nor the spatial relationships can withstand careful analysis.

Equally imaginary is Giuseppe Galli Bibiena's design for painted stage scenery with its tiers of arcades and seemingly endless corridors (Fig. 162). Meticulously constructed in two-point perspective, the design combines a brilliant use of scale with the repetition of architectural elements to create a spaciousness that cannot be contained within the frame. With the view of the inner courtyard seen through the arch at the left comes the realization that the columns partially visible at the top of the drawing are but the bottom half of another story towering above. Except for the staggering amount of intricate architectural detail, careful analysis of the perspective, which is basically two sets of parallel planes set at right angles, reveals that the drawing is merely an elaboration of the assignments in this chapter.

160. Jan Vredeman de Vries (1527–after 1604; Dutch). Perspective study. From *Perspective* (Leiden, 1604). Republished by Dover Publications, Inc., 1968.

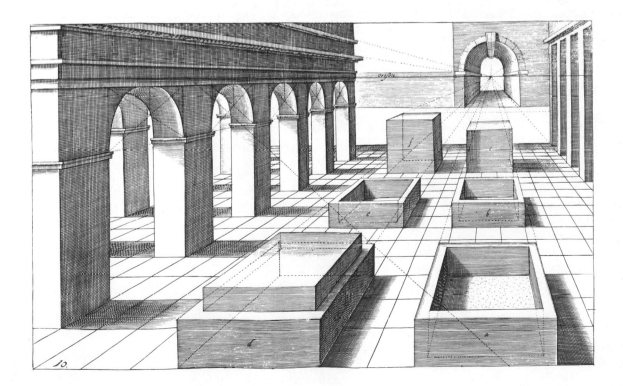

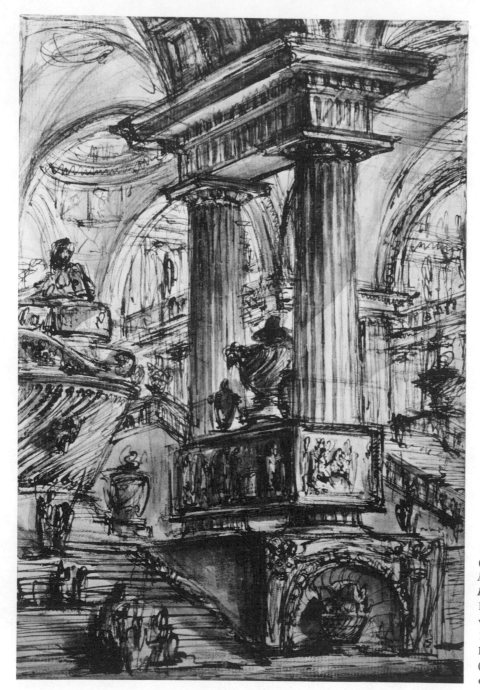

161. Giovanni Battista Piranesi
(1720–1778; Italian).
*Monumental Staircase
Leading to a Vaulted Hall.* c. 1755.
Pen and brown ink over red chalk,
with brown wash;
15 × 10½″ (38 × 27 cm).
British Museum, London
(reproduced by courtesy
of the Trustees).

Shadows

All objects in direct light cast shadows that can be determined by perspective. The factors that govern the drawing of shadows are (1) *source of light,* (2) *direction of light,* and (3) *angle of light.*

The source of light may be either natural light, which produces parallel rays, or artificial light, which creates radiating rays. It is true that light radiates from the sun, but from a distance of about 92 million miles, the rays are virtually parallel when they reach the earth. The direction in which shadows fall relates to the position of the source of light. When the source of light is to the side, shadows are cast to the opposite side. With the light at your back, shadows fall away from you. When you look into the sun, shadows are cast toward you. The angle of light determines the length of shadows. A high source of light creates short shadows, a low light produces long shadows.

The Art Elements

126

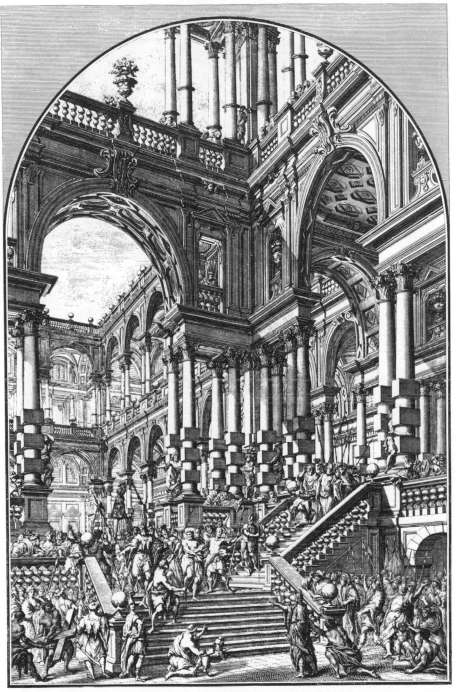

162. Giuseppe Galli Bibiena (1696–1756; Italian). Architectural perspective design for the theatre. From *Architectural and Perspective Design* (Vienna, 1740). Republished by Dover Publications, Inc., 1964.

Sun from the Side

Project 83 Shadows cast by natural light coming directly from the side are the easiest to draw. Select a section of the "one-point fantasy" (Proj. 63) as the subject for this assignment.

Shadows are cast by the shade lines that separate the areas of light and shade of any object. All shade lines for the blocks in this drawing will correspond to various corners and edges of the forms. When the light comes directly from the side, the shadows appear on the ground planes as horizontal parallel bands (Fig. 163). Since all the cubes are drawn in one-point perspective, shadows will be cast

Perspective

127

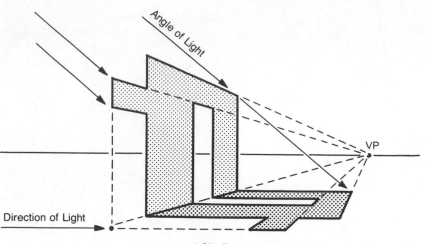

163. Perspective of shadow: sun from side.

only by the sides opposite the sun and by the bottom surfaces of blocks that float or do not rest fully on the ground. Decide upon the direction of light. Draw horizontal lines from the opposite corners of the blocks, extending them away from the source of light to locate the shadows of the vertical corners of the blocks.

Determine the angle of light. A line drawn at that angle from the top of the near corner to the shadow line establishes the length of the shadow. If the sun is high, the length of the shadow will be shorter than the height of the corner; longer if the sun is low. The height of the corner and the length of the shadow will be equal when the sun is 45 degrees above the horizon. Having found the length of the shadow of one corner, you can complete the shadow by drawing a line from that point toward the vanishing point, since lines parallel to the ground plane, as is the upper edge of the cube, cast shadows parallel to themselves (Fig. 163).

If an object happens to lie in the path of the shadow, the horizontal shadow line is diverted vertically up the side to meet the angle of the light line. It may be necessary to continue the shadow across the top surface to complete it.

To plot shadows for objects that do not rest on the ground, vertical lines must be dropped from the corners of a suspended form to a point on the ground plane immediately below (Fig. 163). Direction-of-light lines are drawn through those points. The lines remain horizontal so long as the source of light is directly to the side. The shadow must include the bottom of the block as well as the side opposite the sun. Two lines defining the angle of light must be drawn, one through the bottom corner of the side facing the sun, the other through the upper corner of the opposite side.

Add shading to the blocks and fill in the shadows. The shadows should be darker than the shaded surface of the blocks.

Project 84 Draw a cube in two-point perspective. Follow the procedure described in the last project to construct its shadow as cast by natural light directly to the side. It will be necessary to draw direction-of-light lines at three corners of the cube to complete the shadow.

Sun in Front of Viewer

When the viewer is looking into the sun, shadows are plotted in relation to the source of light located above the horizon and a *vanishing point of shadows* on the horizon line directly below (Fig. 164). Direction-of-light lines radiate from the vanishing point of shadows through the bottom corners of objects or

through the base of imaginary verticals dropped to the ground line. The length of the shadow is determined by the point where radiating lines drawn from the source of light through the top points of all objects intersect the direction lines. Connecting the points of intersection defines the shape of the shadow. Because they are seen in perspective, the shadows appear wider as they approach the picture plane.

Sun behind Viewer

Shadows converge toward the horizon line when the sun is at the viewer's back. The angle of light is determined from the *vanishing point of the sun's rays* (Fig. 165). This point is located below the horizon on a vertical line dropped from the vanishing point of the shadows—the higher the sun, the farther it falls below the horizon line. Lines drawn from each important spot of an object to that point below the horizon intersect direction lines from the base of an object projected to the vanishing point of shadows.

Project 85 Become familiar with the system for constructing shadows cast both toward you and away from you by drawing simple cubes placed in various positions in relation to the source of light. Be certain to include shadows for all planes facing away from the light. Once you understand the basic procedure, apply it to a more complicated cluster of geometric shapes. To locate the shadow of any point it is first necessary to establish a spot on the ground plane directly below, through which a line is drawn to or from the vanishing point of shadows (Figs. 164, 165).

164. Perspective of shadow: sun in front of viewer.

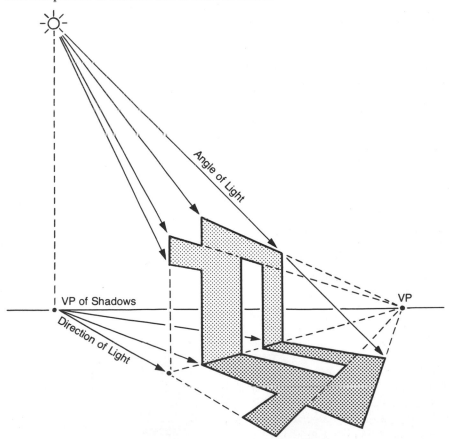

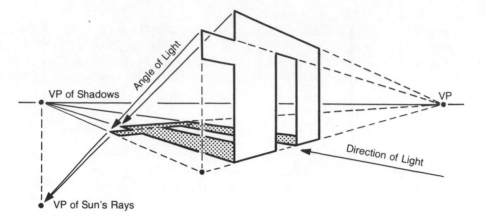

165. Perspective of shadow: sun behind viewer.

Project 86 Drawing the shadow of a simple upright cylinder allows you to see how shadows of curves can be plotted by projecting a series of points from the curve to the ground plane. Begin by adding a number of vertical lines spaced around the visible side of the cylinder to locate corresponding points on the upper and lower rims. Extend lines from the vanishing point of shadows through all points on the bottom rim to intersect with lines from the source of light projected through all points on the upper rim. Connect the resulting points with a curved line to define the shadow cast by the upper rim.

Artificial Light

Shadows cast by artificial light radiate from a point on the ground plane immediately below the light source. The direction of shadows is determined by lines drawn from that point through the base of each object, while the length of shadows is established by rays from the light source through the top of each form. If the shadow meets a vertical surface, it changes direction and continues until cut off by the ray from the light source.

A light centered above a group of objects results in shadows radiating in all directions. If objects rest on different levels, the shadows must radiate from the base level of each individual object. For example, the shadow of a table radiates from a point on the floor, while shadows of objects on the table radiate from a point at table level. Shadows of objects attached to a wall radiate from a point on the wall directly opposite the source of light.

Project 87 Place a group of simple objects around the base of a lamp. Draw them freehand, using the information above to guide you in calculating the correct position and shape of all shadows.

Reflections

An understanding of perspective allows artists to draw reflections and mirrored images convincingly. Beginners often misrepresent mirrored images as a reversed or inverted version of an object, failing to notice that a reflected image changes according to the angle from which it is seen and includes a view of the opposite, hidden side of the form. Another common error is not placing the reflection of the object at the proper distance behind the mirror's surface. The plane of the mirror must appear to be halfway between the object and its reflection; the size of the object must diminish proportionally (Fig. 166).

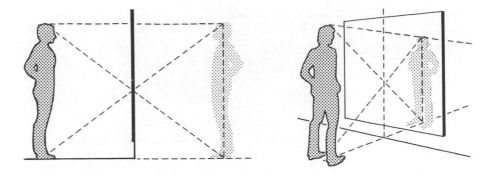

166. Perspective
of mirrored reflections.

Project 88 Select a relatively simple object such as a straight chair or a cardboard box with flaps. Draw the form in two-point perspective so that it is seen parallel to a mirror at the same time that it is sitting on a mirrored floor plane. The vertical measurements in the mirrored image on the floor will correspond exactly to those of the object, while the dimensions of the reflections seen in the wall mirror will diminish. All parallel lines of the object and its various reflections will converge at the same vanishing points.

Water Reflections

Reflections in water tend to duplicate the effect seen with objects placed on a mirror. Reflections appear directly below the object reflected, with each point and its reflection being equidistant from the water line. The water line must be calculated for each point. When objects are set back at a distance from the water's edge, it is necessary to determine what the water level would be at that distance and measure from that point. Sometimes the height of the object above water level is not sufficient to require a complete reflection, if any.

It is possible to simulate water reflections by placing small objects on a mirror, making certain to duplicate the angle from which the object is viewed.

Drawing Designs in Perspective

Complex patterns and designs—geometric elements as found in paving tiles, the patterns of Oriental rugs, curvilinear designs, lettering—can be drawn into perspective on horizontal, vertical, or inclined planes, even on a curved surface by squaring off the design and transferring it to a grid, properly scaled and drawn in correct perspective. The smaller the scale of the grid, the easier it is to transfer complex designs.

Project 89 Transfer the patterns from Figure 167 or other designs of your own choosing onto horizontal and vertical grids drawn in either one-point or two-point perspective.

167. Gridded designs.

168. M. C. Escher
(1898–1972; Dutch).
Other World. 1947.
Wood engraving,
12¼ × 10¼″ (32 × 26 cm).
Escher Foundation,
Gemeentemuseum,
The Hague.

Sketchbook Activities

Continuous practice in perspective drawing sensitizes the eye, so that one unconsciously sees in perspective and can readily perceive errors. If you have studied the diagrams and done the suggested assignments, you are better able to see forms as they exist in space and can avoid the errors most commonly made. You will be able to see when objects do not appear to rest on the same plane and when they are drawn out of scale.

In your sketchbook do perspective drawings from observation and from theory. Draw objects that are both simple and complex—a partially open door, a jumbled array of drawing benches and easels in an art classroom, the confusion of plates and cups and textbooks on a table in the school cafeteria all offer opportunities to consider size, shape, and space relationships. If there is nothing to observe, draw objects in perspective from memory or imagination. Construct large general forms first, then modify them. Remember that most objects can be placed in boxes, which can be transformed by cutting away. With much drawing and much looking, your uncertainties will become less frequent, your drawings more accurate.

Perspective need not be restrictive. Used imaginatively, it offers an artist great freedom, serving as a valuable aid to creativity and expression (Fig. 168).

The Art Elements

Part Four
Drawing Media

A feeling for media, sensitivity to their intrinsic beauty and expressive potential, and a delight in manipulating them are part of the makeup of most artists. For the novice artist, it is essential to discover the medium best suited for one's temperament and talents; exploration is the first step toward discovery. Since pleasure in the craft is an important component of the artistic temperament, the joyful savoring of the particular qualities inherent in each material and each surface contributes to the total effect. The velvety blackness of India ink or compressed charcoal, the pale silvery gray of hard pencil, the grainy vigor of dry-brushed tempera—all these add to the pleasure of drawing, and this pleasure is reflected in the full and sensitive exploitation of each medium.

There are as many kinds of artistic personalities as there are differences in people, in their tastes and abilities. Artists of exacting sensibility who enjoy working patiently and methodically naturally gravitate to those media that demand the most precise control, the most disciplined exercise of manual dexterity, and the most careful manipulation of difficult tools. At the other extreme is the artist who cannot put down ideas with sufficient speed, who can formulate and express an idea in a burst of creative energy of brief duration. To facilitate this rush of enthusiasm, the ideal medium is one that demands neither great precision nor extensive preparation, one that encourages rapid visualization, one that can be worked and modified easily without seeming to imply a lack of technical facility.

Between the two extremes lie a host of talents and temperaments. All of them can be accommodated by the range of available media, some of which are flexible enough to satisfy people who are sometimes methodical, sometimes more free. In fact, any attempt to define or limit the use of a medium to one type of

temperament suggests a categorizing inherently false to the need for experiment, self-discovery, and self-definition.

Chapter 2 introduced the media most commonly employed in drawing by beginning students. This section will explore a fuller range of drawing materials, some more sophisticated and requiring greater skill. While the accompanying projects have been designed to encourage students to experiment with a wide range of materials, esoteric methods and recipes have been purposely avoided. A large body of fascinating literature detailing the procedures of past masters for making and using tools and materials is available to the advanced artist who finds it impossible to obtain desired effects from commercially available materials. Such research cannot be justified for the beginning student, who should devote full time and energy to the major problems of artistic development and self-discovery.

Unduly detailed directives about the use of media, tools, and materials have also been avoided since step-by-step instructions frequently encourage self-conscious and mechanical procedures that interfere with the direct and vigorous expression of native capacities. In general, after accepting certain fundamental and very general procedures, artists work out their own methods. Students should play freely with media before embarking upon their use, for only by a free and inventive manipulation of materials do artists discover and develop their personal preferences and ways of working. It is suggested that you first read through this entire section and then select those media and exercises that sound interesting. When you fix upon a medium or technique that seems particularly satisfying, it is wise to explore it rather fully before moving to another. A series of single cursory encounters with a wide variety of materials and methods can disperse energies and result in confusion, while the production of works that satisfy the artist remains the greatest encouragement and stimulus toward further development.

Papers

Before exploring the categories of dry and wet media, a brief survey of standard drawing papers will afford the student a basic reference. *Newsprint,* manufactured from wood pulp, is the cheapest paper; it has a smooth surface, yellows badly, and is appropriate only for quick sketching in pencil, charcoal, conté crayon, and chalk. *Charcoal paper* has considerably more "tooth" (roughness created by an imprinted texture combined with fine sand) and is available in white, gray tones, and light colors for use with charcoal, chalk, conté crayon, and pastels. *Soft sketching papers* are manufactured for use with soft pencils, ballpoint and felt-tip pens, and colored crayons. *Rice paper,* the traditional surface for Oriental brush-and-ink drawing, provides a soft, very absorbent ground. *Bond papers,* familiar as stationery and typing paper, are smooth, relatively hard-surfaced, lightweight papers appropriate for use with pencil or pen and ink; they are available by pad or bulk in various sizes. *Bristol board,* a very fine, hard-surfaced paper, is manufactured in two finishes; *kid finish,* by virtue of its very slight tooth, facilitates fine pencil work and rubbed pencil-and-graphite combinations; *smooth finish* encourages elegant studies in pen and ink or very hard pencil. *Illustration board* results from layers of variously surfaced papers mounted on cardboard backing. While expensive, illustration board tends to justify its price in its durability and resistance to wrinkling when wet. *Watercolor papers,* as the name indicates, are used primarily for wash and watercolor. The heavier the weight of the paper, the more absorbent, free from wrinkles when wet, and expensive it will be. There are three standard finishes for watercolor paper and illustration board: *rough,* a surface produced in the best papers not by mechanized graining but as the result of a hand manufacturing process, which is best adapted to splashy, spontaneous techniques; *cold press,* which is

moderately textured; and *hot press,* the smoothest and least absorbent surface, which is excellent for very refined, controlled techniques. Papers made of 100 percent rag are the most permanent—and also the most expensive. Charcoal paper, bond, and other common drawing papers are made either from wood pulp, rag, or a mixture of the two. The cost of supplies is an understandable consideration for beginning students, particularly when asked to explore a variety of materials, hence the inexpensive pulp papers are most commonly used. The difference between drawing on pulp paper and on rag paper is immediately apparent, however, and as the student gains confidence and skill, works intended to be finished drawings should be done on pure rag papers.

Dry Media

9

The dry media consist of those materials that leave granular deposits when they are drawn across a surface. Usually (though not always) in stick form, the dry media include charcoal, chalks, pastels, conté crayon, wax crayons, pencil, stick and powdered graphite, and silverpoint (Fig. 169).

Charcoal

Charcoal, probably the oldest drawing medium, is a crumbly material that readily leaves a mark when rubbed against any but a very smooth surface. With it, tentative lines can be put down and subsequently erased; the same piece of charcoal can with ease serve for line drawing or—turned on its side—produce broad tonal masses. Charcoal is equally suited to sketches and rapidly executed preliminary compositional plans (Fig. 170) and to fully developed, large-scale value studies (Fig. 171). One disadvantage of charcoal is that it is rather dirty. Also, because marks are not deeply imbedded in the ground surface, careless movements of the hand or arm across a drawing can almost eradicate it.

The two most popular types of charcoal are stick and compressed. *Stick charcoal* is made by heating sticks of wood about ¼ inch in diameter in closed chambers or kilns until the organic materials have evaporated and only dry carbon remains. Stick charcoal comes in varying thicknesses, the finest quality (called *vine charcoal*) made in very thin sticks of an even, soft texture. Manufacturers classify charcoal in four degrees of hardness: very soft, soft, medium, and hard. *Compressed charcoal* results from grinding the charcoal to powder and compressing it into chalklike sticks about ¼ inch in diameter. Compressed charcoal is also labeled according to hardness, ranging from 00, the softest and blackest, through 0 to 5, which contains the most binder and is consequently the palest and hardest. In general, compressed charcoal produces less easily erased lines and tones than regular stick charcoal and is not well adapted to beginner's needs. It is most effective for large-scale quick sketches or when rich darks are desired (Fig. 172).

above: Plate 1. Hyacinthe Rigaud
(1659–1743; French).
Study of Hands and Drapery.
1735. Pencil heightened with
white chalk on blue paper,
11¾ × 17¾'' (30 × 45 cm).
Fine Arts Museums
of San Francisco,
Achenbach Foundation
for Graphic Arts (gift of
Mr. and Mrs. Sidney M. Ehrman).

right: Plate 2. František Kupka
(1871–1957; Czech).
Study for *Woman Picking Flowers
No. 3.* 1909–10.
Pastel on blue paper,
17½ × 18½'' (45 × 48 cm).
Musée National de l'Art Moderne,
Paris.

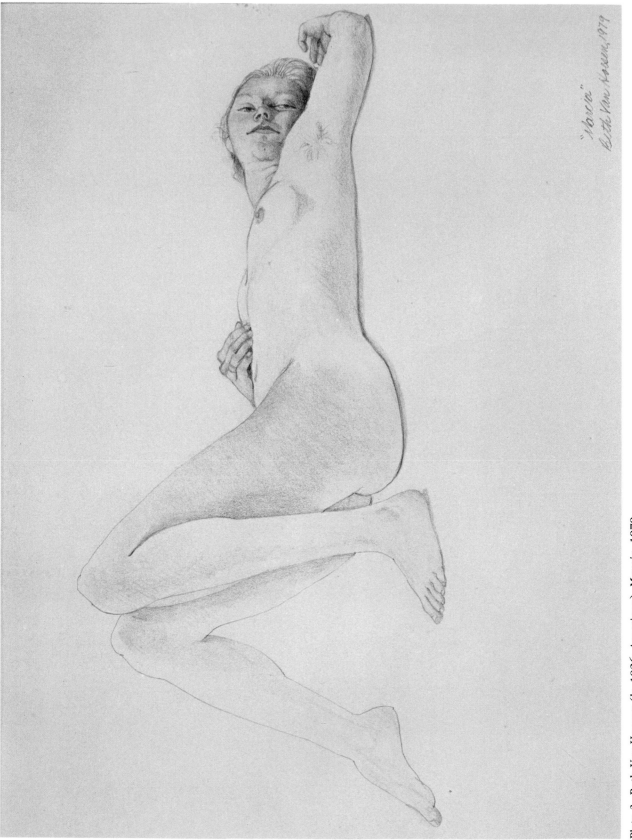

"Marcia"
Beth Van Hoesen, 1979

Plate 3. Beth Van Hoesen (b. 1926; American). *Marcia.* 1979.
Colored pencil and graphite, 11½ × 15½″ (29 × 39 cm). Courtesy the artist.

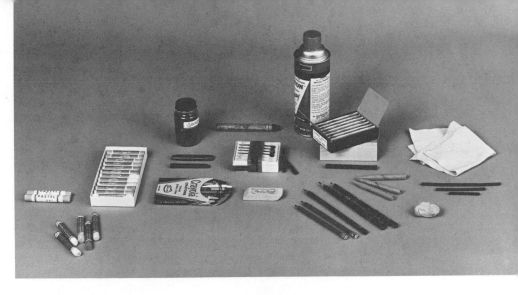

169. The dry media include the following materials (left to right): soft and semihard pastels, chalk (in box), wax crayons, stick and powdered graphite, grease crayon, conté crayons (in box), pencil eraser, graphite and charcoal pencils, fixative (in pressurized can), compressed charcoal (in box), tortillons, chamois, kneaded eraser, and stick charcoal.

170. William Glackens (1870–1938; American). *Study of a Woman Sewing.* Charcoal on tan paper, 7 × 8½'' (18 × 20 cm). Paul Magriel Collection.

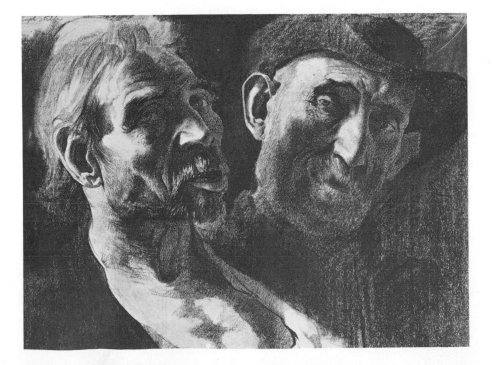

171. Joseph Stella (1877–1946; Italian-American). *Miners.* Charcoal, 15 × 19⅝'' (38 × 50 cm). Yale University Art Gallery, New Haven, Conn. (H. John Heinz III Fund).

Charcoal pencils are made by compressing charcoal into thin rods and sheathing them in paper or wood. They range in degree of compression from 6B (extra soft) through 4B (soft) and 2B (medium) to HB (hard). The chief virtues of the charcoal pencil are its cleanliness and maneuverability, but these also constitute its chief liabilities. The pencil lacks the flexibility of stick charcoal because only the point can be used effectively. The same criticism applies in using metal holders with stick charcoal.

Method

There are three common methods of working with stick or compressed charcoal. The direct free attack, using both the point and side of the charcoal stick, offers maximum flexibility of stroke and tone without the time-consuming fussiness of more finished modes (Fig. 170). An alternate process, involving a disciplined and relatively "pure" application of charcoal, is to build value relationships through systematically cross-hatched lines drawn with a pointed stick of charcoal (Fig. 171). Many enthusiasts consider most desirable a clearly grained texture without any of the soft fluidity of tone that accompanies rubbing (Fig. 171). A third manner of applying charcoal produces carefully developed value studies of even, graduated tone through repeated application of charcoal rubbed into the paper with either the fingers or a tortillon (Figs. 25, 84). This last method, the standard academic technique of the 19th century, is less popular today since most contemporary artists prefer a livelier surface.

Charcoal can be applied to many kinds of drawing paper. Newsprint suffices for quick sketches and studies that do not demand erasing, the careful building up of smooth tones, or permanency. Coarse drawing papers also provide acceptable grounds for quick sketches with all types of charcoal. Regular charcoal paper is best for sustained studies, for it will take repeated erasures and rubbing without losing its grain. Cheap, soft charcoal papers, because they lack tooth, do not hold the flaky charcoal; consequently it is difficult to obtain extended areas of rich dark tones on such papers. Compressed charcoal can be used effectively on relatively smooth bond papers. Most charcoal papers are manufactured in the standard 18- by 24-inch size. Other suitable drawing papers are available in larger sheets or by the roll, which suits the needs of contemporary artists such as Chuck Levitan, who work in charcoal on a more monumental scale (Fig. 173).

In charcoal work, a piece of chamois acts as an eraser to wipe out unsatisfactory lines and tones. The kneaded eraser can be shaped to eliminate small areas of tone, clean away smudges, sharpen an edge, and pick out small light accents. Charcoal drawings can be "fixed" by spraying them with fixative (shellac or a transparent plastic substance dissolved in solvent).

172. Edward Hopper (1882–1967; American). *Town Square (Washington Square and Judson Tower)*. 1932. Charcoal, 12 × 19'' (30 × 48 cm). Sheldon Memorial Art Gallery, University of Nebraska, Lincoln (F. M. Hall Collection).

173. Charles Levitan
(b. 1942; American).
Lincoln Split, 1976.
Charcoal pencil on paper,
each 6 × 10′ (1.83 × 3.05 m).
Courtesy the artist.

Quick Sketching

Project 90 Quick sketching of the kind ordinarily done in a life drawing class develops the capacity to put down rapidly the essential elements of a composition without becoming distracted by minor details. In figure drawing the artist learns to identify the characterizing aspects of a physique, a gesture, and action, or a typical posture (Fig. 170). Forcing yourself to make the same kinds of rapid summaries of the characterizing aspects of buildings, trees, vehicles, animals, people on the street, and any other subject is equally important. Practice making such drawings in charcoal, concentrating on recording the essential character of a form in one-minute, five-minute, and ten-minute sketches.

Finished Composition

Project 91 Select a subject that encompasses a wide range of value relationships—a complex still life, a self-portrait, or an abstraction (Fig. 106). Before embarking upon a highly finished charcoal drawing, establish a preliminary visualization of the full linear and tonal pattern as thumbnail roughs on a piece of newsprint (Fig. 122). Use the side of a short piece of charcoal to rough in the darks. Once you have determined the full value pattern, pin the preliminary study to the wall where you can refer to it and proceed with the finished drawing on charcoal paper. Employ any of the three methods described above to make a fully developed, large-scale dark and light charcoal study. While it is possible to combine these techniques, take care to achieve a consistency of handling throughout the drawing.

Chalk

Chalk, which like charcoal is an ancient drawing material, came into common usage in 15th-century Italy. The term *chalk* covers a wide variety of materials ranging in texture from coarse to fine, from hard to soft and crumbly, and from dry to greasy, which are shaped into rounded or square sticks. It is impossible to establish the point at which chalk becomes crayon or pastel, and the dividing

Dry Media

141

line between chalk and compressed charcoal is equally tenuous. The manufacture of chalk has become standardized to ensure regularity in the sizes of the sticks, the degrees of softness and hardness, the color range and intensity, and the dryness or oiliness. Blackboard chalks, which are most familiar, lack any oily binder and consequently are very dry, dust off easily, and are serviceable only for crude or temporary projects.

Chalk affords the artist a technical versatility similar to that of charcoal. Because it adheres firmly to paper, chalk, like compressed charcoal, is more difficult to erase than stick charcoal, but it offers ample compensation in the potential for richer, darker lines and solid masses. The possible effects are numerous and satisfying, from open, energetic sketching (Fig. 174), through solidly developed but nonetheless freely executed studies (Fig. 90), to carefully finished drawings (Fig. 175). The medium's chief advantage is color, permitting enriched tonal and compositional relationships.

Dark and Light on Toned Paper

Project 92 Using black and white or dark-colored and light-colored chalks on a middle-value paper facilitates the rapid visualization of tonal relationships (Pl. 1, p. 137). The technique has also produced highly finished drawings of great beauty (Fig. 176). Select a subject that will allow a full range of values—a piece of drapery or a paper bag would be appropriate, or if you want to tackle something more ambitious, a well-lighted nude, costumed model, or head. Pose your sub-

below left: 174. Marsden Hartley (1878–1943; American). *Self-Portrait.* Black chalk, 12 × 9'' (30 × 23 cm). Sotheby Parke-Bernet.

below: 175. George Stubbs (1724–1806; English). *A Skinned Horse.* c. 1776. Black chalk, 14¼ × 7¾'' (36 × 20 cm). Royal Academy of Arts, London.

176. Jean François Millet
(1814–1875; French).
Peasant Resting.
Black chalk on white paper.
Mauritshuis, The Hague.

ject against a background of a middle value and draw on toned charcoal paper of a comparable value. Execute your drawing in dark chalk and a very light chalk, allowing the ground to carry as the middle value. Avoid mixing light and dark to create intermediate tones. Let the paper serve as the transitional middle tones. Although pencil has been used, the effect that can be achieved is elegantly demonstrated in Plate 1. Thoughtful analysis of light-dark patterns and preliminary planning will result in a fresh, unmuddied drawing.

If you choose to work in color, the paper and chalks should be closely related in color without strong differences in intensity (brilliance) and, using Figure 83 as your guide, only a few value "steps" apart. Select, for example, a medium tan paper for use with light cream and darker brown chalks, blue-gray paper with pale and darker blue chalks, and so forth. For further interest, add accents in black and white, sparingly.

Pastels

Pastels are high-quality chalks of fine, even texture, available in a wide range of hues of graduated value and intensity. *Soft pastels,* long popular in France and traditionally called French pastels, consist of dry pigment mixed with an aqueous binder, usually compressed into cylindrical form. Soft and crumbly, this type of pastel is nonadhesive and thus requires both a paper of decided tooth and a fixative to assure a measure of permanence. Oil added to the binder causes *semihard pastels* to adhere more readily to paper. Manufactured most commonly as rectangular sticks, semihard pastels possess a number of advantages over ordinary pastels: their oily texture and smooth sides render them less crumbly; the flat planes provide for rapid coverage of broad areas; and the sharp corners make them effective for detailing and accenting. They are sometimes labeled "oil pastels." *Hard pastels,* a more recent development, share the basic characteristics of the semihard variety but are distinguished by an even firmer texture. Both semihard and hard pastels are difficult to erase, so it is wise to make a small preliminary color sketch before commencing on a large-scale composition. Pastels offer a full complement of colors and values to permit what might be termed "drawn painting" (Pl. 2, p. 137). A richness of color results from the direct application of *analogous* colors (closely related neighboring

Dry Media

colors) or *complementary* colors (opposites, i.e., red/green, yellow/violet, blue/orange) side by side or with cross-hatching. Blending colors through rubbing produces lifeless color and uninteresting surfaces. Any of the exercises in the sections on chalk and conté crayon afford practice in the use of pastel.

Conté Crayon

Conté crayon is a semihard chalk of fine texture containing sufficient oily material in the binder to adhere readily and more-or-less permanently to smooth paper. Conté, in sticks about ¼-inch square and about 3 inches in length, comes in three degrees of hardness—No. 1 (hard), No. 2 (medium), and No. 3 (soft). It offers a limited number of colors—white, black, sepia, and sanguine (a Venetian red, and the most popular of conté colors). For sketching, conté crayon's rectangular format provides flat sides for broad strokes of graduated tone, while its corners are capable of creating sharply accented lines. Conté erases with difficulty and consequently best serves the needs of the sure, experienced draftsman.

Project 93 Break a stick of conté into two or three pieces and working on newsprint, do a series of rapid full-sheet drawings of any subject that appeals to you—posed figures, animals, trees, plant forms, a casual grouping of fruit or vegetables. Work for a broad representation of essential forms and movements. View your subject through half-closed eyes so that details are eliminated, allowing you to see the basic forms as simplified patterns of light and dark. Block in the shadow shapes first by using the side of the crayon, adding linear accents later with the sharp corners of the crayon. Practice drawing contours and accents with the corner held flat to the paper rather than raised. Experiment with shifting from the corner to the flat edge of the crayon within a single stroke, both for interesting line quality and as a means of describing the contours of three-dimensional forms.

Fully Developed Drawing

Conté's fine texture is particularly appropriate to the creation of carefully finished drawings with a full value range (Fig. 177). The chalk is greasy enough that it does not rub off readily, and yet its softness allows smooth gradations of dark to light. Modeling can be further reinforced by swipes of the kneaded eraser, which lifts out whites almost in the manner of white chalk marks.

Project 94 If you wish to attempt a highly finished drawing in conté, decide upon your subject and plan your composition in a series of rough layouts on newsprint paper. When you are satisfied with the composition, select a smooth, firm paper. Lay in your initial lines lightly, and then proceed to develop the drawing to full value. You may wish to strengthen drawings done in brown or red conté with black accents or white highlights or both.

Conté crayon on rough paper produces an interesting granular quality, as evidenced by Georges Seurat's portrait *The Artist's Mother* (Fig. 178). Seurat intended his drawing to suggest the precise pointillist style (color systematically applied in tiny spots) of his paintings. Using very even pressure with soft conté, he filled the grain of the paper according to the degree of desired darkness in each area, so that only in the darkest passages does the white grain of paper completely disappear. The even texture of conté as it is used here, without variations in size of the grain or in direction of stroke, contributes to a somewhat impersonal surface to the drawing, which, in combination with the simplified and generalized form, builds an abstract and monumental quality.

above: 177. Charles Sheeler
(1883–1965; American).
Feline Felicity. 1934.
Conté on white paper,
21¾ × 17⅞'' (56 × 46 cm).
Fogg Art Museum,
Harvard University,
Cambridge, Mass. (purchase,
Louise E. Bettens Fund).

above right: 178. Georges Seurat
(1859–1891; French).
The Artist's Mother.
Conté on paper,
12¼ × 9½'' (31 × 24 cm).
Metropolitan Museum of Art,
New York (purchase,
Joseph Pulitzer Bequest, 1955).

Wax Crayons

Inexpensive sets of brightly colored wax crayons manufactured for children are familiar to all. The waxy substance adheres firmly to most paper surfaces and so presents a relatively clean medium to handle. The hardness of wax crayons, however, makes them somewhat inflexible, and it is generally difficult to obtain deep, rich tones, since the waxy strokes do not readily mix or fuse. Some artists find crayons most appropriate for sketching and preliminary color planning; other artists, however, have produced handsome finished drawings with colored crayons.

Grease crayons and lithographic crayons, when applied to grained papers, yield vigorous, clearly defined textures and a richness of values (Fig. 179). Disadvantages of crayons are that they do not erase or allow lines to be fused or blurred easily. When used with firm, smooth paper, lights can be retrieved by scratching or scraping with a knife blade or similar tool.

Pencil

The pencil is probably one of the most familiar tools in our culture, inasmuch as we learn to handle pencils in early childhood, if not for drawing, certainly for writing. Our familiarity may lead us to take the pencil for granted and discourage objective recognition of the medium's actual potentialities and limitations. In addition, habits contracted at school for learning how to write, do arithmetic, and so on, frequently work against the free and expressive use of the medium. Nonetheless, pencil remains a very important and versatile drawing medium.

Pencils are available in an astonishing variety—graphite, carbon, charcoal, wax, conté, lithographic (grease), and a wide range of colors, both soluble and insoluble, each offering a particular quality that renders it valuable for certain effects. The common, so-called lead pencil, our concern in this section, is actually composed of graphite, a crystalline form of carbon having a greasy texture. Suppliers now manufacture graphite pencils in hexagonal, round, and flat

Dry Media

179. Käthe Kollwitz
(1867–1945; German).
Woman on the Bench. 1905.
Crayon and Chinese ink
on brownish paper,
19½ × 24½'' (50 × 62 cm).
Courtesy Galerie St. Etienne,
New York.

shapes, in as many as seventeen degrees of hardness—6B, the softest, possesses the highest graphite content; 9H, the hardest, contains the greatest proportion of clay. The common design for pencils, regardless of content, is a slender lead sheathed in wood or rolled paper, coming to an exposed point. It is also possible to buy drawing leads, black and colored, which can be inserted into metal holders.

Pencil is a determinedly linear medium; its effectiveness is greatest when employed for primarily linear expression. Students attempting to build extended masses of dark tone will discover that overworked areas result in a shiny, mottled surface, sometimes marked with indentations from repeated pressures of the lead.

Soft Pencil

Soft pencils (6B to 2B) are particularly well suited for contour drawings or other similarly free, linear types of notation (Fig. 63). The soft lead also lends itself to informally applied parallel hatchings and loosely executed cross-hatching. Applied lightly and in overlapping strokes, cross-hatching can build a soft, light gray tone to suggest shifting directions of complex forms and further define important contours (Fig. 180). A room interior by Jean Edouard Vuillard (Fig. 181) displays a free, very open style of soft-pencil sketching, in which a meandering line moves in all directions to establish the main forms. Into the matrix of middle-dark sketchy lines, Vuillard has introduced more precise darks that define forms and avoid ambiguity.

Project 95 *Scribble with a variety of soft pencils ranging from 2B to 6B. Select the degree of softness most pleasing to you, and make free notations of any subject you choose. Frequently, a drawing of whatever happens to be within your field of vision has a fresh interest because it has not been carefully selected and arranged. If your immediate environment does not interest you, a pair of hiking boots or running shoes, a friend sprawled in a chair, or a shirt and jeans tossed on a bed or carelessly draped over the back of a chair provide apt subject matter for this kind of drawing. Let your drawings be free and gestural.*

Drawing Media

146

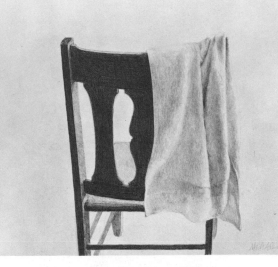

180. Mark Adams
(b. 1925; American).
Still Life: Chair and Towel. 1965.
Pencil, 14 × 17″ (36 × 43 cm).
Collection Duncan and
Cynthia Luce, Laguna Beach, Calif.

181. Edouard Vuillard
(1868–1940; French).
Interior of the Artist's Studio.
c. 1897. Pencil,
4½ × 7″ (11 × 18 cm).
Courtesy Richard L. Feigen & Co.,
Inc., New York.

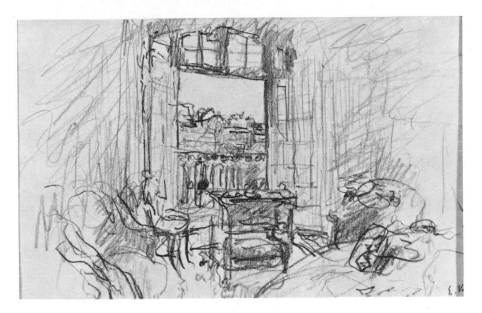

Provide some dark accents, but only enough to begin to give definition to objects (Fig. 181).

Sketchbook Activities

Practice scribble-style soft-pencil sketching to record the animation and vitality of people and events surrounding you. Concentrate on conveying mood rather than details.

Soft Pencil: Formalized Patterns

Soft and medium-soft pencils (6B to B) are frequently combined in a rather formalized manner for depicting architectural and landscape subjects. Board, shingle, brick, and stone patterns; doors; windows; and moldings; all show lively patterns, while shadows under eaves and in recessed doorways, built up from simple hatchings, provide contrasting darks (Fig. 182). Asher B. Durand employed a formalized pattern of short strokes in *Bolton, Oct. 3/63* to suggest the laciness of the foliage masses in contrast to the more boldly delineated branch structure (Fig. 183).

Dry Media

Project 96 Select a building with some degree of surface articulation, trees and foliage, or any other subject in which form, texture, and other details can be suggested with a variety of lively pencil patterns. As you develop foliage masses, be conscious of light and dark patterns that create volume.

Hard Pencil: The Modeled Line

The clean-cut and silvery tone of hard pencil (H to 9H) can yield effects of great elegance. Amedeo Modigliani's portrait of Leon Bakst (Fig. 184) demonstrates the incisive strength of hard pencil used almost as pure line. Hard pencil is also well adapted to a style of drawing in which light shading augments line to convey a fuller sense of form than can be suggested by outline alone (Fig. 185). The delicacy and sensitivity with which forms can be modeled and details rendered is nowhere more evident than in the figure studies, portraits, and architectural renderings of Jean Auguste Dominique Ingres, the acknowledged master of pencil drawing (Figs. 4, 185, 305).

Project 97 Select a subject of some visual complexity, sketch it lightly in medium-hard pencil, and once the boundaries of principal forms have been established, proceed to render the detail as freshly and distinctly as possible. Drawings in hard pencil are best kept small, for if they are too large the pale lines and tone do not carry well. The delicately interlocked petals of a single rose provide a perfect subject for this medium, as do glass, silver, and other smooth-surfaced objects. Life drawings, portraits, costumed figures, and in fact almost any subject are appropriate, provided the artist concentrates on outline reinforced with only a suggestion of modeling. Since some pressure is necessary when using hard pencil, a firm, not too thin paper such as kid-finish Bristol board is recommended, in order to avoid an excessively engraved surface.

Colored Pencils

Contemporary artists, both in fine and commercial art, have begun using colored pencils, alone and in combination with other media, for works ranging

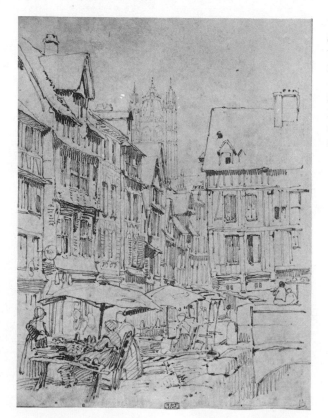

182. Richard Parkes Bonington (1802–1828; English). *View of Rouen.* c. 1824. Pencil on paper, 10 × 7⅝″ (26 × 20 cm). Stanford University Museum of Art, Calif. (gift of the Committee for Art at Stanford).

from sketches to highly detailed renderings. Beth Van Hoesen, a printmaker of distinction, first turned to colored pencils to make preliminary studies for color etchings. She has since found colored pencils an ideal medium for developing full-color drawings without loss of the linear precision and sensitivity with which she is identified (Pl. 3, p. 138).

Yasuhiro Esaki draws with a range of light and dark Prismacolor pencils on a middle-value background of acrylic, gesso, and polymer applied to paper (Fig. 186). *Blue Sheet No. 9* is one of a series of full-page drawings produced over a five-year period in which Esaki has explored the wrinkled and folded surface of a bedsheet. The meticulously rendered *trompe l'oeil* study can be viewed both as a topographical map and as a lyrical abstraction.

right: 183. Asher B. Durand (1796–1886; American). *Bolton, Oct. 3/63.* 1863. Pencil on paper, 16¾ × 22¾″ (43 × 58 cm). New-York Historical Society.

below: 184. Amedeo Modigliani (1884–1920; Italian-French). *Leon Bakst.* 1917. Pencil, 22½ × 16½″ (57 × 42 cm) Wadsworth Atheneum, Hartford, Conn.

below right: 185. Jean Auguste Dominique Ingres (1780–1867; French). Two nudes, studies for *The Golden Age.* c. 1839–43. Pencil, 16⅜ × 12½″ (42 × 32 cm). Fogg Art Museum, Harvard University, Cambridge, Mass. (bequest of Grenville L. Winthrop).

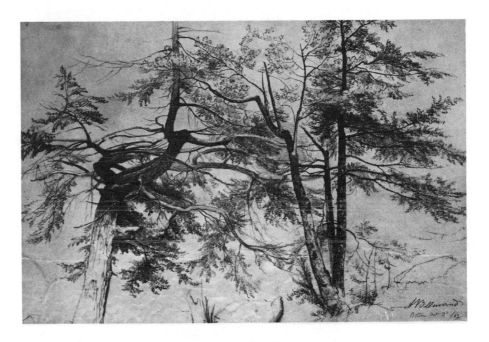

The overwhelming illusion of patterned fabric, molded plastic forms, and mirrorlike metallic surface in Jeanette Pasin Sloan's *Silver Bowl Still Life* (Pl. 4, p. 155) results, in part, from using colored pencils to give increased definition to acrylic washes. Pencil lends itself to a precise delineation of contour and to the skillfully controlled rendering that differentiates between the subtlety of the reflections in the plastic surfaces and the crisp clarity of the reflections in the silver bowl.

Project 98 *Practice various pencil drawing techniques, ranging from loose sketches to carefully finished drawings, using colored pencils. Explore the possibilities of the medium in a series of small studies before undertaking a large-scale composition. Richness and luminosity of color can be achieved by applying layer upon layer of color.*

Stick and Powdered Graphite

Graphite is available in other than the familiar pencil form. Stick graphite (about ¼-inch square and 3 inches long) comes in gradations labeled in the same manner as pencils (B to 6B). The stick can be manipulated like conté crayon or square chalks, the point of the stick producing soft, rich lines, the flat sides depositing broad areas of gray, while the corners create sharp, dark accents (Fig. 187). Stick graphite lends itself to drawing in an open, sketchy manner on a large scale. Figure 188, drawn on paper nearly twice the size of a standard newsprint pad, displays a line quality identical to that in a smaller drawing done with a regular drawing pencil.

Project 99 *Explore various techniques for drawing with stick graphite. Select a subject with planes and angles that will allow you to use the flat sides and corners of the stick to define form—architectural forms are particularly suitable. An adequate alternative would be a random clustering or nesting of empty cardboard boxes—the grouping can be made as complex as you wish. Work large;*

below left: 186. Yasuhiro Esaki (b. 1941; Japanese-American). *Blue Sheet No. 9.* 1979. Pencil and acrylic on paper, 28⅞ × 21½'' (73 × 55 cm). Courtesy the artist.

below: 187. Edwin Dickinson (1891–1978; American). *Souvenir of the Fossil Hunters,* detail. 1927. Pencil, entire work 7⅝ × 9⅞'' (19 × 25 cm). Private collection.

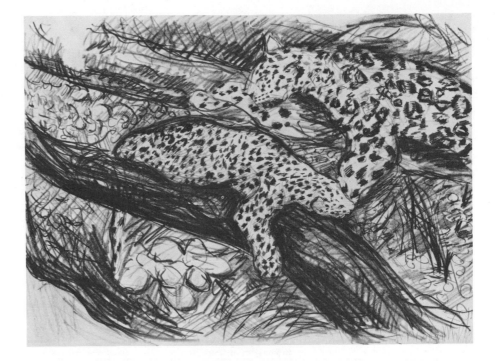

188. Malcolm Morley
(b. 1931; English).
Leopards. 1980.
Pencil on paper,
21 × 30'' (53 × 76 cm).
Courtesy Xavier Fourcade, Inc.,
New York.

do not let your drawing become cramped. Using a full sheet of paper, make a second drawing in which you treat the stick graphite like a giant pencil to sketch freely. Choose a subject rich in textures such as an untended, overgrown garden; a field thick with grasses, weeds, and thistles; or a thicket of trees and brambles.

Finely ground, powdered graphite, packaged in squeeze tubes for purposes of lubrication, can be purchased in hardware stores. Harder than stick graphite, it produces a pale, even silvery tone of great beauty when rubbed onto a kid-finish Bristol board with a soft cloth or paper towel. Drawings can be developed upon this toned background using medium-hard and hard pencil lines with white highlights recovered through erasure (Fig. 189). The technique is well suited for drawings meant to convey a sense of elegance and delicacy.

189. Daniel M. Mendelowitz
(1905–1980; American).
Wild Radish. 1965.
Hard pencil and rubbed graphite,
15½ × 21½'' (39 × 55 cm).
Collection Mrs. Daniel Mendelowitz,
Stanford, Calif.

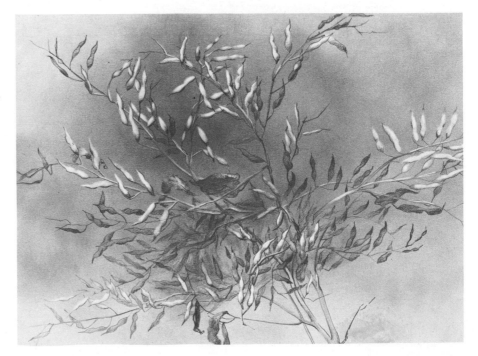

Project 100 Using a soft cloth or paper towel, rub powdered graphite into kid-finish Bristol board until you have a smooth tone of light gray. Draw with light pencil lines and then add darker shading. Erase out whites. If you want small precise areas of white, cut a firm eraser to a fine edge and use it to lift out narrow white lines. Work carefully since all marks, whether penciled darks or erased lights, show on the gray background. You may want to work with an extra piece of paper under your hand to prevent smudging. Leafy plants (Fig. 189), portraits (Fig. 108), glass or metallic objects with reflective surfaces (Fig. 231), or an abstraction of organic forms might prove workable.

Graphite in either stick or pencil form can be powdered on sandpaper and applied with a finger, soft cloth, or paper towel to provide a smoothly textured tone that contrasts effectively with sharply drawn lines, a combination particularly apt for modeling the form of a nude figure.

Silverpoint

Metal points preceded lead or graphite pencils as drawing implements. Over the centuries silver has seemed to provide the most satisfactory metal point, its lovely gray color oxidizing to a gray-brown with the passing of time. A stout wire (preferably silver and available at jewelry and craft supply stores) not more than 1 inch long and pointed by rubbing on sandpaper provides a satisfactory silverpoint. For ease of handling, the wire can be inserted into a regular drafting pencil holder, a mechanical pencil, or a wooden stylus. Any smooth, heavy

below: 191. Pavel Tchelitchew (1898–1957; Russian-American). *Frederick Ashton.* 1938. Silverpoint on white prepared paper, 19⅞ × 12⅜'' (51 × 32 cm). Fogg Art Museum, Harvard University, Cambridge, Mass. (gift of Meta and Paul J. Sachs).

below: 190. Jan van Eyck (1390–1441; Flemish). *Cardinal Nicolo Albergati.* c. 1431. Silverpoint on grayish-white prepared paper, 8¼ × 7⅛'' (21 × 18 cm). Kupferstichkabinett, Staatliche Kunstsammlungen Dresden.

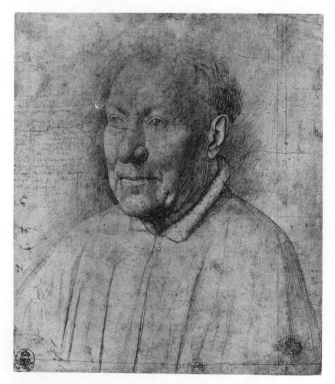

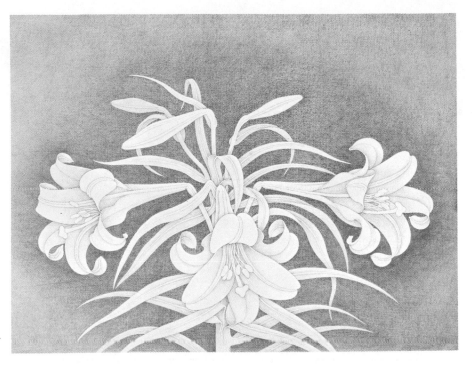

192. Howard Hack
(b. 1932; American).
Silverpoint #97, Lily #6. 1980.
Silverpoint, 30 × 40″ (76 × 102 cm).
Courtesy the artist.

paper—again, Bristol board is excellent—surfaced with white tempera makes an adequate ground for the beginner. A more professional ground results from mounting two-ply Bristol board on a drawing board and coating the paper with thin applications of warm *gesso,* a white, fluid paste made by mixing gypsum or chalk with glue and water. (Commercially prepared liquid acrylic gesso, thinned to the consistency of cream, can be substituted.) When a smooth opaque surface has accumulated and the gesso has been burnished with a soft cloth, the ground is ready for silverpoint (Fig. 190).

Silverpoint yields a thin gray line of even width, like that of a hard pencil. Lines executed in silverpoint will not blur; hence gradations of value must be achieved through systematic diagonal shading, clusters of lines, or cross-hatchings (Fig. 191). Since silverpoint does not erase, students are advised to do a preliminary study in hard pencil, perhaps 4H. Silverpoint is most rewarding to individuals who enjoy methodical procedures and painstaking workmanship to produce drawings of exquisite finish. Although students are encouraged to work relatively small while they are developing a familiarity with the medium, silverpoint drawings need not always be limited in scale, as evidenced by Howard Hack's *Silverpoint #97, Lily #6* (Fig. 192), which measures 30 by 40 inches (76 by 102 centimeters). Rather than duplicate the natural light and dark relationship between blossoms and leaves, Hack focuses on the complexity of the combined forms seen almost as a reverse silhouette against the soft, gray-toned background.

Project 101 Prepare a piece of Bristol board with four coats of tempera or gesso applied thinly to avoid brush strokes. Let each coat dry thoroughly. Brush alternate layers in opposite directions. Select relatively simple forms for your first attempt— one or two yellow apples, lemons, or pears or one egg placed on a saucer or in a small bowl. Avoid subjects that call for rich dark tones. For greater visual interest, consider cutting a wedge or two out of a piece of fruit—drawing an apple doesn't require that it be left whole. A partially peeled lemon or orange with the strip of peel still attached offers interesting possibilities. Do not neglect the cast shadows of any object. Have patience; be willing to build your forms and values slowly.

Dry Media

Wet Media

Any fluid preparation an artist chooses to use could conceivably be termed a "wet" medium (Fig. 193). For instance, artists sometimes draw in brush and oil or in printer's ink (Fig. 209). Our interest here, however, will be such wet media as *inks*—full strength or diluted for *wash*—and those types of paint commonly associated with drawing—watercolor, tempera, acrylics, and gouache.

Ink

Inks, applied with pen or brush, were used for writing and drawing in Egypt, China, and elsewhere long before the beginning of the Christian era. Contrary to common impression, inks can take paste or solid form as well as fluid, but the quality most generally distinguishing ink from paint is fluidity. The *Oxford Universal Dictionary* defines ink as "the colored fluid ordinarily employed in writing with a pen on paper, parchment, etc., or the viscous paste used in printing." Inks are further identified by their purpose (lithographic, printing, writing); by special qualities (indelible, soluble, transparent); by color; and also according to their place of origin (India, China, and so on). Many adapt well to artistic use. Although the most common types of writing inks tend to be too thin and pale for other than sketching purposes, the deep, velvety black of India ink has long been highly prized as an artistic medium.

Pen and Ink

For its elegance and clarity, the medium of pen and ink is unexcelled. It serves with equal success as the vehicle for sharp, detailed observation (Fig. 263), or for cryptic amusement (Fig. 197). By definition a linear medium and one that

Plate 4. Jeanette Pasin Sloan (b. 1946; American). *Silver Bowl Still Life*. 1978. Acrylic and colored pencil on board, 28½ × 38½'' (72 × 98 cm). Security Pacific National Bank, California.

Plate 5. David Hockney (b. 1937; English).
Cataract Hotel, Aswan. 1978.
Crayon, 17 × 14'' (43 × 36 cm).
© David Hockney 1978.
Courtesy Petersburg Press.

156

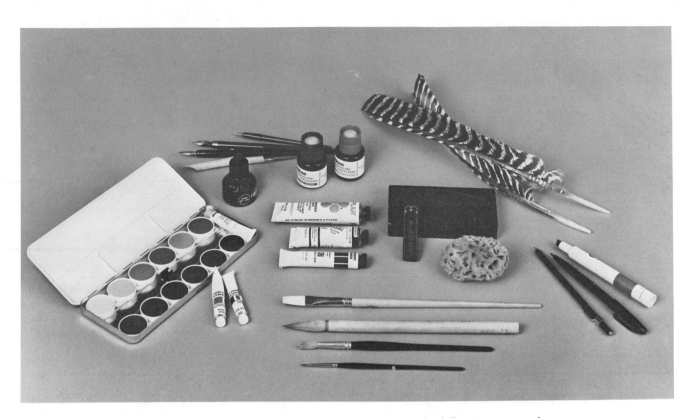

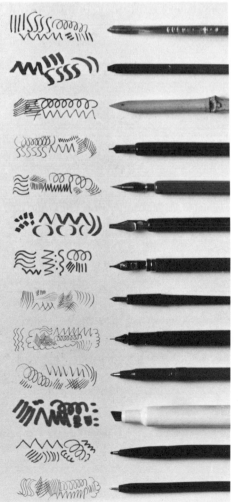

above: 193. The wet media include the following: watercolors, opaque (in tray) and transparent (in tubes); India and colored inks; pens; acrylic, oil, and gouache paints (in tubes); brushes (stiff oil type, Oriental, No. 10 sable, and small sable); *sumi* ink stick and mixing well; sponge, turkey quills; felt-tip and ball-point pens.

left: 194. Pen nibs and the lines they produce (top to bottom): turkey quill; reed pen; bamboo pen; two drawing pens with metal points; two lettering pens, with flat and round metal nibs; "crow quill" pen; rapidograph pen; nylon-tip pen; felt-tip marker and pen; ball-point pen.

does not indulge mistakes, pen and ink demands precise and subtle control. The beginning student will probably have to tolerate initially clumsy results before achieving expertise; ink is a medium, however, that allows the development of distinctively personal styles.

Pen Types

The requirements of a pen are that it be tubular and pointed, with sufficient capacity in the tubular body to hold a fair amount of ink that can flow from the body through the point to the paper (Fig. 194). Quill and reed pens have been in use for both drawing and writing since ancient times. *Quill* pens are cut from the heavy pinion feathers of large birds and shaped to a sharp or angular, coarse or fine point, depending upon the taste of the artist or scribe. As a result of their lightness and pliancy, quill pens respond readily to variations of touch and pressure and consequently produce a responsive, smooth, and flexible line. Today it is traditionally trained calligraphers rather than artists who are most inclined to make and use quill pens.

Reed pens are hewn from tubular reeds or the hollow wooden stems of certain shrubs; they too are cut to suit the user's taste. In general, reed pens are stiff and their nibs, or points, thick and fibrous. The lack of supple responsiveness results in a bold, almost harsh line (Fig. 195). Because the reed pen does not glide easily across the paper surface, it contributes to a deliberate or even

Wet Media

195. Vincent van Gogh
(1853–1890; Dutch-French).
The Crau from Montmajour. 1888.
Reed and fine pen with
light brown ink over black chalk,
19⅛ × 23⅞″ (49 × 61 cm).
British Museum, London
(reproduced by courtesy
of the Trustees).

awkward strength of handling that tends to challenge the artist and thus inhibit overfacility and technical display. Interestingly, it seems to have been the favored drawing tool of Van Gogh (Figs. 118, 195, 255). Contemporary artists who value similarly strong, brittle qualities of line, draw with *bamboo* pens, a type of reed pen imported from the Orient.

The *metal* pen point as we know it today appeared at the end of the 18th century. Used on very smooth, partially absorbent paper, the steel pen can be more completely controlled than either of its precursors and can be handled with nearly infallible accuracy by a sufficiently skilled person. Nibs of varying sharpness, pointedness, and angularity permit almost any desired effect to suit the artist's purpose.

The multiplicity of steel pens available for drawing demands much experimentation and exploration. For general sketching purposes, many artists prefer a pen holder and interchangeable nibs. (An added benefit of pen and ink is that ink, once dry, does not smear or smudge in a sketchbook as do pencil and other dry media.) *Lettering* pen points come with round, straight, or angular nibs ranging in width from 1/10 millimeter to more than ¼ inch. Certain of the straight-nibbed lettering pens yield a line that in its stiff angularity recalls the reed pen. Wide lettering pens also allow the rapid filling-in of large areas. *Fountain* pens are generally more convenient for sketchbook drawing, since once filled they eliminate frequent recourse to a bottle of ink (which is always a risk, especially when transported). Two general fountain-pen types are specially manufactured for sketching and drawing: *quill-style* pens, which will dispense India ink for an extended period of time without clogging or dripping; and *stylus-type* pens, generally termed *rapidograph* pens, with a central cylinderical point that enables the user to move the pen in all directions without varying the line width (Fig. 205). Thorough cleaning of pens—their nibs and reservoirs— after usage greatly prolongs the effective life of these tools. Rapidograph pens, in particular, should be flushed out frequently in accordance with the manufacturer's instructions in order to prevent irreparable clogging of their delicate internal mechanisms.

Drawing Media

158

For sketching purposes, nylon, felt-tip, ball-point, and marking pens have come to be adopted as convenient substitutes for traditional pen and ink. Although they do not dispense a fluid with the rich, opaque darkness of India ink or have the flexibility of a metal pen, their bold, simple lines have a special character of their own (Figs. 34 to 36, 194). However, uncertainty as to the permanence of these inks after prolonged exposure to strong light limits their use for fine art, while, at the same time, illustrators producing art work for reproduction rely upon them heavily.

Simple Line Drawings

A black ink line drawn with pen on a white paper carries with incisive brilliance and energy. Hard, pure, and abbreviated, the simple line drawing creates a kind of shorthand impression of reality by recording only what the artist considers absolutely essential, eliminating all distracting details. Stark though it may be, the pen-and-ink line displays remarkable elasticity in terms of expressive possibilities. The pen line of unvarying width, for example, conveys an impersonal quality reflecting little of the gesture of drawing. Alexander Calder found it particularly appropriate for depicting the characters of his *Circus,* conceived to be executed in wire (Fig. 196). Saul Steinberg's *Benjamin Sonnenberg,* on the other hand, reveals a very simple and direct use of the more conventional flexible pen (Fig. 197). Lines vary slightly in width, with heavier lines in the hat, head, and neck providing both emphasis and enough inflection to give the portrait a strong sense of the art collector's intriguing personality. Each line conveys a sense of certainty. A drawing such as the Steinberg is often inked over a lightly penciled sketch.

The sensitive, less authoritative, profile portrait by Jean Cocteau (Fig. 198) represents another type of simple pen-and-ink technique. Obviously drawn directly from the model, the contour line meanders in discontinuous movements that reflect the artist's sequential observations. Where a mistaken judgement has been modified, as at the back of the head and neck, the correct line has been doubled for greater weight. A simple back-and-forth scribble and light smudging around the eye and at the back of the collar provide soft touches of value and a suggestion of texture.

196. Alexander Calder
(1898–1976; American).
The Circus. 1932.
Pen and ink,
20¼ × 29¼'' (51 × 74 cm).
Courtesy Perls Galleries, New York.

Project 102 Make a series of line drawings that allow you to explore variations of simple pen-and-ink technique. Organic forms, vegetables, fruits, leaves, or flowers make logical subjects, since barely perceptible deviations in contours from those of the actual model are insignificant. Portraits and figure studies present greater difficulties than do still lifes for this reason, but they compensate with increased interest. If you wish, begin with a light, loose pencil sketch to indicate general placement of shapes. Do not make a precise, detailed pencil drawing or follow the pencil lines so closely that all freedom of movement is curtailed. Using the pencil lines only as a general guide, draw in ink directly from the model. Take care not to overload the pen with ink; wipe the pen point against the side of the bottle before starting to draw, or the pen may deposit a large drop of ink when it first touches the paper. Should you have such an accident while drawing on good-quality Bristol or illustration board, allow the ink to dry, gently scrape away the excess ink with a razor blade, and then remove any remaining vestiges of the spot with an ink eraser. Do not, however, attempt to draw again over the scraped portion or the ink will undoubtedly bleed into the disturbed surface. Avoid any temptation to block out mistakes or smudges with white paint except on drawings intended only for reproduction.

Project 103 The Sultan on Horseback by Delacroix was executed rapidly, with a flourish that is reflected in the general exuberance of the drawing and in decided variations of thick and thin that mark individual lines (Fig. 199). Sketch a subject that does not demand exact contours, such as a figure or animal in action. Preliminary guidelines in hard pencil can be followed if they are reassuring, but do not allow them to be restrictive. Attempting to trace over pencil lines with pen and ink inhibits spontaneity. This assignment is most valuable when executed as a series of bold direct drawings of the same subject done one after another in rapid succession, working to achieve fluidity and freshness. Bond paper provides a sufficiently smooth surface for pen-and-ink sketching.

above left: 197. Saul Steinberg
(b. 1914; American).
Benjamin Sonnenberg. 1950.
Pen and black ink,
13 × 10'' (33 × 25 cm).
Collection Mr. and Mrs.
Michael Tucker, New York.

above: 198. Jean Cocteau
(1889–1963; French).
Jean Desbordes. 1928.
Pen and ink,
16¾ × 13⅜'' (43 × 40 cm).
Art Institute of Chicago
(gift of Mrs. Gilbert W. Chapman
in memory of Charles B. Goodspeed).

Drawing Media

above: 199. Eugène Delacroix
(1798–1863; French).
The Sultan on Horseback. c. 1845.
Pen and ink, 8⅛ × 6″ (21 × 15 cm).
Louvre, Paris.

above right: 200. Attributed to
Pietro Testa (1611?–1650; Italian).
Compositional Study, detail.
Pen and brown ink, entire work
11⅛ × 16½″ (28 × 42 cm).
Fine Arts Museums of San Francisco,
Achenbach Foundation
for Graphic Arts.

Cross-Hatching

Because pen and ink is essentially a linear medium, dark values must be built up line by line and dot by dot. There are two standard methods for building pen-and-ink values: *hatching,* a system of carefully applied parallel lines; and particularly *cross-hatching,* criss-crossed patterns of parallel lines. Cross-hatching methods include painstaking, evenly spaced lines (Fig. 200); boldly executed patterns of lines that move in many directions (Fig. 201); and scribbled cross-hatched lines interspersed with spots, splashes, and other textural accents (Fig. 202).

Initial attempts at pen-and-ink cross-hatching inevitably seem stilted, but in time, each artist develops a personal style. The beginner should not be unduly concerned with blotches and mistakes; fluent, consistent, unmarred pen-and-ink lines come only with much experience. It is important to have a fine-quality smooth paper for cross-hatching, lest the surface tear from repeated applications of the pen or become so absorbent that the ink lines lose their sharpness and become blurred. Bond paper is preferable to newsprint.

Project 104 Practice cross-hatching until you can maintain some measure of control. Then sketch a simple subject and proceed to model it in dark and light, letting the form suggest the directional pattern for your lines (Fig. 201). At the beginning, draw brightly illuminated, simple forms with clearly defined areas of shading and minimum of surface texture. When you are ready to attempt a more complex study, you might want to translate some of the pencil drawings done for earlier projects into pen and ink, being familiar with those subjects.

Stippling and Pattern Textures

In highly detailed ink drawings, especially in scientific illustrations (Figs. 341, 342), stippling and formalized patterns serve to describe the very smooth gradations of value that define form, texture, or color modulation. In *Antennarius*

tagus (Fig. 203) lines and dots have been combined with skill and ingenuity. Even the sharpest photograph would not reveal the details of form, texture, and surface patterns with the clarity of this drawing, for in a photograph reflected light and shadows would be intrusive. Though the purpose of this drawing

above left: 201. Käthe Kollwitz (1867–1945; German). *Woman Peeling Potatoes.* c. 1900. Pen and ink on white paper, 16¾ × 11″ (43 × 28 cm). Courtesy Galerie St. Etienne, New York.

above: 202. Henri Matisse (1869–1954; French). *Female Nude Seen from the Back.* 1901–03. Pen and black ink, 10½ × 7⅞″ (27 × 20 cm). Musée de Grenoble.

left: 203. Chloe Lesley Starks (1866–1952; American). *Antennarius tagus* (anglerfish). c. 1900. Pen and ink, 5¼ × 9¼″ (13 × 23 cm). Formerly collection Dorothy Rich, Menlo Park, Calif.

departs from fundamentally artistic expression, its clarity and virtuoso production are in themselves worthy of visual appreciation.

Project 105 In an earlier assignment you were asked to make a pencil rendering of a familiar surface, duplicating the texture as accurately as possible (Proj. 39). Now you are asked to do a similar rendering in pen and ink, concentrating on delineating textured surface or object in as disciplined a manner as possible, relying on stippling and formalized patterns. For this project a more detailed preliminary pencil drawing is permissible.

Pen and ink is also well adapted to drawings in which clearly defined patterns are desired for their expressive and decorative values. Aubrey Beardsley remains an unchallenged master at using pen and ink to achieve unique, original decorative effects and richly patterned surfaces (Fig. 97). Paul Klee has used a system of essentially straight lines, which he has fancifully embroidered into an entertaining complexity of pattern and texture (Fig. 204); Ivan Majdrakoff has chosen curvilinear patterns (Fig. 205).

Project 106 Approach this assignment as if you were doodling with pen and ink. Using dots and lines, begin to invent patterns, letting them evolve into an imaginary landscape.

Van Gogh used pattern extensively in his drawings (Fig. 195). Although often decorative in character, it functioned descriptively as well as to impart vitality to the drawings. In *The Survivor* by George Grosz (Fig. 206), a rich array of texture patterns has been employed both to characterize form and surfaces and for expressive effects. The patterns reveal many varied uses of the pen, and some textures appear to result from pressing fabrics or other materials dampened with ink against the paper.

below: 204. Paul Klee
(1879–1940; Swiss-German).
A Garden for Orpheus.
1926. Pen and ink,
18¼ × 12½'' (47 × 32 cm).
Paul Klee-Stiftung,
Kunstmuseum Bern.

below right: 205. Ivan Majdrakoff
(b. 1927, American).
Head. 1961 Pen and ink,
10 × 7'' (25 × 18 cm).
Collection Mrs. Daniel Mendelowitz,
Stanford, Calif.

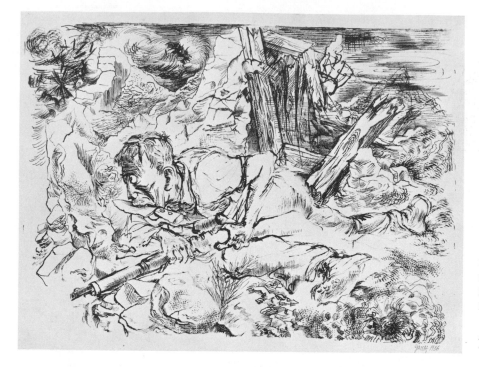

206. George Grosz
(1893–1959; German-American).
The Survivor. 1936.
Pen and India ink,
19 × 24¾″ (49 × 63 cm).
Art Institute of Chicago (gift of
The Print and Drawing Club).

Project 107 Continuing to work with pen and ink, develop a drawing in which you introduce textural patterns for descriptive or expressive purposes. Textures can be suggested rather than being meticulously rendered. While some hatching and cross-hatching is inevitable, incorporate as many different linear patterns as possible. Rocks, brambles, weeds, weathered wood, a derelict automobile in a field offer interesting surfaces and textures.

Pen, Brush, and Ink

Pen and ink, amplified by brush, provides an obvious transition from pure pen-and-ink to brush-and-ink drawing. Brush strokes logically facilitate the production of extended areas of dark and lines of greater width than can be obtained with the relatively less-pliant pen nib (Fig. 207).

Project 108 Select a subject with bold contrasts of dark and light—perhaps a self-portrait illuminated by strong light from one side—and develop it in pen outlines and brushed ink masses, using both tools to create the transitional values and textures.

Brush and Ink

The narrowness of line produced by a pen point gives it its bite and energy and at the same time limits its degree of flexibility and painterliness. When artists wish to expand the scope of line, they pick up a brush, which encourages the expansion of line width and thereby promotes an eloquence and richness that a pen line lacks. A page of sketches by Vuillard (Fig. 208) reveals an unpretentious but expressive use of a small pointed brush dipped in India ink. While the line exhibits greater flexibility than an ordinary pen line, it still lacks the linear strength and bold masses of dark and light we normally associate with brush and ink (Figs. 209, 91).

All kinds of brushes can be used with ink, and each brush imparts its particular character to a drawing (Fig. 193). The long, very pointed Japanese brush, for

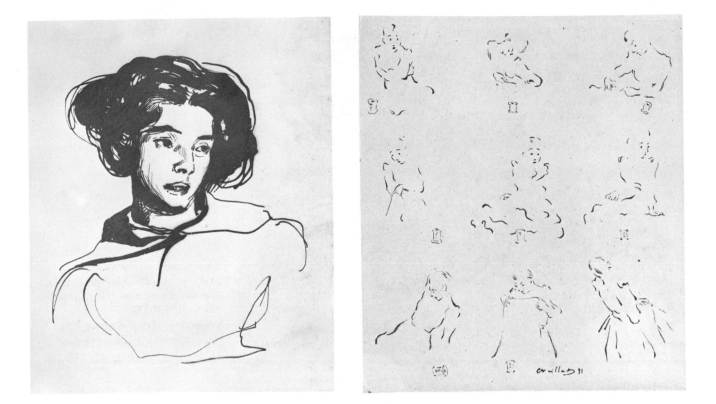

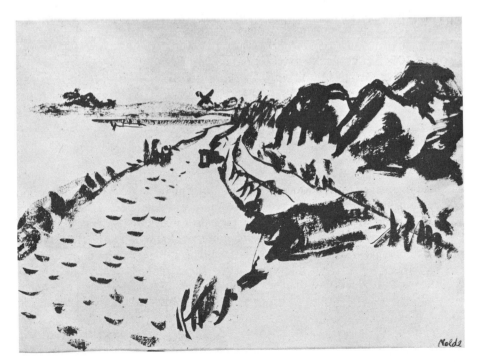

above: 207. Eugène Delacroix
(1798–1863; French).
Madame Pierret.
Pen, brush, and ink;
8¾ × 7¼'' (22 × 20 cm).
Louvre, Paris.

above right: 208. Edouard Vuillard
(1868–1940; French).
Young Seamstress. 1891.
Brush and ink,
14 × 11⅞'' (36 × 31 cm).
Stanford University
Museum of Art, Calif.
(Mortimer C. Leventritt Fund).

right: 209. Emil Nolde
(1867–1956; German).
Landscape with Windmill.
Brush and black printer's ink
on tan paper,
17½ × 23¼'' (44 × 59 cm).
Private collection.

instance, is most responsive to pressures of the hand and so creates lines of unusually varied widths (Fig. 210). A stiff bristle brush for oil painting produces brusque, angular lines, often with heavily dry-brushed edges (Fig. 209). Chisel-shaped lettering brushes draw lines with abrupt differentiations in width, depending upon whether the narrow or wide edge of the brush touches the paper. Frequent and thorough rinsing of brushes, as well as careful storage (especially important so that brush fibers maintain their proper shape) ensures continued

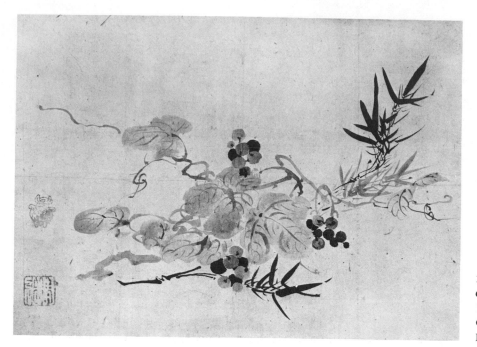

210. Sesson (1504–1589?; Japanese).
Grapes and Bamboo. Ink on paper,
12½ × 17½'' (32 × 44 cm).
Collection Kurt and Millie Gitter,
New Orleans.

quality and dependability of the materials. To facilitate impromptu sketching with brush and ink without the awkwardness of carrying a bottle of ink at all times, manufacturers have produced a brush designed like a fountain pen with an ink cartridge and cap. Its tapered point offers much of the flexibility of a Japanese brush.

Papers also have much to do with the quality of line in brush-and-ink drawing (see pp. 134–135). Soft, absorbent papers like rice paper or blotting paper soak up ink the moment the brush touches them and so create lines that vary considerably in width and the character of the edge (Fig. 211). Hard-surfaced papers, on the other hand, absorb a minimum of ink from the brush, and this contrib-

211. Bunchō Tani
(1763–1842; Japanese).
Fishing in the Melting Mountain.
1818. Brush and ink,
11 × 9⅞'' (28 × 25 cm).
British Museum, London
(reproduced by courtesy
of the Trustees).

Drawing Media

166

utes to continuity of line and clean-cut edges (Fig. 91). A dry-brush effect inevitably occurs when a very rough textured paper is used; conversely, it is almost impossible to achieve an interesting dry-brush quality on very smooth paper.

Other media than ink can serve for brush drawings. Black watercolor, tempera, poster paints, and oils are all good possibilities; the color opacity and viscosity of the media determine their applicability to certain situations. Many experienced painters like to draw with the tools and materials they use for painting, since this practice facilitates developing a drawing into a painting. In such cases, it becomes impossible to tell when drawing ceases and painting begins (Fig. 5).

Project 109 Explore the use of brush and ink, using whatever brushes you have available, including small inexpensive household paint brushes. Work on papers of different textures.

Oriental Calligraphy

Among the most sophisticated and beautiful brush-and-ink drawings are those of the Oriental masters (Figs. 210, 211). The brush is as commonplace in the Orient as the pen is in Western cultures. There has always been a particularly close connection between the art of writing and drawing in China and Japan, since the techniques involved in manipulating the brush are the same; and in both, the ornamental character of the line produced by skillful brush handling has been highly prized. Long years of copying the works of acknowledged masters and learning the exact strokes of a conventional artistic vocabulary constituted an arduous apprenticeship for the Oriental artist. In the drawings of such masters as Hokusai, one is aware of the pure virtuosity of technique and decorative charm (Fig. 212).

Most Oriental brush masters employ *sumi,* a stick of carbon ink that is ground and mixed with water on a shallow stone or ceramic block (Fig. 193). This procedure permits great control over the density of tones. The brush itself is held in a vertical position above a flat ground, neither hand nor wrist being

212. Hokusai (1760–1849; Japanese). *Ebisu Seated.* Brush and ink, with pentimento at top; 15¾ × 10¾'' (40 × 27 cm). British Museum, London (reproduced by courtesy of the Trustees).

allowed to touch the paper or table support. By raising and lowering the hand and loading the brush in different ways—using the side or the tip alone, or combining heavy black ink in the tip with very thin, watery ink in the body of the brush—the artist can regulate an extensive repertoire of strokes. Since the traditional rice paper and silk fabric grounds are very absorbent, lines cannot be altered or deleted, and a skilled craftsman never repeats a line.

Project 110 *A good-quality watercolor brush, blotter or rice paper, regular India ink, and a saucer and water provide substitutes for the standard materials of Oriental calligraphy for those students wishing to explore the technique without purchasing special equipment. For an initial exercise, study Figure 210 to gain a sense of the hand and brush movements and the changes in pressure required for each stroke. Practice one stroke at a time rather than attempting to copy the complete painting.*

Wash Drawing

A wash drawing stands halfway between drawing and painting, and, in fact, often serves as a preliminary value study for a painting. Unlike brush-and-ink drawing, which depends for its effectiveness on a more-or-less solid black contrasting with white, in wash drawing the medium is freely diluted with water for a wide range of grays. Both the brush and the diluted medium are extremely flexible vehicles; they encourage an unusually fluid play of lines, values, and textures (Figs. 213 to 215). Wash has long been a popular drawing medium, especially in periods when painterly effects were highly valued.

"Wash" commonly refers to black ink or watercolor that has been thinned with water to various value gradations. It can also encompass water and tempera, gouache, or acrylics, although these media tend to be less fine-grained than ink or watercolor. Stretching the term still further, "wash" can include oil paints thinned with turpentine. Whatever the pigment, it is the principle of dilution that characterizes wash drawing.

Many students find wash to be an instructive transition from drawing to painting. The equipment needed is modest: brush, ink, black watercolor or tempera, and a not-too-thin, absorbent paper. Because regular watercolor paper of a good quality and illustration board will not wrinkle or buckle when wet, they present satisfactory grounds for wash. Illustration board can be thumbtacked to your drawing board; watercolor paper is best mounted. To mount or stretch watercolor paper, wet it thoroughly on both sides, lay it on the drawing board for about five minutes or until the water has been absorbed, smooth it out slightly, and fasten the edges with paper (not masking) tape. Allow the paper to dry completely so that the buckling disappears. In addition to the equipment and materials already indicated, you will need a quantity of clean water and absorbent rags. A natural sponge will prove helpful for wetting the paper or for picking up areas of the wash that appear too saturated. A white saucer, plate, or watercolor palette can serve as a container in which to mix your pigment.

Flat Washes

Project 111 *While the medium encourages free, spontaneous handling, a rather cautious and systematic procedure is best for those with no experience in wash or watercolor. For your first wash drawing, select a subject with clearly defined planes of dark and light. If you have any sketches or drawings of buildings, they would be appropriate, as would the by-now-familiar cardboard boxes and paper bags. Keep to a modest size, no more than 8 by 10 inches. Make a firm preliminary outline drawing. Plan the distribution of values, leaving pure white paper for the lightest areas. Place a couple of tablespoons of water in your saucer*

or palette, adding enough ink or paint to make a light gray. Load your brush with this tone and spread it over all the drawing except those areas to be left white. When this first application has dried, apply a second wash of gray to the next darkest areas; continue in this manner until you have built up your deepest tones. As you progress toward the darks, intensifying your gray puddle with more pigment will allow you to achieve deep tones more rapidly. Never try to lay a wash over a partially dry surface, for this produces an ugly mottled result.

Modulated Areas: Wash with Other Media

Wash is particularly suitable for free, fluid effects. Whether applied directly to paper without preliminary drawing (Pl. 6, p. 221), or combined with pencil, pen and ink (Figs. 213, 214), charcoal, or chalk, wash reveals a distinctively casual air. When blending wash with other media, it is the artist's option whether the wash precedes or follows the pencil, pen, or charcoal lines. The artist can also control the amount and strength of linear elements in a wash drawing.

Canaletto (Fig. 213) used a systematic application of simple washes to introduce atmospheric effects of light to a pen sketch. Honoré Daumier (Fig. 214), working over what appears to be preliminary charcoal lines, produced an imposing sense of volume by integrating loosely drawn ink contour lines with boldly brushed washes, while Käthe Kollwitz (Fig. 215) relied almost completely on a more painterly wash technique, introducing pen line only to detail the forms and features of the two heads.

Project 112 To develop a painterly approach to wash drawing, mix a fair-sized puddle of middle-value gray in your palette. Proceed to paint, adding water to your middle-value gray when you want lighter tones and concentrated pigment to yield darker tones. Do not try for flat washes or smooth effects; permit brush strokes and gradations of value to show. Work into the washes only while they are still fresh; once the washes have begun to dry, allow them to become completely dry before you introduce additional washes. While an area is still wet, it is possible to recover lights by rinsing your brush in clean water, pressing all the water from the brush with your fingers or paint rag, and lifting out the desired light with the damp brush. For clearly defined edges, apply wash to a dry surface;

213. Canaletto (1697–1768; Italian).
An Island in the Lagoon
Pen and brown ink, with carbon ink wash over ruled pencil lines; 7⅞ × 11″ (20 × 28 cm).
Ashmolean Museum, Oxford.

left: 214. Honoré Daumier (1808–1879; French).
Two Peasants in Conversation.
Pen and wash.
Victoria & Albert Museum, London
(Crown Copyright).

below: 215. Käthe Kollwitz
(1867–1945; German).
Mother and Child by Lamplight at the Table
(self-portrait with son, Hans?). 1894.
Pen and ink with brush and wash,
8 × 10⅝″ (21 × 27 cm).
Courtesy Deutsche Fotothek Dresden.

Drawing Media

216. Paul Klee
(1879–1940; Swiss-German).
Canal Docks. 1910. Pen and ink
over hard pencil, with wash;
3 × 9⅞″ (8 × 25 cm).
Albertina, Vienna.

for softened contours, wet the paper with clear water and apply the wash to the wet surface.

After experimenting freely with this technique, select a subject that lends itself to a more fluid handling of form. Choosing a subject already drawn in an earlier project allows you not only to work with familiar forms, but also offers you the opportunity to see clearly the differences that occur in treating the same subject in dissimilar media.

Project 113 An interesting variation of traditional wash drawing is to draw with ink or concentrated paint on wet paper. The unpredictable runs, blobs, and granular deposits create textures and lines quite unlike the limpid fluidity of typical wash drawing. An unusual drawing by Klee looks as though the ink lines were drawn first with a pen, and, while wet, touched with a water brush (Fig. 216). In this way, the artist managed to control the direction and extent of the ink spread. Experiment with the methods described here for altering the character of ink line drawings.

Project 114 Colored wash reinforced by colored inks, pencils, chalks, and other tinted media offers an excellent vehicle by which students can make the transition to painting. It would be prudent to limit selection to two colors for your initial experiences—brown as a warm color, French ultramarine blue as a cool color. Applying a wash of one color over the other, or allowing the colors to blend will create a range of colors. Do a number of drawings calling forth various wash and line techniques.

Mixed Media

Some artists are purists by temperament and take the limitations of a medium as a challenge. They delight in bending the medium to their respective aesthetic wills and making it do what seems impossible. Jean Auguste Dominique Ingres accomplished this with pencil (Figs. 4, 185, 305) and Charles Sheeler with conté crayon (Figs. 103, 177, 222). Other artists care only to achieve a certain effect and they freely combine media to realize their goals. Many drawings of old and modern masters have developed through improvisation with media. Such drawings frequently were begun in an exploratory medium, perhaps charcoal or chalk. At a later stage, wash or ink may have been added to intensify the darks and, subsequently, white tempera or chalk introduced to strengthen the lights— perhaps even a small amount of colored chalks added to provide a final enrichment. Freedom and invention in the use and combinations of materials, in the hands of an imaginative person, take on fresh and original dimensions.

Wet Media

171

217. Henry Moore (b. 1898; English).
Four Family Groups. 1944.
Pencil, crayon, and watercolor;
9 × 6¾'' (23 × 17 cm).
Courtesy the artist.

Project 115 Experiment using familiar media in unfamiliar ways and in different combinations. Ink drawn or brushed into charcoal and chalk drawings to provide dark accents, adds richness and depth. Although not mentioned in Chapter 9, it is possible to produce wash effects with all of the dry media. Charcoal, conté crayon, and chalk are soluble either with water or turpentine; graphite, wax crayons, and oil pastels dissolve only from turpentine or some other solvent. Because wax crayons and oil pastels are water resistant, interesting qualities result when overlaid with ink wash (Fig. 217). Also investigate different and unusual drawing implements. Try making line drawings using a cluster of bamboo skewers rather than the customary pen or brush. Create texture, build values, and model forms using a small piece of heavily textured cloth, such as corduroy, rolled into a compact ball, which is dampened with ink and pressed against the paper. Try out any other schemes that occur to you. Some will be worth developing, others you will recognize as entertaining gimmicks. While it is essential that you maintain a sense of playfulness and a willingness to explore media and techniques, it is equally important that you refine your ability to discriminate, and reject that which is gimmickry.

Part Five
Traditional Areas of Subject Matter

11 Still Life

11 Still Life

From earliest times artists have been intrigued with the myriad forms and surfaces that surround us and have taken great pleasure in rendering them. An artist in ancient Greece prided himself on the ability to paint fruits so convincingly that birds would peck at them. A 1st-century Greco-Roman wall painting from Herculaneum (Fig. 218) lends credence to the legend. With comparable enthusiasm, artists of 15th-century Flanders reveled in the skill with which they could depict glass, ceramics, fabrics, wood, fruits, and flowers. Throughout the Renaissance and Baroque periods artists repeatedly drew upon still-life materials to create an atmosphere of everyday reality in their works. The emergence of a bourgeois society in the 17th century, with its glorification of middle class values, made the portrayal of material wealth a major thematic concern. In Flanders, especially, artists depicted tables laden with fruit, vegetables, fish, poultry, and meat in what to our more health-conscious age seems a gluttonous display. The Dutch masters of the period added flowers to their repertoire, painting prodigious arrangements complete with sparkling drops of dew and an occasional insect. Still-life subjects continued to be popular with early-19th-century American painters, who patterned their works after Dutch precedents. The late-19th-century American *trompe l'oeil* artists, most notably William Michael Harnett and John Peto, originated a brilliant style of still-life painting employing very shallow space, clearly defined cast shadows, and a meticulous rendering of surface textures (Fig. 219).

Unfortunately, preparatory drawings by masters working in the still-life tradition are extremely scarce (Fig. 220). Perhaps these artists were, for the most part, sufficiently assured to approach the task of painting without benefit of the preliminary studies that customarily preceded religious, mythological, and genre works—studies that constitute our body of master drawings. Thus, despite the long popularity of still life and the fascinating solutions devised over the years to problems of composition, we must restrict our discussion largely to 20th-century examples.

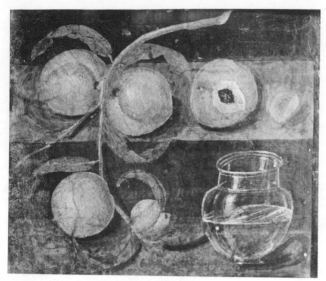

above: 218. *Peaches and Glass Jar.*
Wall painting from Herculaneum. A.D. c. 50.
Fresco, 13½ × 14″ (34 × 36 cm).
Museo Nazionale, Naples.

right: 219. William Michael Harnett
(1814–1892; American).
Old Models. 1892.
Oil on canvas, 4′6″ × 2′4″ (1.37 × .71 m).
Museum of Fine Arts, Boston
(Charles Henry Hayden Fund).

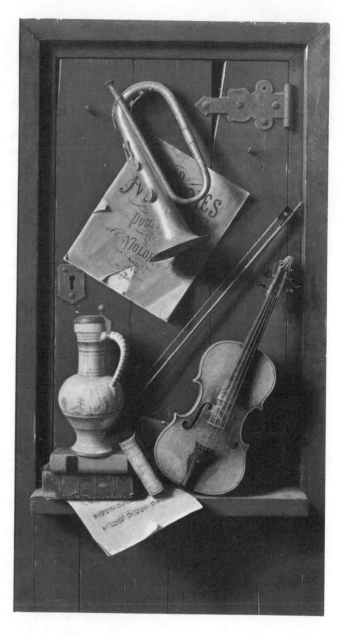

right: 220. Abraham Bloemaert
(1564–1651; Dutch).
Studies of Garden Plants.
Pen and ink, 11⅜ × 14⅞″ (29 × 38 cm).
Ecole Nationale Supérieure
des Beaux-Arts, Paris.

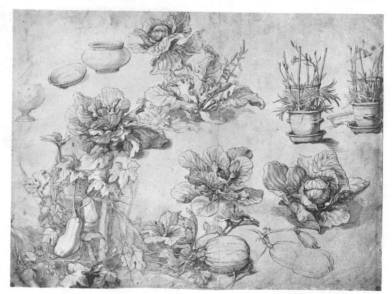

Traditional Areas of Subject Matter

Advantages of Still Life

Still-life drawing presents a number of advantages, which have determined the preponderance of still-life subjects suggested in the preceding projects. Working in a quiet studio, and usually alone, the artist is free from many of the problems that accompany portraiture, life drawing, and landscape drawing. There is no need to schedule sittings with life-drawing models or portrait subjects. The artist can ignore the caprices of weather and work uninhibited by wind, rain, changes in sunshine and shadow patterns, and all the other unpredictables that go with working out of doors. And the studio demands for the still-life artist are minimal; any quiet room with good light, whether natural or artificial, will serve.

For the novice, still life has yet another advantage. The subject, as the name clearly indicates, does not move. Thus, the beginning student has ample time to observe and learn to portray the tremendous variety of surface qualities that characterize all objects, to learn to see, as it were, and to develop the skills involved in depicting the appearances of what is seen. The rendering of form, light and shadow, texture, color, and such subtle phenomena as lustre and transparency can all be attempted at an unhurried pace. Problems of perspective and foreshortening, both elementary and complex, will arise, and these problems can be worked on at the student's leisure. If the arrangement is placed where it need not be moved for some time, and if the subject is not susceptible to withering or decay (an old boot, for instance, in contrast to fruit or flowers), the student can experiment in as many media as desired.

Finally, still life involves little expense. Every home is filled with potential still-life subjects. One need only glance at the illustrations in this section to see that anything from old clothing to edibles, from tableware to cooking utensils, from musical instruments to books, even sections of rooms and furniture, can serve as subject matter. A simple carton of eggs, for example, can provide an excellent subject for the artist with imaginative vision and a sense of composition (Fig. 221); for it is the sympathetic observation of familiar objects, accompanied by the capacity to project these observations into arresting and revealing works of art, that characterizes the true still-life artist.

Project 116 *Select a few ordinary and familiar, nonperishable household items; ideal subjects will have large, clearly differentiated forms. Arrange the chosen objects. An interesting composition need not be complicated nor even "artistic"; learn to recognize and use what can be called "ready-made compositions," those*

221. Mark Adams
(b. 1925; American).
Box of Eggs. 1968.
Pencil, 13¼ × 16¼" (34 × 41 cm).
Courtesy the artist.

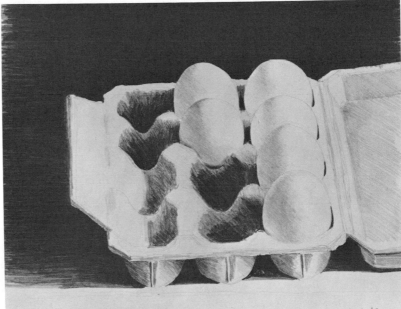

spontaneous and natural groupings of objects discovered just where they were placed as part of daily routine. Sometimes you will see only clutter; just as often you will find an appropriate arrangement. What you must have is a change in perception about what one draws, a change that permits you to accept an egg carton, a towel thrown over the back of a kitchen chair (Fig. 180), or a cluster of cooking ware as objects of visual interest. Once the objects have been selected and arranged, if that be necessary, proceed to draw, using whichever of the media and techniques fit the subject and your mood. Draw just slightly smaller than life size, concentrating upon portraying form and textures. Needless to say, good light is essential—the ideal light comes from above and to one side. Daylight has no particular advantage over artificial light, as long as the artificial light is brilliant (Fig. 221). High-intensity reading lamps work well because of their flexible design. Your drawing board must also be well lighted. It is equally important that one draw in a relaxed position, seated in a comfortable chair at a table of the right height or with your drawing propped at a workable angle. And, of course, the still-life arrangement should be set up where it can remain undisturbed for as long as it is needed. If leaving an arrangement set up presents a problem, be prudent enough to select a technique that will allow you to complete your drawing in a single session or work with a grouping of objects that can be reassembled easily with some accuracy.

Still-Life Forms

Value Study

Much early training in the 19th-century academies of art in Europe and America was devoted to the techniques of rendering forms through traditional chiaroscuro, for which still-life compositions provided ideal subjects. White plaster casts like the one illustrated in Figure 84 were favored for clear illustration of value gradations. Elements of chiaroscuro—highlights, light, shadow, core of

222. Charles Sheeler (1883–1965; American). *Of Domestic Utility*. 1933. Black conté, 25 × 19⅜'' (64 × 49 cm). Museum of Modern Art, New York (gift of Abby Aldrich Rockefeller).

the shadow, and reflected light (see pp. 62–66)—could easily be observed and analyzed on the smooth, colorless plaster surface.

Mark Adams (Fig. 221) and Charles Sheeler (Fig. 222) display an enviable virtuosity of technique and vision. Both artists have revealed form solely by value change; both have used dramatic value contrasts in some areas to define forms in space; thus imparting a sense of space in those portions where little spatial separation has been indicated, such as the overlapping eggs.

Project 117 Compose a still-life arrangement containing large, rather simple forms. If possible, all objects should be closely related in value, preferably light so that the use of chiaroscuro to define form will not be complicated by differences in color. Lemons and yellow or green apples, for example, would be better suited for this project than red apples of darker value. Illuminate the objects with a strong light from above and to one side. Place a simple background close enough behind the grouping so that shadows cast by the objects fall on the background, while the background surface reflects light back into the shadowed portions of the objects. Develop the drawing with one of the dry media. Sketch the objects in light outline to establish size and shape relationships; then proceed to model the forms in dark and light. Study the shapes of cast shadows carefully and render them as thoughtfully as you do the actual objects, paying particular notice to their degree of darkness as compared with the darkest shadow on the objects themselves. To the mature artist, all aspects of the visual experience are significant; the shadows cast by objects provide elements of pattern equal in importance to the objects.

Schematic Form

One of the basic problems in drawing is learning to create a convincing sense of solid, three-dimensional form when a solid object is translated into a series of lines, shapes, and shadings on a flat, two-dimensional sheet of paper. It is not uncommon for initial drawing assignments to be based upon simplified forms that require learning to perceive size, shape, and space relationships, using the measuring techniques described on pages 39 to 41, as well as introducing the use of chiaroscuro. Mastering such simple geometric shapes virtually assures equal success with even the most complex subjects, provided the same basic approach is followed—looking, measuring, duplicating shapes rather than drawing objects. Learning to see complex shapes schematically—reducing objects to their nearest geometric equivalents—is one of the most successful methods of understanding and representing three-dimensional form.

Project 118 Notice in Figures 221 and 222 how aware we are of the basic structure of all the objects depicted, since both artists have reduced each object to its essential structure. Set up a still life containing objects with clearly structured forms; it is not necessary, however, to select only those objects that are simple geometric shapes. Your assignment is to reveal the structural relationships of objects by simplifying them into basic geometric shapes or interrelated combinations of shapes. Intensify the sense of volume with bold chiaroscuro.

Composition and Treatment

Selecting appropriate subject matter creates one of the most persistent blocks for most beginning students, who are reluctant to relinquish the concept that what they choose to draw must be "artistic." It can truly be said that subject matter is unimportant. Throughout the history of art, significant subjects have been rendered meaningless, while seemingly meaningless subjects have been elevated to great significance. While expression remains a critical determining

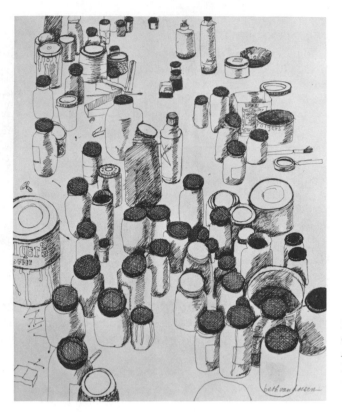

223. Beth Van Hoesen
(b. 1926; American).
Paint Jars. 1969.
Pen and ink,
9⅞ × 8'' (25 × 20 cm).
Courtesy the artist.

ingredient of significance, subject matter achieves aesthetic coherence and interest through the artist's sense of composition or viewpoint and the chosen method of treatment. The elements of still life—fruits and vegetables, pots, plates, bowls, flowers, and so on—all relatively unimportant subjects, can become vitalized by imaginative vision.

Beth Van Hoesen's original viewpoint is evidenced by both her ability to see the potentialities of unpretentious and familiar objects and her capacity to project them into arresting forms and patterns. *Paint Jars* (Fig. 223) transmutes studio litter into a rhythmic flow of jars and jar tops, interrupted by an occasional contrasting shape. Using an open composition in which forms are cropped by all four edges of the drawing allows the viewer to envision paint jars extending across a limitless table top.

224. Giorgio Morandi
(1890–1964; Italian).
Large Still Life with Lamp at Right.
1928. Etching on copper,
9⅞ × 13⅝'' (25 × 35 cm).
Private collection, Milan.
Reprinted from *L'Opere Grafica
di Giorgio Morandi,*
by Lamberto Vitali.
Published by Giulio Einaudi
Editore, Turin.

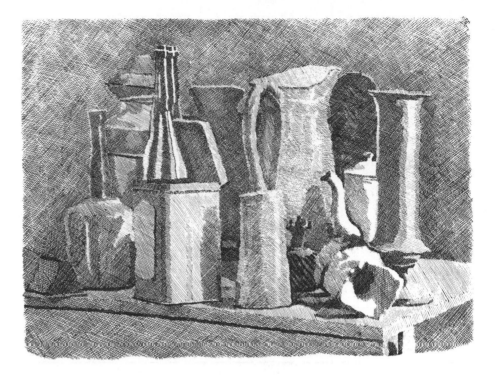

225. Giorgio Morandi
(1890–1964; Italian).
Large Still Life with Coffeepot.
1933. Etching on copper,
11½ × 15¼″ (30 × 39 cm).
Private collection, Milan.
Reprinted from *L'Opere Grafica
di Giorgio Morandi,*
by Lamberto Vitali.
Published by Giulio Einaudi
Editore, Turin.

Project 119 It is difficult to arrange objects as casually as we lay them down when we use them (Fig. 134). If your drawing materials are sitting out, draw them just as you see them, or grab a handful of household tools and lay them down without consciously making an arrangement. Rather than rendering the articles carefully, strive for the incisive vigor that distinguishes Figure 223.

A study of the works of Giorgio Morandi reveals the harmony and sensitivity with which he was able to rearrange the same objects over and over again (Figs. 224, 225). The viewer soon develops a familiarity with Morandi's bottles, pitchers, tin boxes, and canisters, which, each time they are regrouped, appear so deceptively unarranged. The simplification of shapes and the integrity with which they are rendered lend a monumental dignity to very ordinary objects.

Project 120 Arrange several objects in close proximity so that they take on an identity as a group without losing their sense of individuality. As you draw, subordinate surface details and patterns to concentrate on volume and space. When you have completed one drawing, regroup the same objects into yet another configuration and make a second drawing. Work with different media and techniques. Explore the use of closely related values—high key and low key—to create contrasting moods (pp. 73–76).

Fresh fruit and vegetables have been a traditional stand-by for still-life artists, past and present, who have transformed what might seem to be the most trite subject into drawings of fresh and original effect. Jerome Blum produced an image of full, ripe succulence (Fig. 226) in a drawing that offers only one pear delineated with any clarity of form. The minimally descriptive, lost-and-found contours and soft shading evoke a more poetic response to Norman McLaren's *Pears* (Fig. 227), which seem not to exist in this physical reality. Ellsworth Kelly's *Apples* (Fig. 64), described by pure contour line, appear far more tangible. Mu-Ch'i individualized each fruit in his *Six Persimmons* (Fig. 228) through variations of shape, value, and technique—outline for the two at each end, solid areas of ink for the others—and through calligraphic strokes of pure black that make each stem unique. This masterpiece demonstrates the great subtlety of observation that can be attained even in a lightly abstract approach to still life.

Still Life

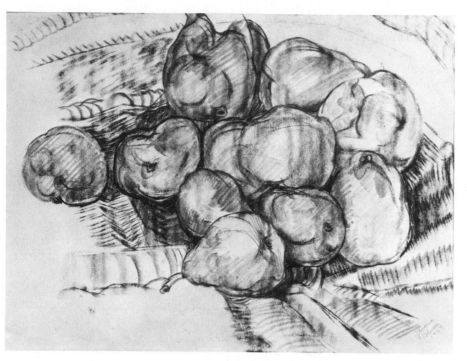

226. Jerome Blum
(1884–1956; American).
Fruit. 1924.
Charcoal and pastel on rice paper,
12½ × 16½'' (32 × 42 cm).
University of Michigan
Museum of Art, Ann Arbor
(gift of Mrs. Florence L. Stol).

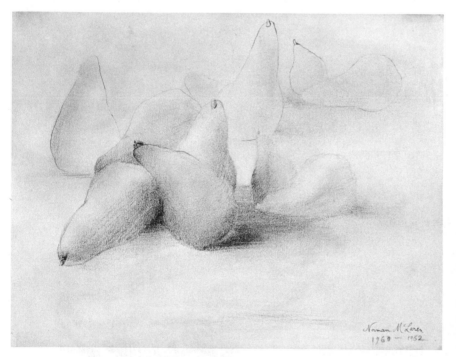

227. Norman McLaren
(b. 1914; Scottish-Canadian).
Pears. 1960–62.
Pencil, 9 × 11¾'' (23 × 30 cm).
Courtesy the artist.

Project 121 Place a group of fruits and vegetables on a table without consciously arranging them in a composition. Draw the group with pure, unmodulated contour lines. Observe any deviations from perfect regularity and describe these with linear exactitude, for they characterize the individuality of each object and differentiate it from its neighbors. Do a second drawing in which you use selected linear accents to reinforce forms that have been defined first with a suggestion of modeling. Do a third drawing using any combination of media, technique, and attitude.

Attention to the surface qualities of objects—their rough or smooth texture, their shininess, their transparency—remains one of the prime concerns of many

Traditional Areas of Subject Matter

182

still-life artists. *Oliva and Turritella* by Allan Jones (Fig. 229) exploits the beauty of shell forms and the complexity of a glass surface. Subtleties of transparency, sheen, and reflection have been rendered meticulously through the admirable and skillful use of dry-brush ink. Glassware arranged on and reflected in sheets of plate glass fascinates Janet Fish as the subject for both drawings and paintings (Fig. 230). The images are depicted with exaggerated patterns executed with a crisp clarity. The artist complicated her task by working with objects partially filled with liquid to distort the shapes of forms that stand behind. A more gentle handling of reflective surfaces is evident in Walter Murch's stu. for *The Birthday* (Fig. 231). Diffused light, softened shadows, controlled use of light and dark accents, and broad areas of generalized texture combine to heighten the effect of this mixed-media drawing.

Project 122 Shine, transparency, and translucence are perhaps the most subtle and intriguing of surface qualities. Although generally thought to be difficult to draw, careful analysis of shapes, patterns, and values, divorced from any concept of what they are supposed to represent, is the key to rendering such effects (Pl. 4, p. 155). Concentrate your first efforts on a single relatively simple object—one spoon or a tin can from which the label has been removed, for example—and then proceed to more complicated subjects. Glass objects that are both reflective and transparent present one problem; highly polished metallic objects, such as a toaster, that reflect whatever is nearby, possibly including the artist, offer an even greater challenge. Analyze the quality of the surface and the nature of the reflections to determine what combination of media and technique would be most effective.

Expanded Subject Matter

While our conception of appropriate subject matter for still life is apt to be limited to small objects commonly found around the house, it can logically be extended to include large pieces of furniture and rooms (Pl. 5, p. 156), and other

below: 228. Mu-Ch'i (13th century; Chinese). *Six Persimmons.* Ink on paper, 14½ × 11¼'' (37 × 29 cm). Ryoko-in, Daitokuji, Kyoto.

below right: 229. Allan Jones (b. 1915; American). *Oliva and Turritella.* Dry brush and ink, 27⅜ × 19⅞'' (70 × 50 cm). Chrysler Museum, Norfolk, Va.

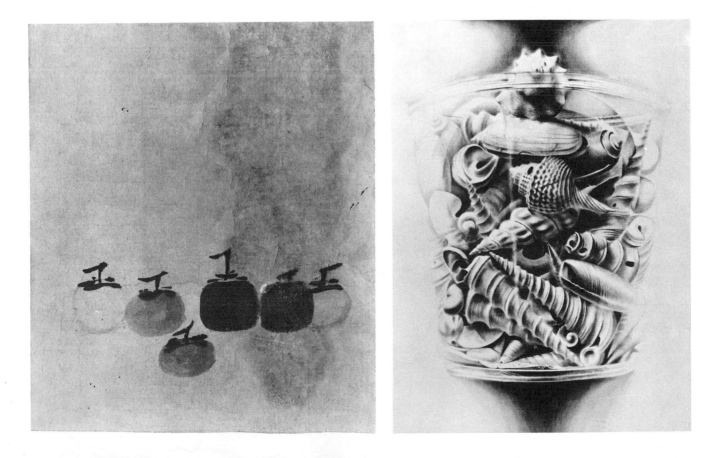

above: 230. Janet Fish
(b. 1938; American).
Rain and Dusk. 1978. Oil on canvas,
4′10″ × 7′1″ (1.47 × 2.16 m).
Private collection.

left: 231. Walter Murch
(1907–1967; Canadian).
Study for *The Birthday.* 1963.
Crayon, pencil, and wash on paper;
23 × 17½″ (58 × 44 cm).
Whitney Museum of American Art,
New York (Neysa McMein Purchase Award).

Traditional Areas of Subject Matter

inanimate or "still" things. Thus Ben Shahn's *Silent Music* (Fig. 49), which shows a group of music stands and chairs left in disarray after the musicians have departed would certainly qualify as a still-life subject. A desk with a mélange of papers and writing materials (Fig. 155) illustrates how broad is the range of interesting subject matter. Even Sheeler's *Feline Felicity* (Fig. 177) could be categorized as a still life, though certainly the cat might move at any minute.

Project 123 Without changing the position of pieces of furniture in your room, study areas through a rectangular viewfinder. Pick two or three compositions that you find appealing and sketch them in the medium of your choice. Egon Schiele's Desk (Fig. 155) and Edwin Dickinson's Studio, 46 Pearl Street, Provincetown (Fig. 104) suggest some possibilities. Deserted drawing studios with easels and drawing horses in disarray before plaster casts and still-life set-ups provide a frequently overlooked source of visual material.

Despite the presence of the figure, *Tom Ready's Store* remains in essence a still life (Fig. 232). The artist, Robert Sullins, portrayed a fascinating array of strange objects and achieved great sophistication of surface texture. The shallow space of the composition and the shabby objects included remind one of Harnett's compositions (Fig. 219), but in this work the rich texture results from the handling of the media rather than through the skillful simulation of real surfaces.

Modern Trends

Still life has a conventional sound that suggests it might be impervious to modern trends, but this is certainly not the case. Contemporary artists bring to bear the myriad possibilities of their rich heritage, both past and present, from abstraction to superrealism, on this still-vital area of subject matter (Fig. 232).

232. Robert Sullins
(b. 1926; American).
Tom Ready's Store.
Ink and pencil,
24 × 18" (61 × 46 cm).
Chrysler Museum, Norfolk, Va.

Jacques Villon departed from the initial real image to create a richly textured semiabstract *Interior,* which is elegant, fresh, and light in mood (Fig. 233). Executed in open cross-hatching, the volumes and forms play against one another in a beautiful, luminous ambience. A now-I-can-identify-it-now-I-can't ambiguity enriches the formal beauty of the design.

The Cubist movement, led by Picasso and Georges Braque, dramatically abandoned perspective as it had been practiced for nearly five hundred years. Forms previously rendered three-dimensionally were broken into a series of flat planes arranged into compositions of intricately overlapping, interlocking shapes to depict another concept of space (pp. 106–107). Braque's *Still Life with Letters* (Fig. 234) exhibits the strict organization of a true Cubist composition. In its formal arrangement, three-dimensional space has been almost obliterated except as suggested by overlapping planes. These planes carry texture patterns inspired by the grain of wood, by letters, and by a linoleum pattern; their surfaces are further enriched by charcoal and pastel lines and dots.

left: 233. Jacques Villon (1875–1963; French).
Interior. 1950. Pen and ink, 9⅛ × 6¾″ (23 × 17 cm).
Museum of Modern Art, New York
(gift of John S. Newberry Collection).

below: 234. Georges Braque (1882–1963; French).
Still Life with Letters. 1914.
Cut and pasted papers with charcoal and pastel,
20⅜ × 28¾″ (52 × 73 cm).
Museum of Modern Art, New York
(Joan and Lester Avnet Collection).

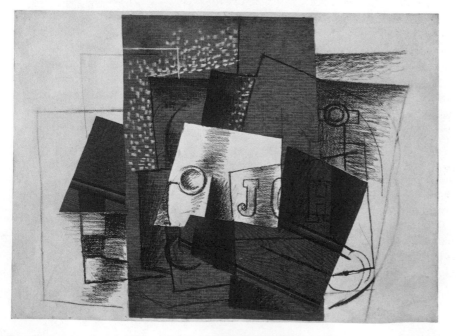

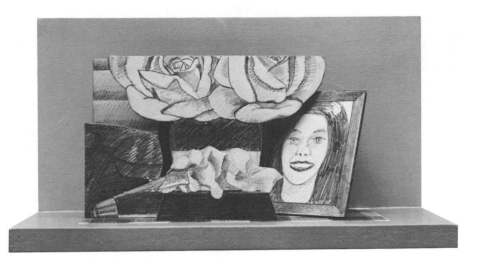

235. Tom Wesselmann
(b. 1931; American).
*Drawing Maquette
for Still Life #59.* 1972.
Pencil on Bristol board
on cardboard,
7¾ × 14 × 5⅞'' (20 × 36 × 14 cm).
Courtesy Sidney Janis Gallery,
New York.

Project 124 Study the Braque drawing (Fig. 234); also Figures 140 and 144. Try to understand the pictorial conventions that concerned the Cubists, such as the simplification of forms to a geometric essence, the flattening of space in relation to the picture plane, and the concern with pictorial composition. Review Project 56 (pp. 106–107). Select some of your more literal still lifes and in a series of rough studies, restructure space and volume without simply copying the Cubist mannerisms.

While the Cubists, at the beginning of this century, began to flatten forms that traditionally had been rendered three-dimensionally, in recent decades some artists have sought to dissolve the demarcation between two-dimensional and three-dimensional art. As the measurements of Tom Wesselmann's *Drawing Maquette for Still Life #59* (Fig. 235) indicate, the work includes a three-dimensional base. The various elements composing the still life, which are broadly rendered in pencil on separate pieces of Bristol board mounted on cardboard, have been cut out and assembled as a series of overlapping shapes on the base. Ambiguity plays an ingenious role, for the eye cannot easily discern where real space exists and where spatial illusions are created through drawn shadows.

Project 125 Collage, made popular by the early Cubists, calls for pieces of newspaper, patterned papers, and cloth, which are pasted onto canvas or other grounds; assemblage is a putting together of three-dimensional objects to make a work of art. Using collage and assemblage techniques, create a work that incorporates one of your drawings with studio equipment. As Wesselmann has done (Fig. 235), replace some of the actual implements with cut-out renderings, adding appropriate shadows for three-dimensional forms. If you can photograph your arrangement, you will be able to judge its effectiveness with greater objectivity. The photograph will by its very nature weld the two-dimensional and three-dimensional aspects of the study into a single entity.

Sketchbook Activities

Accepting still life in the broadest sense to include all the inanimate objects in your environment, you will never lack for something to draw, no matter where you are when you take out your sketchbook. Drawing any object, no matter how insignificant, involves perception, and by now you have developed a repertoire of drawing techniques so that sketches may be exploratory rather than straightforward descriptive recordings of form. Maintain a fresh outlook; reject nothing.

Landscape

12

No body of subject matter equals the landscape in diversity or surpasses it as a resource for artistic expression. When one surveys the drawing and painting of the Orient, Western Europe, and America—whether that of the past or the present—one realizes that landscape has always provided a major stimulus for artistic expression. Its potentialities are infinite; variations of weather, seasonal changes, the thrilling expanse of great stretches of distance—all contribute to the diversity. The patterns and textures revealed by close-up details are frequently breathtaking in their beauty and fascinating complexity.

A view of *The Tiber above Rome* (Pl. 6, p. 221), by the 17th-century landscapist Claude Lorrain, reveals an intense love of nature and its moods. It is one of the great wash drawings of all time, exhibiting a breathtaking virtuosity in both the handling of wash and the ability to catch a momentary late-day atmospheric effect with certainty and power. The open sweep of the Roman campagna, receding to the distant hills, is recorded in freely brushed wash strokes. In the middle distance a few towers, umbrella pines, and cypresses particularize the scene. In the foreground the gleaming surface of the Tiber reflects the heightened luminosity of the twilight sky overhead, contrasting with the velvety darks of the heavy tree masses, deep in the shadow of late day. The entire drawing is silent and reverent in tone, resonant with the artist's feeling of awe before the grandeur of nature.

In our current age, when industrialization and urbanization encroach upon the natural environment, we must expand our conception of landscape to reflect this change. Hence, our survey here can hardly be limited to the illustration of tranquil, rural scenes. We will begin with the more traditional viewpoint and, once familiar with this, explore the cityscape and, finally, the potentialities for abstract composition.

Needs of the Landscapist

It is most important for the landscape artist to be as comfortable as possible, for landscape drawing can involve many discomforts. Heat, cold, glare, wind, human and animal intruders, insects, changing lights and shadows are only a few of the problems. One of the fine 19th-century landscape artists was John Singer Sargent, also a great portrait painter. Drawing and painting from the landscape provided him with a change from the strain of official portrait commissions. Sargent was able to hire a servant to accompany him and carry a great umbrella, a solid stool and easel, and other pieces of equipment that enabled him to work in comfort.

Few of us today can afford the luxury of servants, so we have to care for our own needs. Dark glasses, gray rather than colored, will help cut the glare of bright sunshine on white paper. Some artists are perfectly comfortable seated on the ground working on drawing boards held on their laps. For others, a firm stool and lightweight but stable easel are important. A small tool kit provides a convenient carryall for pencils, charcoal, erasers, a small sketch pad, and the like. A portable lightweight drawing board is essential (the finest drawing boards are of basswood, which is smooth, almost without grain, and sufficiently soft so that paper can be thumbtacked to it without difficulty).

The most logical media for the landscapist are those that permit one to work rapidly and easily. Charcoal, colored chalks, or soft pencil help the beginner to capture the complex forms of nature and the fleeting effects of light and shadow with a minimum of difficulty. Pen and ink or brush and ink discourage erasures and changes; moreover, they are awkward to transport and handle outside the studio.

Landscape Imagery

Individual Elements

While we tend rather automatically to associate the term "landscape" with a panoramic view, artists have often chosen to focus upon a single facet of the landscape, both as a means of approaching an understanding of landscape texture and composition as a whole, and as a rich source of particularly expressive forms. The miracle that can be achieved when the simplest and most familiar scene is scrupulously rendered with complete fidelity is nowhere more apparent than in Albrecht Dürer's intimate view, *The Great Piece of Turf* (Pl. 7, p. 221). Dürer seems to have undertaken an absolutely faithful transmission of facts about his subject. Through this fidelity to nature he created a work of art whose beauty is to a large extent a reflection of the artist's humility and honesty.

A handsome study of a tree (Fig. 236), until recently attributed to Leonardo da Vinci, also reveals a loving sensitivity to detail. But while the drawing is most certainly accurate, there has been no attempt at a slavish copying of nature. One feels the selective eye of the artist noting the characterizing joints, bumps, movements, angularity of branches, and shadow accents that integrate the tree into three-dimensional space. The artist has sought to define the tree's essence through its form.

A section of a hand scroll (Fig. 237) by Li K'an, a 14th-century Chinese artist, provides for equally interesting comparison with *The Great Piece of Turf* (Pl. 7, p. 221). Li K'an's scroll shows a deft, masterful handling of the conventionalized Oriental vocabulary of brush-and-ink strokes, conveying a decorative sense quite different from the sharp photographic images of Dürer's work. Equally observant and equally skilled, the two examples might be said to represent the Western European scientific viewpoint in contrast to the Oriental aesthetic response to visual experience. Notice the gentle effect of atmospheric space that Li

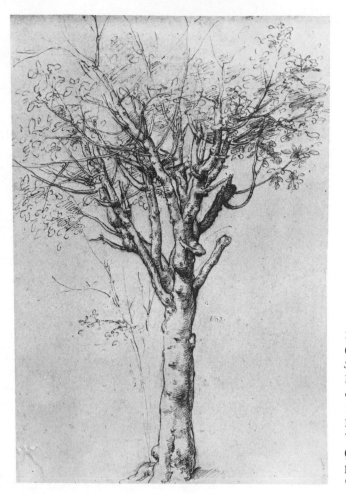

236. Cesare da Sesto
(1477–1523; Italian).
Study of a Tree.
Pen and ink over black chalk
on blue paper,
15¼ × 10⅜'' (39 × 27 cm).
Royal Library,
Windsor Castle, England
(reproduced by gracious
permission of Her Majesty
Queen Elizabeth II).

K'an has achieved through subtle gradations of value, which also prevent the leaves from appearing totally flat and decorative, in contrast to the seemingly airless environment of Dürer's *Turf*.

Project 126 Select a close-up detail from the landscape around you (Fig. 238)—a cluster of rocks, a section of foliage, the complex branching patterns that become visible when you look up into a tree from below or into the interior of a bush, the structure of a patch of wild weeds. By now you are sufficiently familiar with media and techniques to have a sense of which would permit the most effective and sympathetic interpretation of the subject you have chosen. Concentrate on the characterizing attributes of your subject and attempt to convey its uniqueness.

Sketchbook Activities

The previous exercise in direct observation of the endlessly intriguing details of nature is one that should be added to your repertoire of sketchbook subjects. Those of you who find particular satisfaction in rendering intimate details of nature might prefer to keep a separate sketchbook in which you develop more finished drawings, as suggested in the last project. As you gain confidence in your skills, a rewarding project is to create a permanent book of drawings, the book being, in effect, the complete work of art. Many handsomely bound drawing books are available, sometimes made with fine handmade papers. Folded Japanese books, designed as two separate cover pieces attached to a continuous length of accordion-folded paper, provide an interesting format.

Traditional Areas of Subject Matter

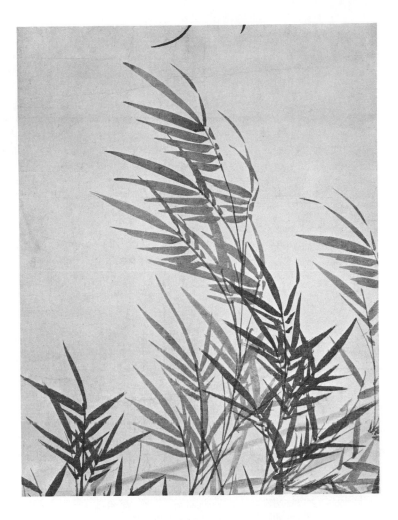

right: 237. Li K'an (1245–1320; Chinese).
Ink Bamboo, detail. 1308.
Handscroll, ink on paper;
entire work 1'2⅝'' × 7'8⅝'' (.38 × 2.38 m).
Nelson Gallery-Atkins Museum, Kansas City, Mo.

below: 238. Richard Wilson (1713–1782; English).
Study of Foliage. Black chalk heightened
with white, 11⅜ × 17⅛'' (29 × 43 cm).
National Gallery of Scotland, Edinburgh.

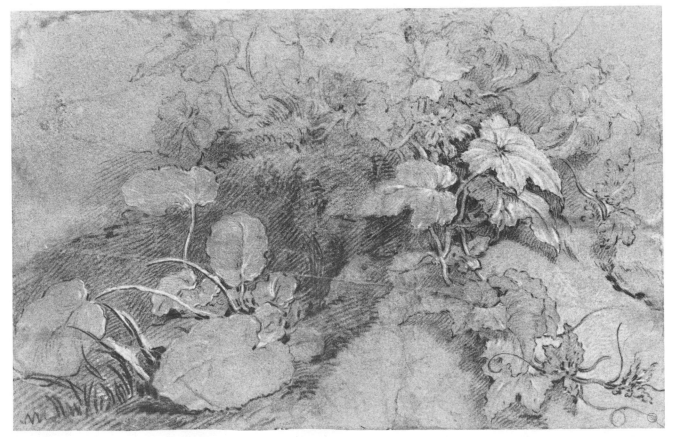

The Total Picture

How the artist perceives and treats individual elements of the landscape obviously has much to do with the overall sense of a landscape drawing. Camille Corot's study of the *Forest of Compiègne, with Seated Woman* (Fig. 239), executed in crayon and pen on white paper, reveals a most attentive consideration of the facts of nature. The slightly undulating movements of the slender trunks of trees formed by their search for sunlight as each tree moved upward over many years, the dark pattern of extended branches seen against the overhead light in contrast to the shine of an occasional branch against the distance, the deep quiet of the shadowy underbrush, the dim mottled light and feathery spurts of foliage—all are presented with a certain gravity of vision. Corot appears happy to transfer the facts of nature onto paper, as Dürer did in *The Great Piece of Turf* (Pl. 7, p. 221). The technique in which the drawing is executed is as sensitive, discreet, and controlled as the quality of the artist's vision. Nowhere does the line of the fine hatching take over at the cost of the subject.

On a somewhat grander scale, Pieter Bruegel's *Mountain Landscape with River, Village, and Castle* (Fig. 240) is extremely complex, but the artist has maintained coherence through a consistency of technique—each form is meticulously rendered by small, sharp pen strokes—and the tight interweaving of details. Darker in the foreground and lighter in the distance, Bruegel's pen lines masterfully convey the sense of deep, panoramic space. In drawing and painting this effect is defined as aerial or atmospheric perspective (see pp. 196–197).

In a magnificent work such as *Solitary Temple amid Mountain Peaks* (Fig. 241), attributed to Li Ch'eng, landscape assumes a formal elegance and refinement that is quite different from the European viewpoint already illustrated (Figs. 239, 240). The concern here is basically philosophic, and the natural environment is conceived as a great matrix against which to play the narrative of humanity. Great, mist-shrouded mountains rise in the distance behind a foreground of twisting waterways, picturesque trees, stratified rock formations, temple buildings, bridges, and figures of miniature scale. Sharp observation of individual forms rendered with skill and subtlety is part of the Chinese tradition. Li Ch'eng has masterfully coordinated these motifs, impregnating each with his own artistic personality in much the same way that a fine musician, when performing, leaves a unique imprint on an established composition.

Texture and Pattern

The textures of landscape and the patterns they compose in conjunction with the play of light have fascinated artists for centuries (Figs. 111 to 115, 118, 195). As explained in Chapter 6, the overall textural interest of a drawing derives from both the depiction of actual surface qualities in the subject and the medium employed—that is, the medium's own texture and the way in which it is applied.

In other than fully rendered drawings of individual landscape elements (Pl. 7, p. 221), as suggested in Project 126, artists most commonly rely upon suggestion rather than a detailed depiction of the textures of nature (Figs. 111 to 115). The textures of a drawing as seemingly detailed as Corot's *Forest of Compiègne* (Fig. 239) are revealed, upon closer study, to be built up of masses of hatching and cross-hatching in combination with scribbled squiggles, which give definition and character to the nearer foliage. Treated as light patterns, the lacy foliage stands out in relief against the rich dense darkness of the trees beyond. The total effect is based on suggestion.

Occasionally there occurs a near perfect blending of individual artistic temperament with the aesthetic expectations of a time and place. Mid-19th-century American landscape painters working in the Hudson River School tradition were expected to be able to draw trees so that both their species and individuality

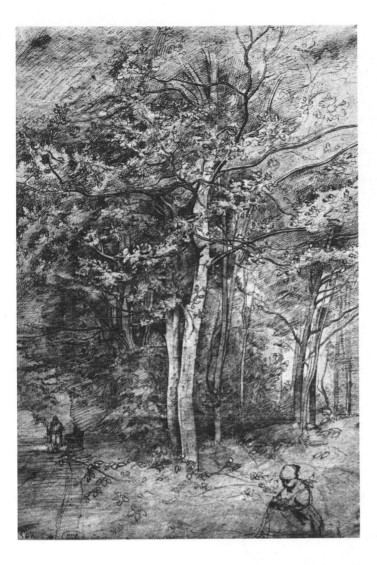

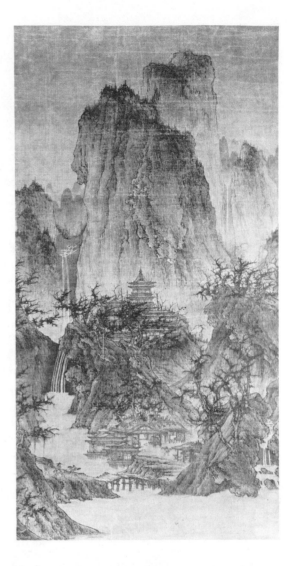

above: 239.
Jean Baptiste Camille Corot
(1796–1875; French).
The Forest of Compiègne,
with Seated Woman. c. 1840.
Crayon and pen on white paper,
15⅝ × 10½'' (40 × 27 cm).
Musée des Beaux-Arts, Lille.

right: 240.
Pieter Brueghel the Elder
(c. 1525/30–1569; Flemish).
Mountain Landscape with River,
Village, and Castle. c. 1550–60.
Pen and brown ink with brown
wash, 14⅛ × 16¾'' (36 × 43 cm).
Pierpont Morgan Library, New York.

above right: 241.
Li Ch'eng (919–967; Chinese).
Solitary Temple amid
Mountain Peaks. Hanging scroll,
ink and slight color on silk;
44 × 22'' (112 × 56 cm).
Nelson Gallery-Atkins Museum,
Kansas City, Mo. (Nelson Fund).

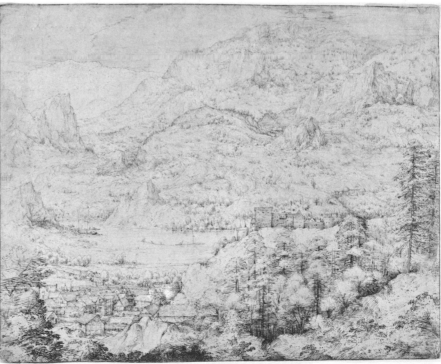

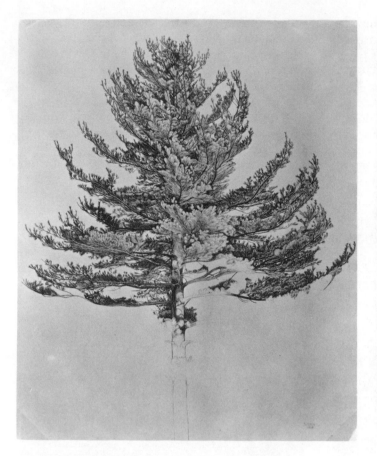

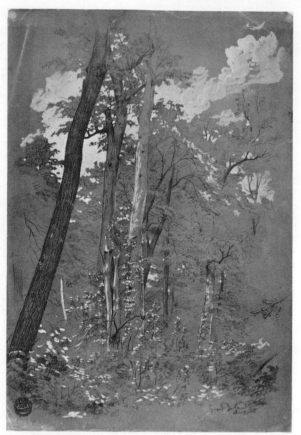

were identifiable. Charles H. Moore's *Pine Tree* (Fig. 242) more than satisfied the requirements. It is a large (slightly larger than a standard sheet of drawing paper) rendering of meticulous detail and superb draftsmanship, providing greater clarity than one would expect from a photograph. Nothing has been suggested, nothing has been generalized; media have been totally subordinated to the image. Very few artists possess the patience and stamina necessary to undertake such a rendering.

The flawless and precise rendering of landscape textures and details, evidenced in Figure 242 and Plate 7 (p. 221), contribute to an effect of almost airless space. Although less specific in textural development, Corot's drawing (Fig. 239) and those that follow (Figs. 243 to 246) are infused with a sense of light and atmosphere. The rich varied texture of *Goat Island August '58* (Fig. 243) is a matter of suggestion rather than delineation; the foreground undergrowth has been treated as penciled shorthand notation accented with scattered highlights in white gouache. Somewhat more attention, however, has been given to defining the shapes of the foliage masses silhouetted against the sky. The alternating patterns of light against dark and dark against light throughout the drawing intensify the sense of mass, space, light, and atmosphere for which Frederic E. Church was famed.

In a rare landscape study, Titian employs a broadly generalized system of slightly curved parallel lines to provide texture and form to tree trunks and ground (Fig. 244), elaborating the pen-and-ink strokes a little more to suggest the soft, sensuous fullness of the foliage. Drawn in the manner of Giorgione, to whom the drawing was earlier attributed, nature has been transformed into visually soothing poetry.

Claude Lorrain's *Study of Trees* (Fig. 245), filled with air and light, explores woodland textures in an intimate, fresh, and spontaneous style. Splotchy application of wash creates the illusion of filtered light. Sketchy pen lines reinforce the broken tones of wash to create fresh, crisp textures.

above left: 242.
Charles Herbert Moore
(1840–1930; American).
Pine Tree.
Pencil with pen and black ink,
24⅞ × 19¾" (64 × 51 cm).
Art Museum, Princeton
University, N.J. (gift of
Elizabeth Huntington Moore).

above: 243. Frederic Church
(1826–1900; American).
Goat Island August '58. 1858.
Pencil and white gouache
on brown paper,
17⅝ × 12" (45 × 30 cm).
Cooper-Hewitt Museum,
The Smithsonian Institution's
National Museum of Design,
New York.

Traditional Areas of Subject Matter

A powerful empathy with the physical world made Van Gogh feel each surface as a living thing capable of movement. An intense, tragically frustrated man, Van Gogh vented his passions in the brusque, vividly animated style of his reed pen drawings (Figs. 79, 195, 255). By contrast, in an example such as *Fountain in the Hospital Garden* (Fig. 118), using the same tools, he produced a work of lyric delicacy.

In the drypoint etching *The Storm* (Fig. 246), James Abbott McNeill Whistler used bold patterns of freely cross-hatched lines to evoke an expressive intensity as well as to capture the visual effect of gathering storm clouds. The land, trees, and grasses have been suggested in the most economical fashion, yet each line, each accent contributes to the bleakness of the scene.

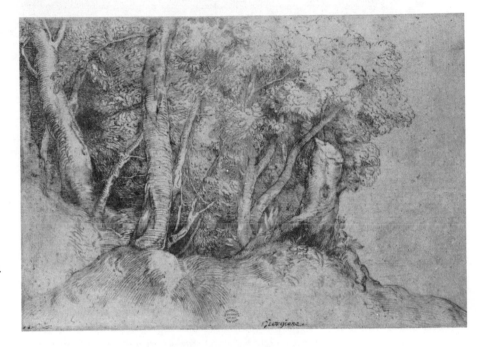

244. Titian (c. 1490–1576; Italian). *Study of Trees.* Pen and bistre, 8½ × 12½'' (22 × 32 cm). Metropolitan Museum of Art, New York (Rogers Fund, 1908).

245. Claude Lorrain (1600–1682; French). *Study of Trees.* 1635–40. Pen, brown ink, and bistre wash over traces of black chalk; 12⅛ × 8⅜'' (31 × 21 cm). British Museum, London (reproduced by courtesy of the Trustees).

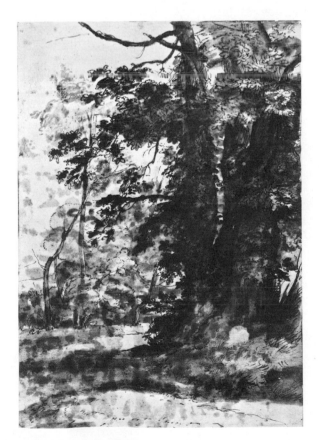

Landscape

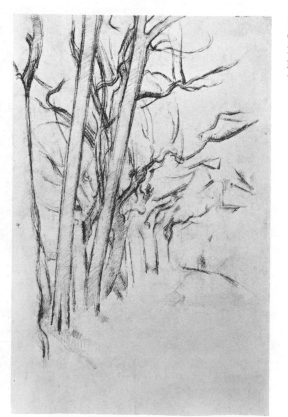

246. James Abbott McNeill Whistler
(1834–1903; American).
The Storm. Etching,
6⅛ × 11⅛'' (16 × 29 cm).
Art Institute of Chicago
(Clarence Buckingham Collection).

Project 127 *The handling of texture and pattern in landscape drawing, as evidenced in the foregoing illustrations, can be as rich and varied as the textures of landscape itself, depending upon the temperament of the artist and the effect desired. This project is an ongoing assignment. You are asked to explore, alone and in combination, the complete range of media and techniques to realize the fullest degree of expressive possibilities in the depiction of landscape. The project might well take a lifetime. The purpose is to go beyond representation, beyond manipulation and technical dexterity, to drawing with expression and feeling.*

Spatial Relationships in Landscape

The conventional linear perspective devices of converging lines, diminishing scale, and overlapping forms are often sufficient to create the illusion of space in landscape drawing (Fig. 247). Many landscape drawings and paintings display a greater degree of spatial complexity in which artists introduce the system of

247. Paul Cézanne
(1839–1906; French).
Tree and House. 1890.
Pencil, 18⅜ × 12'' (47 × 30 cm).
Whereabouts unknown.

aerial, or *atmospheric, perspective* to reinforce the illusion of depth initially mapped out by linear perspective. Atmospheric perspective is based on two observations. The first is that *contrasts of value diminish as objects recede into the distance;* lights become less light, darks less dark, until all value contrasts merge into a uniform, medium-light tone. The second is that color contrasts also diminish and gradually assume the bluish color of the air, but this change is more a concern of the painter.

Sir David Young Cameron achieved a masterful sense of luminous space in his chalk and ink drawing *The Valley* (Fig. 248) through the rather classical device of light foreground, shadowed middle plane, and light background, confining any suggestion of texture and detail to the foreground and middle ground. Using the white of the paper for both the sky and distant cliffs, with only a delicate line to separate the two areas, contributes to the amazing effect of light and space.

Two winter landscapes by Delacroix (Fig. 249) and Chen Chi (Fig. 250) illustrate similar approaches to creating atmospheric effects. Both artists have con-

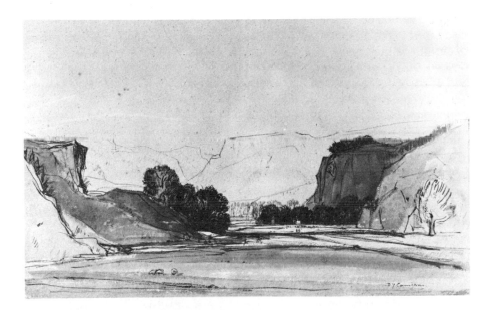

248. David Young Cameron (1865–1945; Scottish). *The Valley*. Black chalk and India ink. Victoria & Albert Museum, London (Crown Copyright).

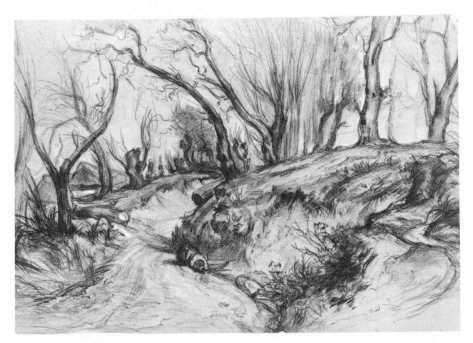

249. Eugène Delacroix (1798–1863; French). *Winter Landscape*. Black and white chalk on buff paper, 10⅜ × 15⅛″ (26 × 38 cm). Sterling and Francine Clark Art Institute, Williamstown, Mass.

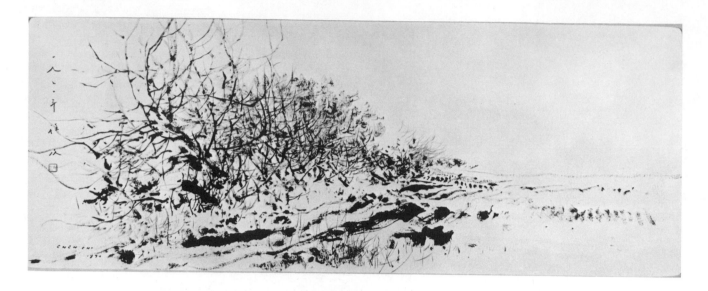

centrated stronger shapes and greater textural development in the foreground, allowing forms to soften and lighten as they recede. In Delacroix's drawing the energetic, animated foreground shapes give way to the fragile shadowy suggestion of forms in the upper right corner, while Chen Chi's textured tangled thicket diminishes toward an almost nonexistent horizon line.

250. Chen Chi (b. 1912; American). *Winter.* 1970. Chinese brush and ink, 13 × 33¾″ (33 × 86 cm). Chrysler Museum, Norfolk, Va.

Project 128 Select a landscape scene encompassing numerous levels of distance and attempt to delineate clearly a sense of deep space by diminishing the darkness and width of your lines. Remember that the boldest darks and whitest highlights occur in the foreground. As the scene moves into the distance, the light and dark contrasts merge into a neutral gray. Do a line drawing with pen and ink or with pencils of varying hardness. Next, try a brush-and-ink technique using full blacks contrasting with white paper in the front plane (Fig. 250). Charcoal, chalk, or pen and ink can serve just as well to create bold textures in the foreground to contrast with paler textures in the distance (Fig. 249).

Project 129 When first beginning to draw landscapes, artists often overlook the importance of cloud configurations. These too are subject to the laws of perspective (linear and aerial), and their representation greatly affects the overall character of a landscape scene. Do a series of skies with different cloud types—cumulus, cirrus, stratus, and so on. Rub charcoal or graphite into your paper to produce a graduated gray ground, darker at the top of the page, lighter as you near the intended horizon. Wipe out cloud patterns with a chamois or eraser. Remember to project the clouds in correct perspective. Clouds tend to appear more rounded overhead, becoming flatter and more horizontal as they near the horizon.

Cityscape

Landscape drawing need not necessarily be limited to the pastoral and rural, qualities that are indeed more and more difficult to experience. Rembrandt's beautiful *Panorama of London* (Fig. 251) gives evidence of artists' early interest in the cityscape. Richard Parkes Bonington, an early-19th-century English artist, captured the bustling ambience of an old market square in his *View of Rouen* (Fig. 182). Whereas 19th-century artists often chose to represent the picturesque charm of old or foreign cities (Fig. 124), 20th-century American artists sought to depict and give dignity to the raw intense vigor of the modern industrial city. The city—bridges, buildings, rooftops, fire escapes, streetlights, fire hydrants— became the subject, not just a background for human activity (Fig. 123).

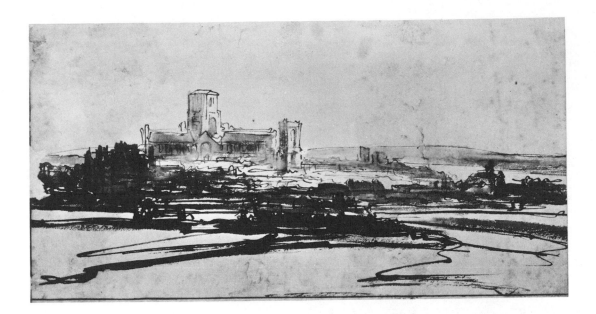

251. Rembrandt van Rijn
(1606–1669; Dutch).
Panorama of London. c. 1640.
Pen and brown ink
heightened with white,
6½ × 12½'' (16 × 32 cm).
Kupferstichkabinett,
Staatliche Museen, West Berlin.

The repetition of strong vertical shapes in contrast to the firm horizontal line across the foreground in Edward Hopper's study for *Manhattan Bridge Loop* (Fig. 252) give solidity both to his subject and his composition. The volume of the buildings is emphasized through the broad simplification of light and shadow. Hopper partially relieved the severity of the geometry and the starkness of the scene by giving prominence to the curvilinear design of the street lamp in the foreground and by utilizing the positive-negative aspects of the lamp, bridge structure, and broken roofline as they are silhouetted against the clear strong light of the sky.

Shifting patterns of smoke and smog that partly obscure distant skyscrapers combine with a greater variety of shapes and more specific detail in Henry Lee McFee's fine pencil study of city rooftops to create a sense of aliveness and vitality (Fig. 253). Using cross-hatching, McFee built value gradations of richness and subtlety that achieve the effect of light changing before the viewer's eyes.

252. Edward Hopper
(1882–1967; American). Study for
Manhattan Bridge Loop, detail.
Lithographic crayon, entire work
8⅝ × 11⅛'' (21 × 28 cm).
Addison Gallery of American Art,
Phillips Academy, Andover, Mass.
(anonymous gift).

Landscape

left: 253. Henry Lee McFee
(1886–1953; American).
The City. c. 1935.
Pencil, 20 × 14½'' (51 × 37 cm).
Addison Gallery of American Art,
Phillips Academy, Andover, Mass.

below: 254. John Constable
(1776–1837; English).
Fishing Boats at Anchor. Ink.
Victoria & Albert Museum, London
(Crown Copyright).

Traditional Areas of Subject Matter

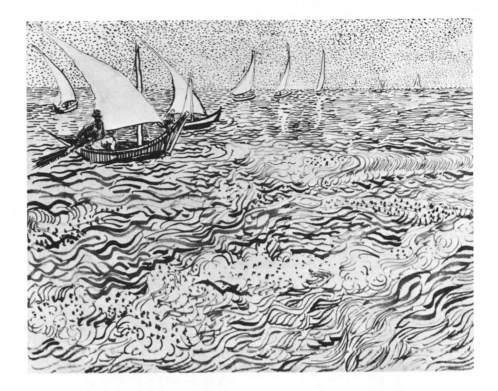

255. Vincent van Gogh
(1853–1890; Dutch-French).
Boats at Saintes-Maries. 1888.
Reed pen and ink,
9½ × 12⅝'' (24 × 32 cm).
Justin K. Thannhauser Collection,
Solomon R. Guggenheim Museum,
New York.

Project 130 While you may not have a metropolitan view outside your window, do not neglect the urban setting in your search for subject matter. If your community has not been completely transformed by urban renewal, older commercial buildlings, particularly those portions facing away from the street, provide considerable visual interest for the artist. Rooftops of older apartment buildings are always interesting, as are industrial areas. Notice patterns of light and shadow as sunlight streams across the facade of a building, and also the richness of shapes and patterns created by air vents, air conditioning units, and other hardware found on the roofs of modern buildings.

Seascape

No discussion of landscape drawing would be complete without the mention of seascape. Throughout time, water and the ocean have fascinated human beings and challenged the expressive powers of artists. All the complexities of water—its transparency and reflections (Fig. 254), its unceasing movement (Fig. 255), its colors and moods, the turbulent excitement of its surface in storms, and its capacity to yield patterns of calm repose or unsettling tension (Fig. 256)—have proved endlessly fascinating to many artists.

Abstraction

The landscape serves as a basic artistic resource even for those artists whose concerns lie in abstracting relationships of form and space. Richard Mayhew's *Nature Solitude I* (Fig. 257) maintains convincing spatial relationships—that is, one can perceive in the changes of light and dark a progression from foreground to distance. Individual forms, however, are amorphous and largely indistinguishable one from another. The dense, controlled texture of this artist's pen-and-ink technique masks what is actually a very careful observation of natural phenomena.

left: 256. Vija Celmins
(b. 1939; Latvian-American).
Untitled. 1969.
Acrylic and pencil on paper,
14½ × 19¼'' (37 × 49 cm).
Private collection.

below left: 257. Richard Mayhew
(b. 1924; American).
Nature Solitude I. 1970.
Ink, 17½ × 23½'' (44 × 60 cm).
Private collection.

In his pencil and charcoal drawing *Chas. W. Hawthorne's Garden* (Fig. 258), Edwin Dickinson, with a few bold strokes, approximated the configuration of sparse bare branches to give meaning to an otherwise undefined mass of tone. The effect is to create an evocative image that seems one moment to be strangely realistic, the next moment meaningless lines and tones.

Jean Dubuffet departed almost completely from recognizable form and space in the drawing in Figure 259. The artist fragmented the landscape into innumerable puzzle pieces, themselves cross-hatched and decorated. And yet, despite its patterned abstraction, Dubuffet's work does adhere to certain landscape conventions. One can discern a transition from land to sky, and what might be cloud patterns dot the upper left corner of the drawing.

Traditional Areas of Subject Matter

Project 131 Compare Dubuffet's landscape (Fig. 259) with Klee's highly imaginative Garden for Orpheus (Fig. 204). Notice how freely both artists have departed from a literal handling of landscape elements. Using whatever medium or technique seems appropriate, do a drawing in which you evoke a feeling of growth in nature without relying upon naturalistic or obviously symbolic representation of landscape elements. Develop a drawing that is rich in line, pattern, texture, and value.

258. Edwin Dickinson
(1891–1978; American).
Chas. W. Hawthorne's Garden. 1935.
Pencil, 14 × 10″ (36 × 25 cm).
Hirshhorn Museum and Sculpture
Garden, Smithsonian Institution,
Washington, D.C.

259. Jean Dubuffet
(b. 1901; French).
Landscape with Jellied Sky.
1952. Pen and India ink,
19¾ × 25¾″ (50 × 65 cm).
Courtesy Pierre Matisse Gallery,
New York.

Figure
Drawing

The forms depicted in the earliest drawings were animals; the walls of Paleo-
lithic, or Old Stone Age, caves abounded with images of bison, bulls, horses, and
deer. Painted images of the human figure rarely appeared in prehistoric cave art.
When included, the figure was depicted as a crudely simplified symbol com-
pared to the extraordinarily realistic rendering of the animal forms. Neolithic, or
New Stone Age, artists, as suggested by the evidence that survives, were more
interested in pattern than in representational art. Schematic and formalized rep-
resentation of the human figure appeared only as an aspect of decorative motifs.
As the early civilizations evolved, the human figure came to be represented
according to severely stylized conventions dictated by concepts of life and reli-
gion. Figures in Egyptian art, based on conceptual images rather than on direct
observation, combined profile and frontal views into the same image (Fig. 260);
differences in scale designated degree of importance rather than spatial relation-
ships. Later, Greek and Roman artists developed remarkable skill in depicting
the extremely difficult and complex form of the human body. Gradually they
mastered the proportional relationship of parts, principles of foreshortening,
and visual sophistication in this demanding art (Fig. 261).

Anatomical Drawings

In the years of the European Renaissance, artistic activity and scientific inquiry
went hand in hand, since both pursuits represented an attempt to expand the
fields of knowledge and come to an understanding of natural phenomena and
their interrelationships. Amid the Renaissance atmosphere of expanded intellec-

tual curiosity about the nature of the physical world—and in particular the
human organism—an increased concern with the structure underlying the sur-
face features permeated the artistic community. By the late 15th century, the
study of anatomy—entailing the dissection of cadavers and consequent analyses
of bones, muscles, tendons, nerves, and the functioning of these various parts—
had begun to command the serious, though clandestine, attention of artists.
Raphael's study is evidenced in a preliminary sketch entitled *The Virgin Sup-
ported by the Holy Women* (Fig. 262), where the skeletal forms project the cor-
rect disposition of the figures for subsequent more fully developed drawings.

Only meticulous study of anatomy with the resultant understanding of the forms of muscles, bones, and tendons as they interlock and combine below the surface to create projections and hollows could have made possible the superhuman figures with which Michelangelo peopled his world (Fig. 263). These powerful, muscled bodies—with their small heads, hands, and feet and their great torsos, thighs, and arms—are completely convincing because they are based on a profound knowledge of bone and muscle structure. The musculature clearly articulated in these drawings is less evident when one looks at a living nude figure. Nonetheless, the grandeur of Michelangelo's figures was such that they established a stylistic ideal that was perpetuated throughout the Baroque period and into modern times (Fig. 264).

Renaissance attempts to codify the proportioning of the body in the manner of the ancient Greeks departed from the newly acquired anatomical familiarity with the human body. This systematic approach to human proportions coincided with the desire to find universal relationships governing all fields. Leonardo da Vinci's famous drawing relates the male body to the perfect geometric forms of the square and the circle (Fig. 265). A figure of idealized proportions, eight heads high (the normal male stands about seven heads high), is subdivided in even parts. The groin is halfway between the top of the head and the soles of the feet, the knees halfway between the groin and the feet, with other proportional divisions indicated on the arms and upper torso.

Project 132 *Study the Leonardo drawing to familiarize yourself with the main divisions of the body. Have your model take a standing pose, feet slightly apart, one arm hanging at the side and the other hand on hip. Measure optically with a drawing implement (see pp. 39–41), the distance from the chin to the crown of the head, and calculate the number of units, or "head heights," composing the*

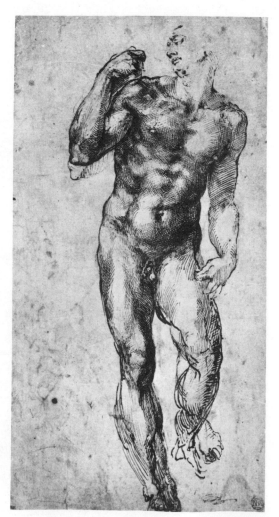

263. Michelangelo Buonarroti (1475–1564; Italian). *Figure Study.* Pen and ink. Louvre, Paris.

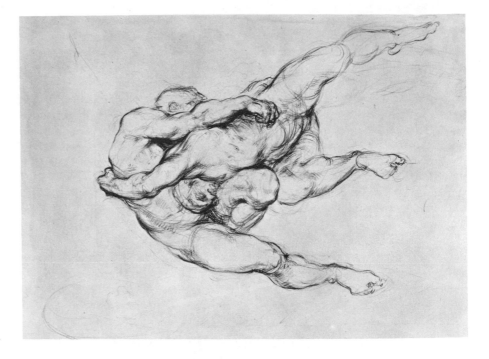

264. Hyman Bloom
(b. 1913; Latvian-American).
Wrestlers.
Black crayon and graphite,
12½ × 18¾'' (32 × 48 cm).
Fogg Art Museum, Harvard
University, Cambridge, Mass.
(purchase, Louise E. Bettens Fund).

total height of the figure. Use the unit measurement to determine as well the placement of nipples, groin, knees, elbows, and so on. Draw the figure in charcoal or soft pencil to facilitate erasures and changes. If no model is available, use a mirror in which you can see your own full-length reflection.

265. Leonardo da Vinci
(1452–1519; Italian).
*Study of Human Proportions
According to Vitruvius.*
c. 1485–90. Pen and ink,
13½ × 9¾'' (34 × 25 cm).
Accademia, Venice.

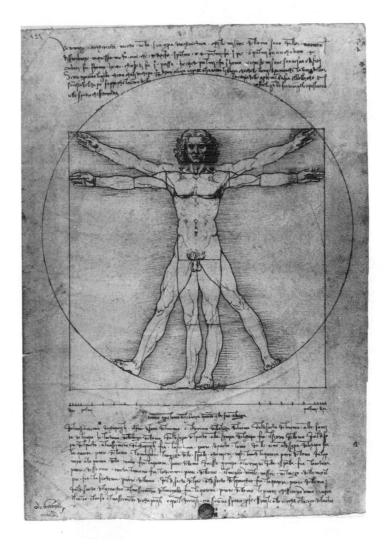

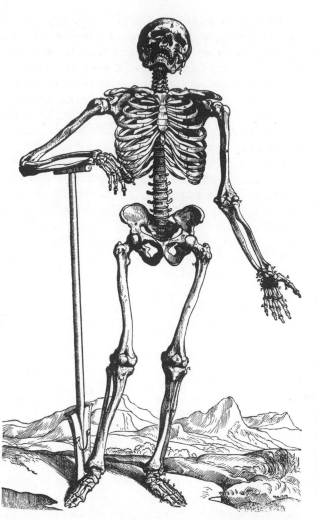

left: 266. Andreas Vesalius (1514–1564; Belgian). Anatomical drawing from *De humani corporis fabrica* (Brussels, 1543). Bayerische Staatsbibliothek, Munich.

below: 267. Jan Wandelaer (1690–1759; Dutch). Anatomical drawings from Bernhard Siegfried Albinus' *Tabulae anatomicae . . .* (London, 1747). Science and Technology Research Center, New York Public Library (Astor, Lenox and Tilden Foundations).

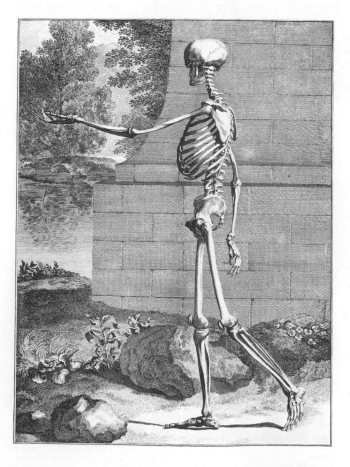

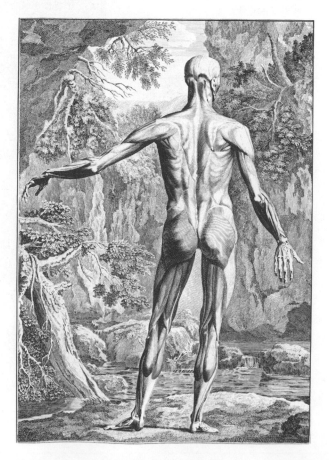

The study of anatomy remained an integral part of life-drawing classes into the 20th century and, in occasional instances, continues today. Some instructors merely assign a series of anatomy plates to be executed, while others continue to lecture on the subject, drawing diagrams on the chalkboard and pointing out on obliging models the relationship between tensed bulging muscles and the bony protrusions of the body (ribs, knees, ankles, and so forth), helping students to analyze what they see as they observe the model. Without the benefit of such instruction, you might find value in looking at one of the standard artist's anatomy books while drawing from a live model.

Anatomical drawings have frequently gone beyond the reference purposes of artists and anatomists to become artistic works in and of themselves. A comparison of an anatomical drawing published by Andreas Vesalius, a 16th-century Belgian anatomist, with those of Jan Wandelaer, an 18th-century Dutch anatomist, gives an interesting illustration of the breadth of possibility. Vesalius' drawings are handsome and informative (Fig. 266). Those of Wandelaer, however, are highly finished works whose aims far exceed straightforward communication and the needs of medical or art students (Fig. 267). The exquisite refinement of finish, the handsome backgrounds, the idealized proportioning of parts—small heads, elongated bodies, delicately tapered extremities—all are far from purely factual rendering and as such are meant to appeal instead to the collector of works of art.

Another group of anatomical studies deserves our attention for their unusual charm. In the 19th century Japanese artists became interested in European artistic concepts. A page of block prints of skeletons by Kyosai entertains us with its whimsical fantasy and humor (Fig. 268). Although the skeleton symbolizes death for many, and consequently seems a rather macabre artistic form, Kyosai found it an unparalleled vehicle for the depiction of human antics.

Project 133 Almost every art department can provide a skeleton, or a plastic replica of one, for study purposes. While it is possible to move the limbs into positions approximating those of a living figure, the skeleton is most generally seen hanging from a stand in a decidedly lifeless manner. It is useful, however, to study the skeleton or the more animated anatomical drawings of Vesalius and

268. Kawanabe Kyosai (1831–1889; Japanese). *Skeletons.* 1881. Woodcuts, each 7 × 5'' (18 × 13 cm). British Museum, London (reproduced by courtesy of the Trustees).

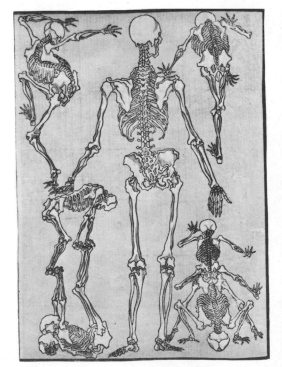
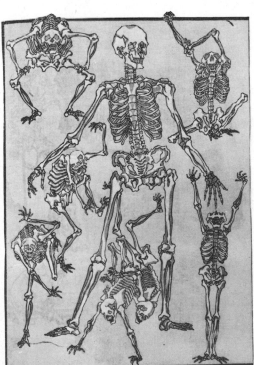

Wandelaer to become familiar with the underlying skeletal structure of the human body. Observe your own body too, noticing the directions in which you can twist, turn, and move with ease. Sense the way each shoulder can be moved independently; feel the rotation of your upper arm in the shoulder socket. Extend your arm, palm up, and then as you reverse the position of your hand, notice how the two bones of the lower arm respond.

Project 134 Probably at one time or another you have represented the human form by means of a simplified stick figure, generally rigidly angular and awkward. When drawing stick figures, most people fail to acknowledge the curvature and movement of which the spinal vertebrae are capable, nor do they take note of the width of the shoulders and the hips. Attending to those three features allows us to create lively gestural drawings of the structural core of the body in the most simplified manner, which can be elaborated into a fuller skeletal form.

Study a model or your own reflected image, or simply try to experience the movement in your body, and do a series of simplified gestural drawings as described above. Pay particular attention to the angle and rotation of the shoulders and hips and to the position of the head in relation to the placement of the feet. Notice the change that occurs in the position of the head when you shift your weight from both feet to one foot. Draw the body in a sequence of continuous movements—a perfect subject would be a person practicing T'ai Chi.

Life Drawing—The Nude Model

Drawing the human figure from a living model—*life drawing*—serves as the principal discipline whereby students acquire knowledge of and sensitivity to the intricacies of the human form. In most life drawing sessions the model starts with quick poses held for 1 to 5 minutes. These provide the student with a warming-up period. Quick sketches are best executed on newsprint paper in charcoal or very soft pencil. One or two 20-minute or 30-minute poses usually follow the quick-sketching period. These permit more fully developed drawing with some modeling of forms in dark and light masses and an indication of anatomical details. Isabel Bishop's ink-and-wash *Nude* (Fig. 269) and Franz

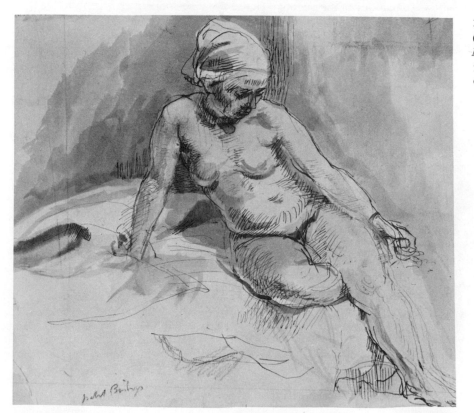

269. Isabel Bishop
(b. 1902; American).
Nude. 1938. Ink and wash,
5¾ × 6½'' (15 × 17 cm).
Collection Edward Jacobson.

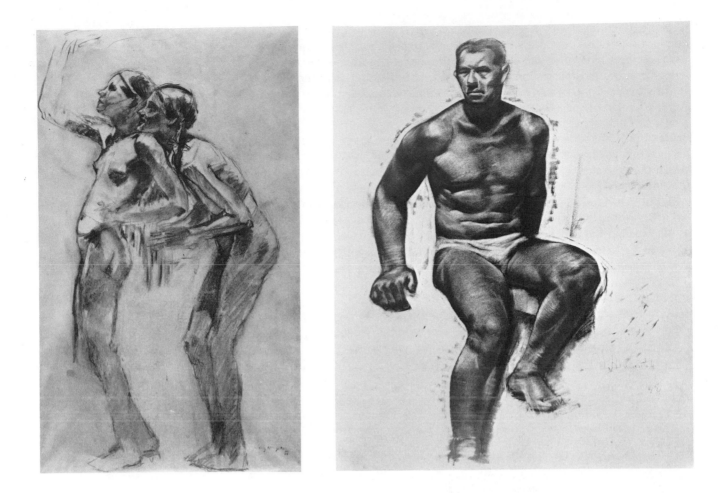

Wiegele's study of one model in two successive poses (Fig. 270) suggest the kind of drawings a skillful student might accomplish from a 20-minute or 30-minute pose. After the longer sketching period, the model generally assumes one pose for the remainder of the session. The same pose sometimes is repeated at successive class meetings, allowing students to complete a fully developed drawing and refine it over a period of hours or days (Fig. 271).

Whereas colleges and art schools provide regularly scheduled life drawing classes as part of the curriculum, students working independently often have only limited access to models for life drawing. The cost of employing a professional model is generally prohibitive for most art students. Even professional artists who enjoy and find value in weekly life drawing sessions join together with friends to share the expense of models. In addition to art school and college life drawing classes, many metropolitan areas provide figure drawing as part of adult education programs. Beginners as well as professional artists can avail themselves of such classes. Local art associations sometimes organize life drawing sessions for their members. The model's fees are generally divided by the number of people in attendance at each session, so that the cost to the individual is probably no more than a dollar or so. While the individual student has little control over the model and length of pose, most students are content having the opportunity to draw the figure.

Project 135 Sketch a nude model in 1-minute, 5-minute, and 10-minute poses. For your initial attempts, use a short stick of compressed charcoal (a 1-inch or 1½-inch length usually works well). Keep the flat side of the charcoal against the paper and rapidly build broad areas of dark with a back-and-forth motion. You might well begin your drawings as a slightly expanded version of the simplified

Figure Drawing

skeletal drawing explored in the previous project. Establish the essential lines of movement—the <u>gesture</u>—followed by some indication of volume and size-shape relationships. As you begin to develop confidence, pay greater attention to shapes and patterns of light and dark. Introduce contour line last as time allows.

The brief duration of each pose prompts most beginning students to plunge into drawing immediately without taking time to look at the figure. Your drawing would be better served if you would spend the first half of each pose studying the model—drawing with your eyes—before setting charcoal to paper.

Many mature artists have adopted as their special province the fully developed life drawing. From Renaissance times on, artists have taken delight in beautiful drawings of the human figure. Michelangelo, Raphael, and a host of other Renaissance artists made such drawings, sometimes as studies for figures in projected paintings (Fig. 263; Pl. 8, p. 222), but just as frequently for their own sakes. The figurative tradition continues in drawings ranging from the lyric classicism of Paul Cadmus (Fig. 272) to the pitiless realism of Philip Pearlstein (Fig. 273).

Project 136 The novice in life drawing derives the greatest benefit from working no more than half an hour on a single pose. Approach a 30-minute drawing in exactly the same manner as the quick sketches, using preliminary gesture lines to indicate the full figure. Then begin to establish general size and shape relation-

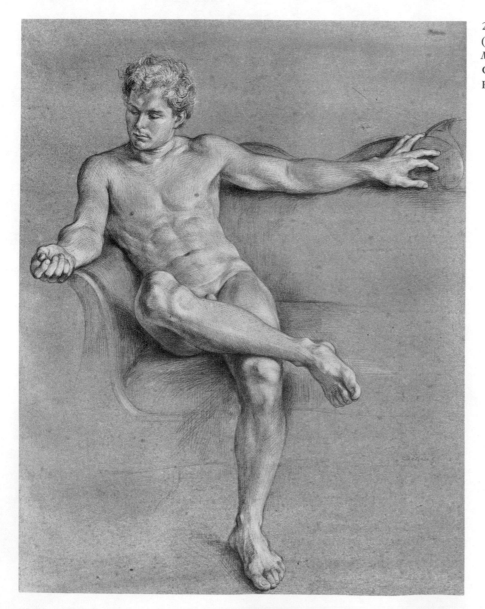

272. Paul Cadmus
(b. 1905; American).
Male Nude NM 50.
Crayon, 24 × 18⅛″ (61 × 46 cm).
Private collection.

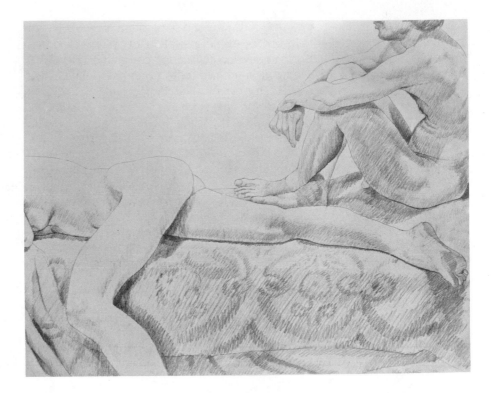

273. Philip Pearlstein
(b. 1924; American).
*Couple on Bed (Male Seated,
Female Lying Down).* 1972.
Pencil, 19 × 24'' (48 × 61 cm).
Collection Mr. and Mrs
Daniel M. Seifer,
Toledo, Ohio.

ships of all the parts, using the measuring devices described in Chapter 3 to determine the location. Beginning students have a natural tendency to start by drawing the head, slowly working their way down the figure, often running out of paper before they reach the feet. Learn to utilize the full sheet of paper for the full figure. Start with a light preliminary sketch to determine the height of the figure and then begin to break up that space by locating the shoulders, hips, knees, and so on. Broadly simplified patterns of light and dark, as seen in Figure 270, provide a sufficient indication of volume.

Project 137 As you become more skilled, you can benefit from increasing the time spent on individual drawings of the figure, although that might not be for some months. For fully developed figure studies, you might prefer to work in a medium, such as conté crayon, that does not smear readily and thus permits reworking. You will want to work on good-quality charcoal paper. Have your model assume a comfortable, seated pose, similar perhaps to that in Figure 271 or Figure 272, which can be easily repeated, since you should spend at least three or four hours developing a finished drawing. Illuminate your subject with a strong light to reveal the anatomical forms in high relief. Study the model carefully and build a sense of form through the use of traditional chiaroscuro (see pp. 64–66). If you have difficulty developing one of the forms in a satisfactory manner, make studies of that detail in the margins of your paper, as suggested in Figure 274; then resume work on the main drawing.

Even seemingly academic sketches and studies display remarkable beauty when executed by a sure and skillful hand (Fig. 274). On top of an earlier study for an *Annunciation*, Agostino Carracci sketched an instructional page of drawings of feet (Fig. 275). The feet are drawn from many angles with amazing certainty and knowledge. Carracci depicted ankle forms, the ball of the foot, the arch, the toes, and the heel with a clarity that makes contemporary draftsmen envious. Nonetheless, a modern page of foreshortened hands by Eleanor Dickinson (Fig. 276) provides an exciting comparison with the feet by Carracci and proves that skill and certainty still work together in our less disciplined age.

Figure Drawing

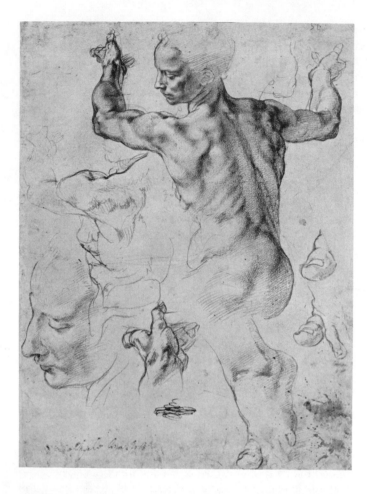

above left: 274. Michelangelo Buonarroti
(1475–1564; Italian).
Studies for the Libyan Sibyl.
Red chalk on paper, 11⅜ × 8⅜'' (29 × 21 cm).
Metropolitan Museum of Art, New York
(purchase, 1924, Joseph Pulitzer Bequest).

above: 275. Agostino Carracci (1557–1602; Italian).
Feet, over an earlier sketch for an *Annunciation.*
c. 1595. Pen and brown ink, 10¼ × 6⅜'' (26 × 16 cm).
Royal Library, Windsor Castle, England
(reproduced by gracious permission
of Her Majesty Queen Elizabeth II).

left: 276. Eleanor Dickinson (b. 1931; American).
Study of Hands. 1964. Pen and ink,
13⅛ × 10⅛'' (34 × 26 cm).
Stanford University Museum of Art, Calif.

Traditional Areas of Subject Matter

Project 138 Do extended studies of hands, feet, heads, and other body details to amplify your knowledge of the figure. Foreshortening is always difficult, with hands and feet perhaps the most complex and problematic parts of the body to draw. If no model is available, draw from your own anatomy with the aid of a mirror. Remember that your task will be simplified if you concentrate on drawing size and shape relationships, rather than thinking about drawing hands and feet.

Project 139 A degree of foreshortening is present in Figures 271 and 272, and undoubtedly some also occurred in your fully developed figure study (Project 137). To do a drawing involving maximum foreshortening, pose the model in a reclining position so that you see the body from head to toe or vice versa. Allowing the model to lie in a relaxed pose, perhaps with one arm extended above the head, and viewing the figure from a slight angle will provide a more visually interesting composition (Pl. 3, p. 138). Draw size and shape relationships as you see them rather than as you think you know them to be.

Perception of Form

It is easy to settle into certain pleasing habits of drawing and neglect many avenues for perceiving and recording this rich and complex form, the human figure. Contour drawing sensitizes the eye to the subtle undulations of edges and helps to establish eye-hand coordination (Fig. 63). Gesture drawing with a searching line conveys a suggestion of action (Fig. 67). The use of rotary, enveloping clusters of lines lend a sense of roundness and helps describe the weight and mass of the figure (Fig. 30).

Figure Groups

Drawing groups of related figures is an important part of the artist's education. Students may become skilled at depicting single figures but remain unable to compose a successful group of related ones. Théodore Géricault's *Fall of the Damned* (Fig. 277) represents an amazing tour de force in its intricately inter-

277. Théodore Géricault (1791–1824; French). *Fall of the Damned.* c. 1817–18. Pencil, 8 × 9″ (21 × 23 cm). Stanford University Museum of Art, Calif. (gift of the Committee for Art at Stanford).

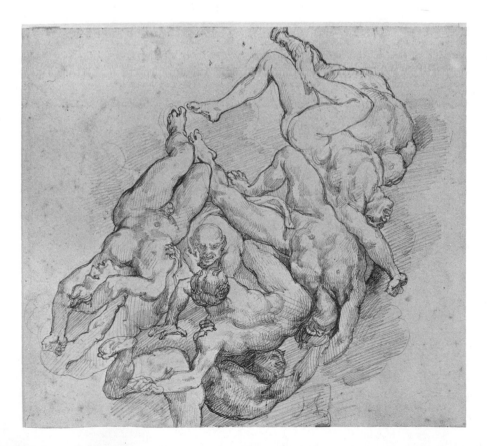

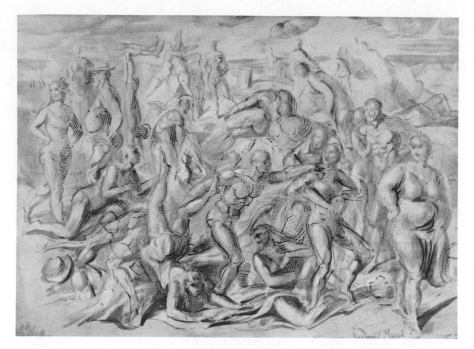

278. Reginald Marsh
(1898–1954; American).
Coney Island Beach. 1948.
Pen and ink with wash.
Courtesy Rehn Gallery, New York.

twined falling bodies. Such a drawing might well be beyond the capacities of many skilled contemporary figure artists, largely because the problem is addressed so infrequently. Because of economic considerations, life drawing classes generally are restricted to a single model; only occasionally do two models pose together. One must realize, however, that large-scale figure paintings of the past, sometimes depicting a cast too numerous to count, were composed from a series of individual figure studies. It is unlikely for example, that the eighteen or more figures in Reginald Marsh's *Coney Island Beach* (Fig. 278) posed together for the artist. Such a drawing, perhaps drawn from imagination, results from thousands of individual figure studies and sketches, a remarkable visual memory, and accumulated knowledge and experience.

Project 140 *Study Figures 271, 277, 278, and Plate 8 (p. 222). Develop a drawing in which at least three or more figures are integrated into a single composition. Your problem will be somewhat simplified if you work with two models since certain spatial relationships can be directly observed. If only one model is available, it will be necessary to consider carefully the placement and scale of each figure to create convincing space. Since figures must not appear to occupy the same floor space and must appear to be drawn from a consistent point of view, an understanding of perspective will prove useful. Without changing your position, relocate the model in space with each change of pose to conform to the composition; chalk marks on the floor will assist you in this. While it is possible to construct a figure composition from an accumulation of individual figure studies, unless all of the drawings are done from the same eye level, an inconsistency in point of view will probably occur. Include reclining, semireclining, standing, and foreshortened figures. Work in charcoal so that confusing overlappings can be erased.*

Drawing the Clothed Figure

Mastery in drawing the clothed figure equals in importance the depiction of the nude form but is often neglected in the training of beginning artists. Solid background in anatomy gave a particular authenticity to Renaissance artists' treat-

279. Gerrit Adriaensz Berckheyde (1638–1698; Dutch).
Standing Woman. Black chalk, 7⅝ × 4'' (20 × 10 cm). Rijksmuseum, Amsterdam.

ment of costumed as well as nude figures. We have already referred to Raphael's skeletal study for his *Virgin Supported by the Holy Women* (Fig. 262). In the 17th century Gerrit Andriaensz Berckheyde clothed his *Standing Woman* so voluminously that one would think all sense of the underlying body would be obscured (Fig. 279). Miraculously, her full hips, broad shoulders, and sharp elbow can be perceived through the clothes. Although the figure conveys an impression of monumentality, there is a greater aliveness in the richly modeled drapery than in the body of the woman. Very different are the figures in Edgar Degas' *Two Studies of Mary Cassatt or Ellen Andrée in the Louvre* (Fig. 280). Recognized as one of the supreme figure artists of any age, Degas captures personality through gesture—the tilt of a head, the lifting of a shoulder, the manner in which a book is held, the way in which only a portion of the figure's weight is supported by the umbrella. The garments are drawn without great elaboration in detail or modeling; however, attention to the silhouette of the coats, fitted to the waist and flaring over the hips, contributes to the suggestion of character.

Käthe Kollwitz, like Goya and Daumier before her, was able to achieve the maximum impact with the greatest economy of drawing because of her mastery of gesture. In her drawing *The Homeless* (Fig. 281), the viewer is made totally aware of the bodies inside the seemingly shapeless garments. The woman's head drops below her shoulders, the chest sags, the belly is thrust forward; her body language speaks poignantly of suffering, anguish, and despair, as do the poses of her companions.

Figure Drawing

217

280. Edgar Degas
(1834–1917; French).
*Two Studies of Mary Cassatt
or Ellen Andrée in the Louvre.*
1879. Charcoal and pastel
on gray paper,
18¾ × 24¾'' (48 × 63 cm).
Private collection.

Project 141 Practice drawing the clothed figure as often as you can, both in the studio and elsewhere. Include the clothed figure as part of your ongoing sketchbook activities. Since you are so constantly in the presence of other people, the opportunities are limitless—on campus, in the cafeteria, library, and classrooms, at shopping centers and outdoor cafes, wherever people congregate. Make sketches of people as you watch television. As you draw be continuously aware of the body inside the clothes and concentrate on revealing the stance or gesture of the figure. Even in longer studies, learn to simplify the clothing, placing emphasis on those lines, folds, and details that most define the body form.

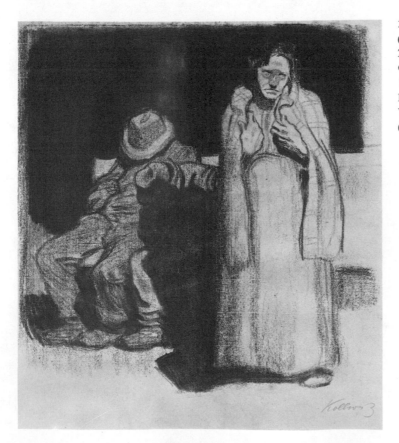

281. Käthe Kollwitz
(1867–1945; German).
The Homeless. 1909.
Charcoal and wash,
13¾ × 12½'' (35 × 32 cm).
National Gallery of Art,
Washington, D.C.
(Rosenwald Collection).

The Figure in Action

Whereas life drawing presupposes a model holding a pose without moving, if only for a short time, most artists generally experience the desire to depict the figure in action. The preceding discussion of the Degas and Kollwitz drawings (Figs. 280, 281) as well as the last project, referred to the gesture of a figure. Gesture, in this sense, is synonymous with posture. Although the figures in the two drawings are standing and seated, each body conveys a feeling of animation and movement. The figures, however, are depicted in static poses; they are not shown in action or in motion. Many artists, skillful at depicting static figures, cannot communicate a sense of movement. Figures meant to be in motion too frequently appear in a state of frozen animation. The solution, of course, is to draw figures in action as often as possible and develop a personal technique for so doing. No two artists share the same method, but observing some master drawings may suggest how to approach the problems involved in representing figures in action.

George Romney used bold, swiftly drawn, gestural pen lines to produce a flowing, rhythmic movement in his drawing of dancing figures (Fig. 282). The sense of movement within a single form is particularly evident in the shorthand-like notation of the figure at the right. Much of the charm of the drawing is that, in addition to depicting a group of dancers, it effectively suggests a continuous sequence of movements.

The figure of Mars that emerges out of the almost frenzied searching line of Giovanni Guercino (Fig. 283) conveys the impression of sequential movement which is the basis of film animation. In Matisse's fine drawing *Dancer* (Fig. 284), sweeping lines implying both motion and transparent draperies carry the eye in an unbroken flow of visual movement from the dancer's ankles to her upraised arms.

below: 282. George Romney (1734–1802; English).
Dancing figures, detail of a page of studies. Pen and ink.
Metropolitan Museum of Art, New York (Rogers Fund, 1911).

right: 283. Guercino (1591–1666; Italian).
Mars and Cupid. c. 1645. Pen and brown ink on white paper,
10 × 7⅛'' (26 × 18 cm). Allen Memorial Art Museum,
Oberlin College, Ohio (R. T. Miller, Jr., Fund).

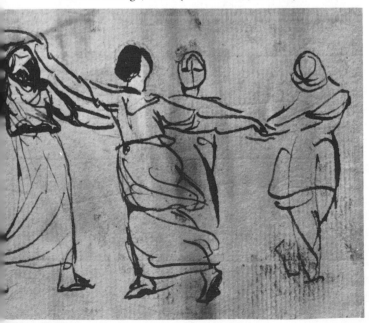

Figure Drawing

219

In delightful contrast to the smooth graceful arc of the Matisse figure is the figure in Hokusai's *Mad Poet,* who leaps about with wild, carefree abandon (Fig. 285), head, arms, and legs projecting at unexpected angles from a complex swirl of drapery. It should be noted, however, that in spite of the poet's expansive gesticulations, the parts of the body have been thoughtfully positioned to ensure the effect of equilibrium. The figure appears perfectly balanced. Balance remains a critical factor in depicting the figure in motion. It is interesting to compare Henri de Toulouse-Lautrec's poster image of Jane Avril (Fig. 286) with the photograph of the famed Parisian entertainer (Fig. 287). The photograph is obviously posed, since in the late 19th century cameras were not sufficiently sophisticated to capture a figure in motion. The poster reveals Toulouse-Lautrec's amazing ability to animate the figure through exaggeration of gestures and shapes, most evident in his drawing of the legs and feet. He has created an image of Jane Avril far more convincing physically than is the photograph. The sense of equilibrium conveyed is similar to that of Hokusai's *Mad Poet.*

Project 142 Draw figures walking, running, or bending. In doing quick sketches look for the essential gesture. Lay in a few lines of action to indicate movement of arms, legs, torso, and head, and then rapidly suggest the major contours of the forms. Once you have developed a successful method of depicting relatively simple, repetitive motions, undertake more dynamic movements. Concentrate on achieving a sense of action, even if it means sacrificing accuracy of shape and proportions. While dancers and athletes seem to be obvious subjects, their movements are generally much too rapid for a beginning artist to attempt. Even the slow deliberate movements of a person practicing T'ai Chi will seem fast as you attempt to record them, but it would be instructive to try.

above left: 284. Henri Matisse (1869–1954; French). Illustration for Mallarmé's *Le Guignon.* c. 1930–31. Pencil, 13 × 10⅛″ (33 × 26 cm). Baltimore Museum of Art (Cone Collection).

above: 285. Hokusai (1760–1849; Japanese). *Mad Poet,* detail from a page of drawings. Ink on paper, entire page 10⅜ × 15⅝″ (27 × 40 cm). British Museum, London (reproduced by courtesy of the Trustees).

Traditional Areas of Subject Matter

Plate 6. Claude Lorrain
(1600–1682; French).
*The Tiber above Rome,
from Monte Mario.* c. 1640.
Brush and bistre wash,
7⅜ × 10⅝″ (19 × 27 cm).
British Museum, London
(reproduced by courtesy
of the Trustees).

Plate 7. Albrecht Dürer
(1471–1528; German).
The Great Piece of Turf. 1503.
Watercolor,
16¼ × 12⅜″ (41 × 31 cm).
Albertina, Vienna.

left: Plate 8. Jacopo Pontormo
(1494–1556/57; Italian).
Three Walking Men, study for the *Story of Joseph* series.
c. 1517. Red chalk, 15¾ × 10½'' (40 × 27 cm).
Musée des Beaux-Arts, Lille.

below: Plate 9. Willem de Kooning
(b. 1904; Dutch-American).
Two Women's Torsos. 1952.
Pastel, 18⅞ × 24'' (48 × 61 cm).
Art Institute of Chicago (John H. Wrenn Fund).

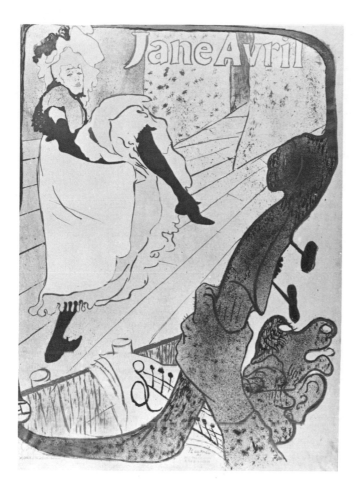

above: 286.
Henri de Toulouse-Lautrec
(1864–1901; French).
Jane Avril, Jardin de Paris.
1893. Lithograph,
4'2¾'' × 3'⅝'' (1 3 × 94 m)
Musée Toulouse-Lautrec, Albi.

above right: 287. Jane Avril.
c. 1892. Photograph. Reprinted
from *Lautrec by Lautrec,*
by P. Huisman and M. G. Dortu.
Published by Edita, S. A.,
Lausanne.

Abstraction and the Human Form

Our discussion of figure drawing so far has stressed an essentially realistic approach. The use of distortion and abstraction, however, lends zest and variety to modern interpretations of the figure. The forms of Klee's *Naked Woman* create a curiously mannikinlike impression (Fig. 288). The oblique eye, sharply profiled head, triangular breast, and dislocated arms and legs fascinate us and suggest some enigmatic being that seems to hover in space. The floating effect is heightened by the three cloudlike forms, which serve compositionally to balance the upraised right leg. Overall, the exquisitely hatched ink lines give this figure a precise delicacy.

When Picasso first saw camouflaged trucks on the streets of Paris at the beginning of World War I, he told his friend Gertrude Stein that the Cubists had invented camouflage. The validity of his claim is supported by Fernand Léger's Cubist drawing *Seated Nude* (Fig. 289), in which the basically descriptive curvilinear contour of the figure all but disappears into the fragmented pattern of angular planes. Paradoxically, the use of hatched shading lends volume to the figure at the same time that it negates the effect of solid form as separate from the surrounding environment.

Also in the Cubist manner, Alexander Archipenko creates a dynamic *Figure in Movement* (Fig. 290) using cut and pasted paper, crayon, and pencil. Anatomical forms are boldly simplified into large geometric entities that have been given a resemblance of three-dimensional weight and solidity by light shading. Opposing rhythms convey a formalized sense of action.

It is possible to see the pastel and charcoal drawing of *Two Women's Torsos* by Abstract Expressionist Willem de Kooning (Pl. 9, p. 222) as incorporating

Figure Drawing

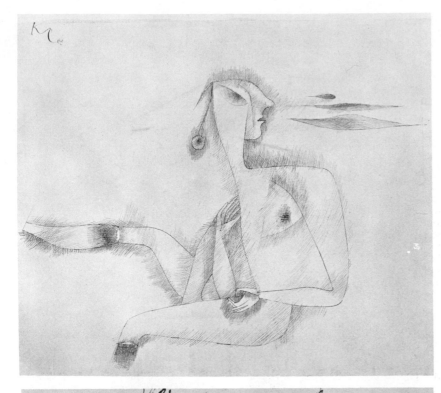

288. Paul Klee (1879–1940; Swiss-German).
Naked Woman, X 7. 1926. Pen and ink,
10⅛ × 11¾'' (26 × 30 cm).
Solomon R. Guggenheim Museum,
New York.

289. Fernand Léger (1881–1955; French).
Seated Nude. 1913. Pen and ink,
15⅞ × 12½'' (40 × 32 cm).
Museum of Modern Art, New York
(Joan and Lester Avnet Collection).

Traditional Areas of Subject Matter

290. Alexander Archipenko
(1887–1964; Russian).
Figure in Movement. 1913.
Collage and crayon,
18¾ × 12⅜'' (48 × 31 cm).
Museum of Modern Art, New York
(gift of the Perls Galleries,
New York).

certain of the elements seen in each of the preceding three works. De Kooning's depictions of the human figure are characterized by the emotional intensity with which he distorts the female form both in shape and proportion. The violence of his gestures (Fig. 76) combine with brutal distortions to project a mood of pessimism and disillusionment with modern life.

Project 143 Distortion, dislocation, stylization, ambiguity, flat patterning, shifting points of view, and the juxtaposition of multiple images are means of approaching abstraction. De Kooning sometimes used the process of shuffling drawings on sheets of tracing paper placed one over the other to create new images. Working from some of the drawings done for other projects in this chapter, experiment with abstracting the human figure while exploring a variety of media and drawing techniques.

The human figure continues to supply vital subject matter for artists. Certainly any student wishing to make a career of illustration (Chapter 15) will be working with the figure, and even architects include people in their renderings, both for a sense of scale and as a reminder of the warm pulse of life. Serious painters and sculptors find in the form strength, beauty, and above all human values. Artists of all persuasions, realists and abstractionists alike, come to this form for inspiration, for it is truly the fountainhead of life and aesthetic expression.

Figure Drawing

The Portrait 14

Much artistic expression has grown from our desire to arrest the hurried passage of experience and immobilize its images for later study and appreciation. The face, more than any other part of the body, has long been an object of scrutiny for artists, because through its myriad expressions pass all the fleeting thoughts and emotions of human experience. From earliest times the making of portraits has been a means whereby human beings have tried to evade the common destiny of all living creatures and to achieve some degree of immortality. Until the invention of the camera in the early 19th century, portraiture, whether sculpted, painted, or drawn, recorded the appearance of those persons who had attained sufficient eminence to command a greater measure of immortality than was the lot of commoners.

A look at the illustrations in this section and elsewhere in the book reveals the tremendous variety of approach to portraiture by individual artists. Some portraits strive for exact replication of every bump and hollow in the face (Fig. 291); in others, there is a telling selectivity (Fig. 292). Stylization sometimes becomes caricature (Fig. 319) and at other times becomes idealization (Fig. 293). It is frequently argued whether the portrait involves psychological perceptions made and incorporated in the work by the artist or whether the telling irregularities that constitute the "psychological" element—particularly those irregularities that convey tension, strain, and lack of inner quietude—are "read into" the drawing by the viewer almost irrespective of the artist's intent. For this reason and because of the inordinate complexity and expressive potential of the subject matter, no field of drawing is more demanding, and perhaps rewarding, than the portrait.

The impersonal, idealized portrait in which distinctive aspects of appearance are sacrificed to a bland, generalized version of the sitter has long been the accepted standard for "official" portraiture. The drawings reproduced here, however, have been chosen for their aesthetic interest rather than their commercial acceptability. Each work by a great portrait artist manifests a characteristic emphasis. It is this personal touch that constitutes the artist's genius and distinguishes such work from the thousands of adequate but merely routine likenesses that predominate in conventional portraiture.

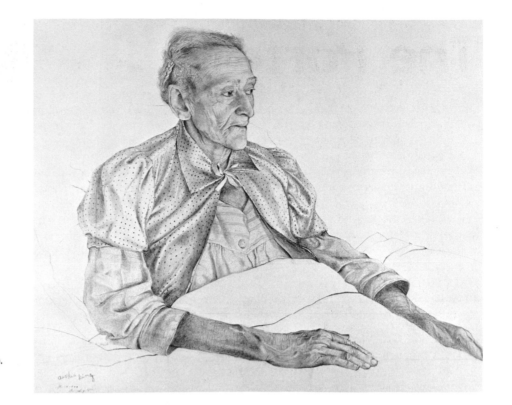

right: 291. Andrew Wyeth
(b. 1917; American).
Deckie King. 1946.
Pencil, 28½ × 34″ (72 × 86 cm).
Dallas Museum of Fine Arts
(gift of Everett L. De Golyer).

below left: 292. Beth Van Hoesen (b. 1926; American). *Theophilus.* 1980.
Pencil, 16¾ × 13½″ (43 × 34 cm). Courtesy the artist.

below right: 293. Thomas Dewing (1851–1938; American).
Head of a Young Woman. Silverpoint on tissue paper, 10 × 8″ (25 × 20 cm).
Memorial Art Gallery, University of Rochester, N.Y. (Bertha Buswell Bequest).

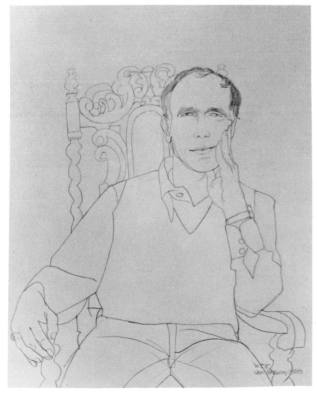

The Portrait

Form and Proportion

Portraiture demands both a rigorous analysis of form and empathy for the sitter. Acquiring the analytical powers comes with practice and experience. Empathy appears to be a deep-seated psychological trait, a part of the emotional make-up of the artist, and whether it can be deliberately developed is open to question.

An extremely complex form, the head is the focus of our attention as we move about and meet people. Despite the fact that we are constantly observing faces, most of us have surprisingly little knowledge of the general proportions and relationships between parts of the face. Perhaps because we attend to the unique individuality of each person, which is the basis of all portraiture, we fail to be alert to the general system of proportions that determines the placement of features. Although individual differences will be apparent to the person who studies the features carefully, familiarity with the general rules of proportion will enable you to avoid the mistakes most commonly seen in unskilled drawings of the head.

Project 144 Before starting to draw, study the diagrams in Figure 294 in relation to your own reflected image. Use a pencil as a measuring device (see pp. 39–41) to check the proportions and alignment of your features.

1. Hold a pencil just in front of your nose to create a vertical center line. The eyebrows, eyes, base of the nose, and mouth can be seen as horizontal lines perpendicular to this vertical axis. When you incline your head to the left or right, your features remain at right angles to the center line. If you tip your head forward or backward the feature lines are seen as downward or upward curves corresponding to the curvature of the skull.
2. Although the features can be located according to the following general rules, a critical factor in portrait drawing is establishing accurately the proportion of head width to height. Variations in the width of the head can alter the effect even when the rules have been carefully observed.
3. The line of the eyes lies about halfway between the top of the skull and the chin. It might appear to be lower depending on the fullness of your hair style.

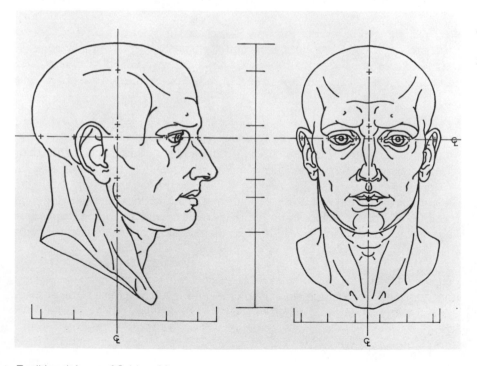

294. Alanson Appleton
(b. 1922; American).
General proportions of the head: frontal and profile.
Pen and ink, 8½ × 12″ (22 × 30 cm).
Courtesy the artist.

(With infants the eyebrow line marks the halfway point, with the eye line dropping approximately one quarter into the lower half.)

4. The distance between the hairline and chin is divided roughly into thirds by the eyebrows and the base of the nose. The lower section may be slightly greater.
5. The center line of the lips, which resembles a flattened letter M, is located approximately one-third of the way between the nose and chin. It is sometimes more than one-third, but less than half.
6. The top of the ears align with the eyebrows; the bottom of the ears fall just below the bottom of the nose.
7. The distance from the edge of the head to the eye, the width of the eye, and the space between the eyes are very nearly equal.
8. The width of the nostrils corresponds to the distance between the eyes.

Project 145 Study your image in profile by using two mirrors. While the frontal view of the head resembles an upright egg, in profile it appears as a tilted egg. The proportions described earlier remain constant, but the shape of the features obviously change.

1. A common error in drawing the profile head is failing to recess the eye sufficiently behind the forehead plane and the nose.
2. The ear is located in the back half of the head. The distance from the outer corner of the eye to the back edge of the ear equals one half the height of the head.
3. The measurement from the earhole to the tip of the nose is equal to the distance from the chin to the eyebrows. The same measurement occurs from earhole to earhole in the frontal view.
4. The earlobe indicates the position of the jawbone.

Project 146 Observe people as you walk in the street, ride on public transportation, and sit in classes. Notice how consistently the placement of their features adheres to the general proportions. While some deviations will be evident, the greatest variation will occur in the width of heads.

Project 147 A plaster head, usually standard equipment in art departments, provides an excellent means for studying general proportions of the head and relationships between its parts. A plaster cast has the virtue of remaining motionless, thus permitting leisurely and accurate observation. It can be repositioned easily so that it can be viewed both above and below eye level as well as in frontal, profile, and three-quarter views. Use your pencil or stick of charcoal for comparative measuring and to establish the correct alignment of features.

One of the problems beginning students experience in drawing the head, particularly in the frontal view, is conveying a convincing sense of structure. Too frequently the features appear to float on the surface of the paper rather than existing as part of a three-dimensional form, even though all the features may be accurately positioned. As has been noted, three-dimensional form becomes most apparent through the use of light and shadow. In a line drawing it is possible to impart a degree of three-dimensionality by overlapping shapes and lines and by introducing gradations into the thickness of lines to suggest light and shadow (Fig. 292).

Project 148 Working from a plaster head or your own reflected image, lighted from above and to one side, do a drawing in which you develop a sense of solid, three-dimensional form. Emphasize bony structure, cheekbones, turn of the forehead from frontal plane to side plane, bony protuberances in the nose, and so forth. Do two drawings, one in line, the other fully modeled in light and dark.

The Portrait

The Features

Once correct relationships of form and features are firmly settled in the beginning artist's perception, achieving a likeness depends upon the accurate analysis of a set of individual features to be superimposed over the preliminary plan. The most common errors result from failure to look at the shape of each feature, drawing instead what one thinks to be the shape of the particular feature. The novice, for example, has a tendency to represent the eye as an almond shape with the upper and lower lids as matching curves meeting at points. Careful observation of the eye reveals that it is more irregular in shape—the high point of the curve of the upper lid occurs closer to the nose; the low point of the lower lid is nearer to the outer corner of the eye. At the inner corner the lids come together to form the tear duct; at the outer corner the upper lid overlaps the lower lid. The iris of the eye appears to rest on the lower lid, while the upper portion is partially hidden by the upper lid. In profile the eye appears as the letter V lying on its side, the upper lid projecting beyond the lower lid and overlapping it at the outer edge.

Alanson Appleton, in his classically rendered portrait of David Roinski (Fig. 295), combines a masterful knowledge of proportions and underlying anatomical structure with thoughtful observation of his model to create a sense of solidity and individuality. Careful analysis reveals how closely the drawing adheres to the system of proportions presented in Figure 294, while at the same time concentrating on the uniqueness of the individual.

Project 149 *Study your own features carefully. Practice drawing your eyes, nose, lips, and ears separately in frontal, profile, and three-quarter views. A single light source above and to the side will reveal the strongest sense of form. You will probably discover that your eyes are not identical in size and shape and that your mouth is not the same on both sides (Fig. 296). Making additional studies of the individual features of other persons will increase your awareness of differences that exist and the necessity for drawing exactly what you see.*

Project 150 *As an exercise in developing sensitivity to the peculiarities of likeness, draw an interesting sitter, preferably someone with a distinctly unusual face. Stress all departures from regularity, differences between eye shapes, and the length and structure of the nose, mouth, lips, and chin. Notice wrinkles, muscularity or flabbiness of the flesh, heaviness of eyebrows and lashes, and quality of hair and direction of its growth. Although it may not please your model, be merciless; kindness produces only a flaccid likeness.*

The Self-Portrait

Classification of the various types of portraits is difficult, for almost none of the possible categories is very sharply defined, and most are not mutually exclusive. Perhaps the most obviously distinct type is the *self-portrait,* but as a glance at the following group of self-portraits will evidence, this form too spans a considerable range of disparate styles and approaches.

Raphael Soyer's drawing (Fig. 296) reveals a most subtle study of himself accompanied by his father. The self-portrait's thoughtful expression, the slight irregularity of eye shape and size, the sensitive mouth, and furrowed brow all bespeak the introspective artist. The prominence given to his eyes and the intensity of their gaze seem to underscore the essential linkage of drawing to seeing. In spite of the almost elusive nature of the modeling, except around the eyes, the head is strongly structured. The head of his father peering over Soyer's shoulder mimics that of the artist in structure but is less well defined in form and may well have been done from memory.

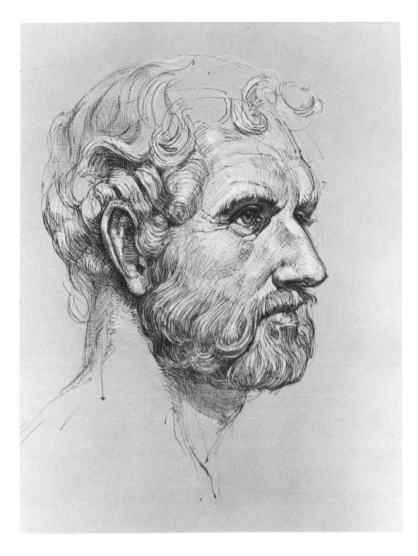

295. Alanson Appleton
(b. 1922; American).
David Roinski. 1976.
Pen and ink with pastel,
10 × 8½'' (25 × 22 cm).
Courtesy the artist.

296. Raphael Soyer
(b. 1899; American).
*Self-Portrait
with the Artist's Father.*
Pencil, 9¾ × 12⅛'' (25 × 31 cm).
Sotheby Parke-Bernet.

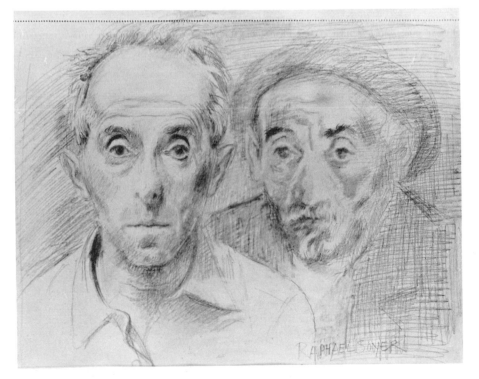

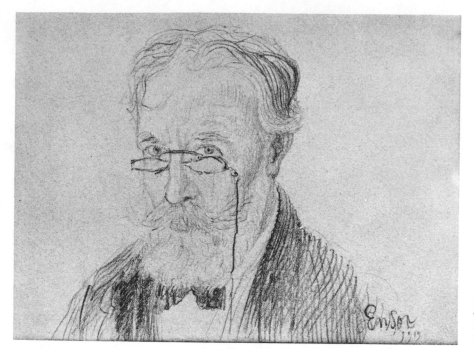

297. James Ensor
(1860–1949; Belgian).
Self-Portrait. 1940.
Pencil, 4½ × 6″ (12 × 16 cm).
Museum voor Schone Kunsten, Ostend.

That drawing is a matter of looking and seeing is made evident in James Ensor's *Self-Portrait* (Fig. 297). One cannot but be conscious that shortly Ensor will shift his gaze from the mirror before him to look through his pince-nez at his paper to add yet another line to his drawing. The eyes clearly dominate the drawing. The structure of the head is suggested by linear accents at the brow and below the nose rather than with fully developed modeling. Ensor displayed skillful and effective use of selectivity as he emphasized some features more than others. In contrast, most beginners feel obligated to delineate every detail with equal clarity.

Marie Laurencin departs from a completely objective recording of appearances to offer an image of compelling ambiguity (Fig. 298). The largeness of the

298. Marie Laurencin
(1885–1956; French).
Self-Portrait. 1906.
Charcoal and pencil,
8⅝ × 6¾″ (22 × 17 cm).
Museum of Modern Art, New York
(purchase).

299. Robert Arneson
(b. 1930; American).
Cheek. 1980.
Conté, oil pastel, and oil stick;
29 × 41⅛″ (75 × 106 cm).
Fine Arts Museums
of San Francisco,
Achenbach Foundation
for Graphic Arts
(Hamilton-Wells Fund).

form on the page and the cropping of the head imply physical closeness, yet the expression of the languid eyes seems withdrawn and distant. Unmodeled cheeks contrast strangely with the pronounced fullness of the lips, which are accented by the strongly defined cast shadow. The head assumes an awkward angle in relation to the neck and shoulders, and the features are not at right angles to the central axis of the head. These elements have been deliberately manipulated for expressive purposes.

In a pencil and gouache color study by Egon Schiele (Pl. 10, p. 255), the artist's almost furtive glance toward the viewer, coupled with the hands clasped protectively in the lap, suggests an uneasiness in the face of the self-analysis. No such uneasiness is evident as Robert Arneson projects a self-image of relaxed warmth and good humor in a tight close-up of crinkly eyes and a wry smile playfully textured with dots, squiggles, and games of tic-tac-toe (Fig. 299).

The self-portrait may serve either as an opportunity for serious introspective exploration or merely as a chance to work one's technical prowess upon an obliging model. For the beginning student the self-portrait offers decided advantages. First, the sitter is always available and easily manipulated. Second, there is no need to worry about offending the sitter's "self-image," no need to apologize for any unflattering drawing.

Project 151 *Whenever possible, study and draw your own face. Concentrate first on learning to construct a solid head; achieving an exact likeness can come later. Experiment with other than the frontal view. Using two mirrors allows you to draw the three-quarter view without the awkward sideward glance. Proceed from structure to features, then to expression. Decide how you can best describe your personality through the way you look. Do a series of self-portraits using various media, techniques, lighting effects, and poses.*

Project 152 *For those of you who have ever been curious about how your appearance would be altered if your head were wider or narrower, this project will allow you to experience that transformation. By now you are aware of the shape of your head. Following the guidelines offered in Project 144, construct basic heads of wider and narrower proportions and adapt your own features to fit those measurements.*

The Portrait

Sketchbook Activities

While careful analysis and thoughtful drawing contribute to one's effectiveness as a portrait artist, John Marin's self-portrait studies (Fig. 300) illustrate a quick-sketch approach to portraiture. Add to your sketchbook routine the habit of making rapid portrait studies, capturing as simply and quickly the essential features that characterize people you see. Practice first with your own reflected image as Marin did. Also use television news commentators and talk show personalities as models. Do a separate drawing each time the camera returns to your model rather than working intermittently throughout a program refining one drawing. With continued practice you will develop the ability to suggest structure, likeness, and character with the most economical means.

The Objective Approach

One fairly standard and broadly accepted ideal of portraiture is pure objectivity. We often equate pure objectivity with "photographic likeness," but the photograph we know can be highly selective and in actuality far from a strictly factual statement. The self-portrait of Chuck Close (Fig. 301) appropriately can be termed a photographic likeness since it is an accurately penciled transcription of a photograph. The objectivity of the image, however, comes in question when we acknowledge that the distortion resides in the photograph, not in the head of the artist. Since "pure" objectivity exists only as a theoretical state of mind, in terms of artistic endeavor, an objective approach involves depicting exactly that which is observed, free from distortion and interpretation. Andrew Wyeth's portrait *Beckie King* (Fig. 291) exemplifies the objective approach more succinctly than can any verbal explanation.

Among the most effective portrait drawings ever produced are the studies Hans Holbein the Younger made for oil portraits (Pl. 11, p. 255). These drawings in pencil, chalk, or charcoal with an occasional bit of color were made as nota-

above left: 300. John Marin (1870–1953; American). Studies of the artist. c. 1940–50. Pencil. Courtesy Kennedy Galleries, Inc., New York.

above: 301. Chuck Close (b. 1940; American). *Self-Portrait.* 1968. Pencil, 29⅛ × 23″ (74 × 58 cm). Private collection.

tions to enable Holbein to paint his portraits with few sittings. Most of his subjects were of the nobility or other individuals of importance. The less time they had to sit for their portraits the more pleased they were. And yet, in conformity with the standards of the day, a most exact likeness was demanded. Holbein's portraits have never been surpassed as objective statements of appearance that at the same time seem to provide an insight into the characters and personalities of the sitters.

Centuries later Edgar Degas created sharp and admirable portrait drawings of a very different nature. Here, too, his genius enabled him at one and the same time to seem to record every detail of feature and form and yet introduce a selective emphasis that appeared to reveal the essence of the sitter's personality (Fig. 302).

The technological triumphs of each age provide special problems and special opportunities. One might think that television and photography would eliminate the need for the objective portrait sketch, but this is not entirely the case. Artists skilled at portraiture can provide more incisive likenesses than the camera; consequently television news broadcasts often use the services of an artist in the courtroom, not only because until recently television cameras were not admitted, but also because more lively characterizations sharpen and add variety to the reporting. Probably the best known of these portrait journalists is Howard Brodie. In a few seconds he records the faces of the judges, defendants, and lawyers, using a spirited, animated line that reveals the surface forms and projects a sense of character as well as a feeling of the courtroom drama. *Dogface*, drawn during the Korean War, is a more finished drawing and one of Brodie's favorites (Fig. 303). Vigorous and free, it reveals the enviable technical assurance that accompanies talents that have been developed and exercised in the course of doing hundreds, perhaps even thousands of drawings.

below: 302. Edgar Degas (1834–1917; French). *Study for Portrait of Diego Martelli.* c. 1879. Black chalk heightened with white chalk, 17½ × 11⅛″ (45 × 29 cm) Fogg Art Museum, Harvard University, Cambridge, Mass. (bequest of Meta and Paul J. Sachs).

below right: 303. Howard Brodie (b. 1915; American). *Dogface.* 1951. Colored pencils, 14 × 11″ (36 × 28 cm). Courtesy the artist.

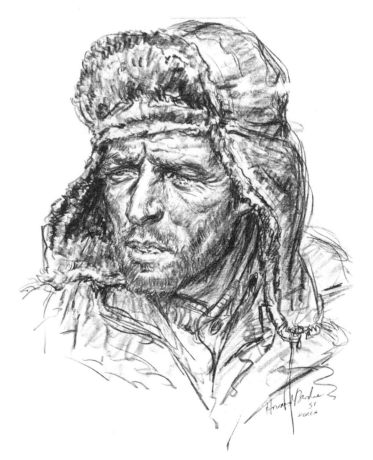

The Portrait

235

In recent years police artists have played an increasing role in the apprehension of criminals. Working in tandem with victims, these artists fashion a likeness of the perpetrator of the crime, often with amazing accuracy. Although relying upon the victim's visual recall, the artist must be able to translate verbal descriptions into credible form.

Project 153 *Study Figure 291 and carefully analyze the rendering of minute details. Keeping the technique in mind, view your own model. (For this exercise, you might find the "weathered" face of an older model easier to draw than the smooth features of a young person.) Make your initial sketch in medium-hard pencil, measuring and checking frequently for verisimilitude. Work slowly and carefully, introducing three-dimensional modeling only when you are certain of your outline. Gradually strengthen the forms and add textures. If you do not comprehend the subtleties of some features, examine the form at close hand until your intellectual comprehension of it clarifies what you see. Use softer pencils for the modeling and a very soft, very sharp pencil for the dark accents in eyes, nostrils, hair, and so forth.*

The Idealized Portrait

Idealization in portraiture can take many forms but in general means a structuring of features to conform to a concept of perfection and minimizing of all irregularities (Fig. 293). In Pierre Puvis de Chavannes' *Study of a Woman's Head* (Fig. 304), features are simplified and modeled after the head of a classical Greek statue. The two sides of the face are identical, and no furrows, wrinkles, or other attributes of skin texture disturb the strong smoothness. The result is a handsome head but one devoid of any sense of individuality.

The major problem of drawing an idealized portrait involves achieving a resemblance that satisfies the sitter as a "likeness" and at the same time irons out the less ideal aspects of the face. One of the marks of genius in idealized portraiture is the ability to fuse and reconcile opposites into a coherent and expressive whole. Ingres had this amazing capacity, as evidenced in his magnificent full-

below left: 304.
Pierre Puvis de Chavannes
(1824–1898; French).
Study of a Woman's Head.
Pencil, 6¾ × 5¼″ (17 × 13 cm).
Sterling and Francine Clark
Art Institute, Williamstown, Mass.

below: 305.
Jean Auguste Dominique Ingres
(1780–1867; French).
Lucien Bonaparte. c. 1807–08.
Pencil, 9⅜ × 7⅛″ (24 × 18 cm).
Private collection.

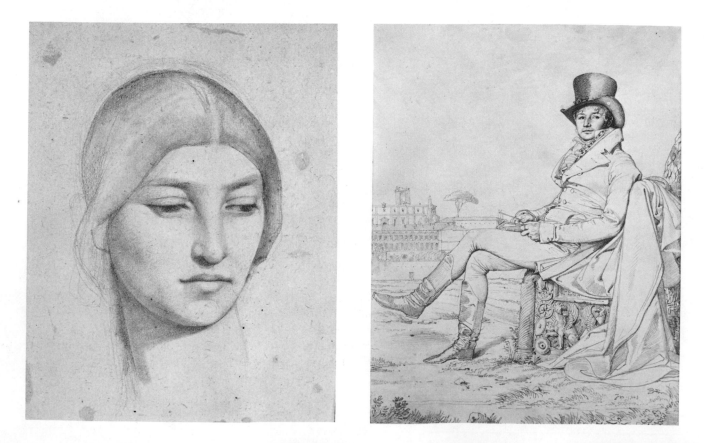

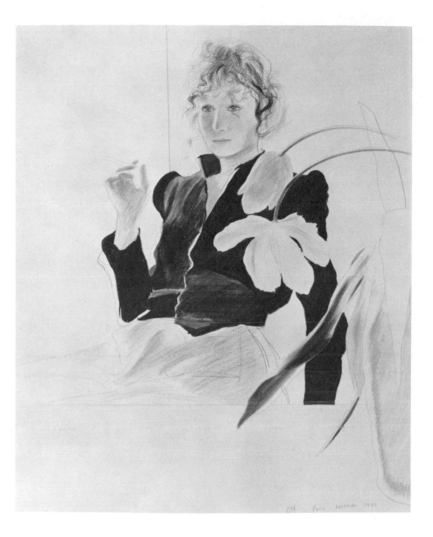

306. David Hockney
(b. 1937; English).
*Celia in a Black Dress
with White Flowers.* 1972.
Crayon, 17 × 14'' (43 × 36 cm).
© David Hockney 1972.
Courtesy Petersburg Press.

length portrait of Lucien Bonaparte (Fig. 305). The head is characterful and the features incisive; we have the illusion of seeing an objective likeness, exact and precise. Yet careful examination reveals clear idealization—perfect symmetry of feature, smooth sculptured form, and flawless skin. The elegant clothing, the beautiful rendering of the antique Roman chair, and the spaciousness of the landscape setting that sweeps to a distant view of Rome, rendered in the most precocious pencil technique, all contribute to an air of aristocratic distinction.

Project 154 Draw an idealized portrait, either of yourself or, better yet, a sympathetic friend (Fig. 306), for it is easier to view another person analytically. Determine how best to flatter your model without loss of likeness. Anyone harboring a desire to be a professional portrait artist would be well advised to focus particular attention to this project. Be certain to use a flexible and easily erasable medium such as soft pencil, charcoal, or chalk. Draw about life-size; a head too large looks clumsy, and drawing too small tends to cramp freedom of hand movement.

The Symbolic Head

More than any other part of the body, the head frequently symbolizes moral and ethical concepts, and certain facial expressions readily lend themselves to symbolic representation—an angelic face, a diabolical grin. Symbolic heads derive from the initial selection of an appropriate type and an emphasis on and exaggeration of certain features and characteristics of that face. Such drawings can

The Portrait

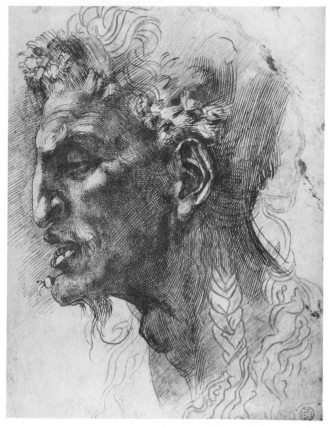

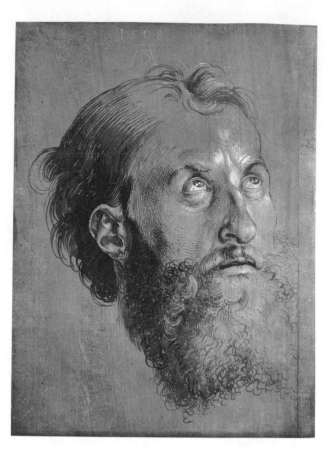

above: 307. Michelangelo Buonarroti (1475–1564; Italian).
Head of a Satyr. c. 1510–20. Pen and ink over chalk,
10⅝ × 7⅞'' (27 × 20 cm). Louvre, Paris.

above right: 308. Albrecht Dürer (1471–1528; German). *Head of an Apostle.*
1508. Pen, ink, and wash, heightened with white; 11⅜ × 8¼'' (29 × 21 cm).
Kupferstichkabinett, Staatliche Museen, West Berlin.

left: 309. Charles White
(b. 1918; American).
Preacher. 1952. Ink on cardboard,
21⅜ × 29⅜'' (54 × 75 cm).
Whitney Museum of American Art,
New York.

Traditional Areas of Subject Matter

thus easily veer toward caricature, an aspect of portraiture that receives special consideration later.

The expressive possibilities of the symbolic approach is evident in comparing a satyr's head imagined by Michelangelo (Fig. 307) and Dürer's *Head of an Apostle* (Fig. 308). Michelangelo's satyr provides a wonderful symbol of the playful half-man, half-goat of mythology—sensual, cunning, and surging with vitality. The brilliant cross-hatching in clear, strong pen lines contributes much to the strength and conviction of the conception. With his apostle, Dürer created a symbol of sanctity. Virtue normally seems less dramatic than evil; hence Dürer's apostle at first glance strikes us less forcefully than Michelangelo's satyr. In Dürer's head the eyes are cast heavenward; the handsome features are noble, the expression reverent and thoughtful. Here again masterful technique contributes to the conviction of the image. Dürer has used a middle-value, toned paper and then applied dark lines and white highlights to emphasize the full, rounded forms and create an image of unusual solidity.

In *Preacher* Charles White has symbolized a moral leader (Fig. 309). Here the selection of a particularly apt type has constituted the initial step. Foreshortened enlargement strikingly dramatizes the preacher's hands and conveys the sense of leadership. The face is reverent, handsome, and strong as the preacher delivers his ardent, impassioned sermon. The physical strength of the forms and the solidity with which they are rendered convey the sense that there is no contradiction between spirituality and full-blooded flesh and bone.

Project 155 Create a symbolic head, but avoid caricature and obvious stereotypical images. If you are at a loss for subject matter, remember that decadence tends to be more pictorial than virtue. It might be helpful to imagine how you would apply theater makeup to alter or heighten the features of an actor playing a symbolic role. Symbolic representation does not necessarily preclude the depiction of individuality.

The Psychological Portrait

Some drawings seem mostly to record externals (Fig. 302), while others create the illusion of penetrating the surface and revealing inner aspects of personality—tensions, withdrawn self-sufficiency, or warmth and sociability. In many of the self-portraits already discussed, the artists have included visual clues that explore character as well as appearance. The variety with which artists are able to reveal personality traits, their own and others, is one of the most fascinating aspects of portraiture.

Walter Sickert portrayed the famous English caricaturist Max Beerbohm as a warm, sympathetic observer of life (Fig. 310). The raised brows, heavy-lidded eyes, and slightly open mouth all seem to describe the inner life as much as they do external appearances. The raised hand adds an accent as though Beerbohm needed a gesture to give full meaning to his words.

The very turbulence of the crayon scribbles with which Oskar Kokoschka has drawn his *Portrait of Olda* (Fig. 311) creates a disturbing mood, which is intensified by the abstracted look in the eyes, the crooked mouth, and the thoughtful pose. The rather unusual combination of free execution, suggesting the artist's spontaneous approach to the act of drawing, and the sense of the subject as a tense withdrawn personality seems paradoxical. The sensitivity of Kokoschka's perception is evidenced in his selective delineation of features, the hair and collar being drawn more emphatically than the subject's eyes. Olda's introspective nature, in contrast to Sir Max Beerbohm's outward focus, is immediately apprehended.

Alice Neel draws with power and subtlety. In her portrait of *Adrienne Rich* (Fig. 312), the bright, alert eyes and controlled smile provide a clue to the tenor

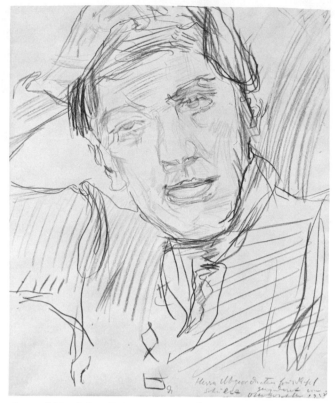

above: 310. Walter Sickert (1860–1942; English).
Sir Max Beerbohm. Pencil on cream paper.
Sotheby Parke-Bernet.

above: 311. Oskar Kokoschka (1886–1980; Austrian).
Portrait of Olda. 1938. Blue crayon,
17¼ × 13⅞'' (44 × 35 cm). Allen Memorial Art Museum,
Oberlin College, Ohio (R. T. Miller, Jr., Fund).

below: 312. Alice Neel (b. 1900; American).
Adrienne Rich. 1973. Ink heightened
with Chinese white, 30 × 22'' (76 × 56 cm).
Courtesy Graham Gallery, New York.

below: 313. William Michael Harnett (1814–1892; American).
Portrait of a Young Girl. Black crayon and gray wash
with touches of white, 19⅜ × 16⅛'' (50 × 41 cm).
Fogg Art Museum, Harvard University, Cambridge, Mass.
(bequest of Meta and Paul J. Sachs).

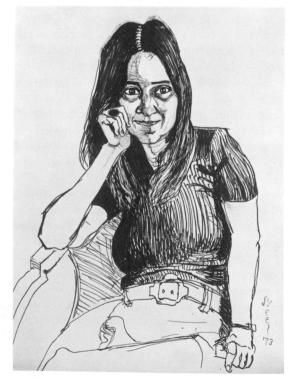

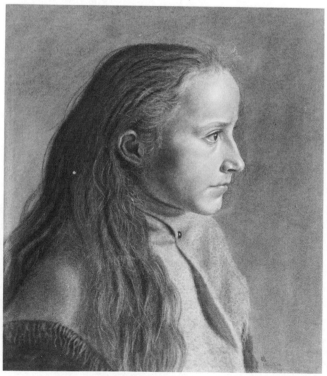

Traditional Areas of Subject Matter

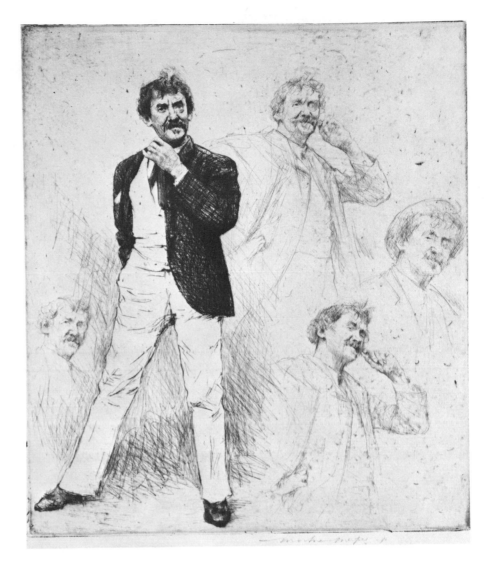

314. Mortimer Menpes
(19th century; American).
Whistler: Five Studies.
Drypoint, 6¾ × 6'' (17 × 15 cm).
Print Collection,
Art, Prints and Photographs
Division, New York Public Library
(Astor, Lenox and Tilden
Foundations).

of the subject's thoughts. The entire pose, reinforced by the loose, easy drawing suggests an introspective, yet relaxed bemusement.

Harnett, best known for his *trompe l'oeil* still-life paintings (Fig. 219), created an image of haunting intensity in his *Portrait of a Young Girl* (Fig. 313). The drawing, executed in charcoal, exemplified the best qualities of 19th-century academic tradition—solidly realized form and modeling of exceptional delicacy. The nuances of texture have been rendered with amazing fidelity, the softness of skin, hair, and wool shawl contrasting with the sharply defined profile and the accented clarity of the eye.

Often the personality of an individual is revealed as much through posture and gestures as with facial characteristics. The unabashed posturings of the artist J. A. M. Whistler, delightfully recorded in an etching by Mortimer Menpes (Fig. 314), are clearly those of a colorful eccentric who willfully flaunted tradition, baiting critics and the public alike. He was described as "one of the great professional characters of the 19th century," a man of "engaging arrogance."

Posing with a fake parrot may appear to be either eccentric or contrived, yet in Joyce Treiman's self-portrait (Fig. 315) it seems quite natural. The quietness of the drawing is deceptive; at first glance it appears as an exercise in objective reporting. Gradually one begins to see traits of character revealed in the pose—thoughtfulness, commitment, determination, self-assurance, and vitality, well centered and supported by the foot firmly resting on the bench.

The Portrait

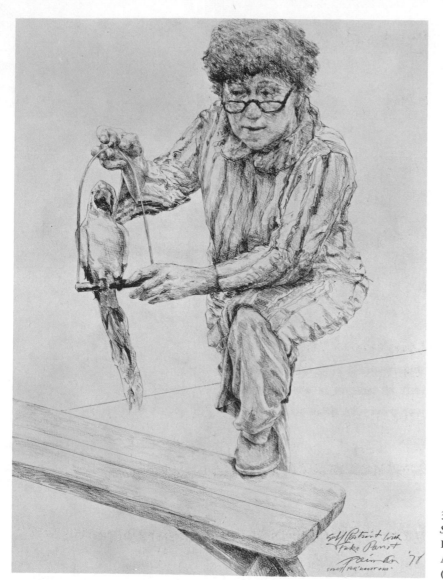

315. Joyce Treiman (b. 1922; American).
Self-Portrait with Fake Parrot. 1978.
Pencil, 29⅝ × 22″ (76 × 57 cm).
Art Institute of Chicago
(gift of Fairweather-Hardin Gallery).

Project 156 As you study portrait drawings, distinguish between those that aim at a purely objective recording of features and those that go beyond to suggest subtle facets of personality (Fig. 316). When you have developed confidence in your ability to render a likeness objectively, begin to introduce a note of subjectivity into your drawings. Allow your drawing to reflect more than the external characteristics of your subject; try to find the means to respond to the personality of your model in ways that are visually expressive.

Caricature

Webster's dictionary defines caricature as "a picture in which certain features or mannerisms are exaggerated for satirical effect." While in many kinds of portraits the minor eccentricities and idiosyncratic details of feature and expression are minimized (or almost completely eliminated as in the idealized portrait), such elements provide the essence of caricature. Caricature demands a special talent. The ability to select and sharpen telling details of feature, head shape, posture, and particularly expression seems closely related to a heightened sense

316. Mark Adams
(b. 1925; American).
Margery. 1980.
Pencil, 24 × 19'' (61 × 48 cm).
Courtesy the artist.

of character. Like all satire, caricature can be humorous and kindly, mordant and biting, or almost ribald in the gusto with which it depicts its subject. Many a fine caricaturist cannot do a "straight" portrait; many a fine portrait artist cannot caricature.

Caricature goes far back in history. Artists have reveled in vividly expressing human evils through astute selection, exaggeration, and distortion. Medieval art abounded with devils and demons presented in the most fearsome forms. In more recent centuries such treatment is most frequently applied to politicians, who are often almost savagely caricatured in the printed news media. Robert Pryor has created an ingenious potpourri of political powers, including nine presidents of the United States (Fig. 317).

The particular genius of the caricaturist has rarely received more brilliant expression than in the drawings of David Levine (Fig. 318). Less than a month following the 1980 presidential election, Levine's interpretation of the victorious Ronald Reagan preparing to assume the presidency beamed from the cover of a prestigious national periodical. The eyes, cheeks, and expansive crooked smile can be recognized immediately, yet there is something unfamiliar about the image. Levine, obviously responding to the repeated jokes about the true color of Reagan's hair, has depicted him white-haired and wrinkled, seated before a

**Candidates
and Presidents.
Who's Most Like Whom?**
Moving clockwise from the left, George
Wallace, Morris Udall, Ellen McCormack,
Henry Jackson, and Frank Church resemble
Woodrow Wilson. Ronald Reagan and Terry
Sanford would govern in Franklin Roosevelt's
manner. Sargent Shriver and Nelson Rockefeller
have motives like those of Dwight Eisenhower,
while Jimmy Carter and Milton Shapp
resemble Lyndon Johnson. Gerald Ford is
most like Richard Nixon. In the center of
the picture, Birch Bayh, Hubert Humphrey and
Lloyd Bentsen display Herbert Hoover's
pattern. Morris Udall, Nelson Rockefeller and
Fred Harris are like Harry Truman.
(Udall and Rockefeller appear twice because
their motivation resembles that of two Presidents.)

above: 317. Robert Pryor (20th century; American).
Candidates and Presidents. Who's Most Like Whom?.
Reprinted from *Psychology Today* Magazine.
Copyright © 1976 Ziff-Davis Publishing Company.

left: 318. David Levine (b. 1926; American).
Ronald Reagan. Reprinted with permission
from *The New York Review of Books*.
Copyright © 1980 Nyrev, Inc.

319. Henri de Toulouse-Lautrec
(1864–1901; French).
Yvette Guilbert, study for a poster.
1894. Pencil and oil on paper,
7¼ × 3⅝'' (19 × 9 cm).
Musée Toulouse-Lautrec, Albi.

theatrical mirror, an ample assortment of makeup containers before him. The delicacy with which the lipstick is held perhaps suggests the deftness with which the makeup is to be applied. Levine's use of cross-hatching to emphasize features and create volume has been widely imitated.

Visual recognition remains the essential ingredient of successful caricature, and for that reason most caricaturists focus their attention on well-known public personalities. Entertainers have always provided a special attraction for artists and public alike. Toulouse-Lautrec, a veritable fixture in the cabarets of Paris, immortalized in his drawings, paintings, and posters the colorful and eccentric music hall performers who were his friends (Fig. 286). "For Heaven's sake, don't make me so atrociously ugly," pleaded the horrified cabaret singer Yvette Guilbert in a letter to Toulouse-Lautrec when she first saw his sketch for her poster (Fig. 319). Later, when critics praised his interpretation and she realized the value of the poster to her continued popularity, her wounded vanity was considerably healed. The sketch reveals the artist's fascination with Yvette's ugly grace as he captures every nuance of feature and gesture. One cannot but take delight in the contrast between her almost clownlike makeup and the affected elegance of her pose.

The Portrait

320. Al Hirschfeld
(b. 1903; American).
Danny Kaye at the Palace. 1953.
Pen and ink, 30 × 24'' (76 × 61 cm).
Reproduced by special arrangement
with The Margo Feiden Galleries,
New York.

The world of Broadway theater would be incomplete without the talents of Al
Hirschfeld. For the past half-century his sure, witty pen has witnessed every
major, and sometimes not so major, theatrical event and has portrayed stars of
major and minor magnitude. His drawings (Fig. 320), which are reproduced in
newspapers, magazines, and theater yearbooks, are developed from sketches
made during rehearsal and try-out periods. He explains that the essence of the
performer is revealed only in performance. Only by observing comedian Danny
Kaye in action would it be possible to conceive of the rhythmic patterns of
multiple images that convey the frenetic gracefulness of his movements—six
feet, eight elegantly expressive hands, and one head drawn in such a manner
that it, too, seems more than a single image.

Project 157 If you have not attempted a caricature, do so now. Regular features
will prove difficult to caricature. Strongly distinctive or irregular features allow
greater potential for exaggeration. Distortion often serves as the basis for carica-
ture (Fig. 317). If you are working from life, it is best to study your subject engaged
in conversation or some other activity, for it is then that traits of character and
individuality are revealed.

Part Six
Synthesis in Drawing

15 *Illustration*

This book is illustrated with drawings exhibiting great diversity in subject, media, style, and purpose. In the context of the book, all of the drawings can be identified as illustrations. Technically, only some of the drawings, including all of those in this chapter, can be classified as illustrations.

What Is Illustration?

Illustration is as old as civilization itself, writing having originated in easily recognized object drawings known as pictographs. Perhaps the most encompassing definition that can be given for illustration is "visual language." If we accept that interpretation, any drawing or painting that communicates information, ideas, or feelings could be labeled illustration. Art that emphasizes storytelling is often described—and frequently dismissed—as being "illustrative."

The technical distinction between "fine art" and "illustration" is that the latter is created expressly for the purpose of commercial reproduction. Apart from that condition, many drawings done as illustrations fit easily into the category of fine art and are exhibited and collected as such. Many major artists have at one time or another worked as illustrators—William Blake, William Hogarth, Vuillard, Picasso, and Matisse among them. Some turned to illustration out of choice; others, such as Winslow Homer (Fig. 102) and Edward Hopper (Fig. 321), were forced to earn their livings as illustrators for a period of their careers. Much of Hopper's commercial work was included in a bequest to the Whitney Museum in New York in 1968. An exhibition of his illustrations, both at the Whitney and at other museums around the country, attests not only to Hopper's significance as an artist, but to a renewed interest in the art of illustration.

Illustration Versus Fine Art

Illustration is the area of commercial art most closely related to fine art. Whether creating fine art or illustration, artists embrace the traditional areas of subject matter (Chaps. 11–14), are knowledgeable about the elements of art (Chaps.

4–8), and use media and technique (Chaps. 9–10) in imaginative ways (Chap. 16). There are, however, decided differences. The fine artist works independently, choosing when, what, and how to draw, generally without having to please anyone else. In contrast, the commercial illustrator works under the guidance of an art director, must be concerned about how the work will reproduce, has to meet a deadline, and is responsible for satisfying a client. Beyond that, the illustrator must create an image that will be understood by the greatest number of viewers. The legendary American illustrator Norman Rockwell spoke of this restriction: "You've got to please both the art editor and the public. This makes it tough on the illustrator as compared with the fine artist, who can paint any object any way he happens to interpret it."

The distinction between illustration and fine art began to be made early in this century with the clash between the traditional literalism of illustration (Fig. 321) and the modern art movement (Figs. 234, 289). For more than half a century the art of illustration developed more or less independently from fine art. The difference between the two fields was perhaps greatest during the late 1940s and 1950s, which were dominated by nonrepresentational art. That difference has lessened in recent years, with illustration beginning to reflect aspects of contemporary art at the same time that figurative and representational elements have reappeared in fine art. Once again artists are working successfully in both fields. No longer is it considered demeaning for a fine artist to engage in illustration. This apparent merging of the two areas of art may have started when, in the late 1950s and 1960s, a number of major corporations introduced works by prominent contemporary artists into their advertising.

A resurgence of interest in illustration has occurred. Bookstores abound with books reproducing the works of major illustrators, past and present; poster art as art flourishes, with leading auction houses conducting sales devoted exclusively to poster art. Illustrations are being exhibited in major museums, and the works of some contemporary illustrators, as well as those of legendary figures in the field, are sought after by collectors.

321. Edward Hopper
(1882–1967; American).
In a Restaurant. c. 1916–25.
Conté on illustration board,
26⅝ × 21¾" (68 × 55 cm).
Whitney Museum of American Art,
New York (bequest of
Josephine N. Hopper).

Types of Illustration

Commercial illustration in its various forms now appears to be divided between drawing and painting on the one hand and photography on the other. Three major categories of illustration are editorial, advertising, and medical and scientific, each making its own demands on the artist. While versatility is an asset, most professional illustrators select an area of specialization. This survey of the purpose and requirements of certain kinds of illustration and the limited sampling of examples that can be reproduced offer only a general introduction to this diverse field. For an expanded look at the richness and variety of contemporary illustration, you may want to consult the several handsome illustration yearbooks that are published annually.

Editorial Illustration

Editorial illustrations accompany stories and articles in books, magazines, and newspapers. Although guided by an art director, the illustrator must have an awareness of the content and structure of each story or article to insure that the choice of imagery, plus style and technique, are compatible with the text and grasp the essential meaning of the piece.

Book Illustration Nineteenth-century novels were almost always illustrated; today adult books rarely are. Illustrations are confined mostly to book jackets, special limited editions designed for book collectors, and what might be considered "children's books for adults," such as those created by Edward Gorey (Fig. 322) and David Macaulay (Fig. 147).

Book jackets, originally called "dust jackets," were intended simply to protect the covers of books. Today they play an integral role in the sale of books, designed as they are to attract the attention of buyers. The function of the jacket or cover is to suggest the essence of the book quickly, effectively, and truthfully. Some covers use only type; many others incorporate illustration as well, combining the talents of graphic designers and illustrators (Fig. 323).

322. Edward Gorey
(20th century; American).
"The summer she was eleven,
Drusilla went abroad
with her parents." Illustration
for *The Remembered Visit*
(Simon & Schuster, 1965).
Copyright © 1965
by Edward Gorey.

Illustration

251

Project 158 Visit a bookstore and study book jackets. Take note of the books that immediately attract you out of the hundreds of volumes crowded side by side on display racks and tables. Spend time in different sections of the store becoming aware of the great variety in book jacket and cover design, noticing how illustrations are used and integrated into the designs. Also study your own books at home. Determine why the cover illustration was chosen and judge whether it is appropriate.

Project 159 Select a book that you have read and know well and do a drawing that would be effective as a jacket illustration, letting it indicate the general character of the book rather than depict one specific event or aspect. Style and technique as well as subject matter or image should be carefully considered. As a professional illustrator you would have to know about methods of reproduction in order to prepare a drawing or painting suitable for the process to be used. That aspect of illustration, however, is beyond the scope of this book. For this assignment, be concerned only with the appropriateness and effectiveness of the illustration. Since most illustrators are required to submit preliminary sketches for approval, adopt the habit of making a few rough drawings for each illustration.

323. Susan Stillman (20th century; American). Jacket illustration for *Bellefleur,* by Joyce Carol Oates. 1980. Reprinted by permission of the publisher, E. P. Dutton.

Contemporary book illustrations are often used to depict character and establish mood (Fig. 324) rather than to portray specific episodes from the narrative. One of Barron Storey's illustrations for *The Great White Whale* forcefully captures the mood of the book, suggesting the insane obsession of Captain Ahab, who stands defiantly erect against the battering forces of the sea, his ivory leg planted firmly on the deck. Storey's handling of pen-and-ink cross-hatching remains very much in the tradition of 19th-century illustrations reproduced by wood engravings, a technique widely used by illustrators today, as evidenced by other examples in this chapter. Line drawings, being the easiest and most economical to reproduce, are usually specified for adult book illustrations.

Project 160 Assume that you have been asked to submit two sample illustrations for a fiction or nonfiction book of your choice. The drawings, to be done in ink line, will be judged for content, the effectiveness and accuracy with which they convey the character of the book, consistency of style, and their ability to be reproduced. All illustrations for a single project should be drawn in the same scale to minimize reproduction costs. Determining size for the original art work is an important consideration. Because much of the detail of intricate, fine line drawings will be lost if too much reduction is necessary, it is best to keep drawings to no more than twice the size they will be reproduced.

Famed turn-of-the-century British illustrator Arthur Rackham commented that "the most fascinating form of illustration consists of the expression of an artist of an individual sense of delight or emotion, aroused by the accompanying passage of literature." Illustration originates with and must be true to the words of the author. Good illustration should amplify the text, but it should not depend upon a caption to explain its meaning.

Professional illustrators are called upon to provide drawings for subjects that lie beyond their own personal experience. Artists, authors, filmmakers—all persons who create visual and verbal images pertaining to subjects apart from their immediate situation—must learn how to use reference material to search for any information that will provide authenticity to their work. It is of incalculable value to know how to use the resources of libraries. Of particular import to the illustrator are the picture collections maintained by major libraries. The New York Public Library offers the largest picture collection in the United States— more than 2,250,000 pictures, with another 30,000 added annually. While all

324. Barron Storey
(20th century; American).
Captain Ahab, illustration for
The Great White Whale
(Reader's Digest Association, Inc.).
1978. © 1981 Barron Storey.

Illustration

253

libraries do not boast such impressive picture holdings, they can provide considerable assistance to the illustrator. There are also several indexes that assist artists in locating published illustrations on specific subjects—for example, *Picture Sources,* edited by Celestine Frankenburg (Special Libraries Association, 1975). Having found appropriate information, the illustrator relies upon a knowledge of perspective and the human figure to adapt the material to the immediate need. David Macaulay's remarkable visual recreation of the building of a Gothic cathedral (Fig. 147) would have been impossible without, first, researching the building techniques of the period and, second, having sufficient mastery of perspective to construct drawings from such unusual vantage points.

Children's Books Children's books by tradition have been and continue to be richly illustrated. In many instances the illustrations have become as legendary as the stories themselves—Sir John Tenniel's classic illustrations for *Alice's Adventures in Wonderland,* for example (Fig. 325). While in adult books drawings are generally seen as incidental enrichment, much of the success of a children's book depends upon the contribution of the illustrator since a child's imagination is activated through the combination of verbal and visual imagery.

In children's books the text and illustrations go hand in hand, the illustrations both following and advancing the story. Children are an appreciative but critical audience who expect drawings to be faithful to the text. While free to select style, the illustrator is not free to reinterpret even the most minute details of the text, as anyone who has ever attempted to satisfy a child's questioning can attest.

A survey of children's book illustrations reveals great diversity of styles. Most drawings, however, retain a certain literalness in representation so that visual identification is assured. This can be accomplished without sacrificing imagination and invention. While children's literature frequently incorporates a sense of fantasy and make-believe, successful illustrators are able to treat the commonplace with whimsy, vividness, vitality, and excitement (Figs. 326, 327).

325. John Tenniel
(1820–1914; English).
The Lobster Quadrille,
illustration for
Alice's Adventures in Wonderland.
Reprinted from *The Annotated Alice,*
edited by Martin Gardner.
Published by Crown Publishers,
Inc., 1962.

Synthesis in Drawing

254

above: Plate 10. Egon Schiele (1890–1918; Austrian).
Self-Portrait. c. 1917.
Pencil and gouache, 18⅛ × 12″ (46 × 30 cm).
National Gallery, Prague.

right: Plate 11. Hans Holbein the Younger
(1497/98–1543; German).
George Brooke, 9th Baron Cobham. 1538–40.
Black and colored chalks, with pen and black ink;
11¼ × 7⅞″ (29 × 20 cm).
Royal Library, Windsor Castle, England
(reproduced by gracious permission
of Her Majesty Queen Elizabeth II).

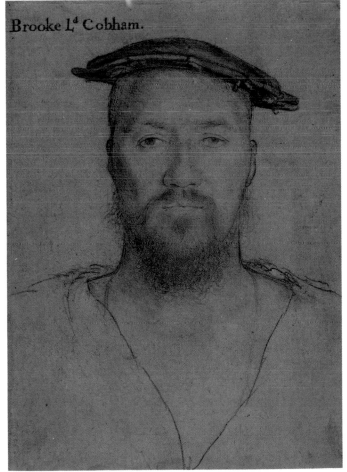

Brooke Lᵈ Cobham.

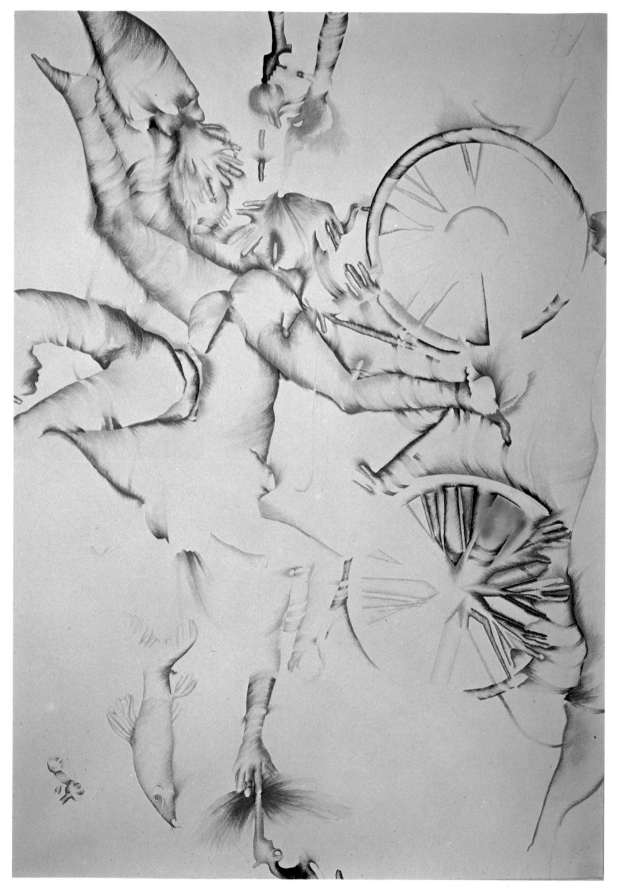

Plate 12. Marisol (Marisol Escobar; b. 1930; Venezuelan).
Lick the Tire of My Bicycle. 1974. Colored pencil and crayon, 6′ × 8′10′′ (1.83 × 2.69 m).
Courtesy Sidney Janis Gallery, New York.

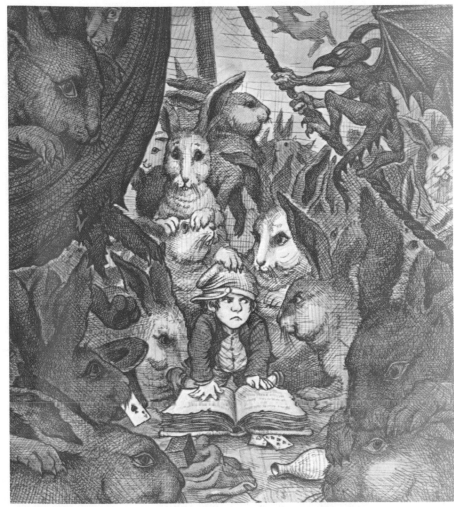

326. Mercer Mayer
(20th century; American).
Illustration for *A Special Trick*.
Copyright © 1970 by Mercer Mayer.
Used by permission of
The Dial Press.

327. Maurice Sendak
(b. 1928; American).
Illustration for
"The Three Feathers" from
*The Juniper Tree
and Other Tales
from Grimm,* translated by
Lore Segal and Randall Jarrell.
Pictures copyright © 1973
by Maurice Sendak.
Reprinted by permission of
Farrar, Straus & Giroux, Inc.

Illustration

328. John Steptoe
(20th century; American).
Illustration from
Daddy Is a Monster . . . Sometimes.
Copyright © 1980 by John Steptoe.
By permission of J. B. Lippincott,
Publishers.

The works of many of the best-known 19th- and early-20th-century illustrators of children's books have been made available in recent years in paperback editions, and the illustrations of Maurice Sendak (Fig. 327) are the subject of a major study. Anyone interested in illustrating children's books should become familiar with what has been done and what is being done. While many illustrators continue to use rather traditional methods, other artists are exploring different techniques to create a more contemporary effect (Fig. 328).

Project 161 *For this project it would be best if you could work only from the text of a children's story so as not to be influenced by existing illustrations. If you feel any flair for storytelling you might want to write and illustrate your own story. Although the drawings must also appeal to adult buyers, consider the age of the child to whom the book is directed. Do several drawings that are consistent in style and sustain a character or group of characters through a variety of situations and expressions. You might choose to design your illustrations to include the text.*

Magazine and Newspaper Illustration While certain book illustrators, such as Edward Gorey (Fig. 322) and Maurice Sendak (Fig. 327), develop a personal style that remains relatively constant from book to book, illustrators of stories and articles for magazines and newspapers are expected to be able to change style almost from one assignment to the next. Change is inherent in all aspects of contemporary life, particularly in the field of mass communication in which capturing the largest percentage of public attention is, of necessity, the prime consideration.

A glance through any magazine or newspaper will reveal the use of both photographs and drawings; photographs accompany current news stories, while feature articles and fiction are frequently illustrated with drawings or paintings. The artist or photographer is generally called upon to provide a single major illustration that will both attract the attention of the reader and establish the

character of a story or article in an effective and substantially truthful manner (Fig 329). Readers willingly accept some slight exaggeration, but they are greatly offended by gross misrepresentation.

Art directors play a major role in determining what illustrations will be. Without a well-established reputation, an illustrator cannot expect to be granted complete independence in developing drawings. For this reason it is important that art students, especially those who think they might want to work in the commercial field, learn to follow assignments, accept criticism and suggestions made by instructors, be willing to make suggested changes, and complete projects on time.

The range of articles printed in popular periodicals requires illustrators who are capable of working with a variety of subjects and who are versatile in employing media and techniques, without allowing technique to become more important than content. Because magazines and newspapers focus upon topics of current interest, there is the additional demand of meeting deadlines.

Project 162 Select a feature article or story from a periodical and prepare a topical illustration conveying a general impression of the subject. As suggested by Figures 329 and 330, such drawings often tend to be symbolic, with the meaning immediately perceived when viewed in conjunction with the title of the article. Considerable boldness of drawing is required for drawings to be reproduced on the newsprint used for daily papers. Line drawings are most effective. Jack Desrocher has introduced spattering to achieve interesting textural quality for a newspaper illustration reproduced as a line drawing (Fig. 329). The technique provides a change from the cross-hatching so commonly used (Fig. 330).

Spot Drawings Spot drawings are used in books, magazines, and newspapers to attract the attention of readers and to provide visual interest for articles and stories that are not featured with a major illustration. Spot drawings are often related to the subject in a general way rather than being specific, as seen in David Suter's clever anthropomorphizing of a lunch bucket and gloves to convey the effect of unemployment for a magazine article entitled "A More Severe Slump" (Fig. 331). The drawing of feathers (Fig. 332) is one of a series that illustrate a book of poetry, *The Ancient Ones*. The drawings were executed as an artist's poetic response to verbal imagery rather than as precise illustrations of particular poems or lines.

329. Jack Desrocher
(20th century; American).
My Wasted Life, illustration
for the *San Francisco Examiner.*
1980. Pencil, width 10'' (25 cm).
Courtesy the artist.

left: 330. Brad Holland (20th century; American).
Illustration for *The New York Times Book Review.* © 1978
by The New York Times Company. Reprinted by permission.

above: 331. David Suter (20th century; American).
Illustration for "A More Severe Slump," *Time* Magazine.
1980. Felt-tip pen, 10″ (25 cm) square. Courtesy the artist.

left: 332. Daniel M. Mendelowitz
(1905–1980; American).
Prayer Feathers. 1978.
Pencil, 8″ (20 cm) square.
Collection Mrs. Daniel Mendelowitz,
Stanford, Calif.

Synthesis in Drawing

Some publications use spot drawings as "fillers"—that is, simply to fill unused space and at the same time introduce visual interest to a page. Since the need for fillers cannot be anticipated, such drawings usually are unrelated to the surrounding text and exist as a charming or whimsical bonus of no intended importance. Spot drawings also can be useful to impart information, as evidenced in the simplified step-by-step drawings common to "how-to" books. Although perhaps appropriately considered as an aspect of graphic design, spot drawings are frequently used in television newscasts to provide visual interest for stories for which no film coverage is available.

Sports Illustration The ability to depict movement, excitement, and atmosphere is essential to successful sports illustration, which tends to be a highly specialized field. The sports illustrator must understand sports and must be knowledgeable about the human figure and able to represent it convincingly in action (Fig. 333). It might seem that the camera is better able to freeze the image of figures in motion, yet very few of the photographs that appear in the sports section of daily newspapers convey the quality of movement and excitement associated with sports precisely because the action has been frozen. In most instances, top sports illustrators are better able to suggest the feeling of energy and movement that fans associate with sports seen live or viewed on television. While it is probable that many sports illustrators use photographs in their work, they have the skill to inject a sense of aliveness and vitality by means of clarification, simplification, and exaggeration. Robert Handville's dynamic representation of the speed and power of hockey players (Fig. 333) depends more on the energy contained in the strength of his gestural drawing than on detailed accuracy of form. Aspiring sports illustrators should avail themselves of as much life drawing as possible, with particular emphasis upon quick sketching (Proj. 135) and gesture drawing (Proj. 142).

333. Robert Handville
(b. 1924; American).
"Go, Bobby! Go—".
Illustration for
Sports Illustrated. 1965.
Reprinted by permission.

Project 163 You are well aware of the difficulty in drawing moving figures from life, and you also realize that drawings made from a figure who has assumed an action pose generally lack a convincing vitality. As an attempt at sports illustration, select a suitable photograph and make a series of loose gestural drawings until you arrive at one that appears both spontaneous and dynamic. By drawing on tracing paper, keeping all figures in the same scale, you may achieve a sense of animation through overlapping images. If you are sufficiently knowledgeable about the human figure you can alter the pose slightly on subsequent drawings to create the effect of action as seen in multiple-exposure photographs. You will discover that sports illustrations are most effective when combined with color.

Editorial Cartoons and Caricature There is a long and continuing tradition of political cartoons and caricatures as illustrations in popular periodicals. Cartoons remain a standard feature of the editorial page of most newspapers. The brilliant, biting look at the antics of national and world leaders have won Pulitzer prizes for some of their creators. Since their topics must be as current as yesterday's news, editorial cartoonists work under extreme deadline pressures.

The impact of an editorial cartoon generally results from the successful combination of visual image and caption, sometimes supplemented by dialogue incorporated into the drawing. Political cartoonists depend almost entirely on broadly exaggerated caricature.

Feeding the public's insatiable appetite for information about the famous and the infamous remains a primary function of popular periodicals. Although articles and news items most frequently are accompanied by photographs of such personalities, some magazines and newspapers continue the tradition of using caricatures to depict the familiar faces of politicians, literary figures, and entertainers (pp. 242–246). Drawings by David Levine (Fig. 318), Al Hirschfeld (Fig. 320), and other well-known caricaturists appear regularly in leading periodicals.

Advertising Illustration

A second major area of commercial illustration embraces everything done for advertising purposes. The categories include fashion, product, and travel illustration. As with all illustration, the purpose is to attract attention—in this area, the attention of potential customers, to flatter and stimulate interest in a particular article or commodity.

Fashion Illustration Fashion drawing falls into two categories: *reporting* (Fig. 334) and *advertising drawings* (Fig. 335). Reporting, which is a more limited field, is directed toward revealing new trends in fashions; drawings are intended to convey the general characteristics of forthcoming styles rather than to depict specific garments in detail. Fashion reporting treats fashion as news.

Fashion drawings that appear in advertising are designed to sell merchandise. Though often highly stylized, individual garments are rendered with considerable concern for accurate detail. Illustrators working in the field of fashion are likely to specialize in drawings of women, men, children, accessories, shoes, or jewelry.

The style of representing fashion changes as rapidly as fashion itself. Illustrators must be versatile, flexible, and imaginative. Not only must they be up to date, they must also be able to anticipate and initiate change. Strictly literal representation, no matter how well drawn, lacks buyer appeal.

In the fashion field, competition between artists and photographers is keen. While the camera has the advantage of recording action and introducing varied and interesting backgrounds, the photographer can do little to alter the actual appearance of the model. In contrast the artist has greater freedom to change, exaggerate, dramatize, simplify, add, or eliminate. A skilled artist, working from any model, can totally transform the character of the figure at will.

right: 334. Steven Stipelman
(20th century; American).
Illustration for *Women's Wear Daily.* 1980.
Pen and ink. Reproduced by permission
of the Fairchild Syndicate.

below: 335. George Stavrinos
(20th century; American).
Advertisement for Bergdorf-Goodman
published in *The New York Times.* 1980.
Courtesy the artist.

Training for a fashion artist should include drawing from nude and clothed models whenever possible. Knowing how the body works in motion and understanding how the figure is constructed permit effective distortion. Figures in fashion illustrations are rarely realistic or conceived as anatomical studies, yet they must appear to have an underlying sense of structure, proportion, and balance. Pose, gesture, and movement, while exaggerated, must at the same time be convincing and plausible. Structure and pose both determine how a garment hangs, as does the weight and character of the fabric. A garment must appear to fit; it must follow the contours of the body and appear to move with the body. Although still-life studies of pieces of draped cloth perhaps seem uninspiring, fabric is the "stuff" that fashions are made from. The ability to suggest and render different materials and textures in a variety of media and techniques is a basic requirement for fashion artists.

Working from live models is desirable but costly. Fashion illustrators develop the ability to work without models. They learn to make quick sketches to capture interesting poses, movements, and gestures. They practice constructing figures, often using photographs for reference, in order to visualize figures from different angles to show a garment to best advantage. It is general practice to develop on tracing paper rough drawings that can be refined before being transferred to smooth paper for line drawings or to illustration board for wash drawings.

Figures in fashion illustrations are drawn according to completely arbitrary proportions that bear no resemblance to the general proportions for the human figure as presented in Chapter 13 (p. 206). Although the legs and feet have not been indicated, the highly stylized figures drawn by Steven Stipelman for *Women's Wear Daily* (Fig. 334) appear to be at least thirteen heads tall. Fashion figures, in general, are shown as tall and slender, though not always exaggerated to the same degree. Proportions, in fact, vary according to the particular fashion illustrated, the mood to be created, the occasion for which the garment would be worn, and the clientele at whom the drawing is directed. For example, the proportions of figures wearing casual clothing are generally closer to reality than those for figures in elegant evening wear. Not only would the proportions differ, so too would the style of drawing, the pose and attitude of the figures, the treatment of the face and hair, the setting; all aspects of the drawing must be consistent with the character of the garment (Fig. 336). For women's fashions a note of theatricality is frequently introduced (Fig. 335).

Fashion drawings, as with all other categories of advertising illustration, must be developed as part of a layout that includes headings, advertising copy, and the client's name (Fig. 337). Unless the illustrator is also responsible for the layout, it is necessary to learn to work within the prescribed format to create a visually stimulating ad. Fashion illustration often includes groupings of figures, sometimes represented in the same scale in a unified setting (Fig. 335), but often a series of single figures of different scale juxtaposed into an effective design.

Male fashion drawings rely upon highly idealized forms that only slowly are beginning to break away from stereotypical concepts of masculinity. In Figure 337 the facial features and the pose are suggestive of strength and energy. The details of the sweater, shirt, and pants are boldly simplified; only those folds and wrinkles that suggest action are delineated. The emphatic use of diagonal lines in the lower half of the body adds vigor to an otherwise relaxed pose.

Adjectives that describe the desired qualities for fashion drawings of children are "charming," "unself-conscious," and "animated." Careful attention to gestures and posture is important in drawing children, as is an understanding of the proportional changes that occur in children of different ages. Fashion illustrators generally specialize in drawing women, men, or children; only rarely do drawings of one include either of the other two.

Accessories provides one additional area of specialization in fashion illustration. Hats, bags, shoes, scarves, belts, jewelry are, in effect, the province of the fashion still-life artist, who is expected to make such objects stylish and appeal-

above: 336.
Erté (Romain de Tirtoff;
b. 1892; Russian-French).
Ermine with Moleskin and Beads.
1917. Reprinted from
Designs by Erté,
edited by Stella Blum.
Published by Dover Publications,
Inc., 1976.

above right: 337. Gail Hicks
(20th century; American).
Advertisement for Joseph Magnin
published in the
San Francisco Chronicle.
1981. P. K. Kirtley, Art Director.
Courtesy Joseph Magnin,
San Francisco.

ing without obvious falsification. This speciality requires an artist skilled at depicting detail and rendering textures and materials with a sense of flair.

Project 164 Perhaps more than in any other field, one learns about fashion illustration by studying fashion drawings, fashion magazines and journals, and window displays of fashionable stores. Because the style, both of the fashions and illustrations, changes so rapidly, it is important to be familiar with what has been done in the field over a period of years. Libraries can supply magazines from previous years, and since so many fashion drawings are done for newspaper advertising, check to see if your library has <u>The New York Times</u> or other major metropolitan newspapers on microfilm. It is possible to make photocopies from microfilm of drawings you would like to have for reference. Begin to accumulate a file of outstanding examples of fashion illustration—drawings that employ interesting techniques and photographs of figures—to use for reference. Carefully analyze the most interesting drawings, noting how proportions have been exaggerated; how heads, hands, and feet are drawn; how forms are simplified; and how details and textures have been rendered. Working on tracing paper, begin to translate fashion photos into fashion drawings that appear natural and effortless. A well drawn head is important. Select the most effective preliminary study and make a finished rendering.

Illustration

265

Product Illustration The area known as "product illustration" includes almost anything that can be manufactured and offered to the consumer. While in the most literal sense product illustration would seem to be restricted to depicting objects, illustrations created for record albums and to advertise movies and television programs are product-related (Fig. 338). Such assignments are facilitated by an artist's background in figure drawing.

The representation of objects involves a knowledge of perspective and rendering techniques. The illustrator is expected to depict commonplace objects with style, to make them attractive to the public. The objects cannot be falsified; they can, however, be idealized and dramatized. Frequently an unusual or exaggerated perspective is introduced to intensify the form, while bold modeling in light and dark and dramatic rendering of surface and textures complete the effect. Standard still-life experiences provide the basis for such illustrations.

A well-known song title, altered by the substitution of a "sound-alike" word, provides the theme for Penelope Gottlieb's imaginative advertising drawing for a combination lighting fixture and ceiling fan (Fig. 339). The clever combination of the new title—"As Time Glows By"—with images of an upright piano, a smoldering cigarette, and the shadowy silhouette of a figure clad in a trench coat and fedora, are calculated to delight generations of film buffs, especially Humphrey Bogart fans, who would immediately associate the mood of intrigue, danger, and romance with Rick's Café Américain, the setting of the film classic *Casablanca.*

Project 165 Select a familiar commercially manufactured product and explore various ways of depicting it that would be appropriate for an advertising illustration. Stylize and dramatize the object without falsifying the form. Try different rendering techniques. Make preliminary studies before attempting final drawings.

below left: 338. Bob Ziering (20th century; American). *Janis Joplin.* 1974. Pen and ink, 17 × 14" (43 × 36 cm). Courtesy the artist.

below: 339. Penelope Gottlieb (20th century; American). *As Time Glows By,* advertisement for Brown & Gold Lighting. 1981. Pencil, 20 × 15" (51 × 38 cm). Courtesy the artist.

340. Tom McNeely
(b. 1935; Canadian).
CNE 100. 1978. Watercolor,
22 × 30″ (56 × 76 cm).
Courtesy the artist.

Travel Illustration The extensive advertising programs sponsored by the travel industry call for a varied assortment of illustrations from elaborate full-color paintings to spot drawings. Styles and techniques are as varied as the services provided, offering artists assignments that include landscape, architectural subjects, and figures (Fig. 340).

Project 166 Assemble an assortment of visual information relating to a specific city, country, or other tourist spot. Combine a variety of interesting and characteristic elements into a composite drawing that establishes the specific character of the subject place. It is not necessary in such a montage that separate elements be drawn in proper scale. Use tracing paper overlays to arrive at your final composition. Additional tracings in ink can be helpful in establishing a fresh and spontaneous final drawing.

Medical Illustration

While artists traditionally rely upon anatomical drawings as a means of understanding the construction of the human body, similar drawings are used to impart information to persons in the medical profession. Medical illustration is "the graphic representation of any medical subject made for the purpose of communicating medical knowledge" (Fig. 341).

To become a medical illustrator, it is necessary to have a scientific background and interest as well as extensive art training. Since absolute accuracy is critical in medical illustrations, the artist must possess highly trained powers of observation and meticulous draftsmanship. It is necessary to do more than just reproduce what is seen—a camera can do that. The artist is called upon to do what the camera cannot do—clarify and simplify, select what is essential in order to communicate effectively and completely. Drawings used to illustrate articles published in medical journals are prepared in collaboration with surgeons, often from sketches made on location in the operating room as the surgeon describes to the illustrator what the drawing is to reveal. The artist must have both the knowledge and imagination to visualize what is desired and find the most effective means to communicate the information. Medical illustrators are also employed to prepare drawings for courtroom presentation in suits involving medical testimony.

Illustration

267

Right hepatic
Left hepatic
Hepatic sinusoids
Hepatic portal
Inferior vena cava
Splenic
Inferior
mesenteric
Superior
mesenteric

Doreen Davis HL

341. Doreen Davis Masterson
(20th century; American).
The veins of the
hepatic portal system.
Reprinted by permission from
Spence, Alexander P., and
Elliott B. Mason,
Human Anatomy and Physiology,
Menlo Park, California,
The Benjamin/Cummings Publishing
Company, Inc., 1979
(Fig. 20-24, p. 554).

A number of major university medical schools offer specialized training in medical illustration, which includes learning to work with doctors in the operating room. Admission requirements to such programs vary. Interested art students should prepare by taking classes in life drawing, anatomy, still life, perspective, design, composition, rendering, watercolor, and air brush.

342. Bryony Carfrae
(20th century; British).
Stone Crab. 1977. Pen and ink,
life-size; 2 × 3¾'' (10 × 5 cm).
Courtesy the artist.

Scientific Illustration

Each of the scientific disciplines has its own needs for illustrative materials. The qualities required for all scientific drawings are accuracy, clarity, and neatness, as evidenced in Figures 203 and 342. Details of form and surface characteristics must be accurately observed and meticulously rendered. Forms must be evenly lighted without obscuring shadows. It is fairly standard procedure to place the source of light at the upper left. Stippling is the most common method used for shading. Darker tones are achieved by more dots in closer proximity. Stippling takes time and patience; the pattern of dots should be random but never careless. It is the size of the pen, not pressure, that determines the size of the dots. Dots that are too fine will be lost in reproduction. Light drawings reproduce better than dark drawings. Artists must learn not to overwork their drawings. It is generally advisable to introduce some tone through the entire drawing rather than fully develop any one area.

Project 167 *Use the stipple technique described to do a scientific drawing of some appropriate form available to you. If possible, mount the object on a vertical surface directly in front of you, or place it so you can view it from above to avoid a foreshortened view. Keep your source of light constant once you begin stippling.*

Preparing a Portfolio

If you seek employment as an illustrator, it is essential to prepare and maintain a portfolio with samples of your best work to show agencies, art directors, and potential clients. Never include any drawing with which you are not totally satisfied; it is better to include few drawings of high quality than many of poorer quality. Be extremely selective. Put aside any sentimental attachments you have to particular drawings and include only your best. It is also important that you keep your portfolio up to date. It is unwise to show the same drawings if you make return visits to the same people.

Your portfolio should demonstrate both variety and consistency. Select pieces using different media and techniques, but be certain that your own sense of style is evident. If you know in advance what type of accounts an agency or art director handles, you can select pieces that most closely meet those needs.

It helps to include an example of your work that has been reproduced, to show both how your drawings reproduce and that they have been used. If you are an "unreproduced illustrator," as it were, it is possible to have some pieces commercially photographed with prints made at a slightly reduced size from the original drawings. A sample of a preliminary rough with the corresponding finished drawing provides an indication of your ability to "follow through."

Concentrate upon making the best possible presentation. All drawings should be clean, well matted, and easy to handle. If possible use mats of uniform outer dimensions with openings appropriate to the individual drawings. Smaller drawings can be attractively grouped in a single mat board. Drawings should be attached to a backing board the same size as the mat with the mat hinged to the backing board with paper tape. Covering each drawing with acetate is less troublesome than placing protective tracing paper over the complete mat.

Put as much thought and effort into preparing your portfolio as you did into doing the drawings. While it is the art that counts, art directors are influenced by the quality and degree of imagination evident in your presentation.

Illustration

269

Imagination

16

The elements of imagination are so diverse and so different in each person that we could not begin to describe them all. Even if we were to make an exhaustive list, adding all those factors together would still not approach the entire scope of imagination. There is no aspect of artistic expression in which the play of imagination is not necessary, for imagination fosters the heightened power of communication that characterizes the arts. Every person exhibits imagination to some degree, if only in the form of daydreaming. While daydreaming can be defined as undirected imaginative wandering, we develop the ability to transform that imaginative potential into patterns of creativeness through doing.

To begin to understand how imagination works, we might isolate some of its aspects that are reasonably easy to categorize. Four of these are *empathy, fantasy, particularization,* and *generalization.*

Empathy

The ability to empathize is basic to imaginative activity. It is characterized by the capacity to identify with the subject, to conceive and share feelings and experiences not readily evident in surface appearances, to perceive an emotional character even in inanimate objects, and above all to project this sympathetic attitude through the work of art. Empathy might also be described as the ability to externalize feelings, enabling the artist to give meaning to the commonplace.

It is possible for artists to become so caught up in recording what is observed that they fail to respond to the subject. Considerable emphasis has been focused on learning to see as a fundamental element in learning to draw. Once you have developed your perceptive abilities and have gained technical proficiency with media and techniques, you are free to begin interpreting what you see, drawing subjectively rather than objectively. You can begin to direct your attention to "what to draw" instead of "how to draw." The ultimate goal is to respond naturally and intuitively without consciously having to decide how to respond.

To draw with empathy is to draw with expression. Just as some persons learn to play musical instruments with technical facility, but without feeling or warmth, so too do some artists develop the necessary proficiency to draw well, but their drawings lack personal expression and interpretation. While subject

matter, choice of media, and technique contribute to the effectiveness of a drawing, it is the expressive qualities to which the viewer most responds.

Whereas an artist of limited imagination might well have been satisfied doing a literal rendering of a pair of gloves, Toulouse-Lautrec's charming drawing of *Yvette Guilbert's Gloves* (Fig. 343) is as much a portrait of the entertainer as that seen in Figure 319. Even carelessly draped over a theatrical trunk, the gloves are vibrant with character and individuality. The originality of Toulouse-Lautrec's concept has been forgotten; perhaps the image even seems trite since movies and television have so frequently employed close-up shots of an object to provide a poignant symbolic ending to films about legendary persons.

The warmth and tenderness with which Morris Broderson has depicted *Tolstoy and His Granddaughter* (Fig. 344) clearly reveals the difference between subjective and objective drawing. Broderson has portrayed the Russian novelist with such depth of feeling that the drawing becomes a moment of intimacy shared between the artist, his subject, and the viewer.

The first principle of Chinese art, as conceived in approximately A.D. 500, set artists to the task of creating a life-force or aliveness by identifying with subject matter, absorbing it, and drawing it internally as it were, not as something alien and seen from outside. Working in that tradition, Awashima Chingaku's delightful brush drawing of a cat (Fig. 345) is drawn not so much from observation or memory as from total identification and oneness with the animal.

Project 168 Select a sampling of the drawings that you have done until now. In looking again at some of the early drawings, you may be amazed at the progress you have made. As you review the drawings, perhaps you detect that some are more expressive than others; in some instances it can be credited to the more

below: 343.
Henri de Toulouse-Lautrec
(1864–1901; French).
Yvette Guilbert's Gloves.
1894. Oil on cardboard,
24½ × 14½″ (63 × 37 cm).
Musée Toulouse-Lautrec, Albi.

below right: 344.
Morris Broderson
(b. 1928; American).
Tolstoy and His Granddaughter,
detail. 1971. Pencil,
sheet 13 × 10″ (33 × 25 cm).
Courtesy Ankrum Gallery,
Los Angeles.

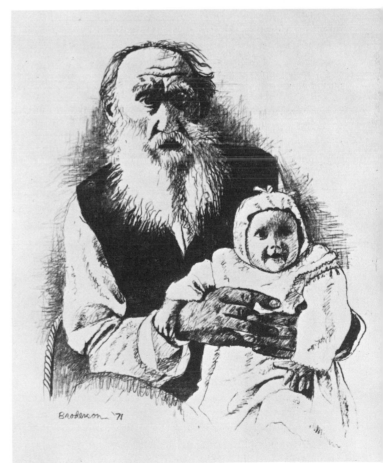

Imagination

271

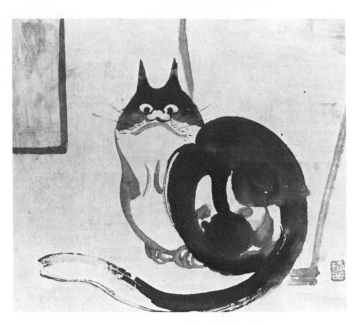

345: Awashima Chingaku
(1822–1888; Japanese). *Cat.*
Kakemono, ink and color on paper;
15⅜ × 40½″ (39 × 103 cm).
Private collection of Harold Philip Stern,
Ann Arbor, Mich.

skillful manipulation of media and technique, while in others it is because you drew with feeling. Pick out some drawings of subjects that interest you but that lack expression. How would you now, with your increased experience and skill, interpret the subjects differently? What conscious exaggeration of line movement, of light and dark, of texture would communicate your feelings more forcefully than would an objective drawing?

Fantasy

Fantasy is perhaps the most obvious aspect of imagination and the most familiar to the general public. The ability to fantasize involves conceiving objects, as well

below left: 346. René Magritte
(1898–1967; Belgian).
The Thought Which Sees. 1965.
Graphite, 15¾ × 11¾″ (40 × 30 cm).
Museum of Modern Art, New York
(gift of Mr. and Mrs.
Charles B. Benenson).

below: 347. Alfred Kŭbin
(1877–1959; Czech-Austrian).
The Serpent Dream. c. 1905.
Pencil, 10 × 8¼″ (25 × 21 cm).
Albertina, Vienna.

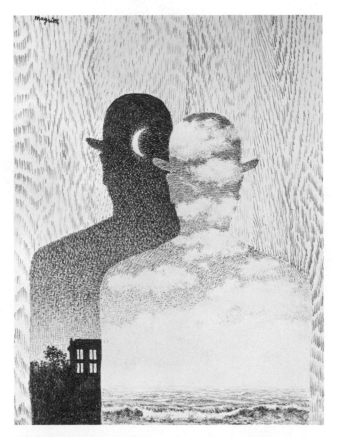

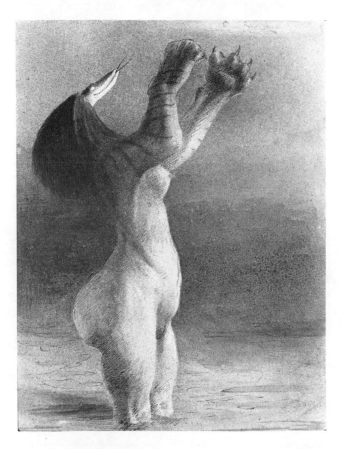

as combinations of and relationships between objects, that do not occur in the external world. Fantasy is the opposite of reason. As in a dream world, familiar forms are assembled in a manner that violates all rational everyday relationships (Fig. 346) and often conjures a grotesque but fascinating world (Fig. 347).

Project 169 Create a dreamlike fantasy using unexpected juxtaposition of recognizable forms and the metamorphosis of images. Employ a medium such as chalk, charcoal, or powdered graphite that you can manipulate freely and from which lights can be erased. Skillful use of traditional chiaroscuro to define three-dimensional form lends a reality to Alfred Kŭbin's Serpent Dream (Fig. 347).

Almost everyone has experienced and can identify with the strange combinations and transformations of images and identities that characterize the dream world. Many people, however, including some artists, are limited in their response to the waking world by the external appearance of things. The eyes of Claes Oldenburg know no such limitation; for him, the appearance of the real world is but a source for fanciful and surreal reinterpretation (Fig. 348).

Another aspect of fantasy allows for the visualization of projects involving the transformation of the real world in a manner that violates all conventional thinking. Thus Christo conceived of wrapping and tying the Allied Chemical Tower in New York City as if to facilitate its transfer to another site (Fig. 349). As the

below: 348. Claes Oldenburg (b. 1929; Swedish-American). *Proposal for a Cathedral in the Form of a Colossal Faucet, Lake Union, Seattle.* 1972. Crayon, pencil, and watercolor; 29 × 22⅞'' (74 × 58 cm). Whitney Museum of American Art, New York (gift of Knoll International and purchase).

below right: 349. Christo (b. 1935; Bulgarian-American). *Packed Building,* project for Allied Chemical Tower, New York. 1968. Pencil, charcoal, and color pencil; 8 × 3' (2.44 × .91 m). Private collection, Paris

350. Paul Klee
(1879–1940; Swiss-German).
A Balance-Capriccio. 1923.
Pen and ink,
9 × 12⅛″ (23 × 31 cm).
Museum of Modern Art, New York
(A. Conger Goodyear Fund).

catalogue to the Whitney Museum exhibition remarks, this fanciful drawing challenges and teases the viewer with an idea that will never be realized.

Fantasy can also depart almost completely from the world around us and move into a realm of playful improvisation. Klee was an acknowledged master of this type of imaginative activity (Fig. 350). More than almost any other late-19th-century or early-20th-century artist, Klee initiated a new sensibility by exploring the world of fantasy and feeling with almost no dependence on the conventions and disciplines of his day.

Project 170 *Just as the unexpected juxtaposition of images lends itself to fantasy, so too does unexplained change in size from large to small or small to large. Do a drawing of familiar objects in which fantasy is a factor of ambiguity in scale. It is essential that the size discrepancy appear intentional, rather than the result of inaccurate drawing.*

Particularization

The third and fourth forms of imaginative activity—particularization and generalization—represent opposite facets of the ability to "see" relationships, similarities, and differences. It is this capacity that enables us to classify, relate, and differentiate. "Particularization" means selecting the characteristic details that evoke the image of the whole. The caricaturist does this with remarkable effectiveness, individualizing a face by exaggerating unique features to the point where likeness and fantasy are poised in delicate equilibrium (Fig. 319). René Bouché's portrait of Frederick Kiesler (Fig. 351) is a splendid example of selective emphasis of features and details that most reveal the thoughtful attentiveness of the sitter.

Project 171 *This assignment can be done from life or by working from an essentially objective drawing from an earlier assignment. The subject can be a person or object; your aim is to particularize, to stress unique features. Study your subject carefully to select those features that most clearly identify the person or object and draw just those details. Leave out as much as possible; draw no more than is necessary to establish the identity.*

Synthesis in Drawing

351. René Robert Bouché
(1905–1963; Czech-American)
Frederick Kiesler. 1954.
Pencil, 25 × 19'' (64 × 48 cm).
Museum of Modern Art, New York
(gift of the artist).

Another aspect of particularization is to play with a fact of appearance until its character is most sharply defined and to communicate this with such intensity that the observer sees the object with the sensitivity of the artist.

Project 172 *Selective choosing of characteristic details to convey the essence of the subject does not preclude manipulation and distortion of appearances for increased expressive effect (Figs. 17, 22). If in the preceding project you chose to define the selected features in a strongly realistic and literal manner, do another drawing incorporating distortion or manipulation of scale to provide greater insight into the subject.*

Generalization

Generalization creates symbols that reveal relationships and similarities. The artist who discards individual idiosyncracies of form to create a monumental symbol, as did Michelangelo with the human body (Fig. 263), has this capacity. Umberto Boccioni was intrigued with the idea of communicating a dynamic sense of movement through another mode of generalization—semiabstracted forms. In his study for *Dynamic Force of a Cyclist* (Fig. 352) he created an abstraction to symbolize speed and movement, the dynamic elements of cycling. Much as a poetic phrase can condense into a few words a complex experience that would demand lengthy prose exposition, so here, through imagination, a complex time-space experience is compressed into a potent abstract pattern. Marisol interprets much the same theme in an imaginative color pencil and crayon drawing (Pl. 12, p. 256), the impact of which is intensified with life-size images.

352. Umberto Boccioni
(1882–1916; Italian). Study for
Dynamic Force of a Cyclist, II.
Ink, 8¼ × 12¼″ (21 × 31 cm).
Yale University Art Gallery,
New Haven, Conn.
(Collection of Société Anonyme).

Project 173 Select a subject or activity, perhaps one involving a series of sequential movements that can be compressed into a semiabstract symbolic image. Analytical and inventive capacities must work together to achieve such imaginative compression. Symbolize rather than define objects and persons. De Kooning's Two Women's Torsos (Pl. 9, p. 222) might be studied both for form and technique.

Imagination and the Art Elements

We have seen a variety of drawings in which some aspect of the external world has provided a point of departure for an imaginative interpretation of experience. The art elements can in themselves provide inspiration, for a line, a texture, or a pattern can also stimulate imaginative activity. In *Large Drawing #4* (Fig. 353), Lucas Samaras evidences greater interest in the labyrinthian complexity of linear pattern than in the X-ray origin of the skull.

Klee's charming ink drawing *Costumed Puppets* (Fig. 354) appears to have been inspired by a source other than observing puppets. Close examination reveals this drawing to be made almost entirely from lines that begin and end in spirals. One can visualize Klee entertaining himself by seeing how many such lines he could use to construct parts of the human anatomy or costume details, improvising playfully almost in the spirit of doodling.

As in all of Klee's works, the formal and abstract factors interplay continuously with evocative and poetic elements (Figs. 18, 60, 138, 204, 216, 288, 350). Thus, though his initial inspiration may have been lines beginning and ending in spirals, and though we may be fascinated by the ingenuity with which Klee fitted the spirals together to make the doll-like figures, the completed work evokes a sense of the whimsical and droll gaiety of puppets. The titles of his works, the works themselves, and his diaries all reveal imaginative play of exhilarating variety and sensitivity. Klee saw relationships between remote and previously unrelated objects, as the depths of his subconscious mind fed the artist's capacity to generate fanciful and unexpected affinities. The faded, pastel colors of an old cloth, a certain kind of line, or some unusual texture might provide the initial stimulus, after which his imagination, moving in its own oblique and unpredictable trajectory, made illuminating contacts with the cityscape; the landscape; the

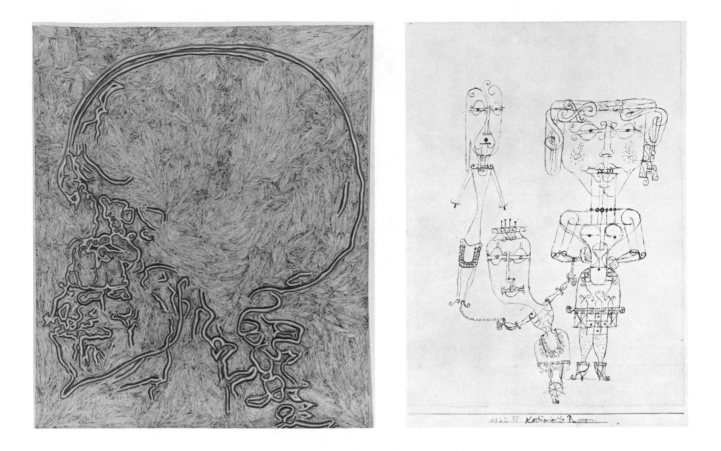

world of music, literature, and the theater; and other of his many areas of intense enthusiasm.

Imagination can, of course, operate on a purely formal level, as in Ilya Bolotowsky's *Blue and Black Vertical* (Fig. 355). The precisely ruled vertical and horizontal ink lines have produced value and texture of elegant richness, suggestive of, though not representing, sections of beautifully finished fine-grained wood.

Project 174 Select a line, shape, or texture and do a drawing that is an imaginative elaboration of that one element. Although the element selected may have been suggested by something in the visible world, do not do a representational drawing of that form. Use it only as a point of departure for a drawing that may have no further reference to the initial stimulus.

Imagination and Temperament

Viktor Lowenfeld, one of the most systematic students of the development of pictorial expression, perceived that various types of personalities reacted to visual experience in different ways. Lowenfeld theorized that there are two main types of expression that represent two extreme poles of artistic personality: the *visual* and the *haptic.* Visual people concern themselves primarily with the visible environment. Their eyes constitute their primary instrument for perception, and they react as spectators to experience. Haptic, or nonvisual, people, on the other hand, relate their expression to their own bodily sensations and the subjective experiences in which they become emotionally involved; they depend more on touch, bodily feelings, muscular sensations, and empathic responses to verbal descriptions or dramatic presentations. Quite obviously, the temperament—the predominant personality type—of the artist will seriously affect the

Imagination

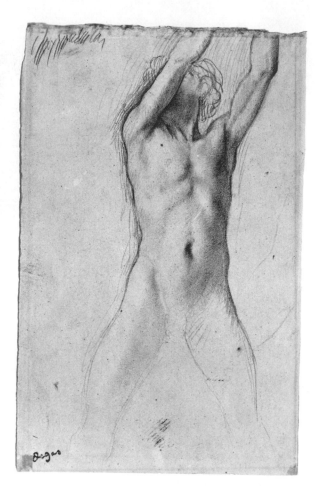

way the imagination is brought to bear. To illustrate this point, we might compare two artists, Edgar Degas and Rico Lebrun, as characteristic examples, respectively, of visual and haptic personalities.

Degas made the depiction of forms in movement a major concern of his work, and the visual "truth" of his pictorial statements gives ample evidence of this concern. In his study of a nude youth (Fig. 356) we see that even as a young

above left: 355. Ilya Bolotowsky
(1907–1981; Russian-American).
Blue and Black Vertical. 1971.
Pen and ink, 30 × 22'' (76 × 56 cm).
Private collection.

above: 356. Edgar Degas
(1834–1917; French).
Nude Youth. c. 1860.
Pencil on paper,
11¼ × 7'' (29 × 18 cm).
Detroit Institute of Arts
(bequest of John S. Newberry).

left: 357. Rico Lebrun
(1900–1964; Italian-American).
Running Woman with Child.
Ink on gray paper,
18¾ × 25⅜'' (48 × 64 cm).
Sheldon Memorial Art Gallery,
University of Nebraska, Lincoln.

358. Irmagean
(b. 1947; American).
Emerging. 1980.
Charcoal on paper,
24½ × 42⅛″ (62 × 107 cm).
Courtesy the artist.

artist his sharp eye and skilled hand recorded with unerring certainty the nuances of gesture, balance, and form. Degas' line, even in his freest sketches, is controlled; it exists only to describe the visual appearance of form. In contrast, Lebrun's anguished image, *Running Woman with Child* (Fig. 357) forcefully recreates the physical "truth" of the bodily sensation of running.

Van Gogh's haptic personality shaped a style of enormous expressive intensity. Unlike a visual artist's description of texture, Van Gogh seemed to feel each surface in physical terms; he empathized with each roughness and smoothness, as well as with each movement beneath the surface (Figs. 79, 118, 195, 255).

Almost no one is completely visual or completely haptic in orientation, and, more than ever before, contemporary artists are exploring their experiences through senses and sources other than their eyes. The rhythmic movement in Irmagean's *Emerging* (Fig. 358) conveys a strong haptic response to dancing figures, while the handling of the voluminous drapery suggests an equally strong visual response. Forms that at one moment seem to define individual dancers suddenly disappear into broad, sweeping strokes of charcoal that duplicate the actual movements of dancers' arms and bodies in time and space. To the degree that one remains receptive to a wide variety of stimuli, a rich and diverse imagination develops.

Project 175 Assume the same pose as a figure you wish to depict. Experience the movement and tensions in the back, head, legs, and arms. Perceive the distribution of weight and balance or stress of the posture before you begin to draw. To render the texture of a subject, supplement your visual perceptions with actual tactile experience.

Improvisation

Imaginative play in artistic expression can take the form of improvising on a simple and familiar motif. In his *Numbers* (Fig. 359) Jasper Johns has enriched the simple Arabic numerals by playful texturing of numbers and background. He has manipulated forms generally associated with flatness to achieve visual and spatial ambiguity. Almost any familiar shape or object can provide the subject for visual improvisation, in the same way that a simple melodic theme can initiate elaborate musical invention.

Larry Rivers has improvised upon Rembrandt's painting *The Polish Rider* in his study for *Rainbow Rembrandt* (Fig. 360). The title refers to the row of

squares with color notations across the top of the drawing, inspired by the color scale used by commercial photographers when copying a work for reproduction. It is doubtful that Rembrandt would object to Rivers' reinterpreting his painting since Rembrandt himself took delight in revising the works of such masters as Leonardo da Vinci.

Doodling is an imaginative activity and can function as a stimulus to creativeness. The surrealistic superimposing of images in Pavel Tchelitchew's *The Blue Clown* can be viewed as the elaboration of a doodle (Fig. 361). Doodling need not be, and perhaps never is, meaningless scribbles. Tchelitchew spoke of "the spontaneous draughtsman's rapid line . . . supported by intuition based on past observation." Any concept or experience that stimulates you to draw acts as a legitimate and important resource for artistic activity.

359. Jasper Johns
(b. 1930; American).
Numbers, detail. 1960.
Charcoal on paper;
3 of 10 drawings matted separately,
each 2¾ × 2¼'' (7 × 6 cm).
Courtesy Leo Castelli Gallery,
New York.

360. Larry Rivers
(b. 1923; American).
Study for *Rainbow Rembrandt.*
1977. Pencil on paper,
29¾ × 41¾'' (76 × 106 cm).
Courtesy Robert Miller Gallery,
New York.

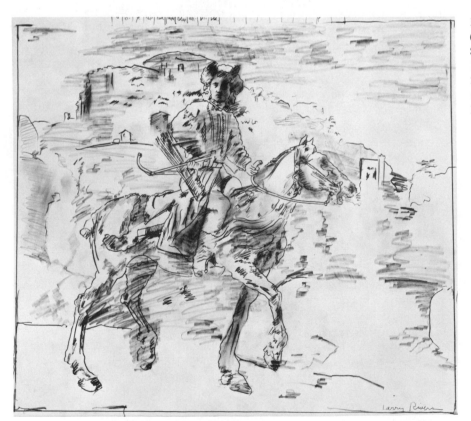

Project 176 On those occasions when you find yourself with pencil, pen, or any other drawing implement at hand, and nothing else to do for even a few minutes, develop the habit of drawing extemporaneously. Draw freely, joyfully, without any preconceptions. Let forms and images emerge in the process of drawing. Your initial efforts may seem forced, but when you relinquish the idea of "making a drawing" and become willing to let anything occur or not occur, you will soon find yourself caught up in imaginative play.

Imaginative Use of Media

Imagination manifests itself in how, what, and with what one draws. The imaginative person thinks of unconventional uses for familiar materials, or unorthodox combinations of media, and extends the limits of techniques by invention. An imaginative artist might, for example, experiment with drawing with clusters of pencils or pens, possibly of different colors. Such a person will be equally imaginative about inventing situations in which the resulting effects can be used for expressive purposes.

Traditional concepts of "correct" methods for using or combining materials may inhibit imaginative exploration by defining too strictly the boundaries of acceptability. Children are rarely hindered by such artificial constraints, and from their art work mature artists can take refreshing inspiration. Unusual mix-

361. Pavel Tchelitchew
(1898–1957; Russian-American).
Study for *The Blue Clown*. 1929.
Pen and brush and ink,
16 × 10½'' (41 × 27 cm).
Museum of Modern Art, New York
(Mrs. Simon Guggenheim Fund).

Imagination

tures of media often result in unexpected patterns and textures; since mixed media cannot always be controlled, the artist must be prepared to incorporate the resulting accidental effects.

Robert Rauschenberg was one of the first artists to introduce printed images from newspapers and magazines into his drawings (Fig. 362). The newspaper or magazine page, dampened with lighter fluid, is placed face down on the drawing paper, and the image is transferred by rubbing with a pencil. The pattern of pencil strokes becomes part of the reverse image.

The American Eat (Fig. 363) is one of a series of drawings created by Robert Indiana using exactly the same method that children use to make rubbings of coins (see also Proj. 38, p. 78). The technique is called *frottage*. Indiana has made his rubbing from brass stencils with conté crayon. The beauty of the drawing lies not in the letters, but in the variety and richness of the tones created by his hatching. Indiana's drawing bears strong resemblance to Jasper Johns' *Numbers* (Fig. 359). The two artists could easily exchange symbols—Johns taking the letters, Indiana the numerals—without significantly altering what each has done since medium and technique is the context of their drawings.

Using yet another transfer method, David Hammons took a bold leap in the exploitation of media to conceive his *Injustice Case* (Fig. 364). He covered his body and the chair to which he was bound with paint, ink, and other substances, then pressed the entire ensemble to a piece of paper as another artist might print an etching plate or lithographic stone. Both the scale of the print and its content contribute to the power of the image as a unique protest against injustice. Created during a period of widespread political protest, the flag border provides added impact.

Artists have been encouraged to explore new uses and combinations of materials by the great expansion of artists' media that has resulted from modern technological developments. All challenge the artist's inventive powers, but the abundance of new materials and the inventive attitude toward techniques so characteristic of today is not an unmixed blessing. An undue concern with invention, with new materials and techniques, can distract one from more profound expressive concerns. It is easy to become enamored of surface qualities without giving sufficient thought to the deeper levels of interpretation and meaning that constitute the major significance of works of art. It is also possible to flit from one fascinating material to the next without ever fully exploring the potential of any one. A period of exploration and experimentation is necessary, however, for every artist, because only by such a process does one find the materials best suited to one's individual temperament.

362. Robert Rauschenberg (b. 1925; American). *Battery.* 1965. Combine drawing, 24 × 36″ (61 × 91 cm). Courtesy Leo Castelli Gallery, New York.

363. Robert Indiana
(b. 1928; American).
The American Eat. 1962.
Conté crayon rubbing,
25 × 19'' (64 × 48 cm).
Yale University Art Gallery,
New Haven, Conn. (lent by
Richard Brown Baker).

Feeding the Imagination

Picasso is quoted as saying, "If the subjects I have wanted to express have suggested different ways of expression, I never hesitated to adopt them." Whether he actually was born knowing how to draw, as has been suggested, Picasso had the technical skills necessary to give form to all the inventions of his fertile imagination. Imagination is of little value to artists if they have not mastered their craft sufficiently to provide visual realization for their concepts.

This final chapter has reiterated, as was stated near the beginning of the book, that expressive drawing requires more than accurate rendering and skillful manipulation of media and technique. There are, unfortunately, no foolproof formulas or successful mechanical approaches to drawing with expression. You must determine what works for you.

Most people by nature like to do what they can do successfully. Willingness to experiment leads to development and growth, and you are encouraged to initiate change. That does not mean that every drawing must be different; it merely suggests that you should avoid prolonged repetition of only those things you are comfortable doing. In your quest for creative growth, be aware that imagination does not demand complete orginality. When pursued for it's own sake, originality quickly exhausts itself. Imagination and originality, as we have seen, need be nothing more than your own unique interpretation and expression of feelings.

It is not uncommon to hear students say, "All I want to do is draw" (or paint or sculpt or throw pots). If one chooses to be an artist, commitment is important, even imperative. Commitment is reflected in the eagerness, willingness, and persistence to do more than settle for the easiest and most obvious solution to a project. At the same time, however, art students are responsible for more than mastering the craft of drawing and painting. They must be willing to expand their awareness to include other areas of learning and experience beyond the studio to stimulate creative growth.

364. David Hammons
(b. 1943; American).
Injustice Case. 1970.
Mixed media print,
5'3'' × 3'4½'' (1.6 × 1.03 m).
Los Angeles County Museum of Art
(Museum Purchase Fund).

The noted science fiction author Ray Bradbury, when asked, said that he had never experienced "writer's block," because he had spent his life "feeding the muse." Looking, seeing, reading, and being aware of and sensitive to life are essential to all creative people; they are as necessary to an artist as learning to draw. To say that you have no ideas means that you have stopped experiencing.

Ben Shahn (Figs. 39, 49, 81), writing about the education of an artist, states, "There is no content of knowledge that is not pertinent [to the artist]." He advises the student to learn everything possible about art by taking classes, working independently, looking at art, going to museums and galleries, and reading about art. Beyond that, he stresses the importance of studying all other subjects, both in the humanities and science. He urges the student to read, to be knowledgeable about literature, religion, history, and philosophy. Other recommended learning experiences include getting a job, observing people, listening to people, talking to people—and, perhaps most important, thinking about and integrating the accumulated experiences so that they might feed the imagination and become part of the identity of an artist. As Shahn points out, "Such an art education has no beginning and no end."

Index

Index

Photographic Sources